The Incomplete

Volume 2

Highsnobiety Guide
to Creative Collaborations

gestalten

Contents

4	The Key Is in the Collaboration, A Letter from David Fischer, *Founder, Highsnobiety*
6	A$AP ROCKY X PUMA
12	AUDEMARS PIGUET X KAWS
16	FENDER X HIROSHI FUJIWARA
20	AUDEMARS PIGUET X 1017 ALYX 9SM
24	POKÉMON X VAN GOGH MUSEUM
28	HEINZ X ABSOLUT VODKA
30	EVIAN X VIRGIL ABLOH
32	THE NORTH FACE X BIALETTI
34	PUMA X DUNKIN'
36	NIKE X SACAI
38	MERCEDES-BENZ X MONCLER BY NIGO
42	LEGO® X NASA
46	LEGO® X STAR WARS™
52	How Marc Jacobs, Kim Jones, and Virgil Abloh Made Collaborations Luxurious
62	PRADA X ADIDAS
66	PRADA X HOMER
68	RICK OWENS X DR. MARTENS
72	DIOR X AIR JORDAN
74	DIOR X STONE ISLAND
76	LOUIS VUITTON X NIKE
78	JJJJOUND X BAPE
82	NIKE X OFF-WHITE™
84	LOUIS VUITTON X SUPREME
88	STÜSSY X DRIES VAN NOTEN
94	LOUIS VUITTON X TIMBERLAND
98	APPLE X BEATS
102	GANNI X NEW BALANCE
106	RIMOWA X OFF-WHITE™

108	AURALEE X NEW BALANCE
110	AIMÉ LEON DORE X NEW BALANCE
114	BEAMS X ARC'TERYX

118 Novel Ideas: Kitsch, Novelty, and the Power of Surprise

128	DUNKIN' X SCRUB DADDY
130	DUNKIN' X SAUCONY
134	BRAVEST X KID CUDI
136	CROCS X KFC
138	CROCS X SALEHE BEMBURY
142	DIOR X KAWS
146	Y/PROJECT X UGG

150 From Pop to Pop Culture: Art's Crossovers with Streetwear, Fashion, and Consumer Products

158	OVO X NFL
162	DENIM TEARS X LEVI'S
168	HUF X KODAK
172	ADIDAS ORIGINALS X WALES BONNER
180	STÜSSY X BIRKENSTOCK
184	SANDY LIANG X SALOMON
188	HOKA X SATISFY
192	STÜSSY X MOUNTAIN HARDWEAR
196	BALENCIAGA X CROCS
200	THE NORTH FACE X MM6 MAISON MARGIELA
204	MONCLER GENIUS
214	UNIQLO X JW ANDERSON
218	UNDERCOVER X EVANGELION

222 "X" Marks the Spot: The Recipe for a Perfect Collab

232	MERCEDES-BENZ X VIRGIL ABLOH
238	PALACE X MERCEDES-BENZ
244	AIMÉ LEON DORE X PORSCHE
250	PAUL SMITH X LAND ROVER
252	BMW X JULIE MEHRETU
258	BMW X JEFF KOONS
264	PORSCHE X LA MARZOCCO
266	OMEGA X SWATCH

270 URL to IRL: The Future of Collaboration

278	PHOTO INDEX

The Key Is in the Collaboration

A Letter from David Fischer

4

There was no grand plan when Highsnobiety launched in 2005—just an impulse to document and share the things that fascinated us. Streetwear was a subculture on the rise and collaborations were still a rare phenomenon. At the time, a collaboration wasn't a marketing strategy; it was a creative exchange, a meeting of minds between brands and artists who respected each other's work. Seeing someone wearing an early streetwear collaboration back in those days—like Supreme and Nike, UNDERCOVER and A Bathing Ape, or Stüssy and Fragment—felt like a secret handshake, a nod to those paying attention.

As Highsnobiety grew, so did the world of collaborations. At the beginning, we were one of the only publications to even cover the rise of streetwear and the universe of collaborations it spawned. Then, what started in the underground seeped into the mainstream, collaborations shifted from niche partnerships between streetwear and sneaker brands to luxury fashion stunts. Designers like Marc Jacobs, Kim Jones, and Virgil Abloh played crucial roles in bringing collaborations to the realm of high fashion—Supreme x Louis Vuitton, and Fendi x Versace wouldn't have happened without those designers being so attuned to what was happening in streetwear. Then, the floodgates opened and the rest of fashion followed.

Today, collaborations are everywhere: Vetements teamed up with DHL, Prada created a NASA spacesuit with Axiom Space, Supreme released boxing gear with Everlast, the list goes on. The novelty of the collaboration has evolved from being about exclusivity to creating unexpected moments that redefine cultural credibility.

While collaborations may have evolved, what makes a good one hasn't. Meaningful collaborations are about more than simply doubling logos, they're a genuine exchange that leads to something new and unexpected from both partners—something that neither brand could have achieved alone. But most importantly, it has to feel undeniably now.

At Highsnobiety, we've never just been observers of this culture—we've been part of its evolution, even working behind-the-scenes to matchmake some of our favorite pairings. Our own releases have allowed us not just to document, but actively innovate the realm of collaborations. We've brought cultural institutions like the Bauhaus Archiv, Café de Flore, and the Barbican into the fashion space, often for the first time. Whether celebrating heritage, redefining aesthetics, or bridging unexpected worlds, these collaborations reflect our core belief: that culture is built through connection.

With collaborations now a confirmed force across industries, the question isn't whether they'll continue but rather, how they'll evolve. As the landscape shifts, the best collaborations will be the ones that bring something entirely new to the table, going beyond hype to create lasting impact. They'll be the ones that feel organic, that tell stories, that make us see something familiar in a new light.

Looking ahead, we see endless opportunities. As technology reshapes how we interact with culture, collaborations will extend into new territories, from digital fashion to immersive experiences and beyond. But at its heart, collaboration will remain what it has always been: a way for visionaries to meet, to exchange ideas, and to create something bigger than themselves. That's why it will always be central to Highsnobiety—this book both reflects our journey and offers a glimpse of what's to come.

David Fischer
Founder, Highsnobiety

Revving Up the F1 Collab with Sleek, Street-Inspired Designs

A$AP ROCKY **X** **PUMA**

Building on his cultural influence, A$AP Rocky brings his signature blend of luxury and streetwear to Puma's F1 collaborations, infusing the collection with a futuristic, automotive-inspired aesthetic.

Puma's relationship with Formula 1 has spanned over two decades, providing high-performance, cutting-edge athletic gear to teams and drivers. In 2023, the brand brought A$AP Rocky on to act as a holistic creative designer across the culture of the brand, following successful partnerships with stars like Rihanna and J. Cole. The resulting A$AP Rocky x Puma F1 collaborations fuse high fashion with automotive culture, resulting in a sleek, futuristic aesthetic that draws inspiration from both luxury cars and Rocky's signature streetwear style. The designs across jackets and shoes are bold and performance-driven, featuring clean lines, metallic finishes, and striking angular shapes that mirror the precision and elegance of Formula 1 cars. Sneakers like the RS-X^3 blend materials such as suede, leather, and mesh with reflective accents, chunky soles, and dynamic, eye-catching silhouettes. Rocky's influence extends to the campaign visuals, videos, and activations, which are infused with a high-energy, polished look that bridges the worlds of music, fashion, and motor sports.

The collaboration was a hit, earning Collaboration of the Year at the Footwear News Achievement Awards (the "Shoe Oscars"), furthering Puma's reputation for pushing boundaries and making a statement across fields. Rocky's impact on the collaboration went beyond the product itself—he became the driving creative force behind the campaign, curating activations at Grand Prix races in Miami and beyond. He even served as the creative director for all of the marketing and visuals surrounding the collaboration. His hands-on approach included creating exclusive videos and experiences, enhancing the overall narrative, and making the collab an immersive experience for fans. He's currently set to continue shaping all future Puma x F1 products, from racewear to fan wear to fashion, bringing his stylistic perspective to every aspect of the brand.

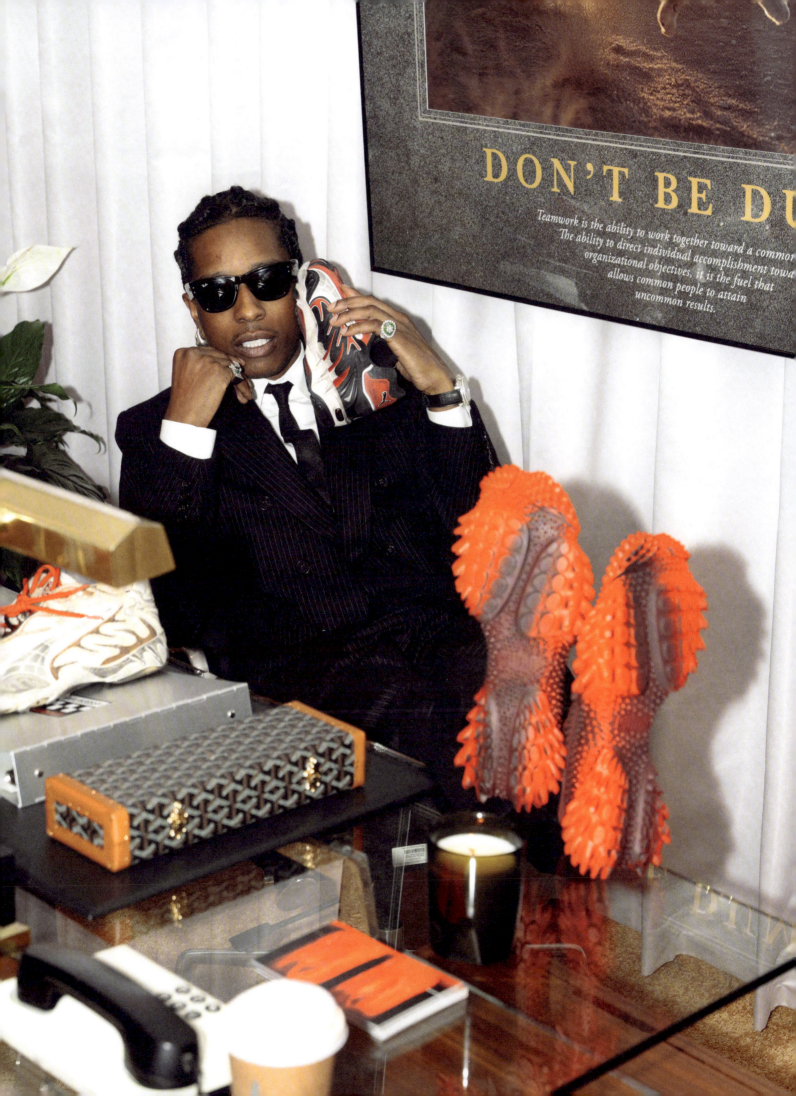

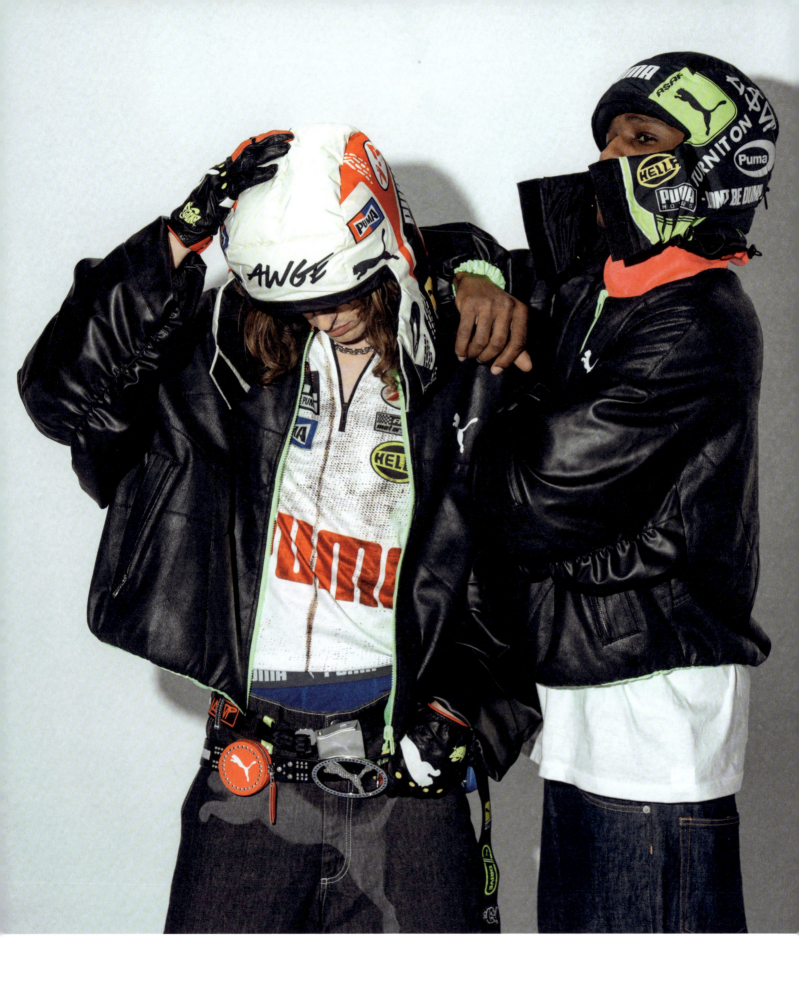

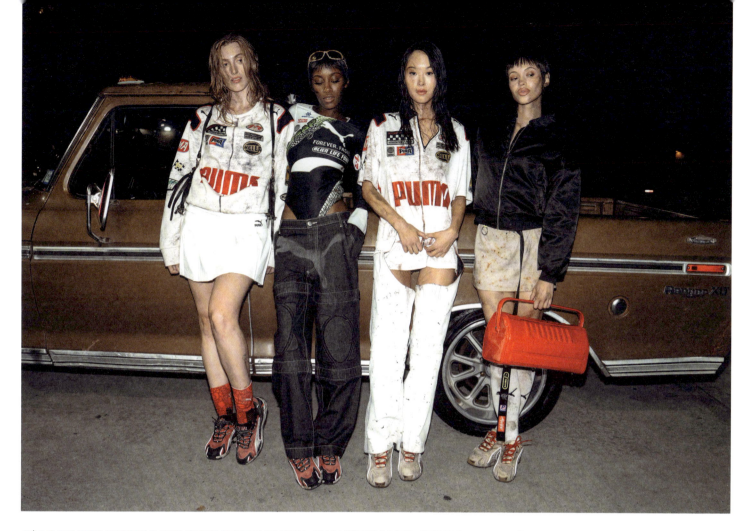

A$AP ROCKY BRINGS HIS SIGNATURE BLEND OF LUXURY AND STREETWEAR TO PUMA'S F1 COLLABORATIONS.

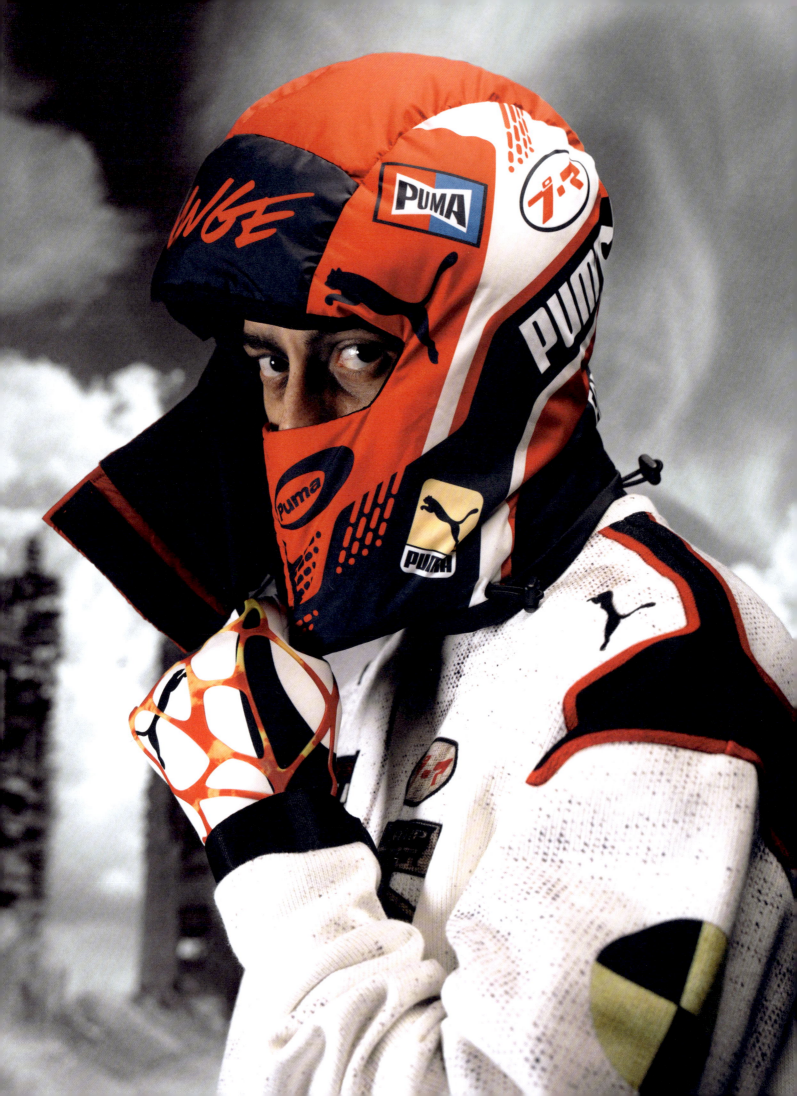

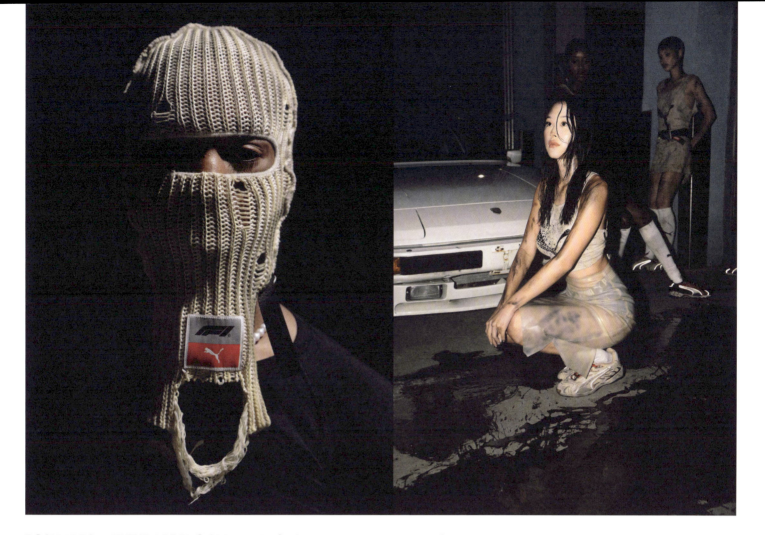

ROCKY BECAME THE DRIVING CREATIVE FORCE BEHIND THE CAMPAIGN, CURATING ACTIVATIONS AT GRAND PRIX RACES.

The Iconic Royal Oak Concept Is Visited by a "COMPANION"

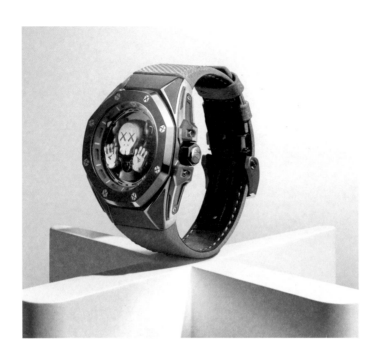

AUDEMARS PIGUET X **KAWS**

The iconic luxury watchmaker teams up with the famed New York-based artist for a singular timepiece that blends high-end craftsmanship with KAWS's signature style.

In late 2024, Audemars Piguet (AP) teamed up with legendary artist KAWS for a collaboration that introduced a unique twist to the legendary watchmaking company. The partnership was announced with the unveiling of the Royal Oak Concept Tourbillon "COMPANION"—a stunning limited-edition timepiece that brought KAWS's iconic COMPANION character to life in a way never seen before.

The collaboration resulted in a stunning 43-mm limited-edition Royal Oak Concept Tourbillon, crafted in titanium with a ceramic crown. At the heart of the timepiece is a miniature KAWS COMPANION, a nod to the artist's signature character, placed directly at the center of the dial. The COMPANION figure (made of solid titanium, of course) appears to be pressing his hands and face against the crystal, peering outward. The design's brilliance lies in its ambiguity: is he gazing adoringly at the wearer? Or is he trapped and pleading to be set free? Equal parts whimsical and unsettling, this watch is a perfect example of KAWS's distinctive genius.

From a technical perspective, one of the most striking features of the watch is its peripheral time display, a revolutionary design that moves the hour and minute hands to the outer edge of the dial, offering a clear, unobstructed view of the COMPANION character. The time hands rotate around the periphery, driven by two visible superimposed gear wheels, guided by rollers. This innovative design pushes the boundaries of traditional watchmaking, ensuring the COMPANION takes center stage. The watch is powered by a hand-wound movement, Calibre 2979, which also features a tourbillon at the 6 o'clock mark. The tourbillon, a high-end complication designed to counteract the effects of gravity on the watch's accuracy, adds another layer of sophistication to this already luxurious timepiece.

This limited-edition watch was unveiled during the KAWS:HOLIDAY exhibition in Le Brassus, Switzerland, where KAWS also created an 18-inch walnut sculpture of COMPANION sitting atop the AP headquarters as a symbolic tribute to the collaboration. The Royal Oak Concept Tourbillon "COMPANION" showcases the fusion of KAWS's bold artistic style with AP's precision craftsmanship, making it a truly unique and collectible piece in the world of luxury timepieces.

AUDEMARS PIGUET X KAWS

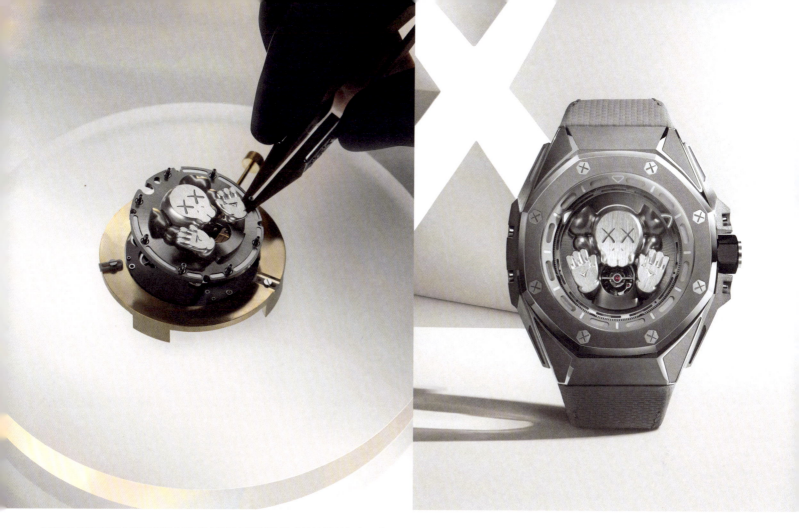

THE WATCH SHOWCASES THE FUSION OF KAWS'S BOLD ARTISTIC STYLE WITH AP'S PRECISION CRAFTSMANSHIP.

A Minimalist Telecaster for the Modern Musician

FENDER

Building on their legacy of high-profile collaborations, Fender and Hiroshi Fujiwara's fragment design drop a limited-edition Telecaster guitar alongside a capsule collection featuring the cryptic phrase "MUTING CONGRESS."

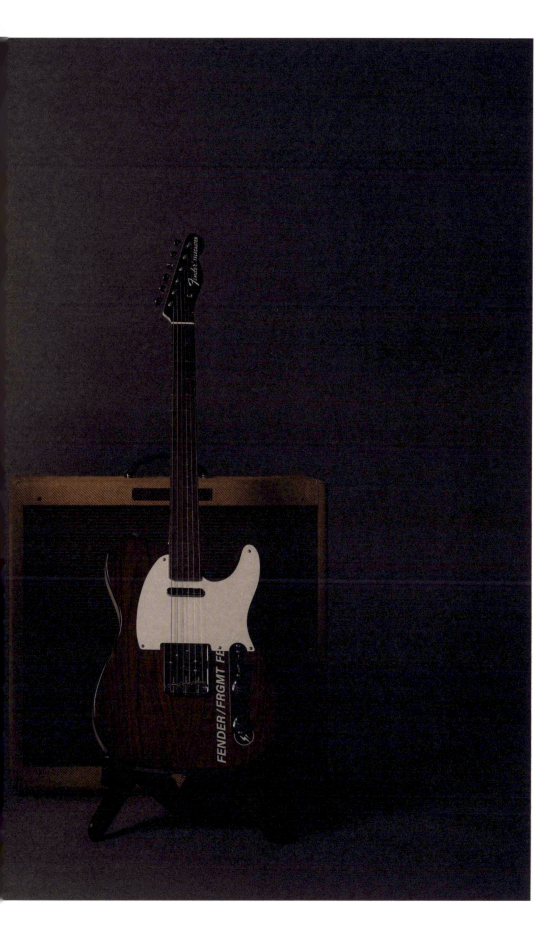

HIROSHI FUJIWARA

Fender's collaborations have always been at the intersection of music, fashion, and artistry, from having guitars customized by artists like Nile Rodgers and Kurt Cobain to creating signature models for rock icons like Jimmy Page of Led Zeppelin. The brand has even ventured into the streetwear world with releases alongside Supreme, blending iconic guitar craftsmanship with fresh, trend-forward design. Now, their latest collaboration with fragment design—Hiroshi Fujiwara's creative agency/fashion label—builds on that legacy, marking yet another exciting chapter in Fender's exploration of culture and creativity. In December 2024, Fender and fragment design unveiled a limited-edition Telecaster guitar that masterfully blended the worlds of fashion and music.

The Telecaster features a body and fingerboard crafted from rosewood, chosen for its rich grain and warm tones. Both the body and neck plate bear subtle "FENDER/FRGMT" engravings, adding a touch of understated branding. Departing from traditional designs, the fingerboard omits dot markers, offering a sleek and clean aesthetic. Available in black and white colorways, the engravings on each guitar match its respective body color, maintaining a cohesive look.

This collaboration emerged from a mutual appreciation for minimalist design and superior craftsmanship, culminating in a coveted instrument. Fujiwara approached the design with the philosophy of crafting "a simple and beautiful Telecaster guitar that is like a warm piece of furniture," reflecting his penchant for blending functionality with art. The use of rosewood not only enhances the guitar's visual appeal but also enriches its tonal quality, providing musicians with a unique playing experience.

To complement the guitar, the collaboration also included a capsule collection, with guitar straps, picks, and apparel emblazoned with the phrase "MUTING CONGRESS." While not widely defined, "muting congress" could be taken to symbolize Fujiwara's approach of reducing unnecessary noise in design—both literally and figuratively. It implies stripping down and simplifying things to their core, removing any excess that distracts from the essence.

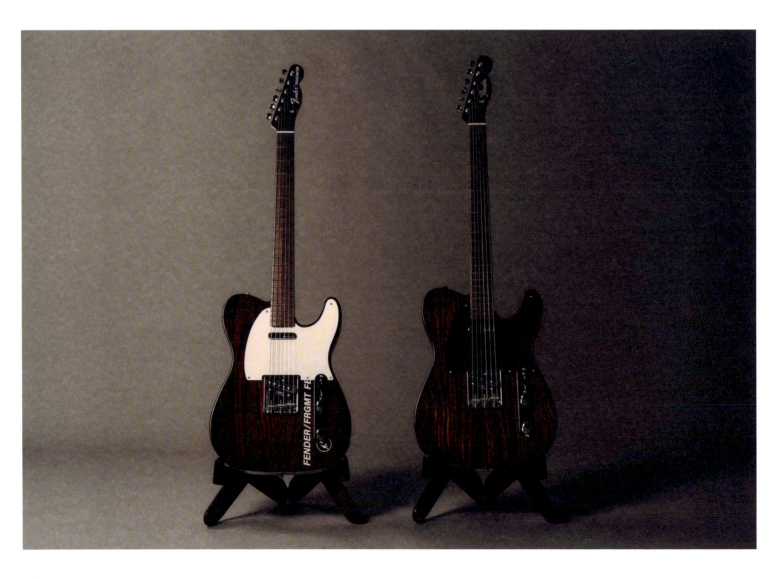

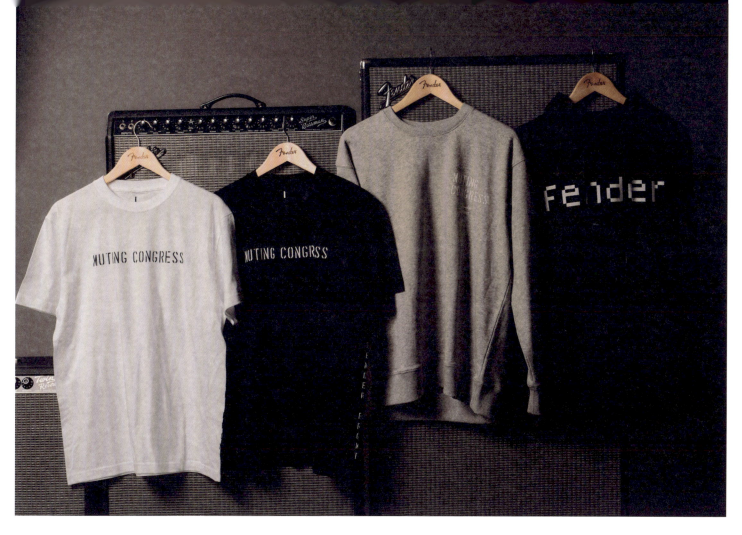

FENDER'S COLLABORATIONS HAVE ALWAYS BEEN AT THE INTERSECTION OF MUSIC, FASHION, AND ARTISTRY.

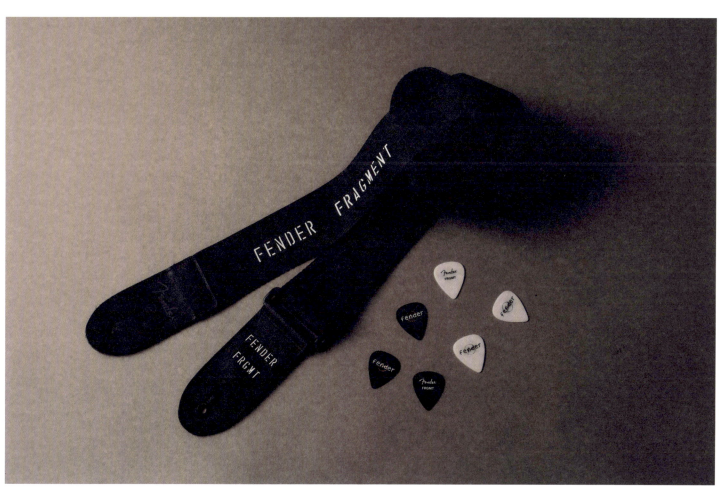

Where Luxury Meets Streetwear in a Timeless Collaboration

AUDEMARS PIGUET X **1017 ALYX 9SM**

The iconic Royal Oak and Royal Oak Offshore get a bold, minimalist makeover in this groundbreaking partnership, blending Audemars Piguet's watchmaking mastery with Matthew M. Williams's streetwear edge.

When Audemars Piguet (AP) and Matthew M. Williams's 1017 ALYX 9SM decided to join forces, the watch world buzzed with anticipation. The collaboration was first announced in Tokyo, with a focus on the Royal Oak and Royal Oak Offshore, AP's iconic luxury watches, known for their distinctive octagonal bezel, exposed screws, and integrated metal bracelet, which redefined traditional watch design when it debuted in 1972.

The collection unveiled four distinct timepieces, each a testament to refined simplicity. The 37-mm and 41-mm Royal Oaks, both crafted in 18-karat yellow gold, feature vertically brushed golden dials paired with luminescent hands. The 41-mm variant stands out as a chronograph, its subdials elegantly floating without traditional chapter rings. The 42 mm-Royal Oak Offshores, available in yellow and white gold, boast integrated chronographs with flyback functions, maintaining the collection's sleek design. A unique 41-mm, two-tone Royal Oak Chronograph, with a black PVD-coated dial and gold accents, was auctioned for over $1 million for a charity event raising money for underprivileged children, highlighting just how rare, and sought after, the collaboration was.

A defining feature of these watches is their minimalist aesthetic. Williams and AP stripped back the gold dials to their purest essence, showcasing elegant vertical satin finishing and three ultra-pared-down sub-dials. Notably, the face has no numbers or time notations, and instead, the design relies on the sub-dials—positioned at 3, 6, and 9—to orient the wearer. This ingenious simplicity emphasizes the vision for clean design and results in timeless monochrome pieces that marry refined aesthetics with advanced watchmaking. When asked about how he managed designing in a different form, Williams replied: "A collaboration like this allows for me to explore and extend my knowledge to another area of excellence."

THE SIMPLICITY EMPHASIZES THE VISION FOR CLEAN DESIGN AND RESULTS IN TIMELESS MONOCHROME PIECES.

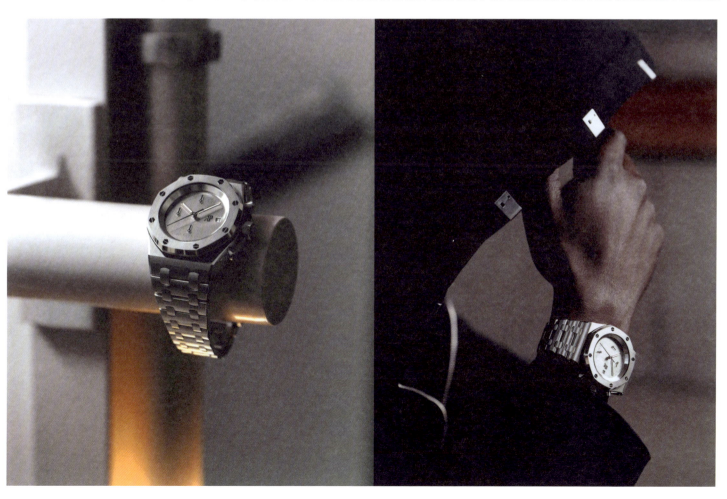

AUDEMARS PIGUET X 1017 ALYX 9SM

A Colorful Interactive Art Installation in Amsterdam to Celebrate a World of Wonder

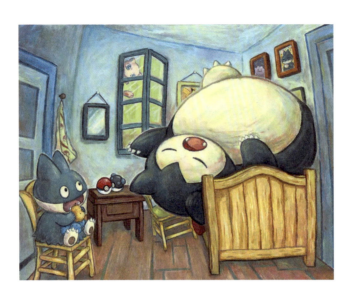

POKÉMON X **VAN GOGH MUSEUM**

From interactive sculptures to an immersive art exhibit, Pokémon found new ways to blend its vibrant world with fine art. The Van Gogh Museum exhibit reimagines masterpieces, such as with Pikachu in a Van Gogh self-portrait, in an effort to introduce the artist's legacy to the next generation.

For fans of the Pokémon franchise, the idea of spotting Pokémon in the wild is incredibly thrilling, and over the years, the popular franchise has made a point of giving ecstatic fans the chance to do just that. Pokémon sculptures have appeared in various public spaces, often tied to special events or collaborations—life-sized Pokémon statues can be found at Pokémon Center locations in cities like Tokyo and Yokohama; Pokémon art installations have popped up in London and New York; and the very popular Pokémon GO game allowed for players to use their phone cameras to "see" Pokémon hidden in the background of their everyday lives. But in 2023, Pokémon found their way into uncharted terrain: the world of fine art. Inspired by the connection between Vincent van Gogh and Japanese art—an influence that shaped many of the artist's most famous works—Amsterdam's Van Gogh Museum aimed to introduce the artist's legacy to a new generation, particularly children, via a sprawling, interactive installation.

The centerpiece of the partnership was a special exhibit, "Pokémon at the Van Gogh Museum," featuring six new Pokémon-themed paintings that reimagined van Gogh's masterpieces through a Pokémon lens. Pikachu was reinterpreted in the style of van Gogh's *Self-Portrait with Grey Felt Hat*, and Snorlax appeared in a piece inspired by van Gogh's *The Bedroom*. These whimsical art pieces celebrated the iconography of the animated characters while wrapping them into paintings—a visual effect that amplified the fantastical, dreamy nature of both the iconic artist's work and the imaginary world of the creatures they featured.

The collaboration offered various interactive elements, such as the Pokémon Adventure activity, which guided visitors through the museum to discover the Pokémon-themed art and learn about van Gogh's work, including offering visitors a Pikachu trading card, which could be earned by completing the activity. Online learning materials, like "Van Gogh at School," further encouraged children to explore the connections between the two worlds. The project was so successful that the Pokémon Center released exclusive Pikachu and Eevee items inspired by van Gogh's work, including plush toys, jigsaw puzzles, and trading cards, all designed to merge the playful world of Pokémon with the timeless artistry of van Gogh.

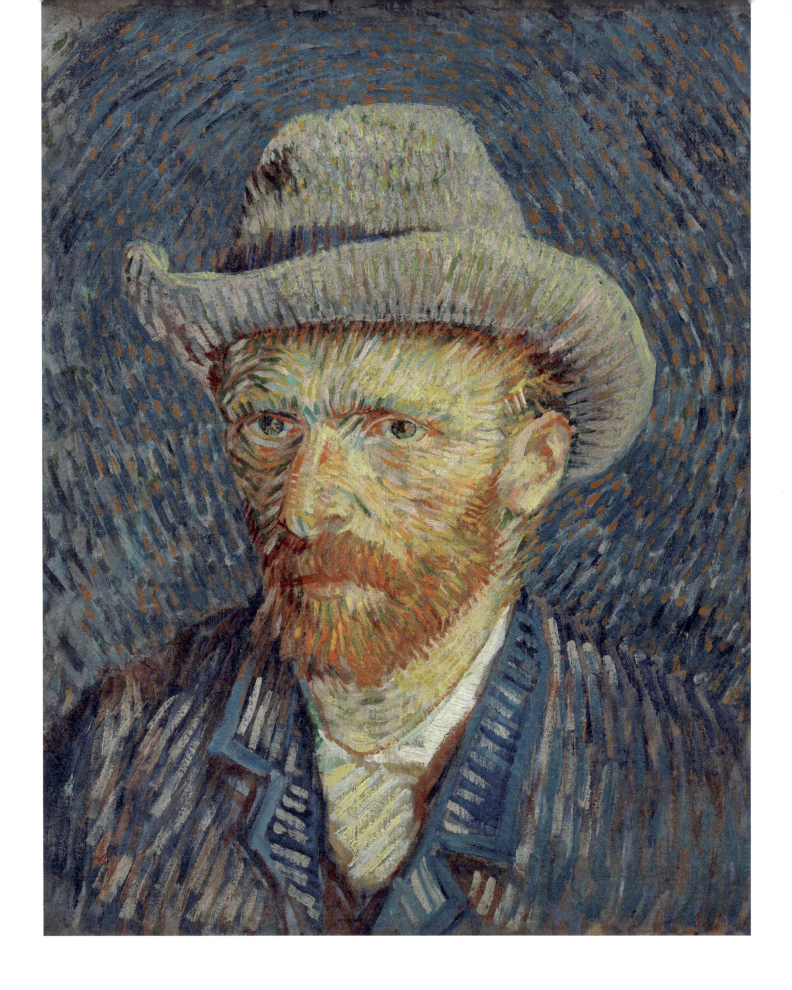

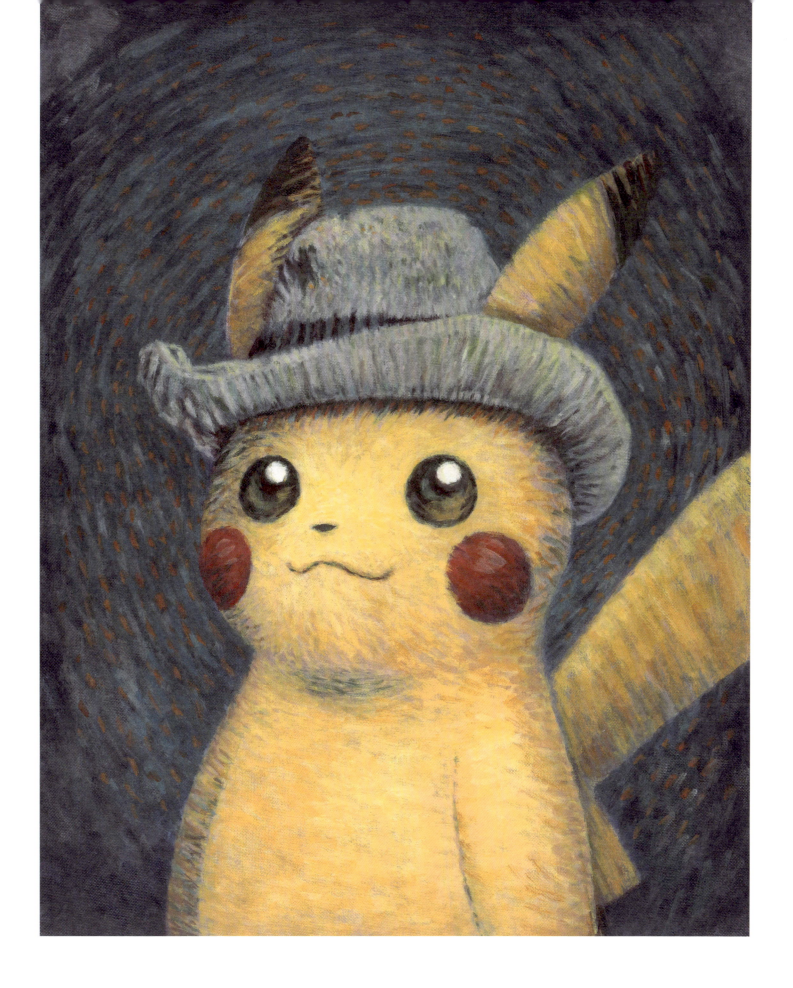

POKÉMON X VAN GOGH MUSEUM

How a Supermodel's Viral Video Sparked Heinz x Absolut Vodka Sauce

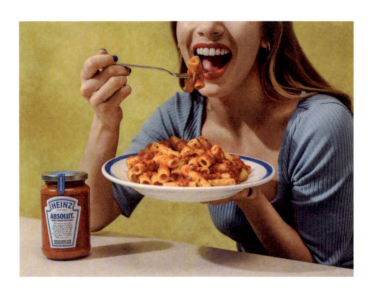

HEINZ **X** **ABSOLUT VODKA**

When a simple recipe became a go-to for home chefs and celebrities alike, two global powerhouses saw their opportunity to capitalize on the trend with a fun, campy twist.

Sure, pasta with vodka sauce has long been a menu item at upscale, American-Italian spots like Carbone, Rao's, and Il Mulino, where chefs have perfected their own versions of the dish. These white-tablecloth renditions often come with luxurious riffs like truffle oil or seafood, with plenty of influencers flocking to restaurants just to take photos with their pink pasta. But with coveted reservations harder to score than ever, and the desire for a little decadence still alive, why not make something as chichi as vodka sauce accessible and affordable?

Enter a global pandemic, a pause in dining out, and a shift in how people approach food. In 2020, a video that Gigi Hadid made of her *penne alla vodka* went viral, sparking a full-blown vodka sauce craze. What started as a simple, indulgent recipe quickly turned into a social media sensation, with millions of home cooks jumping on the trend. In 2022, inspired by Hadid's viral video and the growing love for the creamy pasta, Heinz—which had already started expanding their line of condiments to include pasta sauce—saw an opportunity. Heinz, masters of the tomato, recognized the need for vodka expertise to complete their vision. After collaborating with their creative team at VML, Absolut became the clear and obvious choice. This win-win partnership leverages the iconic status of both brands, with the campaign paying homage to Absolut's groundbreaking 80s advertising.

The timing couldn't have been better. With pandemic-driven changes in home cooking and an explosion of food trends on social media, the collaboration wasn't just timely—it was a direct response to a cultural moment. Home chefs, increasingly inspired by Instagram and TikTok, were searching for quick, elevated meals that didn't require much effort. And with its limited-edition run, the Heinz x Absolut sauce had the foresight to see how abruptly taste, and trends, might evolve. It was a quick convenience with a fine-dining twist.

The ad campaign played into this pop culture moment with tongue-in-cheek references to the Absolut bottle and punny taglines like "ABSOLUTELY PASTA, RIDICULOUSLY GOOD." The packaging even took the classic Heinz label design and added the delicate, calligraphic font you'd recognize from classic Absolut bottles. The visuals were a playful nod to the intersection of social media, pantry staples, and those viral food trends that are as fun to try as they are to share *for the 'Gram.*

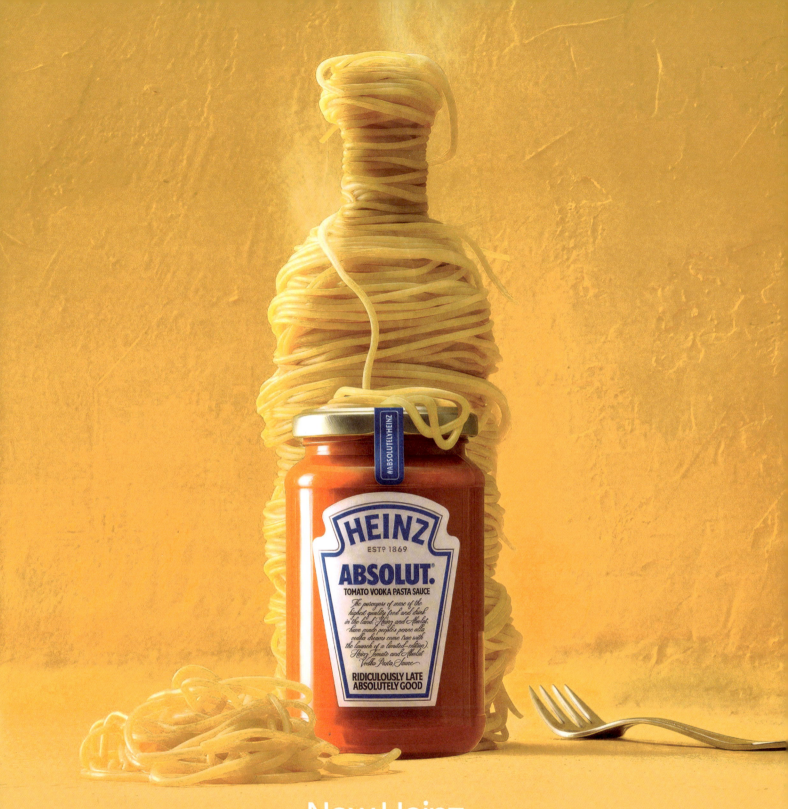

A Redesigned, Recycled Bottle for a Sustainable Future

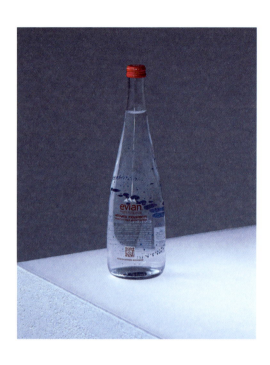

EVIAN X **VIRGIL ABLOH**

As evian's Creative Advisor for Sustainable Innovation, Abloh unveiled a new bottle made entirely from recycled materials, highlighting fashion and sustainability in evian's commitment to a circular economy.

The late Virgil Abloh, visionary designer and founder of Off-White™, was a trailblazer in integrating sustainability into fashion, seamlessly blending eco-conscious practices with cutting-edge design. Throughout his career, he championed recycled materials and waste reduction, pushing the boundaries of fashion's environmental and social impact. For example, Abloh introduced garments made from recycled fabrics and repurposed materials, such as recycled polyester and organic cotton. The brand also explored circular fashion concepts, such as using biodegradable or recyclable materials in some of its pieces, while Abloh's collaborations with brands like Nike often incorporated sustainable design elements, focusing on reducing waste and promoting eco-friendly practices in footwear and apparel.

Abloh's commitment to sustainability caught the attention of bottled-water brand evian, which appointed him as their first ever Creative Advisor for Sustainable Innovation Design. In 2018, they revealed their first, striking collaboration: a bottle made entirely from 100% recycled plastic. The label design was sleek and minimalist, with the iconic evian logo prominently displayed on the front and the bottle, which was made using a unique molding process, and featured a distinctive hammered texture, each indented mark symbolizing the transformation of waste materials into something new and valuable. The ultimate goal: to make a bottle that matched evian's iconic status while embodying the idea of reinvention.

Evian's history of partnering with leading designers such as Jean-Paul Gaultier and Issey Miyake has long elevated its brand—all while promoting eco-friendly innovation. (The brand was certified as carbon neutral, in an effort to demonstrate its commitment to tackling climate change.) Abloh's bottle design was considered a further step in evian's broader sustainability efforts, including its ambitious goal to become a fully circular brand by 2025. Through this collaboration, evian acknowledged the excessive use of plastic in the bottled water industry and declared a new standard for the future of eco-conscious packaging in the beverage industry at large.

A Collaboration That Brews Adventure

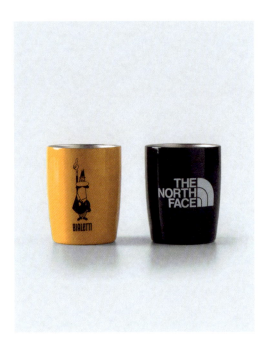

THE NORTH FACE X **BIALETTI**

 This collaboration offers adventurers the ultimate outdoor coffee experience, complete with a portable moka pot, insulated mugs, and thermoses—ensuring that your morning ritual stays intact no matter where you are.

For camping enthusiasts, there's nothing quite like the ritual of brewing a hot cup of coffee to kickstart the day in nature. Whether enjoyed while watching the sunrise from a mountaintop or warming up by the campfire, coffee is, arguably, just as essential to the outdoor lifestyle as a good sleeping bag or a sturdy backpack. It makes sense, then, that in 2024, The North Face and Bialetti teamed up for a collaboration that blended rugged adventure with the art of coffee making.

 At the core of the collection was a portable espresso maker, merging Bialetti's iconic moka pot design with The North Face's durable materials. (A moka pot is a stovetop espresso maker that brews coffee by forcing hot water pressurized by steam through ground coffee—creating a rich, espresso-like drink.) Made from lightweight, durable aluminum, the espresso maker was built to withstand the harsh conditions of the wilderness while delivering an authentic coffee experience. Whether brewing by a campfire or on a hike, it ensured your morning ritual didn't have to be sacrificed for nature.

 Alongside the moka pot, the collection featured a range of accessories perfect for outdoor enthusiasts. Insulated mugs keep coffee hot for hours, ensuring your brew stays warm through chilly mountain mornings or brisk winter hikes. Crafted from high-quality stainless steel with double-wall insulation, these pieces offered both functional and stylish appeal with sleek, minimalist designs. The mugs featured The North Face's bold color palette, including signature red and black tones, while maintaining Bialetti's understated elegance and simple, clean lines.

 The marketing campaign for the collaboration was equally adventurous, showcasing the products in action—from steaming cups of coffee brewed at high altitudes to early-morning campfire rituals. The partnership celebrated coffee as an integral part of the outdoor lifestyle, creating the perfect blend of style, function, and adventure. On a mountaintop or by the campfire, The North Face x Bialetti collaboration made sure the perfect cup of coffee was always within reach.

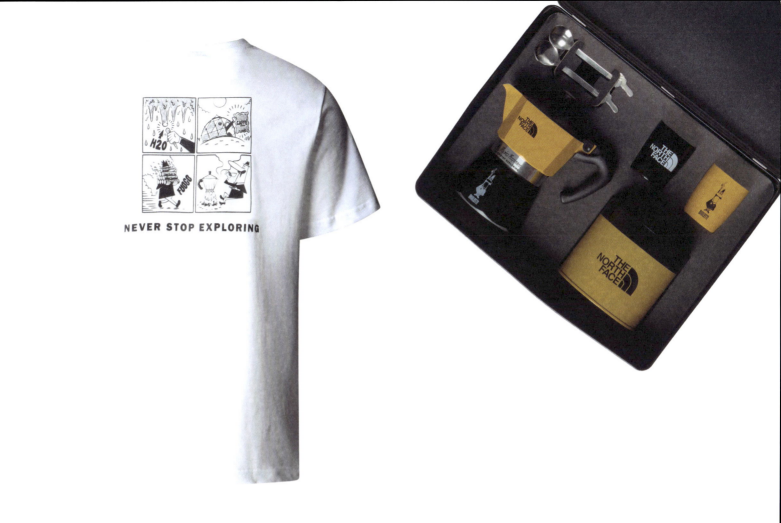

THEY TEAMED UP FOR A COLLABORATION THAT BLENDED RUGGED ADVENTURE WITH THE ART OF COFFEE MAKING.

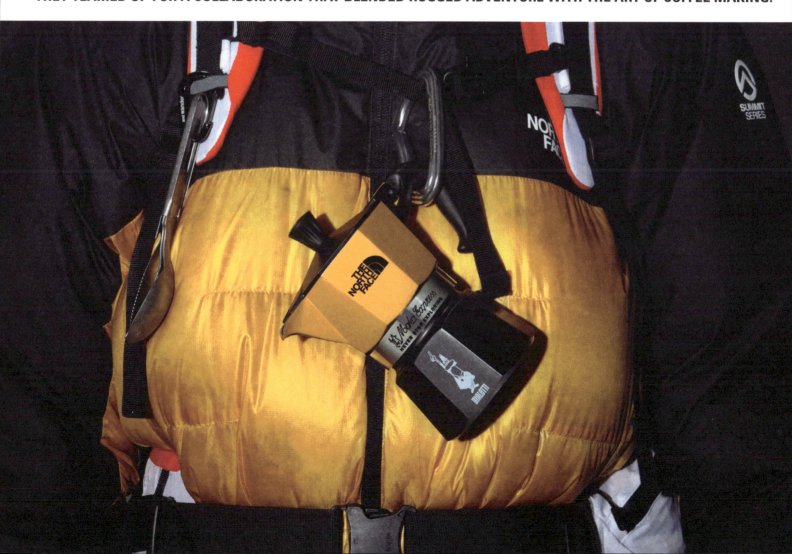

A Sweet Sneaker Collab for a Cause

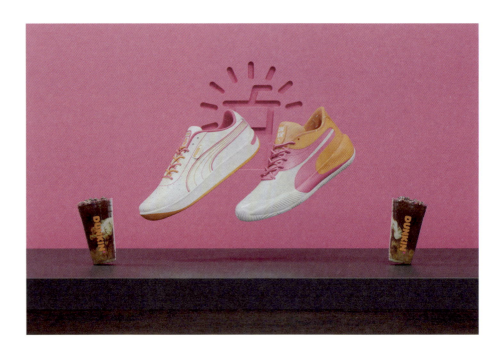

PUMA **X** **DUNKIN'**

This release, featuring reworked versions of PUMA's GV Special and Triple Basketball models, brought Dunkin's signature pink and orange branding to life in footwear form.

In a surprising but utterly charming blend of sportswear and coffee culture, PUMA and Dunkin' teamed up for a limited-edition footwear collection that brought Dunkin's signature colors and branding into the sneaker world. The collaboration, which dropped in May 2022, featured reworked versions of PUMA's classic GV Special and Triple Basketball models. The design process was a playful nod to Dunkin's iconic iced-coffee cups and donuts, with sneakers featuring two-tone pink and orange laces, sprinkles-inspired sock liners, and co-branding that proudly showcased both logos. The GV Special, for example, combined white synthetic uppers with the familiar Dunkin' pink and orange hues, while the Triple Basketball model also mirrored the distinctive color palette, but with the added whimsical touch of a sprinkled motif inside the shoe. Each pair celebrated Dunkin's fun, lighthearted branding with a wearable flair.

The collection's marketing campaign was timed to coincide with Dunkin's annual "Iced Coffee Day"—a charity-driven event that supports children in local hospitals. This added a layer of purpose to the collaboration, encouraging fans to get involved with Dunkin's community initiatives. PUMA and Dunkin' also capitalized on social media to drum up excitement for their sneaker collaboration.

The quirky collaboration isn't out of line for the food brand, and tracks with Dunkin's increasing trend of merging coffee culture with fashion. Having previously partnered with brands like Saucony for limited-edition sneakers, Dunkin' has even released its own line of branded apparel, ranging from socks to hats. In doing so, the company continues to strengthen its unique position at the intersection of streetwear and food branding. By tapping into this niche, Dunkin' isn't just offering coffee anymore—they're serving up style too.

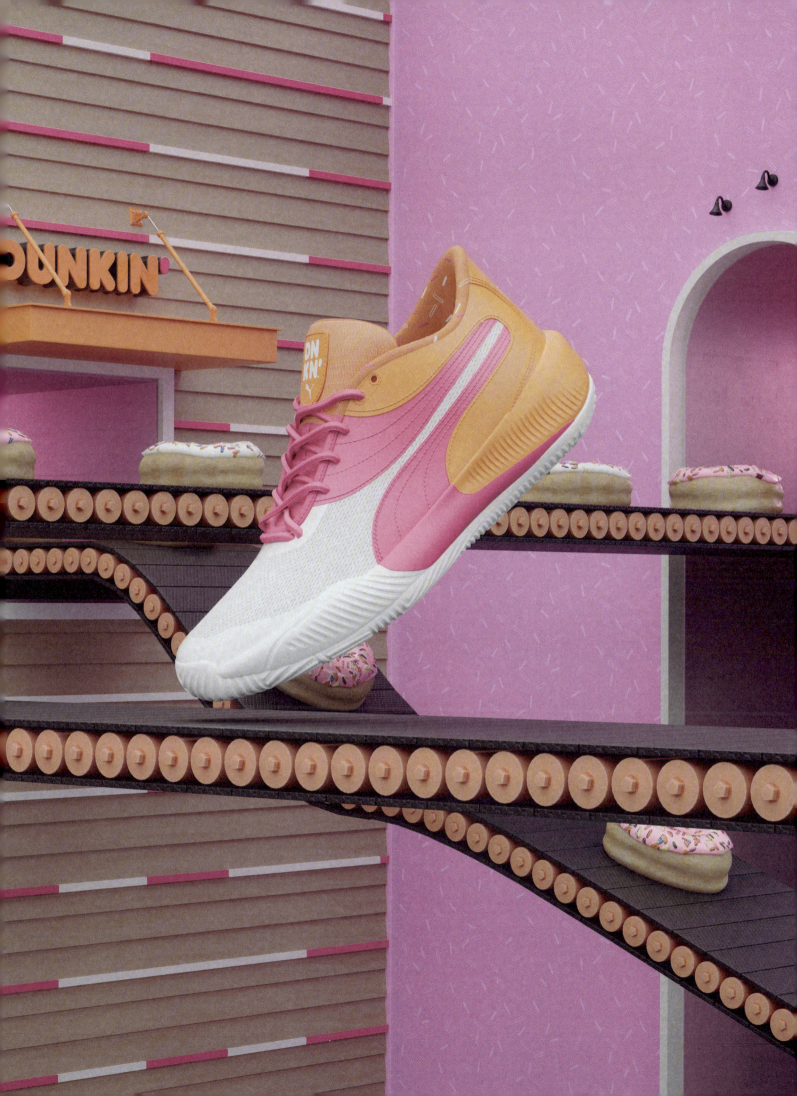

A Sneaker Reborn

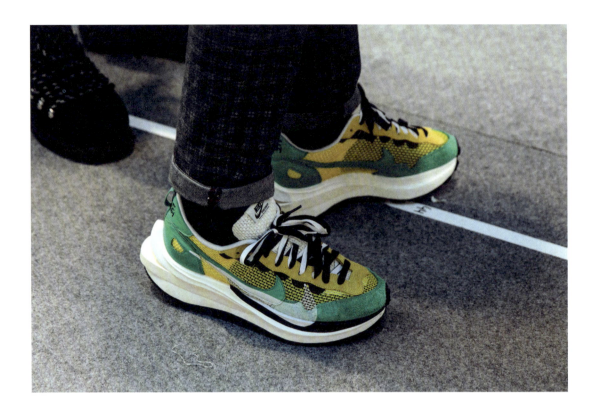

NIKE **X** **SACAI**

Chitose Abe's signature layering transforms iconic Nike sneakers into hybridized, multi-dimensional designs, merging sports, style, and innovation. From bold neons to soft pastels, the 2019 collaboration showcases Sacai's mastery in exciting ways.

Chitose Abe's innovative approach to fashion, which blends contrasting elements to create something entirely new, was the driving force behind the Nike x Sacai collaboration. Known for her mastery of layering, Abe—who worked at Comme des Garçons before founding Sacai in 1999—has always pushed boundaries, transforming simple garments into complex, multi-dimensional pieces. Her avant-garde vision caught Nike's attention, leading to a collaboration that seamlessly blended high fashion with the brand's performance-driven DNA. The result? Sneakers that told stories through their unique layering and deconstruction.

This partnership with Nike wasn't Sacai's first foray into streetwear collaborations. Abe's other projects included Sacai x fragment design x Converse, which gave the humble Chuck Taylor an ultra-sleek, minimalist makeover, and Sacai x Undercover x Nike, which combined Sacai's style with Undercover's punk edge. Sacai had also joined forces with The North Face to merge high fashion and outdoor wear in bold, color-blocked jackets and sneakers. Each collaboration highlights Sacai's ability to fuse luxury, streetwear, and sportswear in groundbreaking designs.

The debut Nike x Sacai collection, released in 2019, featured hybridized silhouettes like the LDWaffle and VaporWaffle sneakers. These reimagined Nike running shoes featured Sacai's signature layered design, including double-layered Swooshes, and unexpected material combinations—think suede, nylon, and leather—adding depth and texture to each piece.

Colorways ranged from neon greens and yellows for an energetic punch to contrasting red and navy, bringing Sacai's unique aesthetic to life. Black and white options offered a minimalist approach, while earthy tones like beige and tan grounded the collection. Soft pastels like light blue and pink brought a fresh touch, showcasing Sacai's talent for merging streetwear with sportswear. Each colorway emphasized the sneakers' unique construction, blending form and function seamlessly.

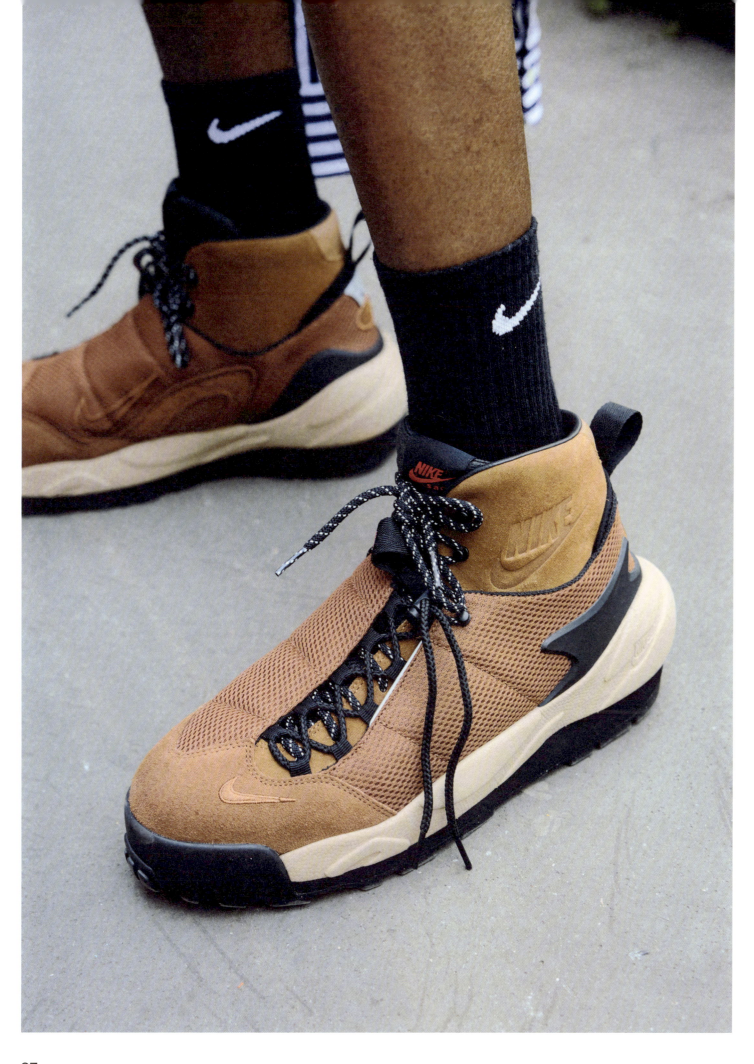

"Project G-Class" Brings Nostalgic Flare to a Contemporary Classic

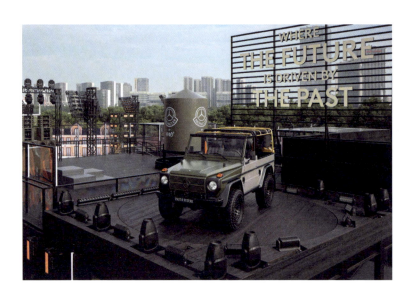

MERCEDES-BENZ X **MONCLER BY NIGO**

From the 2023 "Project MONDO G" to the 2024 "Past II Future," the Mercedes-Benz x Moncler partnership combines the rugged G-Class with Moncler's iconic quilted designs—reimagined here by NIGO with a '90s-inspired twist.

The partnership between Mercedes-Benz and Moncler began with the futuristic "Project MONDO G," unveiled at Moncler's 2023 London Fashion Week show. This collaborative art piece fused the rugged Mercedes-Benz G-Class with Moncler's signature luxury outerwear aesthetic. Like something straight out of sci-fi, the SUV turned heads with its huge, chrome-finish tires whose marshmallow-like treads mimicked the look of a Moncler quilted puffer jacket. The collaboration evolved with the "Project G-Class Past II Future," debuting at the 2024 "City of Genius" show in Shanghai with a projected 2025 release date. Designed by NIGO, the Japanese fashion designer and music producer, the project blended nostalgic '90s-inspired design with modern fabrics and tactical automotive functionality.

The centerpiece of the collaboration was the "Past II Future" art piece, a reworked G-Class from the '90s, restored to perfection and given an ultra-contemporary makeover. NIGO's aesthetic blends streetwear, high fashion, and '90s nostalgia, influenced by hip-hop and Japanese subcultures—he's known for mixing luxury materials with urban styles, reinterpreting iconic items with a focus on both nostalgia and innovation. That style can be seen in the truck's exterior, which features a minimalistic two-tone palette of olive green and gray, accented by gold and black details. Notably, the G-Class maintains its iconic spare wheel on the rear, foldable windscreen, and black steel wheels from the '90s, while also showcasing futuristic design flourishes like a removable, high-tech sound system developed in collaboration with audio designer Devon Turnbull.

Alongside the art piece, a limited-edition G-Class model was produced, with only 20 units made available to the public. Each car mirrors the design of the art piece but with additional touches, such as checkered upholstery and special edition badging, reinforcing the cultural connection between past and present. Moncler and NIGO also released a capsule collection as part of the collaboration, featuring '90s-inspired urban fashion, with gender-neutral pieces like varsity jackets, hoodies, and lightweight down jackets. The collection, launching in April 2025, will embrace vintage aesthetics with modern functionality, reflecting the collaboration's timeless and forward-thinking ethos.

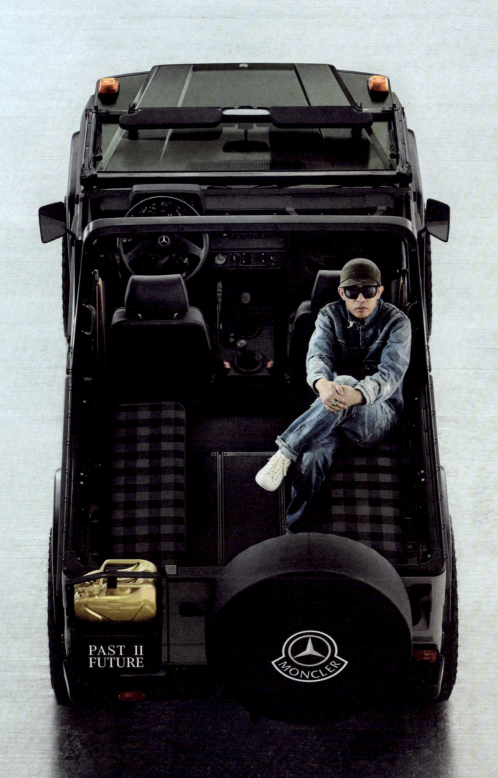

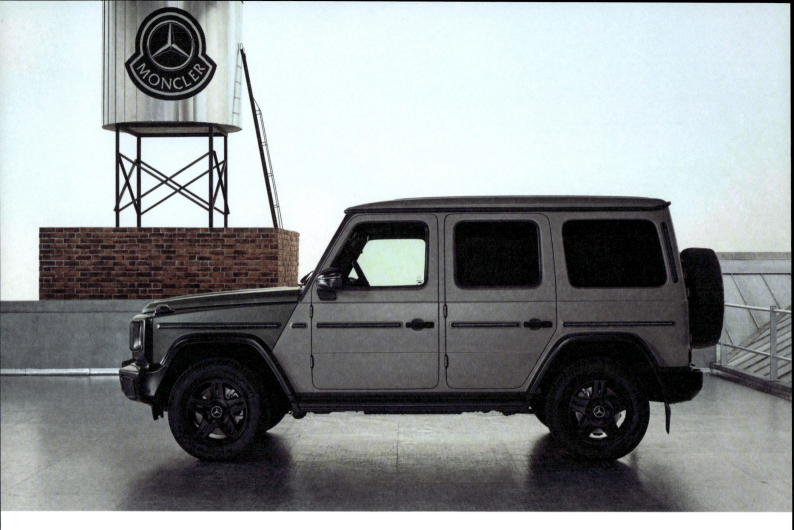

PROJECT "G-CLASS" BLENDS NOSTALGIC '90S DESIGN WITH MODERN FABRICS AND TACTICAL AUTOMOTIVE

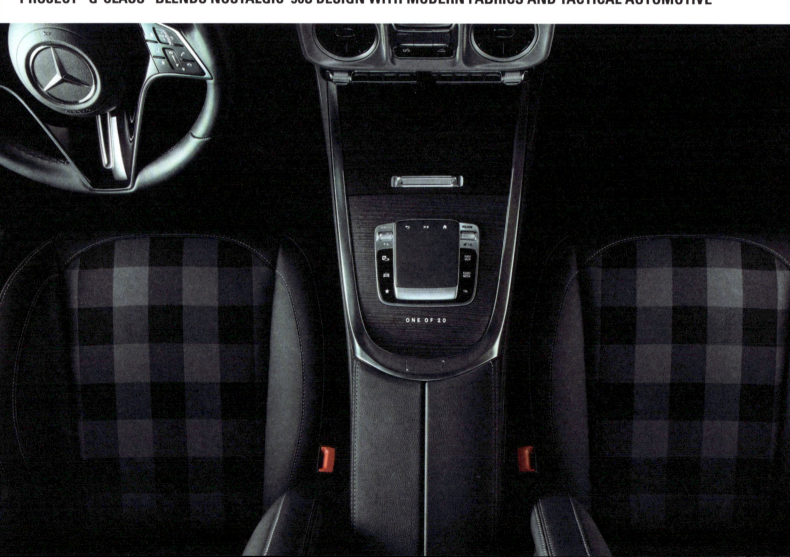

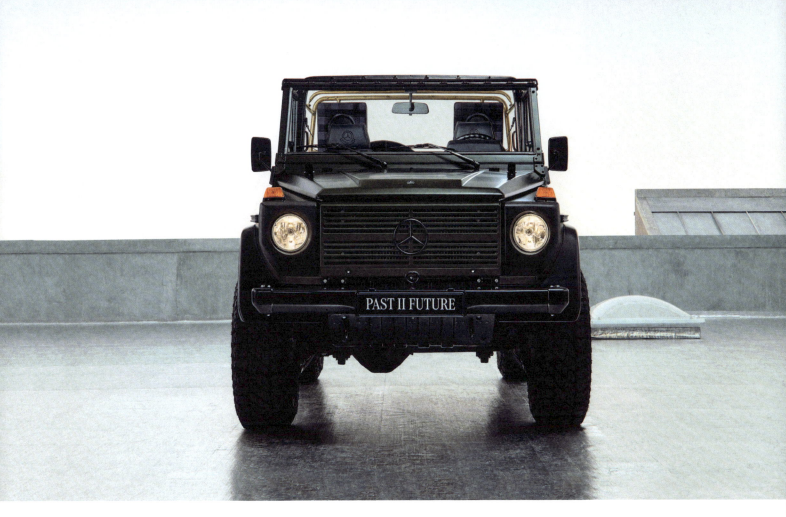

FUNCTIONALITY, HIGHLIGHTED IN A REWORKED G-CLASS, LIMITED EDITIONS, AND A CAPSULE COLLECTION.

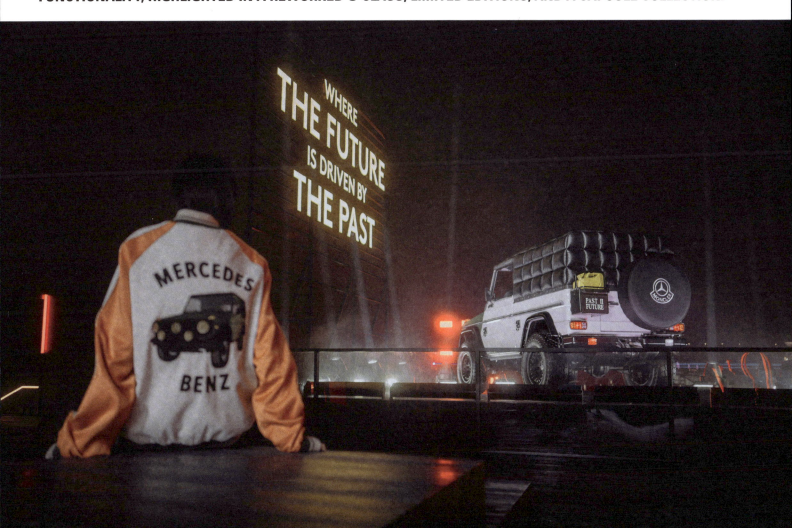

Building the Future of Space Exploration, One Brick at a Time

LEGO® X **NASA**

This collaboration combines creativity, STEM education, and iconic space missions, from the Apollo Saturn V rocket to the space shuttle Discovery.

When LEGO® and NASA teamed up, it was like merging two worlds built on curiosity and ingenuity. The collaboration began with LEGO's mission to encourage STEM (science, technology, engineering, and mathematics) education, which perfectly complemented NASA's role in pushing the boundaries of what we know about the universe. With a shared passion for exploration, creativity, and innovation, the collaboration was a well-suited—and exciting—union.

The process of selecting the right models was rooted in the idea of telling NASA's story through the most iconic moments in space history. The team at LEGO worked closely with NASA to ensure they captured both the complexity and the historical significance of each spacecraft. They wanted to highlight missions that had a lasting impact—not just on the space industry, but on the collective imagination of humankind. The first standout product was the NASA Apollo Saturn V set, a model that pays homage to the Apollo missions of the 1960s and '70s, which allowed builders to recreate the rocket that sent astronauts to the moon. With over 1,900 pieces, it offered intricate details, including the rocket's multiple stages and a model of the lunar lander, providing an authentic representation of NASA's historic achievement and the complexity and engineering that went into one of humanity's greatest feats.

Following the success of the Saturn V set, the duo also released the LEGO Space Shuttle Discovery set—a tribute to NASA's shuttle program and a nod to its enduring legacy. It wasn't just about building models, though. Every kit, whether the shuttle or the Saturn V rocket, also came with educational content, allowing builders to learn more about the missions and the incredible technology behind them. By combining the precision of space engineering with the creativity of LEGO building, the collaboration sparked a sense of nostalgia and an interactive way for children to learn about space, one lego at a time.

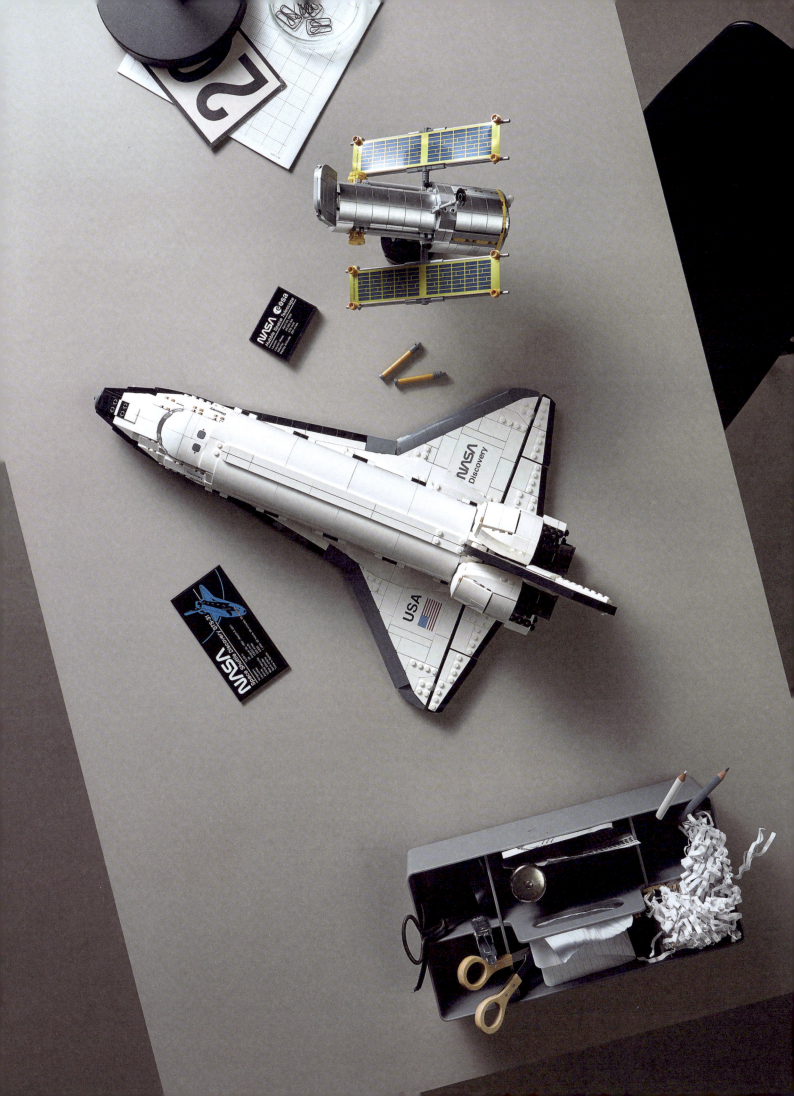

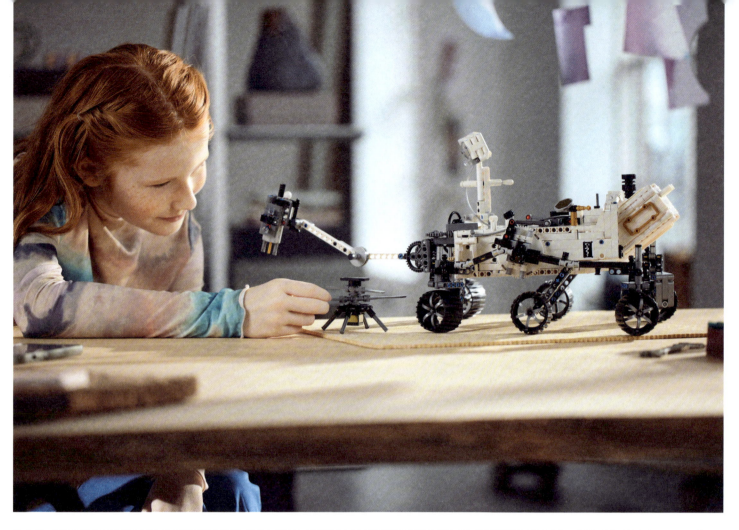

LEGO AND NASA MERGE CURIOSITY AND INGENUITY, TELLING NASA'S STORY THROUGH ICONIC SPACE HISTORY.

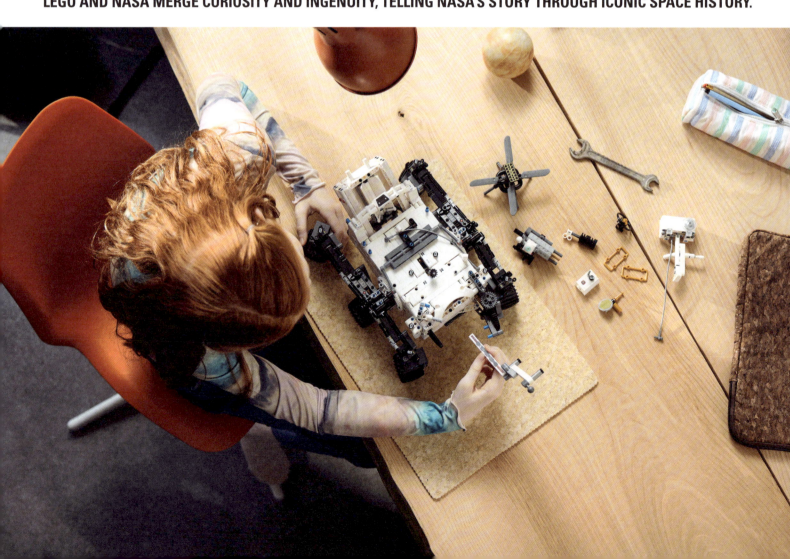

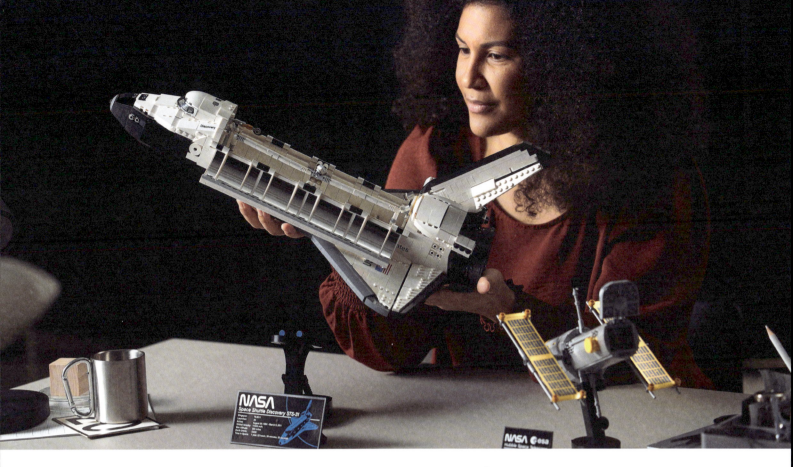

EACH KIT BLENDS PRECISION ENGINEERING WITH CREATIVE BUILDING.

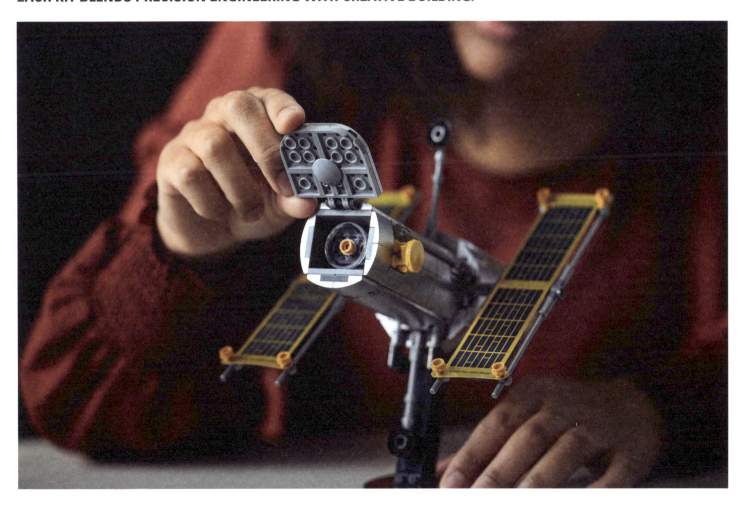

45 LEGO® X NASA

Over Two Decades of the Ultimate Fantasy Toy Collaboration

LEGO®

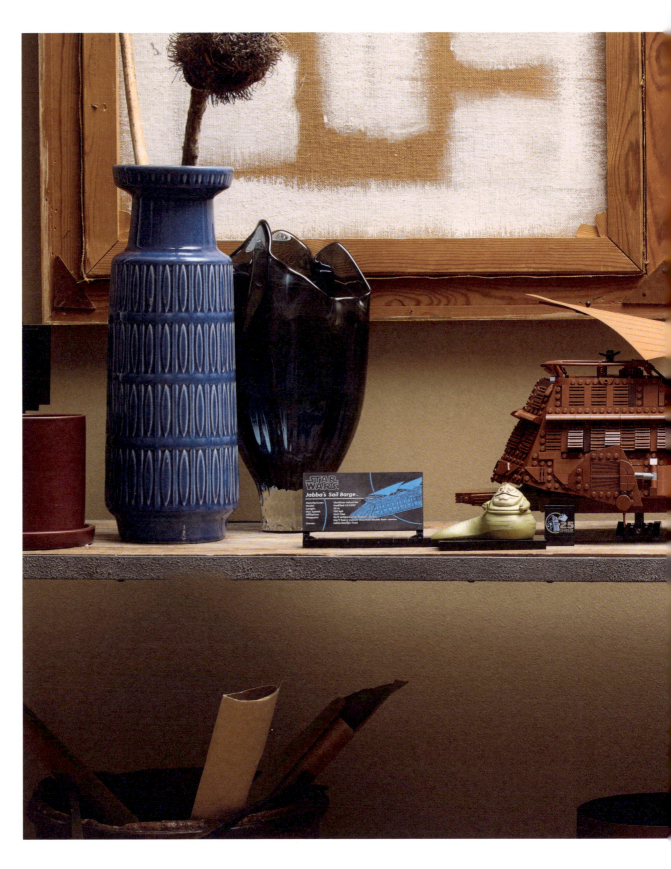

LEGO® X STAR WARS™

From X-Wing Starfighters to the Millennium Falcon, the LEGO x Star Wars partnership has been bringing iconic ships and scenes to life since 1999.

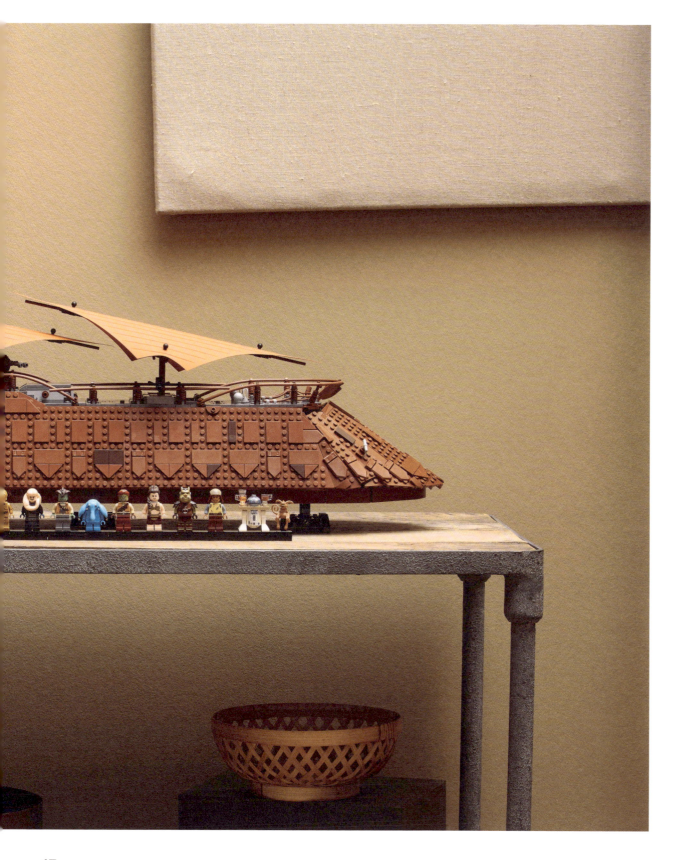

STAR WARS™

Every space fantasy geek has dreamed of wielding a lightsaber or getting their hands on the Millennium Falcon—in 1999, the first ever LEGO® and Star Wars™ collaboration gave the world of toys and pop culture a game-changing development, allowing fans to immerse themselves in a galaxy far, far away. The first set in the LEGO x Star Wars line was the X-Wing Starfighter in homage to one of the franchise's most beloved ships. It was a perfect example of how LEGO captured the essence of *Star Wars*—taking a recognizable object and transforming it into an intricate, yet accessible building experience. The set was an instant hit, launching a whole series of models ranging from minifigures of key characters to large-scale models of iconic ships like the Millennium Falcon and the Death Star.

Two decades later, the playful collaboration continues to evolve. While early sets focused on the ships and characters, later collections began incorporating more complex, intricate designs, like the LEGO Star Wars UCS Millennium Falcon, a 7,541-piece set that remains one of the largest and most detailed LEGO models ever made. The line also stayed in tune with the ongoing Star Wars franchise, creating sets inspired by both the original trilogy and the newer films, expanding the series to include *The Mandalorian, The Clone Wars,* and *The Rise of Skywalker*.

The partnership released two highly anticipated diorama sets: the LEGO Star Wars Endor Speeder Chase and the LEGO Star Wars Death Star Trench Run. These sets, which dutifully recreated scenes from the *Return of the Jedi* and *A New Hope* became instant fan favorites. Beyond the bricks, each LEGO set is infused with love for the Star Wars universe, from minifigures that recreate the personalities of fan favorites like Darth Vader, Chewbacca, and Luke Skywalker to intricate building instructions that teach fans about the design elements that make these ships iconic. Whether for casual builders or hardcore collectors, this collaboration offers something for everyone in the galaxy.

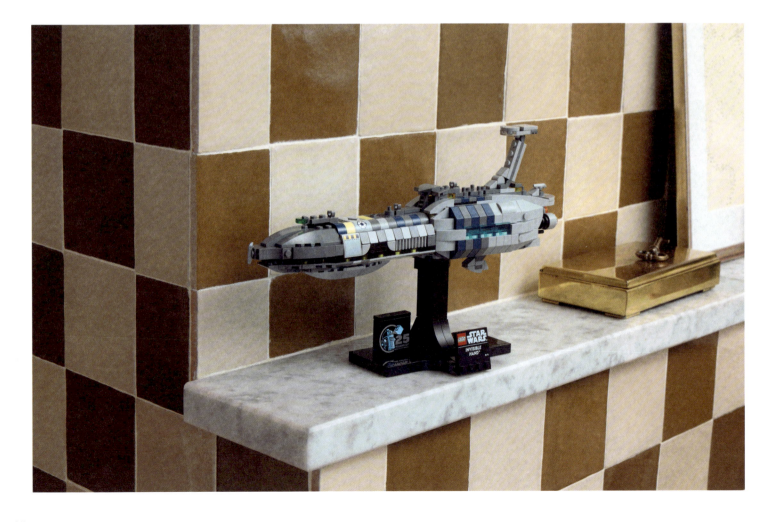

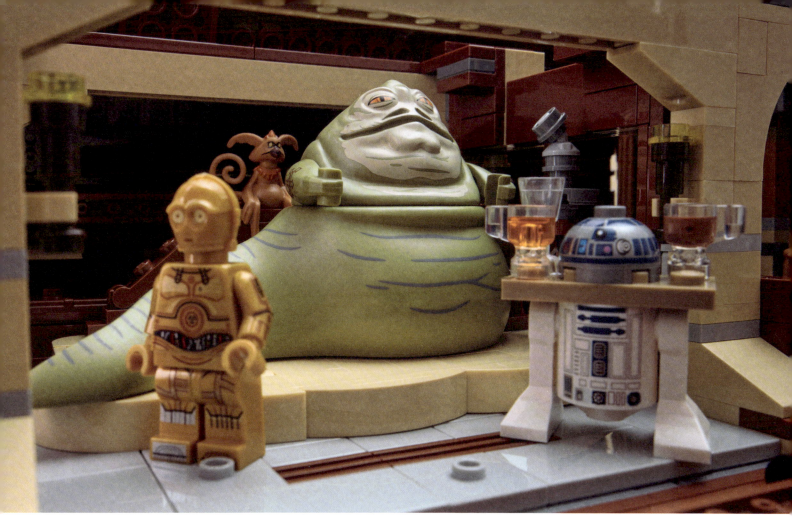

ICONIC SHIPS AND SCENES SINCE 1999, A GAME-CHANGING TOY AND POP CULTURE COLLABORATION.

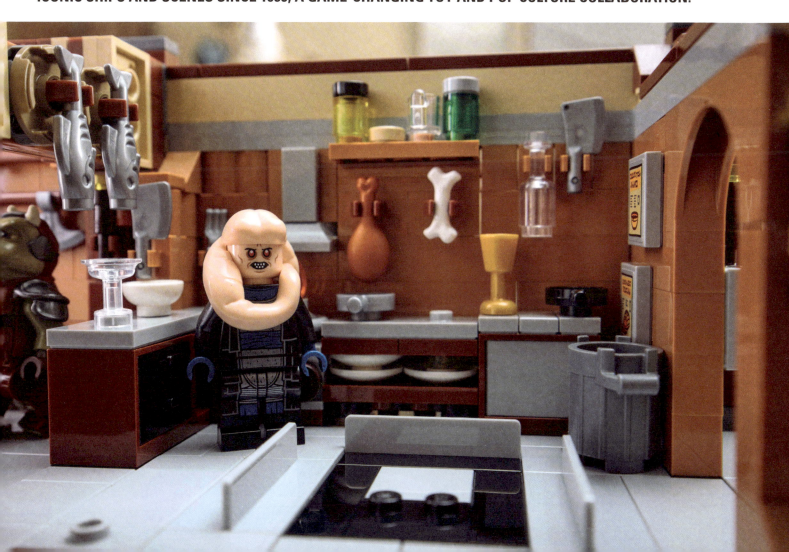

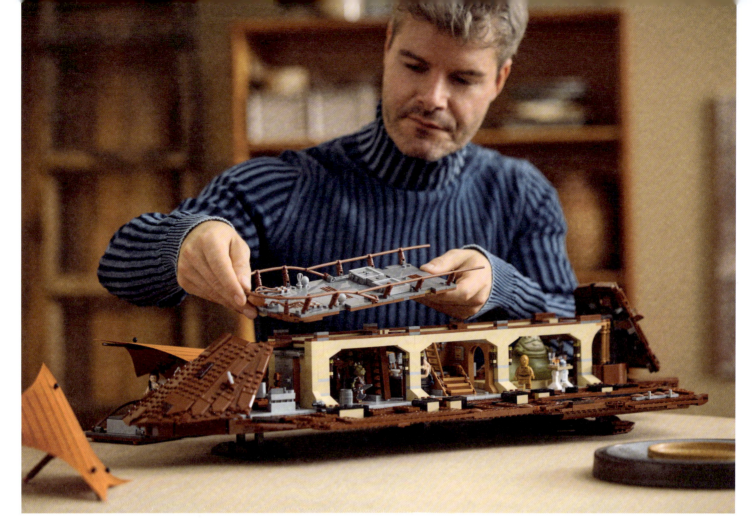

EACH SET IS INFUSED WITH LOVE FOR THE STAR WARS UNIVERSE, FROM MINIFIGURES THAT RECREATE THE

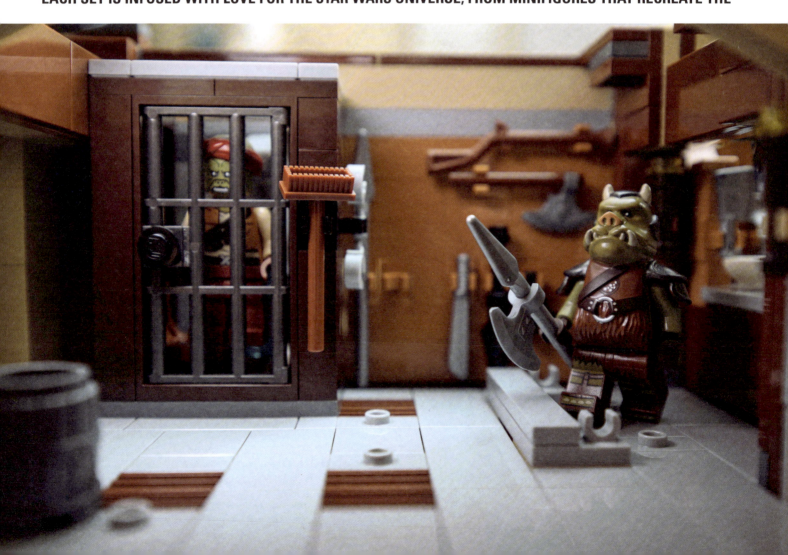

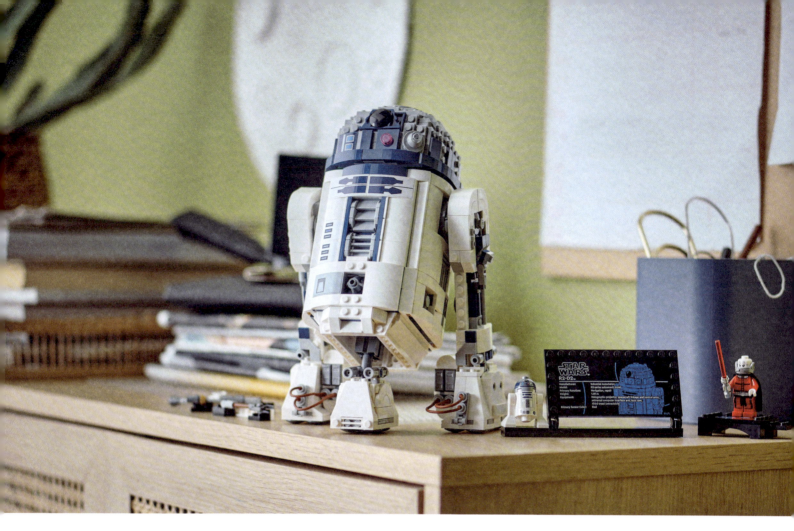

PERSONALITIES TO INTRICATE BUILDING INSTRUCTIONS THAT TEACH FANS ABOUT THE DESIGN ELEMENTS.

How Marc Jacobs, Kim Jones, and Virgil Abloh Made Collaborations Luxurious

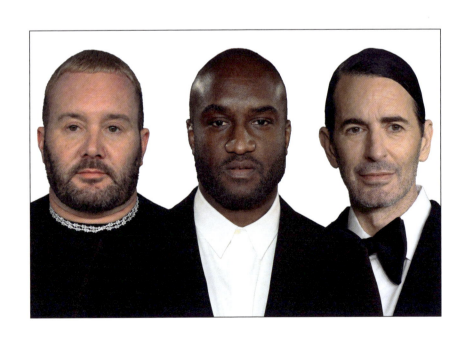

Kim Jones, Virgil Abloh, Marc Jacobs

52

Marc Jacobs' reputation as a humorous designer and epic collaborator precedes him. So much so that one of the most popular internet memes referencing his work features an extremely tongue-in-cheek clothing label that reads: "Jacobs By Marc Jacobs For Marc By Marc Jacobs In Collaboration With Marc Jacobs For Marc By Marc Jacobs." Marc Jacobs' journey as a designer is a story of creative risk-taking, cultural influence, and boundary-pushing collaborations that have shaped modern fashion. Upon graduating from New York's High School of Art & Design in 1981, the Teaneck, New Jersey native enrolled at the prestigious Parsons School of Design, where his contemporaries included Isaac Mizrahi and Tom Ford. His graduate collection consisted of a line of oversized sweaters featuring polka dots and smiley faces, which were quickly picked up by forward-thinking boutique Charivari, where Jacobs once worked as a stockboy when he was 15. The sweaters became a staple of early street style in a time when Bill Cunningham's famous "On The Street" column for *The New York Times* was one of the few places fashion fans could see how real people were putting together the hottest brands of the day. Jacobs' graduate collection also earned him prestigious honors like the Gold Thimble awards by Perry Ellis and Chester Weinberg, which recognized outstanding student designers.

These accolades were early harbingers of Jacobs' meteoric rise. In 1988, just four years after graduating from Parsons, Jacobs was named creative director for Perry Ellis' women's design unit. But even before landing the top creative position at one of the most respected American fashion brands at the time, Jacobs' fashion career was already on an upward trajectory. One of Jacobs' early champions was Robert Duffy,

filmed in New York and wore the collection, not only putting the sketches and the show itself in the video, which also marked one of the earliest modeling appearances by the *ultimate* downtown cool girl: Chloë Sevigny. But the critics hated the collection, and a few months later, Marc Jacobs was fired from Perry Ellis. In a 2010 interview, Courtney Love even admits that Jacobs sent her and Kurt Cobain the collection after its debut—they responded by burning it. Perhaps, like many of the moments in Jacobs' career, this was a case of him being a little *too* early to a trend.

But that setback certainly didn't stop the momentum for Jacobs. If anything, it helped him hone a crucial skill for any genre-pushing designer: the art of knowing when, and how far, to push boundaries. Unfazed by the grunge debacle, Jacobs began to build out his eponymous line, expanding into menswear in 1994. The brand developed a reputation for its ability to blend relevant cultural references with a unique kind of accessible luxury. They were clothes that felt like Fashion with a capital "F" but possessed a self-contained modernity. That became apparent when he launched his diffusion line, Marc By Marc Jacobs, in 2001, but also in charitable projects like T-shirts that merged high fashion imagery with AIDS advocacy. Having lost several loved ones to the disease, for Jacobs it was an incredibly personal endeavor. When he was appointed as the creative director of Louis Vuitton in 1997, it also set a precedent that his successors have continued to build upon.

Given the unenviable task of creating something from nothing, Marc Jacobs introduced a ready-to-wear collection at Louis Vuitton—a maison known primarily for its handbags. His debut Fall 1998 show featured 50 looks noted for their minimalism and distinctly American flair, something *Vogue*

IT WAS EVIDENT THAT MARC JACOBS HAD A UNIQUE TALENT FOR WEAVING CULTURE INTO HIS CLOTHES.

an executive for the fashion brand Reuben Thomas, who secured him a job designing for Sketchbook, one of their sub-lines. By the mid-1980s, the two had formed a business partnership, and the Marc Jacobs label made its debut in 1986. It only took one year for Jacobs to become the youngest designer ever awarded the Council of Fashion Designers of America's award honoring new fashion talent—another award named in honor of the late Perry Ellis. From his first collections, it was evident that Jacobs had a unique talent for weaving culture into his clothes, taking inspiration from his nights out at various clubs where he kept tabs on what all the cool girls were wearing. In many ways, he pioneered the now-ubiquitous aesthetic of the "uptown girl with a downtown sensibility." His most famous (or infamous, depending on who you ask) moment at Perry Ellis was his Spring/Summer 1993 "grunge" collection. Inspired by the thrift-store aesthetic of the Seattle music scene, Jacobs transformed flannel shirts and slip dresses into high-fashion staples, printing flannel on silk, making oversized colorful knit beanies, and licensing the artwork of underground comic artist Robert Crumb, which he printed on graphic tees. The star-studded runway show featured Naomi Campbell, Kristen McMenamy, and Kate Moss, and it was equal parts revolutionary and controversial.

The grunge collection should have been a hit, as it came from a place of authenticity; it wasn't an outsider trying to appropriate a subculture—there was an earnest appreciation that went into the collection. Made prior to the show itself, the music video for Sonic Youth's "Sugar Kane" serves as a testament to its legacy in pop culture. Wishing to utilize Jacobs' studio space for the music video, the lesser-known band

called "an American in Paris vibe." As Jacobs says in the July 1998 issue of the magazine: "I think people were expecting a lot of monograms. It's impossible to please everyone, but we started at zero—this was a company that had never done clothing before. The clothes were contemporary, classic, luxurious, a backdrop for a luggage company—utilitarian and practical. Was it too utilitarian for the French? Well, you know, one of the first Louis Vuitton trunks was gray and flat so it would be stackable. It was very practical; I mean, there's a method to all this madness."

When Marc Jacobs tapped one of his idols, the artist Stephen Sprouse, for a collaborative refresh of the house's iconic monograms, it marked a transformative era. The Graffiti collection of bags altered the one thing Vuitton once told Jacobs he couldn't touch: the logo. And yet, Sprouse's scrawled version of the house name was emblazoned all over a series of bags and accessories, with the Graffiti Speedy bag being an instant standout. By printing Sprouse's graffiti "tag" over the top of the famous "LV" monogram, it created the illusion that a classic LV bag had somehow been vandalized. After all, what was the bag worth if Sprouse's neon scrawl all but obscured the coveted monogram design? This was a radical design choice for the time, and the collection resonated with a younger, edgier clientele. This partnership wasn't just about design; it was a cultural statement, bridging the gap between high art and commercial fashion in a way that felt fresh while maintaining Vuitton's luxury DNA. It was "logo hacking" two decades before Demna and Alessandro Michele would do something similar at Balenciaga and Gucci, respectively, trading the codes and signifiers of the respective houses to create an uncanny-valley collaboration that

straddled the line between bootleg and homage. Similarly, in 2022, Kim Jones and Donatella Versace joined forces for the "Fendace" collaboration, mishmashing Versace's Medusa logo with Fendi's signature interlocked Zucca.

Jacobs' collaboration with Takashi Murakami in 2003 had pushed this concept even further. Murakami's multicolored monogram bags, streetwear-infused Monogramouflage, and Japanese-influenced cherry blossom prints were a global sensation. They injected whimsy and irreverence into Vuitton's image, making the brand more accessible without sacrificing its prestige. Murakami and Jacobs' partnership extended beyond accessories, influencing pop culture through ad campaigns and exhibitions. It invited a new class of monied tastemakers into the fold, creating must-have items for artists like Pharrell Williams and Kanye West. The long-running partnership continued well into 2008, when the Brooklyn Museum feted a Takashi Murakami exhibit by selling the Louis Vuitton partnership in a street market meant to emulate the counterfeit-ridden Canal Street. Ramshackle shops were built to stock the legitimate collection, with the LV monogram cheekily spraypainted on closed garage doors. Part performance art, part social commentary, the Murakami collaboration epitomized Jacobs' ability to innovate by combining worlds to create brand-new ones. It's no surprise that after retiring the successful motif for a time, Louis Vuitton decided to resurrect it for its 20th anniversary in 2025.

Throughout his tenure, Jacobs continued to invite artists into the Vuitton fold, with works from Richard Prince's painterly creations to Yayoi Kusama's polka-dot motifs. Each collaboration was a case study in expert storytelling, using the artist's distinct language to recontextualize Vuitton's heritage.

circle. One of his nicknames was the "Louis Vuitton Don," so of course West's pair is made with cues from popular mid-tops like the Air Jordan 3. Meanwhile, the high-top Jaspers have references to the straps from the Air Yeezy, as well as elements inspired by the obscure high-fashion Japanese sneakers from Ato Matsumoto. As for the low-top tasselled boat sneakers? Those take their name from Mr. Hudson, a songwriter and producer who frequently collaborated with West.

That wasn't the only time Marc Jacobs lent his collaborative touch to the sneaker world. In 2005, he partnered with Vans on a capsule collection reimagining some of the brand's most iconic sneakers. The comprehensive collaboration ranged from shiny patent leather interpretations of the Sk8-Hi and Old Skool to novelty prints on the Classic Slip-On, including one done in the style of a partially-solved crossword puzzle. He brought a high-end touch to a streetwear staple, going as far as making a woven leather checkerboard upper for the Classic Slip-On, and another rendition reinterpreting the humble shoe with plush shearling. Jacobs' collaborations with brands like Vans further cement his cross-cultural impact, proving that he isn't just a designer but a storyteller who captures the zeitgeist, interrogating what fashion can mean and who it can speak to.

Not content with simply revitalizing Vuitton's product and consumer base, Jacobs revolutionized their runway shows. His presentations for Louis Vuitton became theatrical spectacles, from a functioning carousel to a train that pulled into the show venue. These immersive experiences demonstrated how a fashion show could transcend a traditional format and become a cultural event, heightening anticipation for the collections and reinforcing Vuitton's relevance.

THE PARTNERSHIP WASN'T JUST ABOUT DESIGN; IT WAS A CULTURAL STATEMENT, BRIDGING THE GAP BETWEEN

These projects turned the brand's monogram into a malleable symbol of creativity, setting a template for how luxury houses could engage with contemporary art.

Beyond fine artists, Marc Jacobs also empowered some of today's best-known collaborators. In 2004, he enlisted NIGO and Pharrell Williams (the future artistic director of Louis Vuitton men's) to design a pair of shades that have become a modern icon for the house. The Millionaire sunglasses are a silhouette inspired by classic aviators, with added metallic accents that make it not just more luxurious, but a recognizable status symbol. In her book *Raising Kanye,* the late Dr. Donda West recalled buying a pair for her son at the suggestion of Don C, who thought they were the ideal present for the man who has everything. When Virgil Abloh took the reins of Vuitton's menswear in 2018, it was one of the first designs he revisited. In fact, he partnered with NIGO to create a spiritual successor in 2022: the aptly named Zillionaires.

Speaking of Kanye West, Jacobs was one of the first high-fashion designers to collaborate with the artist on a series of luxurious sneakers. Riding high off the success of the first Air Yeezy sneaker with Nike, it was unprecedented that he would follow that up with a line of shoes for Louis Vuitton. Ranging in price from $840 to $1,140, the shoes were pricey for the average sneakerhead even then. Although modern resale prices for the first Air Yeezy have since skyrocketed above that, it was a lofty price of admission for a customer used to paying around $200 a pair—but that didn't stop them from selling out. The colorful collection consisted of the Don, the Jasper, and the Hudson—taking names from West's inner

After leaving Louis Vuitton in 2013, Jacobs turned his focus to his namesake brand, experimenting with both commercial ventures and artistic projects. In 2020, Jacobs launched Heaven by Marc Jacobs, a sub-label with digital-native creative Ava Nirui at the helm. Heaven channels a nostalgic yet contemporary aesthetic, with a range of collaborations, from cult designers like Kiko Kostadinov, emerging artists like Yung Lean and Charli XCX, to youth culture icons such as Winona Ryder. The line reflects Jacobs' enduring ethos of inclusivity and experimentation, resonating deeply with Gen Z consumers while maintaining ties to the DIY culture that inspired his early career. By appointing Nirui to lead Heaven, Jacobs has not only proven his enduring ability to recognize and nurture new talent, he's also cemented his legacy of challenging norms and fostering cross-disciplinary collaborations.

While Marc Jacobs was making his indelible impact on Louis Vuitton as a house and its womenswear collections, Kim Jones was responsible for making sure its menswear line left a lasting legacy, too. Appointed as the style director for the men's ready-to-wear division in 2011, he replaced Paul Helbers, who held the position for five years. Born in London in 1979, Jones spent his childhood on the move. His hydrogeologist father brought his family to exotic locales for work, spending a significant amount of time in African countries like Tanzania and Kenya. He considered following in his father's footsteps—weighing a career in conservation or zoology—but ended up more interested in his sister's expansive collection of fashion magazines. In his teens, he developed the roving collector's itch that he's still known for today, starting out with vintage Levi's pieces before discovering

Opposite top left: Louis Vuitton x Takashi Murakami Mini Speedy
Opposite top right: Louis Vuitton x Stephen Sprouse Speedy 30
Opposite bottom: Pharrell Williams and Nigo eyewear collection for Louis Vuitton

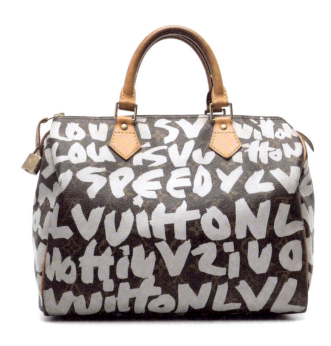

HIGH ART AND COMMERCIAL FASHION IN A WAY THAT FELT FRESH WHILE MAINTAINING VUITTON'S LUXURY DNA.

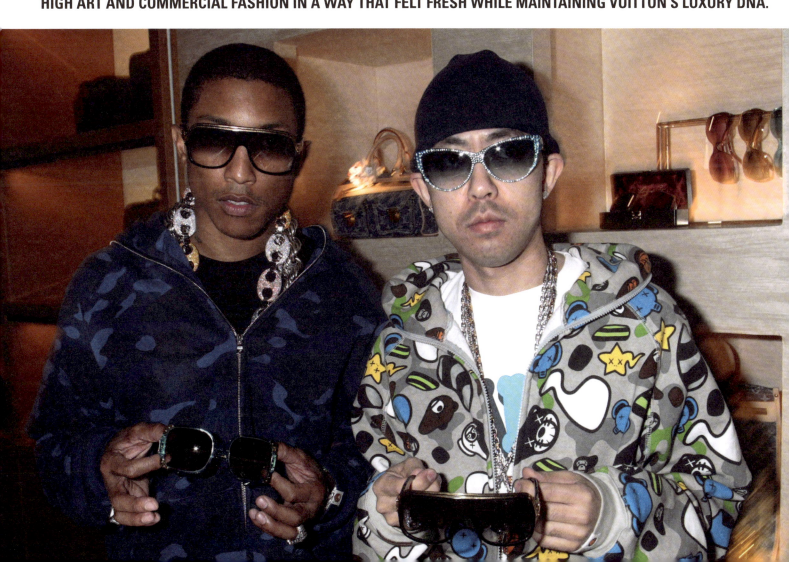

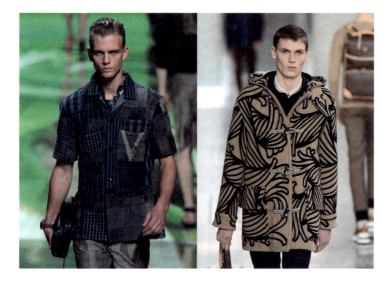

the work of 1980s London designers like Vivienne Westwood, Stephen Linard, Modern Classics, Rachel Auburn, and Christopher Nemeth—whose pieces still remain in his archive today.

Jones taught himself how to design by cobbling together garments in a DIY style largely inspired by the work of Vivienne Westwood and Malcolm McLaren and their Seditionaries label. After showing some of his early work to the late Louise Wilson, the esteemed head of fashion at Central Saint Martins, she secured him a spot in the program. His 2002 graduate collection famously caught the attention of John

introduced contemporary designs while respecting the brand's classic aesthetic, striking a balance between tradition and modernity with a worldly lens. He designed items like coach jackets made from luxurious materials, and imbued certain silhouettes with a Japanese flair, creating sportcoats that blurred the line between blazer and kimono. When he landed at Louis Vuitton in 2011, he took that Japanese influence with him.

For his Spring/Summer 2013 collection, Jones enlisted the help of Kiro Hirata to create a collection of genuine Japanese boro denim pieces for Louis Vuitton. Hirata is the heir and designer of cult label Kapital, a brand based in Japan's Okayama prefecture, revered for its history of denim production and preservation of traditional denim manufacturing. Boro is an intricate technique that involves weaving together fragments of fabric, usually discarded materials, creating a wabi-sabi, neo-vintage appeal. Only recently has Kapital become more popular in the realm of covetable streetwear, but this early example is a testament to Jones' prescience and his ability to tap into the cultural zeitgeist.

Jones' seven-year tenure at Vuitton firmly established the brand's reputation in menswear. Vuitton's credibility was in large part thanks to Jones' ability to understand what was happening in the space and elevate it to a level worthy of a luxury house. For his Fall/Winter 2014 collection, he famously took inspiration from Patagonia's Retro-X line of fleeces, making them in upscale shearling and leather. A year later, he paid homage to one of his favorite designers, Christopher Nemeth, with a collaborative capsule collection utilizing Nemeth's rope patterns. Of course, Jones's tenure at Louis Vuitton is mostly remembered for its notable collaboration with Supreme in 2017.

KIM JONES'S TENURE AT VUITTON IS MOSTLY REMEMBERED FOR ITS NOTABLE COLLABORATION WITH SUPREME.

Galliano, who bought half of it. At the same time, Jones was also cutting his teeth in the world of streetwear, working his first job in the industry at Gimme Five, an early distributor of brands like Stüssy, A Bathing Ape, and Supreme founded by Michael Kopelman, who also ran a highly influential boutique called The Hideout with Fraser Cooke. Jones' experience working with Kopelman and Cooke set the stage for his remarkable collaborations with Supreme and Shawn Stüssy much later in his career.

From the beginning, Jones not only showed a talent for mixing culture, design, and sportswear, he was also a sharp-eyed collector who knew what certain items of his could fetch on the resale market. When he made his eponymous debut at London Fashion Week, he self-funded the collection by selling one of his prized Vivienne Westwood parachute shirts on eBay. Largely inspired by '90s youth culture and raves, his first collection mixed ombré-dyed denim, tribal print bombers, and patchwork trousers with nylon track pants and Nike Terminator high-tops—a favorite among discerning sneakerheads. Jones' design codes are characterized by this unique narrative, which resonates across various cultural landscapes, often resulting in a seamless fusion of streetwear and high fashion.

In 2006, Jones collaborated with British sportswear brand Umbro on a collection that reimagined the uniforms of football-loving Casuals. Taking quintessentially English colors, his vibrant printed hoodies perfectly complemented a line of minimal sneakers that were elevated with the use of woven leather panels. By 2008, he shuttered his own label after he was appointed as Creative Director at dunhill, where he was tasked with revitalizing the heritage brand. There, Jones

This groundbreaking partnership merged the worlds of luxury fashion and streetwear in a way no one saw coming. Streetwear had long been infiltrating the realm of high fashion, and for the longest time, it was the antithesis of luxury. Brands like Supreme and Stüssy hacked the logos and motifs of houses like Vuitton, reinterpreting them for a different audience (and at times drawing the ire of those brands' legal teams). This collaboration shattered a longstanding barrier: what was once a rebellious counterculture had become part of the establishment. Elevating Supreme's famous box logo hoodie into a luxury piece by adorning it with Louis Vuitton's monogram and adding details like metal toggles walked a fine line between absurdity and brilliance. It was the ultimate high/low collaboration, a massive collection spanning everything from a custom Vuitton trunk designed to carry a skateboard to a reinterpretation of the house's grained Épi leather into a chain wallet and a bold red Speedy.

The collection's campaign stayed true to Supreme's spirit, enlisting photographer Terry Richardson to shoot the collection and depicting the epic collaboration on the bodies of Supreme's most notable friends and family. Old-school Supreme affiliates like Jason Dill and Mark Gonzales shared the spotlight with Supreme's modern skate team, including Nakel Smith, Sage Elsesser, Aidan Mackey, Sean Pablo, and Tyshawn Jones. It kept the lo-fi visuals that Supreme had built its brand on intact, but with a luxury fashion price tag. The collection also carries the distinction of being one of the few Supreme collaborations that was never sold at any of the brand's stores. Instead, Louis Vuitton curated special pop-ups where interested consumers could sign up for a chance to dig into the pricey collaboration.

Top left: Louis Vuitton Menswear Spring/Summer 2013, Paris
Top right: Louis Vuitton Menswear Fall/Winter 2015, Paris
Opposite: Louis Vuitton Menswear Fall/Winter 2017-2018, Paris

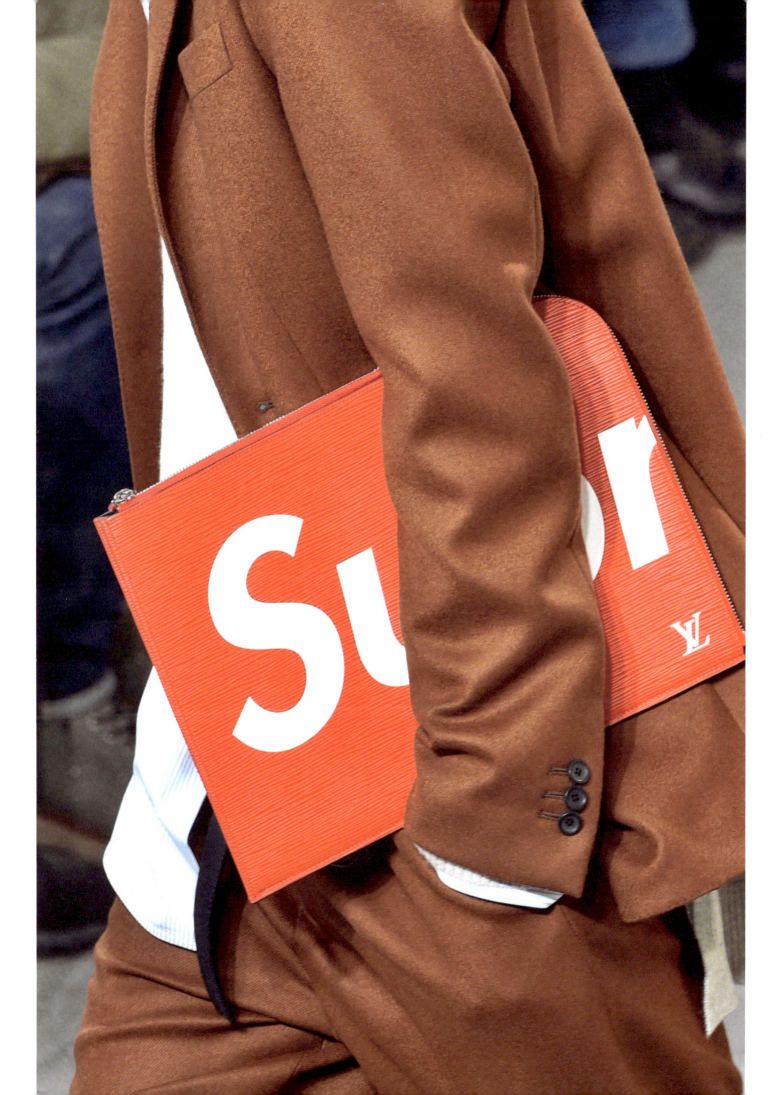

A year after turning the dichotomy between streetwear and luxury on its head, Kim Jones was appointed as the artistic director of Dior Men, where he continued to make collaboration central to his design philosophy. Jones' approach at Dior reinvented the collab, positioning it as a valid and innovative form of fashion design that enriches the brand's heritage with modern influences. His first collection for Dior Men—his Spring/Summer 2019 collection—was designed entirely in collaboration with the artist Brian "KAWS" Donnelly.

"I've always wanted to work with KAWS. I think it's nice that he's the first person I'd work with at Dior because I love his work," said Jones in his cover story for *Highsnobiety* magazine issue 17. "For me, for the generation that's coming up now, he's the most important artist in the world."

The artist left his stamp on every aspect of the collection, rewriting the house name in his signature, comic book-esque typeface, creating a giant floral sculpture of his cartoonish BFF figure with "Xs" for eyes that became a centerpiece for the runway, and even reimagining the house's signature bee motif. Mix in Dior's savoir faire, and the result was not just commercially viable jersey pieces and covetable designer sneakers, but even made-to-order embroidered jackets and truly luxurious items that felt like couture pieces—and were priced accordingly. The KAWS collection set the tone for Jones' Dior tenure: a blend of luxury, art, and street culture.

The strategy of collaboration-as-collection continued for much of his early Dior offerings. After KAWS, he worked with the Japanese artist Hajime Sorayama, known for his erotic, hyperreal depictions of robotic figures, and later joined forces with visionary artists such as punk illustrator-turned-fine

Ironically, the collection was marketed as "Dior x Shawn," since Stüssy as a brand still very much exists, and after a few years of trying to reclaim its former glory, has since regained its respectability without alienating its core tenets of accessible prices and subcultural influences. But Shawn Stüssy's Dior collection elevated a lot of what made his time at the brand so great—the multicolored influences from reggae, ska, and new wave, the 1980s style inspiration, and the graffiti handstyle slogans—now repurposed into the mantra: "I want to shock the world with Dior." And perhaps the most shocking thing about the

BECOMING THE FIRST BLACK ARTISTIC DIRECTOR AT LOUIS VUITTON, ABLOH'S CAREER WAS A MASTERCLASS IN

artist Raymond Pettibon, British artist Alex Foxton, and American visual artist Daniel Arsham, known for his uncanny, eroding sculptures of everyday objects. Jones described this approach as having roots in Christian Dior's affinity for the arts, wanting to work with artists he thought Mr. Dior would appreciate in the here and now. His collaborations with artists like Arsham and Amoako Boafo at Dior highlight his commitment to integrating contemporary art into fashion. Boafo's vivid portraits brought African art to the forefront of Dior's storytelling, while Arsham's "Future Relics" aesthetic challenged notions of time and history in design.

But when it came time to find a partner for his Pre-Fall 2020 collection, Jones would break the mold yet again. Closing yet another streetwear circle, he tapped the long-retired Shawn Stüssy to create a collection for Dior. After founding Stüssy in 1980, Shawn Stüssy was the driving force behind the brand, the cultural dot-connector whose very signature made the label what it was. It was he who formed the International Stüssy Tribe, a global collective of like minds that included DJs like Alex Turnbull, the Japanese godfather of streetwear, Hiroshi Fujiwara, and British purveyor Michael Kopelman—the man who had given Kim Jones his first job decades earlier. In 1996, Stüssy retired from the brand he had built, focusing on raising his family and returning to his first love, shaping some of the world's best surfboards. For a time, he dabbled in smaller brand projects, running a label called S/Double that was primarily sold in Japan, but this Dior collection was an opportunity for him to manifest what he knew the Stüssy brand always should have been—a creative, convention-busting powerhouse worthy of the world stage.

collection was that it also introduced the world to the first luxury sportswear collaboration.

As good as the collection was, it was almost outshined by the reveal of the Dior x Nike Air Jordan 1. The project cemented Jones' ability to bridge subcultures with ease, further solidifying sneakers as a key component of modern menswear. Completely made in Italy at Dior's ateliers, the shoe featured a slightly larger *Swoosh* inlaid with Dior's signature canvas and finished with handwork usually reserved for luxury purses. A high-top and low-top version were made in an extremely limited run, and originally retailed for over $2,000. It didn't take long for resell prices to rise to significantly more than that. This particular collaboration reflected how far sneaker culture had come—the Air Dior was the ultimate status symbol for any sneakerhead, so much so that during the 2021 inauguration of President Joe Biden, so many eyes went to the feet of Nikolas Ajagu, the husband of Kamala Harris' niece Meena, who not only managed to secure a pair, but wore them to the occasion. Instead of being derided for wearing sneakers to such a high-profile event, Ajagu was actually lauded for it. After all, if you had the world's most wanted pair of kicks, who *wouldn't* proudly wear them to a once-in-a-lifetime celebration?

If there's one person who would have understood the importance of wearing Jordans to a presidential inauguration, it was the late, great Virgil Abloh, who succeeded Kim Jones as artistic director of Louis Vuitton's menswear. Abloh not only built on the collaborative codes established by Marc Jacobs and Kim Jones, he took them to unparalleled heights, cut short only by his unfortunate, untimely death on

Top: Dior Men's Pre-Fall 2020, Miami
Opposite: Louis Vuitton Menswear Spring/Summer 2019, Paris

November 28, 2021. Abloh's journey from a Chicago kid with big dreams to one of the most influential creatives of his generation is a testament to the power of innovation, collaboration, and authenticity. His work spanned fashion, art, music, and design, redefining the boundaries of what a designer could be and what streetwear could represent—and he did it all in a way that never compromised his distinct sense of individuality.

From his early days working with Kanye West to becoming the first Black artistic director at Louis Vuitton, Abloh's career was a masterclass in defying norms, empowering marginalized communities, and reshaping cultural narratives. He was born in Rockford, Illinois to Ghanaian immigrant parents; Abloh's father worked for a paint company, and his mother was a seamstress who taught him the basics of sewing—a skill that would eventually factor heavily into his career. Abloh's childhood was steeped in an appreciation for craft and creativity, but his academic path initially revolved around architecture.

He earned a degree in civil engineering from the University of Wisconsin–Madison in 2003 before pursuing a master's in architecture at the Illinois Institute of Technology. The campus, designed by Ludwig Mies van der Rohe, exposed him to modernist principles like "form follows function." His architectural background was evident throughout his career, as he had a way of framing his work within a structure. He operated by a series of self-set codes, hacks, and shortcuts as a means of promoting efficiency, reflected in the prolific amount of work he was able to produce. Indeed, it could be said that he designed "structures" rather than specific objects, and those structures could be garments, sneakers, furniture, or cultural movements.

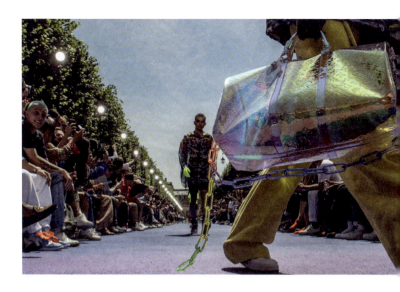

DEFYING NORMS, EMPOWERING MARGINALIZED COMMUNITIES, AND RESHAPING CULTURAL NARRATIVES.

Virgil Abloh's creative trajectory changed forever when he met Kanye West in 2002. In 2009, the two began an internship at Fendi. Even though West already had an established career as one of the most influential musicians of the modern era, it was an endeavor he wanted to honestly pursue, and Abloh was there as his right-hand man. Soon after, Abloh became the architect of Kanye West's visual and cultural empire, overseeing everything from album art, stage design, merchandise, and collaborations.

One of their most iconic projects was the cover for the 2011 album *Watch the Throne,* designed with former Givenchy creative director Riccardo Tisci. The intricate, gold-embossed design symbolized the merging of art, music, and luxury, earning a Grammy nomination for Best Recording Package. They followed that up with another boundary-breaking collaboration—two capsule collections with French apparel brand A.P.C. Blending the brand's penchant for minimal essentials with West's elevated sensibilities, the partnership subverted expectations through its keen mix of streetwear codes like militaria and workwear and high fashion tastes like the perfect T-shirt. Despite commanding retail prices slightly higher than most streetwear consumers would expect (a plain white T-shirt retailed for $120), the line not only dominated the media landscape, it instantly sold out, creating a frenzy as eager shoppers lined up outside A.P.C. stores, something the brand had only experienced when it had released hotly anticipated collaborations with Nike.

Abloh's contributions reached beyond aesthetics; he helped turn merchandise into a legitimate extension of an artist's brand, setting the stage for an era where tour-merch drops felt as exciting as a Supreme release day. From the *Yeezus* tour to *The Life of Pablo,* Abloh and West treated tour merch as an extension of the artist's vision, elevating it from a throwaway souvenir to a cultural artifact. *The Life of Pablo* pop-up shops, which appeared in cities worldwide, showcased Abloh's ability to turn ephemeral moments into global phenomena. While a lot of that creative energy also was tied to West's cult of personality, Abloh's contributions became more evident when he achieved similar success while working with Houston artist Travis Scott, whose rowdy shows were known for turning any venue into a mosh pit. This multidisciplinary ethos became a hallmark of Abloh's career, as he seamlessly navigated between industries and elevated street culture to new heights.

In 2013, Abloh launched Off-White™, a Milan-based fashion label that quickly became a cultural juggernaut. The brand's name referenced the "gray area" between black and white—that is, between high fashion and streetwear. Off-White™'s signature design elements, including quotation marks, zip ties, and industrial text, became instantly recognizable and deeply influential. Off-White™ wasn't just about clothes; it was about creating a language. Each piece told a story, whether through its typography, its graphic references, or its playful subversion of luxury fashion norms. In 2015, Off-White™ became a finalist for the LVMH Prize, solidifying its place in the fashion world and marking Abloh as a designer to watch.

Virgil Abloh's 2017 collaboration with Nike, titled "The Ten," deconstructed 10 of Nike's most iconic silhouettes, including the Air Jordan 1, Air Max 90, and Converse Chuck Taylor, infusing them with Abloh's signature aesthetic. Exposed stitching, sans serif typefaces, Abloh's signature quotation marks, and zip ties turned each sneaker into a statement piece. This partnership wasn't just about sneakers; it was about storytelling as a form of reinvention, and empowering the sneaker community to see everyday objects as canvases for creativity. Each shoe offered a fresh glimpse into Abloh's process and invited the wearer to become part of the narrative. The project didn't just feel like a collaboration between Nike and Abloh but also between the designer and his audience. The impact of The Ten was seismic. It redefined what a sneaker collaboration

could be, inspiring countless imitators and solidifying Abloh's status as a cultural innovator. It also transformed how sneakers were perceived within fashion.

In 2018, Virgil Abloh made history as the first Black artistic director of Louis Vuitton's menswear division. His appointment was groundbreaking not only in terms of inclusivity and representation, but also for what it symbolized: the formal recognition of streetwear's influence on luxury fashion. Under Abloh's direction, Louis Vuitton blazed a new path, embracing a more inclusive, youth-driven vision. He incorporated elements

and present, the collection allowed Abloh to write a new chapter for its future. It wasn't long until NIGO himself was brought into the LVMH fold as the artistic director KENZO. Abloh also expanded Vuitton's previous stake in the skate world with Supreme by signing skateboarder Lucien Clarke to the luxury label—another first—and even gave him his own signature shoe called "A View," a nearly-$1,200 sneaker meant to be worn down through rigorous hours of skating. From legitimizing street culture legends in the world of luxury to bringing skateboarding to the highest echelon of fashion in a real way, each project added a new layer to Louis Vuitton's narrative, reinforcing its relevance in a rapidly changing cultural landscape.

While Kim Jones broke the mold of sportswear and luxury collaborations with the Dior Air Jordan, Abloh took the concept and made it his own through an expansive collaboration between Nike and Louis Vuitton that dropped in 2022. [Virgil Abloh had already passed away by this time.] Returning to the roots of sneaker culture, he reimagined the iconic Air Force 1 shoe in multiple colorways, designing 47 pairs that were meant to emulate the ubiquity of popular sneaker retailers like Foot Locker. The idea was to reinterpret the familiar sight of a retail sneaker wall—something commonly seen on popular YouTube series like Complex's *Sneaker Shopping*—and putting it in the context of a luxury house.

The range and breadth of the offering had Abloh's fingerprints all over it. Replacing his iconic zip ties with leather LV luggage tags, emblazoning the industrial "AIR" text on the sole, and even including colorways that referenced Canal Street bootlegs and obscure parodies like Ari "Sal" Forman's Newport Cigarette-inspired "Ari Menthol 10s," every single shoe

HIS PHILOSOPHY OF COLLABORATION AND INCLUSIVITY PAVED THE WAY FOR A NEW GENERATION OF CREATIVES.

of his Off-White™ aesthetic, from bold graphics to playful typography, all while respecting the brand's storied heritage.

Take for example Abloh's debut collection for Louis Vuitton, which was an ecstatic celebration of diversity and creativity. The show featured a diverse cast of models who walked a rainbow-colored runway wearing pieces that blended Vuitton's sophistication with Abloh's contemporary sensibilities. The collection included everything from oversized monogrammed coats, reflective interpretations of Vuitton's leather goods, and covetable sneakers paying homage to tried-and-true sportswear silhouettes, showcasing Abloh's ability to honor tradition while pushing boundaries.

The show was more than a presentation—it was a moment of cultural reckoning. It demonstrated that luxury fashion could be inclusive and forward-thinking, and it positioned Louis Vuitton as a leader in a new era of creativity. Under Abloh's leadership, Louis Vuitton embraced collaborations that bridged cultures and industries. In 2020, Abloh debuted a capsule collection with NIGO called LV2, elevating the BAPE founder's design codes to the level of a French luxury house. Similar to how Kim Jones gave Shawn Stüssy the opportunity to create the line he always dreamed of, LV2 was a celebration of both Japanese streetwear and French luxury. What made Abloh so great is that he didn't just appreciate NIGO's work, but was a true fan of his career. NIGO's ability to make camouflage Pepsi cans and candy-colored patent leather sneakers covetable was something that could easily translate to a label like Louis Vuitton—and Abloh was the conduit that finally gave NIGO the platform. Connecting the threads between streetwear's past

was a chapter about the rich culture of sneakers and streetwear. And by launching the partnership through a series of global activations and pop-ups, the immersive experience allowed consumers to be part of the excitement, regardless of their ability to afford the expensive pairs, which retailed between $2,750 to $3,450.

Abloh's work wasn't just about fashion—it was about creating opportunities. Through initiatives like his "Post-Modern" Scholarship Fund, he supported Black students pursuing careers in fashion and design. His philosophy of collaboration and inclusivity paved the way for a new generation of creatives to follow in his footsteps. The fund raised over $1 million in its first year, reflecting Abloh's commitment to creating opportunities for underrepresented voices in the industry. This ethos of mentorship extended to his collaborations as well. Abloh frequently worked with emerging designers and creatives, using his platform to amplify their voices.

Virgil Abloh's career was a testament to the power of collaboration to communicate larger ideas about how he wanted to see the world. He wasn't confined to fashion alone—his work spanned furniture design, automobiles, beverages, and more. Abloh's collaborations weren't just partnerships; they were cultural moments that reframed how brands and creatives could interact, expanding the aperture of what a so-called "designer" could achieve. These projects underscored Abloh's belief that design is universal. Whether it was a sneaker, a handbag, or a water bottle, he approached each medium with the same level of intention and innovation, proving that no object was too small or insignificant to be elevated through design.

Top: Louis Vuitton x Nike Pilot Case
Opposite: Louis Vuitton x Nike Air Force 1

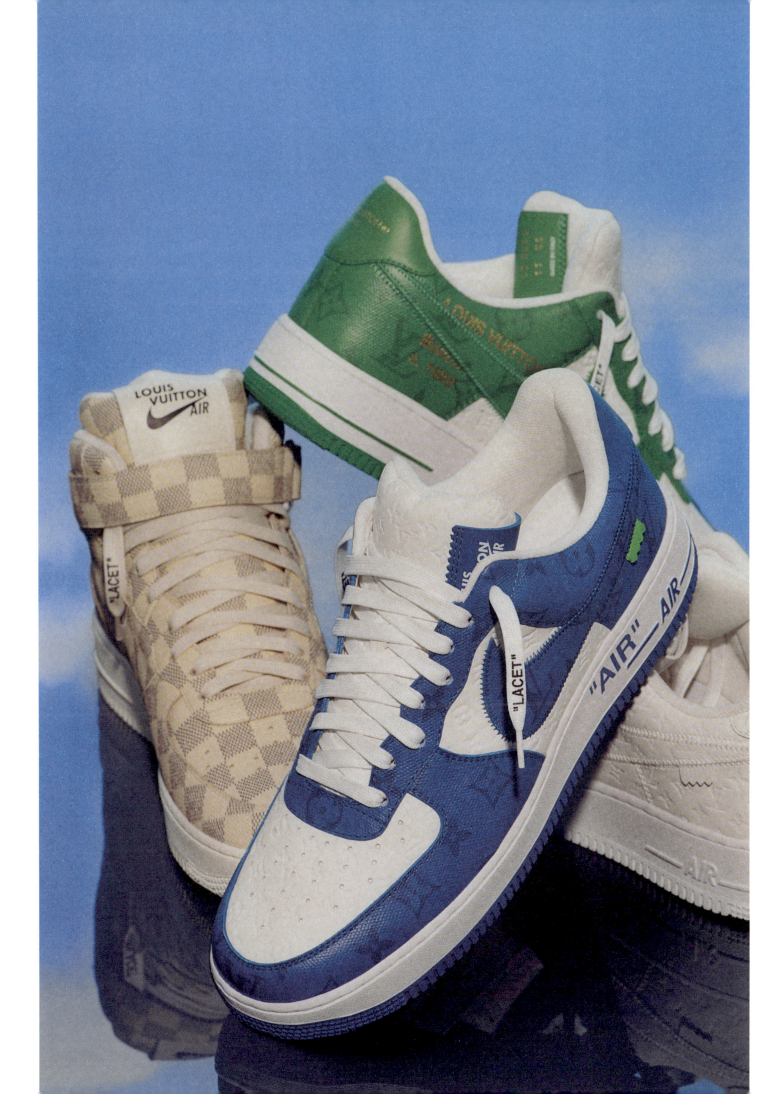

Where a Passion for Sailing Meets Luxe Craftsmanship

PRADA

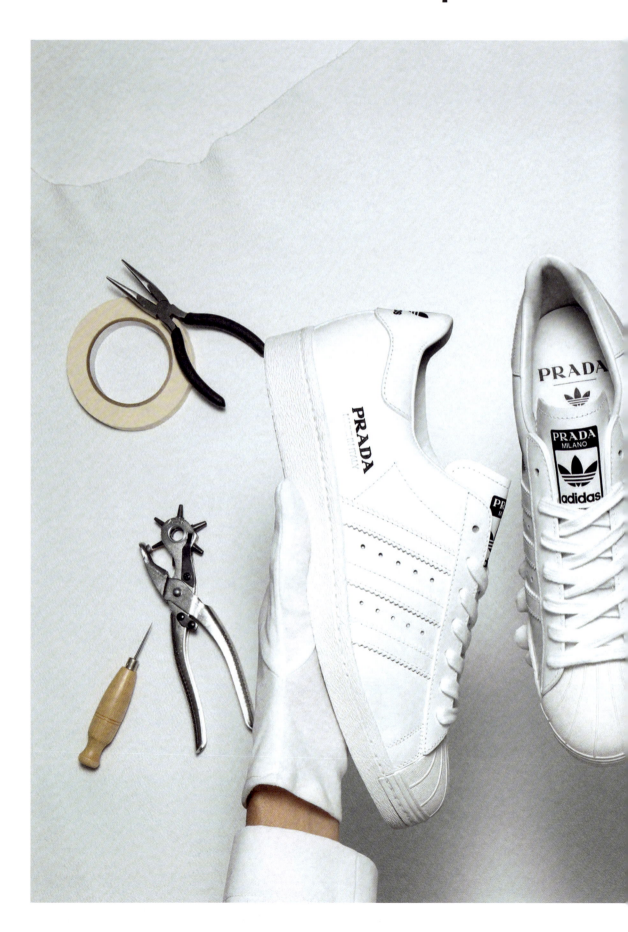

PRADA X ADIDAS

From revamped Superstars to reimagined duffels, the collection blends sleek design and cutting-edge technology, proving the power of sports and style.

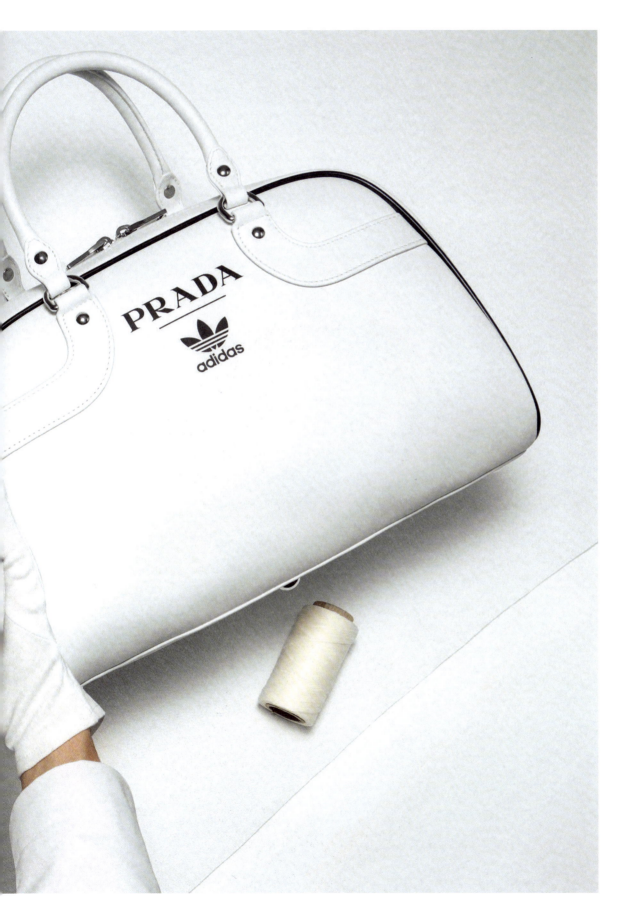

ADIDAS

In November 2019, Prada and adidas came together for a collaboration that once again blended fashion with sportswear, but with a personal passion hidden within it. The line was inspired by the Prada family's deep love of sailing as a hobby and sport, with the company's CEO Patrizio Bertelli being an avid sailor himself. The connection is so deep that the brand launched their own Luna Rossa team, which has been competing in the America's Cup since 1997. Under Bertelli's leadership, Luna Rossa has become known for pushing the boundaries of technology and design in extreme environments. This love of high-energy sport resonated with adidas, whose legacy in performance-driven innovation has been shaping all aspects of modern sportswear, from cutting-edge running shoes and cleats to everyday attire.

While the brands have released multiple editions of sportswear, their first drop in 2019 featured only two limited-edition items: the go-to adidas Superstar updated with Prada's craftsmanship, and the iconic Prada bowling bag reconstructed for the functionality of a sports duffel. The classic styles got a luxury makeover, using premium leather, suede, and expert Italian craftsmanship. *(The Cut* reported that each limited-edition item required a hundred people handcrafting the pieces through a hundred-step process.) The Superstar more or less maintained its classic look, with the addition of sleek white leather and Prada branding, adding a high-end twist to the iconic streetwear sneaker. Meanwhile, the bowling bag mirrors the Superstar's clean white design and black detailing, with an adidas logo emblazoned under Prada's moniker.

Sailing fashion is all about function with style—think technical outerwear, waterproof materials, and designs that prioritize comfort and durability. And the success of this launch proved that there was so much more these two brands could accomplish in collaboration. adidas and Prada would go on to do several drops, including multiple designs of Luna Rossa-themed sailing shoes and Re-Nylon collections of bags, jackets, hats, and sneakers made from recycled materials. Through each one you can see the original inspiration—Prada's passion for sailing—reflected in the collection, with high-tech fabrics, clean lines, and thoughtful details that capture the essence of their blended vision while still feeling entirely new.

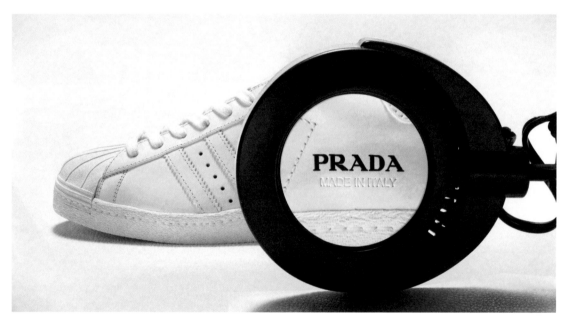

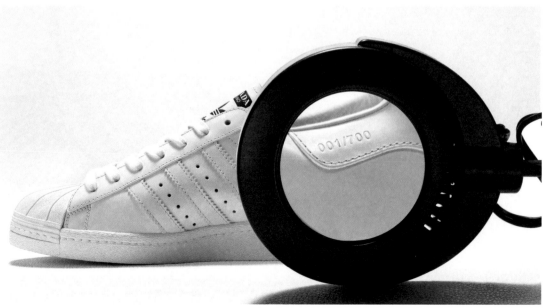

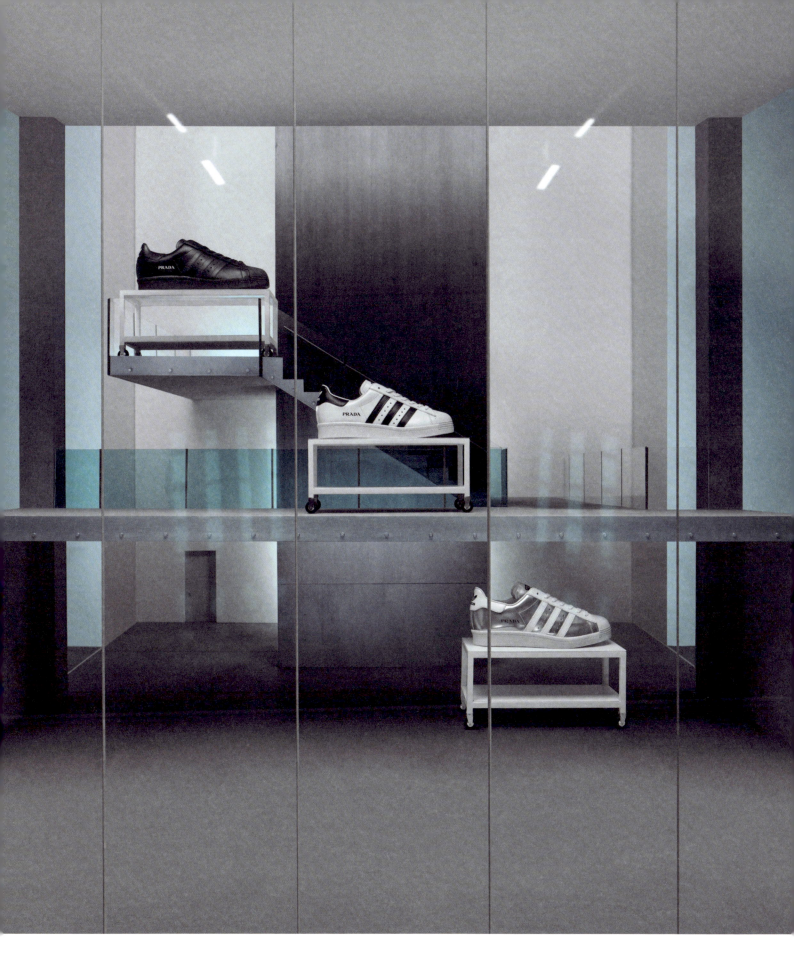

Frank Ocean's Introspective Intimacy

PRADA X **HOMER**

Homer's collaboration with Prada merges high fashion with personal storytelling, blending minimalist design and raw emotionality into a collection that's both intimate and innovative, redefining luxury in the process.

Frank Ocean's brand Homer's 2021 collaboration with Prada marked a significant moment where music, art, and fashion converged. Known for his deeply introspective, genre-defying work, Ocean had already made waves with his brand Homer, an art and jewelry label that embodies his minimalist, nature-inspired aesthetic. His partnership with Prada, a brand synonymous with innovation and craftsmanship, created a collection that seamlessly blended both worlds.

Ocean's influences in the collaboration were unmistakable. Known for his dreamy, melancholic aesthetic, his style often draws from his own experiences with identity, memory, and longing. In the Prada x Homer collection, these themes were translated into pieces that fused classical luxury with a fresh, experimental take. Homer, founded by Ocean in 2021, draws on a minimalist yet deeply evocative design philosophy, characterized by clean lines, natural motifs, and rich materials. This collection blended traditional luxury, personal storytelling, and raw emotional texture.

The line included custom jewelry pieces, sleek apparel, and accessories, each imbued with Ocean's signature cool, understated vibe. Notable items included oversized earrings with abstract geometric shapes, pendants shaped like delicate ears (a Homer signature motif symbolizing listening and intimacy), and custom-designed sunglasses that combined retro influences with subtle Prada detailing. The collection also featured a chic, unisex bomber jacket and a minimalist range of luxe, soft-toned, knitwear—pieces meant to reflect the blend of high fashion and streetwear sensibility that Ocean gravitates toward.

Ocean's design process drew heavily from his own experiences with memory and identity, which were central to the pieces. "It's about creating something that's personal—something that speaks to me," Ocean said. His collection wasn't just about clothing; it was about telling stories through design. Presented at New York Fashion Week in 2021, the collaboration was worn by models like Rosalía and Evan Mock, signaling the fusion of deep vulnerability, elevated craftsmanship, and cross-cultural capital. The pieces stood out for their ability to merge high fashion with intimate, honest expression and proved that luxury doesn't have to be distant or impersonal. It can be masterful, emotional, and deeply resonant—a perfect encapsulation of Frank Ocean's larger creative ethos.

A Grungy Reimagining of an Iconic Shoe

RICK OWENS **X** **DR. MARTENS**

Fusing Owens' subversive vision with Dr. Martens' timeless appeal, this collaboration yields a striking boot that embodies rebellion and innovation.

Rick Owens, the avant-garde designer renowned for his fusion of fashion and music culture, has consistently drawn inspiration from his subversive philosophy, infusing his designs with a raw, rebellious energy. Known for his dark, deconstructed aesthetic, Owens blends elements of gothic, punk, and post-apocalyptic design to create garments that challenge traditional fashion norms. His collaboration with Dr. Martens, initiated in 2021, exemplifies this synergy, blending Owens' distinctive vision with the iconic footwear brand's enduring appeal.

The partnership yielded a series of reimagined Dr. Martens boots, notably the 1460 DMXL Jumbo Lace Boot. This iteration features oversized brushed silver eyelets, a prominent external zipper, and extra-thick wraparound laces, all set upon an inflated DMXL sole. Crafted from supple Lunar leather, the boots offer an unexpected softness, merging Dr. Martens' ruggedness with Owens' avant-garde vision. The boots were first debuted by DJ Sissy Misfit, who embodied the collaborative spirit and avant-garde nature of the design during their public reveal.

The design process was personal for Owens, who reflected on his love for defying expectations and pushing boundaries with his work. The exaggerated features of the boots, including the jumbo laces and heavy hardware, pay homage to his rebellious aesthetic, while the thick side zip and extended geometric tongue add a contemporary twist. The collaboration not only reinterprets Dr. Martens' classic silhouettes through Owens' unique lens but also reflects a shared ethos of non-conformity and innovation. By intertwining elements of music, fashion, and personal history, Rick Owens and Dr. Martens have crafted a collection that resonates with both heritage and modernity, appealing to those who dare to defy convention.

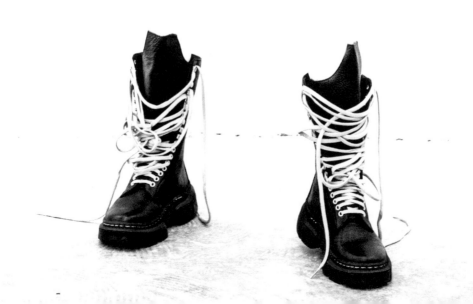

A Luxury Reimagination of a Generational Classic

DIOR **X** **AIR JORDAN**

This iconic partnership merges high fashion with basketball culture, culminating in the exclusive Air Jordan 1 High OG Dior sneaker and a limited-edition capsule collection that showcases timeless elegance and sporty audacity.

In 2019, the former Dior Men's Artistic Director Kim Jones partnered with Jordan Brand, the home of Michael Jordan's most famous shoe, to create a groundbreaking collaboration that bridges the worlds of high fashion and basketball culture. This partnership culminated in the unveiling of the Air Jordan 1 High OG Dior sneaker during Dior's Men's pre-Fall 2020 runway show in Miami, which coincided with the 35th anniversary of the Air Jordan brand.

The Air Jordan 1 High OG Dior sneaker was meticulously crafted in Italy, reflecting Dior's commitment to luxury and craftsmanship. The design featured a harmonious blend of white and Dior Gray leather, with the iconic Nike Swoosh adorned with Dior's Oblique monogram pattern, symbolizing the fusion of the two brands' legacies. Hand-painted edges and a translucent outsole bearing the "Air Dior" logo further emphasized the sneaker's exclusivity and attention to detail.

To complement the sneaker release, the collaboration also introduced a capsule collection that merged Dior's tailoring expertise with the spirit of 1980s American sportswear. It featured relaxed, minimalist wool suits with subtle blue and white striped linings, bomber jackets emblazoned with the Air Dior emblem and the Jumpman logo, and silk shorts adorned with a graphic motif of the "CD" initials. Additional pieces included gray suede hoodies, cashmere sweaters, shirts, polo shirts, pants, and accessories such as leather goods, bucket hats, necklaces, jacquard ties, and square silk scarves that combined Dior's Toile de Jouy and Wings prints.

The collection was available at select Dior stores and pop-up locations worldwide, offering a unique opportunity to experience the intersection of luxury fashion and basketball heritage. Because its release coincided with the onset of the pandemic—and with its nearly $2,000 price tag—the exclusivity of the shoe sky-rocketed, making it one of the most expensive Jordans ever.

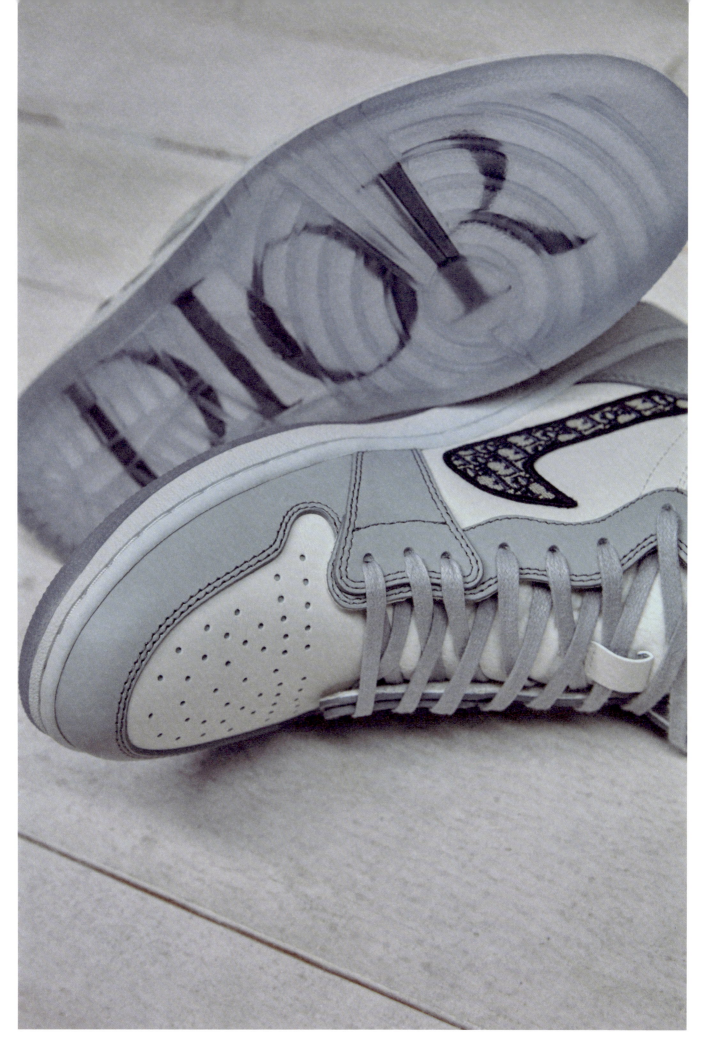

A Fusion of Haute Couture and Functional Design

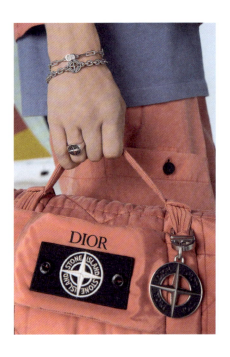

DIOR X **STONE ISLAND**

The 2024 collaboration between Dior and Stone Island merges the luxury of haute couture with military-inspired functionality, creating a new era in menswear.

When Dior and Stone Island first joined forces, it was the perfect pairing of two brands obsessed with functionality, craftsmanship, and innovation. Stone Island has long taken the practical feel of military materials and pushed it further by experimenting with different fabrics, such as nylon, wool, and cotton blends, often treating them with unique, experimental techniques. For instance, Stone Island's signature Raso (a heavy-duty, military-grade textile) and Tela (a reinforced, dense cotton fabric) are reminiscent of military uniforms, designed to withstand the rigors of the elements.

Kim Jones, the former Dior Men's Artistic Director, drew from both brands' shared commitment to perfection, offering a fresh, modern perspective on durable menswear. As he puts it, the collaboration represents a meeting of high fashion and technical expertise, a new kind of "clothing alchemy," where the art of fashion meets the science of technical wear. As a result, the collaboration blends Stone Island's signature garment-dyeing techniques with Dior's renowned savoir-faire, creating a seamless union of style and function. Key pieces include outerwear and knitwear that explore innovative garment-dyed embroidery, drawing inspiration from Dior's 1955 and 2013 haute couture archives. A standout piece is the reworked 1988 Stone Island field jacket, reimagined with silk cotton and embossed leather instead of the original cotton and rubber, lending it refined elegance while maintaining the garment's rugged appeal—a testament to the creative power of this collaboration.

Color plays a central role, too, with the "alchemy of color" theme seen throughout the collection. Classic shades from Stone Island's archives are reinterpreted with luxurious new materials, while Dior's iconic "double pleat" tailoring motif is integrated into Stone Island's practical "Dutch rope" internal structures, creating a dynamic blend of style and functionality. In footwear, the collection introduces hybrid boots, derby shoes inspired by climbing gear, and a sneaker crafted from Stone Island fabric, stitched with Dior's signature Oblique pattern. Accessories, including a circular leather trunk adorned with Stone Island's compass rose, add the finishing touch, blending, yet again, luxury with high function.

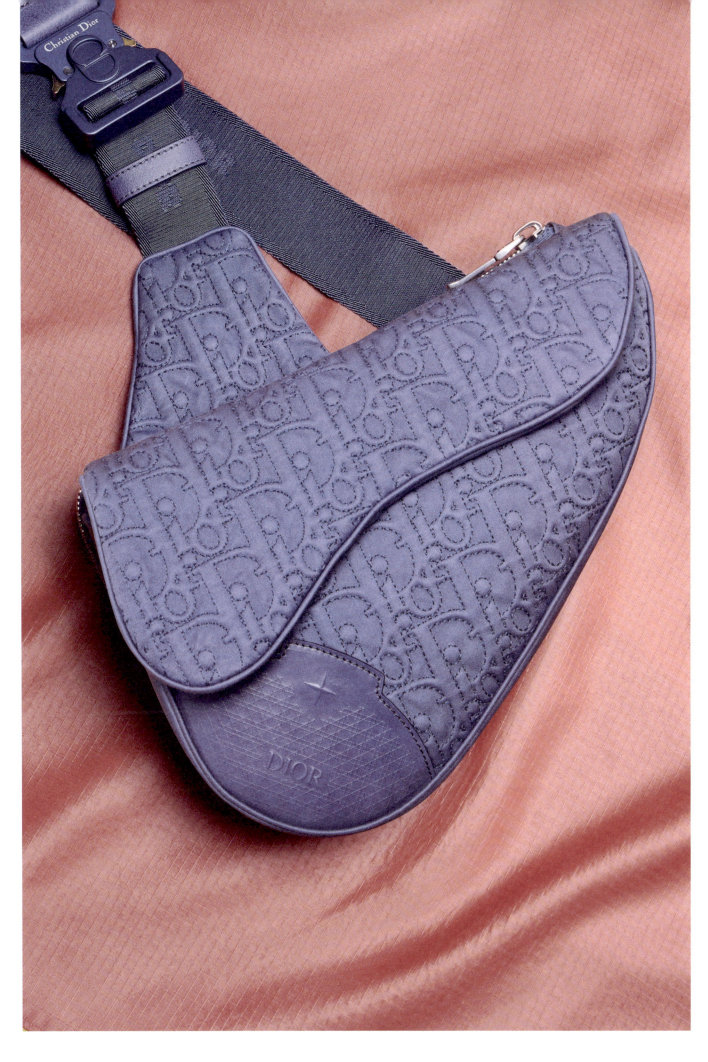

Virgil Abloh Redefines Sneaker Luxury

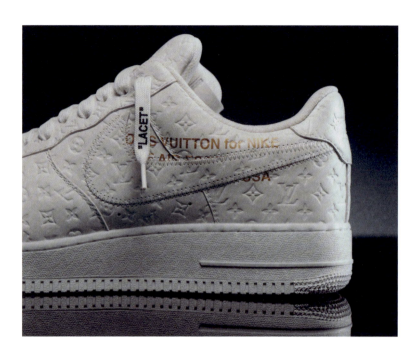

LOUIS VUITTON X **NIKE**

From his pioneering work with Nike's The Ten collection to his groundbreaking Louis Vuitton x Nike partnership, Virgil Abloh consistently reshaped athletic streetwear's boundaries.

Before his groundbreaking Louis Vuitton and Nike collaboration, Virgil Abloh was already making waves with a series of high-profile partnerships that blurred the lines between streetwear and luxury fashion. In 2017, Abloh's creative studio and luxury brand, Off-White™, partnered with Nike to release The Ten collection, which reimagined iconic sneakers like the Air Jordan 1 and Air Presto. The collection, which has now reached legendary status among sneakerheads, put his signature deconstructed approach to sneaker design on the map. Later, Abloh went on to collaborate with artists like Takashi Murakami and even brands like IKEA, merging art, fashion, and lifestyle in ways that reshaped contemporary fashion and design at large.

In early 2021, as Louis Vuitton's new director of menswear, Abloh partnered with Nike once again for a groundbreaking Nike x Louis Vuitton collaboration featuring a series of 47 bespoke Nike Air Force 1 editions, designed for LV's Spring/Summer 2022 runway collection. Each pair fused Nike's classic Air Force 1 silhouette with Louis Vuitton's luxurious materials and craftsmanship, produced in the Maison's Italian workshop. Unfortunately, Abloh never saw his creations on the runway: in November of 2021 he passed away after a private-two-year battle with cancer. The news of his untimely death rocked the fashion and design worlds—communities that continue to mourn his passing today.

The sneakers from the LV x Nike collaboration were released posthumously in New York City in May 2022, a few months after Abloh's passing. The event, held at Greenpoint's Terminal Warehouse, combined elements of his design philosophy with a playful nod to hip-hop culture—ultimately acting as a poignant tribute to his larger impact on fashion. The exhibition, with its surrealist ideas, sneakers on magnetized walls, holographic displays, and whimsical pieces, served as a bittersweet reflection on the beloved designer's limitless creativity. Abloh's deep connection to hip-hop and his exploration of "high and low" culture were evident in the sneakers themselves, embodying the very streetwear ethos he redefined. Even in his absence the endurance of his influence endures, a testament to his groundbreaking ability to unite disparate worlds with authentic, futuristic vision.

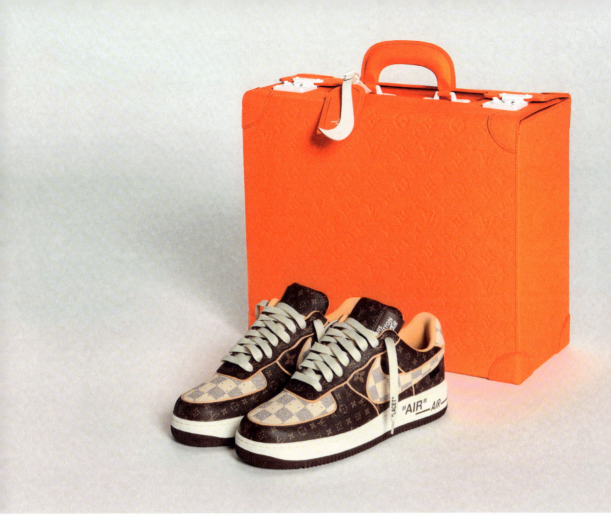

ABLOH'S BLEND OF HIGH FASHION AND SPORTSWEAR REDEFINED STREETWEAR, LEAVING A LASTING LEGACY.

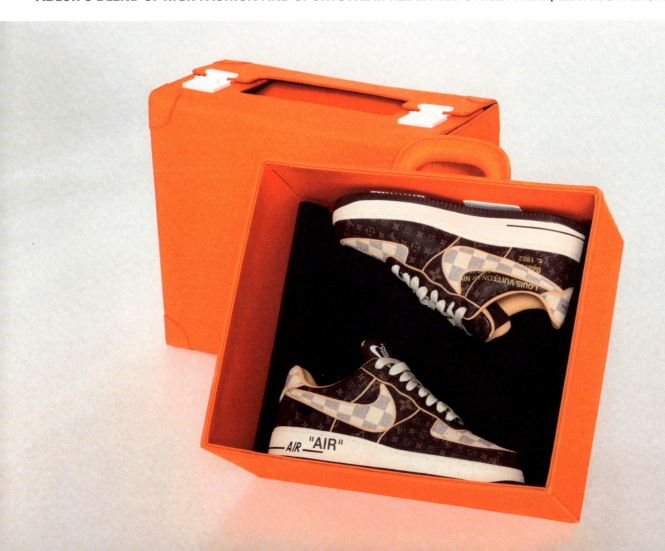

A Minimalist Meets a Streetwear Go-To

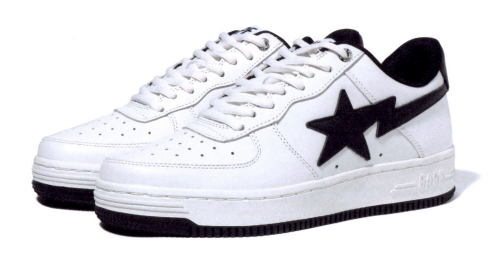

JJJJOUND X **BAPE**

In a union of understated elegance and bold street culture, JJJJound and BAPE partnered for a sleek, limited-edition sneaker that blends subtlety with statement.

JJJJound, the Montreal-based design studio founded by Justin Saunders in 2006, has earned a reputation for its minimalist, refined approach to design. With a focus on creating functional pieces that blend high-end fashion with everyday wearability, JJJJound has become a name synonymous with timeless style. Known for its neutral tones, clean lines, and avoidance of loud logos or excessive embellishments, the studio has built a loyal following in the fashion and design communities.

One of JJJJound's standout collaborations came in 2022, when they partnered with BAPE, the legendary Japanese streetwear brand, for a limited-edition sneaker release. The result was a reimagined version of the classic BAPE STA, stripped of the usual bold, busy aesthetics that BAPE is known for. Instead, the design took on a more refined and subtle look, featuring a clean white leather upper with tonal detailing on the rubber sole. The co-branding on the sneaker's heel tab kept things simple, a nod to JJJJound's minimalist ethos, while original elements like the iconic shooting star motif helped preserve some of BAPE's signature dynamism.

A break from BAPE's typical explosion of pop-art colors, the pared-down design lent the shoes an elegant, timeless appeal. A second release in early 2023 saw the BAPE STA reimagined in a navy and white colorway, further cementing the collaboration's sleek, sophisticated approach. The shoes were crafted from high-quality calf leather and packaged in custom blue camo BAPE packaging, making them even more desirable for collectors.

Accompanying the sneakers was an apparel collection, featuring hoodies, sweatpants, and caps, each with "A Timeless Ape" branding, further enhancing the cohesive collaboration and catching the attention of streetwear fans. Hype aside, the design and marketing campaign were strategically minimal, showcasing a focus on craftsmanship and simplicity while still retaining BAPE's streetwear influence.

REFINED LOOK, CLEAN WHITE LEATHER. A REIMAGINED BAPE STA, STRIPPED OF THE USUAL BOLD AESTHETICS.

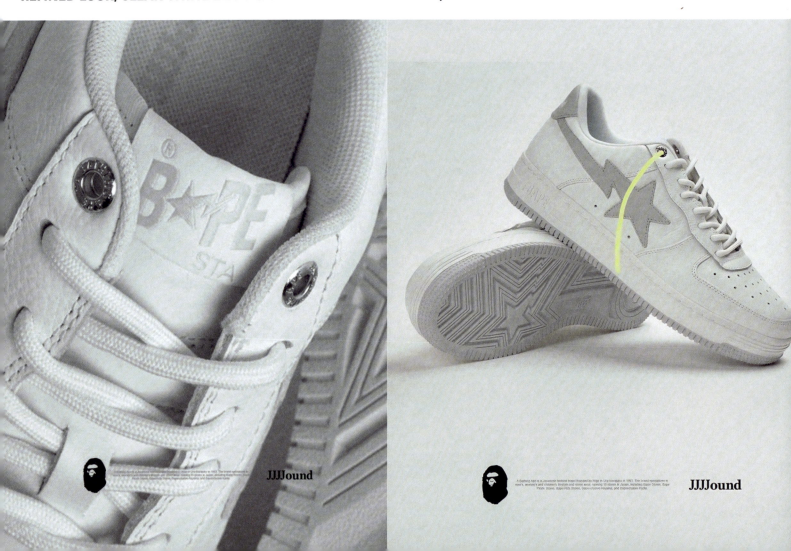

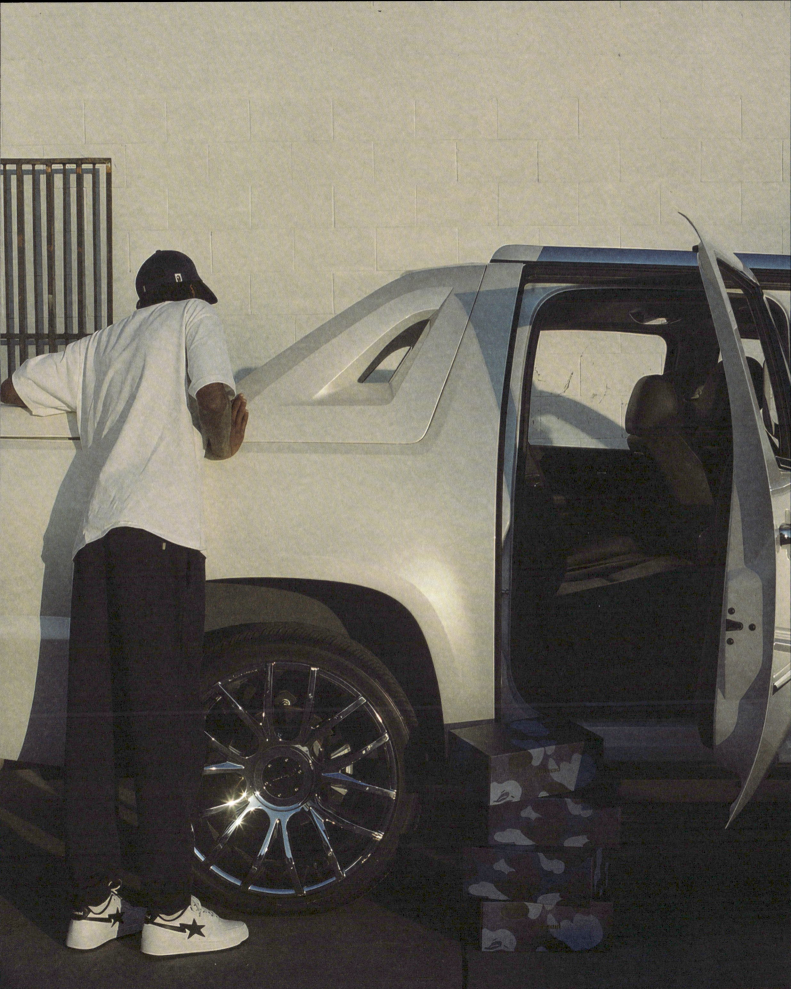

How Virgil Abloh's The Ten Revolutionized Sneaker Design

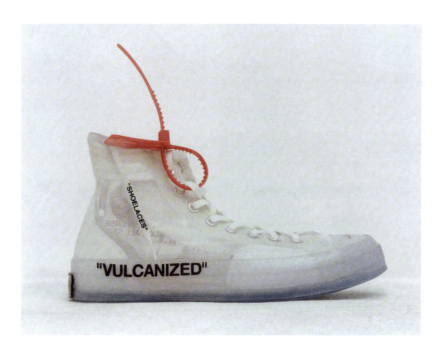

NIKE X **OFF-WHITE™**

With deconstructed designs, themes of transparency and "ghosting," and a focus on accessibility, *The Ten* redefined sneaker culture and gave everyone a chance to participate in high-level design.

In 2017, Nike and Off-White™'s Virgil Abloh unveiled The Ten, a groundbreaking collaboration that forever altered the sneaker landscape. Abloh, known for his conceptual approach to design, combined his streetwear sensibility with Nike's legacy of performance and innovation. The partnership was deeply personal for Abloh, who had long admired Nike's iconic silhouettes. His relationship with the brand dated back to his youth in the '90s when, like millions of others, he idolized Michael Jordan, with whom Nike has had a long-standing partnership. Abloh's admiration for Jordan culminated in the collaboration's focus on revisiting classic Nike styles—reinterpreting them through his deconstructed lens.

The Ten included 10 reimagined Nike classics: the Air Jordan 1, Air Presto, Blazer, and more. The concept was rooted in themes of "revealing" and "ghosting." The "revealing" theme focused on the idea of exposing the inner workings of a shoe—tapping into a sense of transparency. Abloh removed the usual layers of design to highlight raw, unfinished elements, such as visible stitching, exposed foam, and oversized Swoosh logos, making the structure of the shoes as important as their aesthetic. The "ghosting" theme, on the other hand, played with the idea of removal and emptiness, seen in the translucent materials that created a "faded" effect on the shoes—blurring the boundaries between the physical and the abstract.

What made The Ten even more revolutionary was its open-source approach. Abloh released the designs in such a way that others could follow his lead, with highly visible branding and a DIY, handcrafted feel. At the time he said he was inspired by the average kid with a passion for design who might not have the means to fully indulge their creativity. He wanted to create a space where fashion met accessibility, allowing anyone to appreciate and participate in high-level design, even if they couldn't afford the original pieces. That feel is apparent, with the use of raw, unfinished elements—like exposed stitching and loose fabric—creating the illusion of a shoe in-progress, allowing wearers to feel like they were part of the design process and reshaping the way we interact with design.

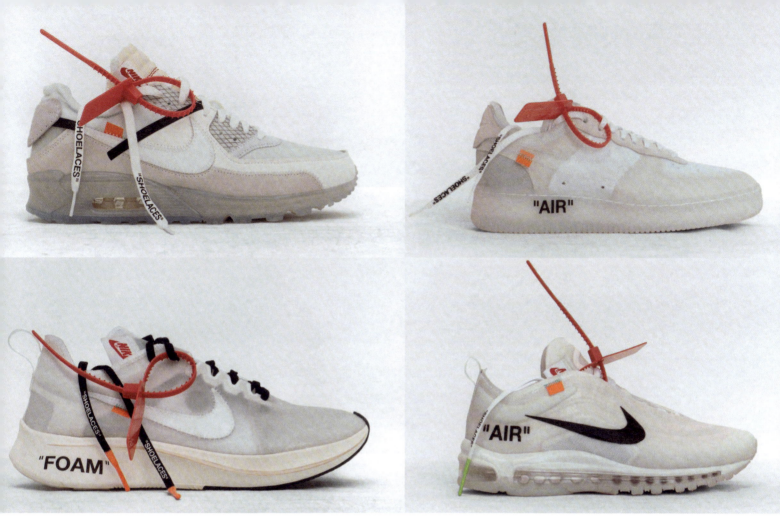

THE OPEN-SOURCE APPROACH MADE HIGH-LEVEL DESIGN ACCESSIBLE, INSPIRING ANYONE TO PARTICIPATE CREATIVELY.

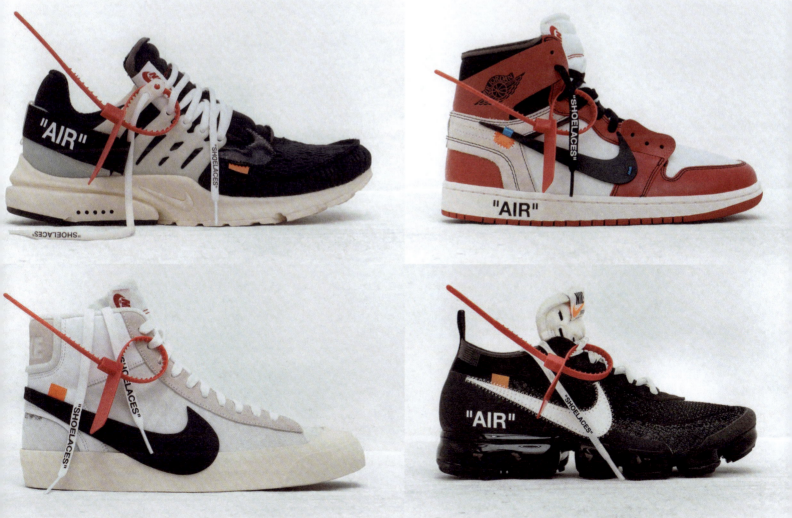

A 17-Year-Old Legal-Spat Turned-Fashion-Revolution

LOUIS VUITTON

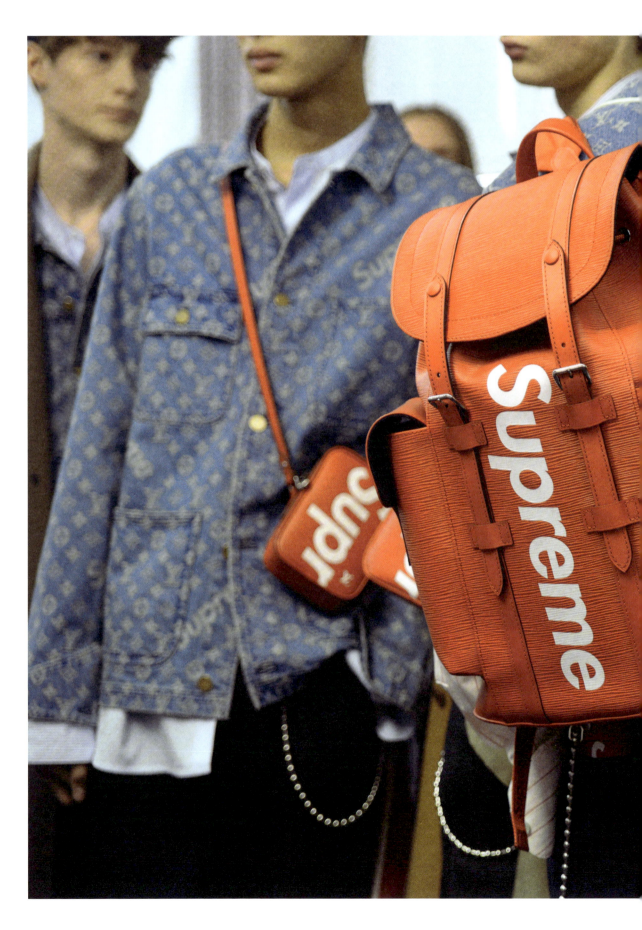

84 LOUIS VUITTON X SUPREME

What began as a trademark conflict over a streetwear drop culminated in an iconic fashion collaboration with the first-ever 360-degree runway show.

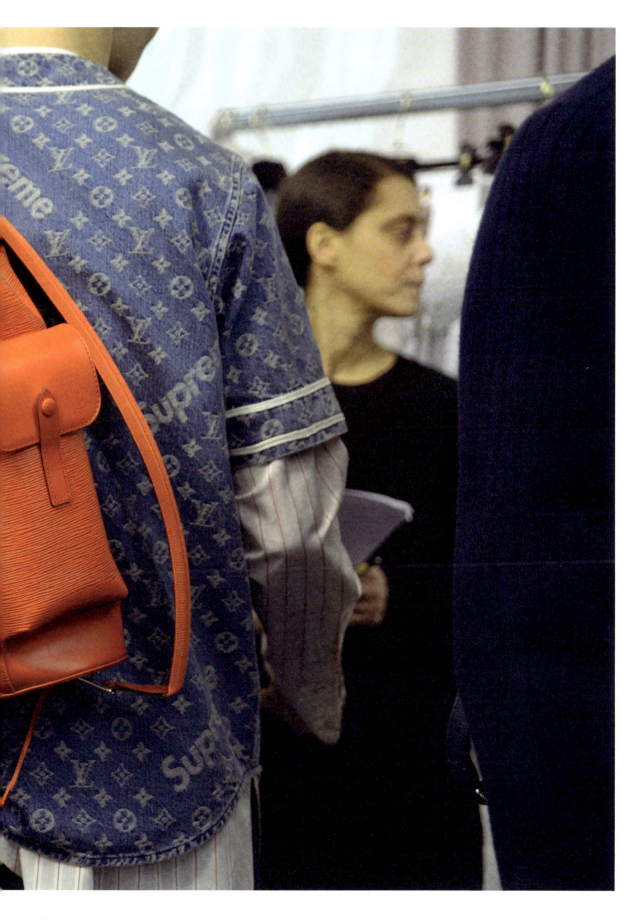

SUPREME

85 LOUIS VUITTON X SUPREME

In 2017, when Louis Vuitton and Supreme finally teamed up for their iconic collaboration, it felt like the ultimate resolution to a nearly two decades long saga. Back in the year 2000, Supreme had released a line of streetwear and skate decks featuring Louis Vuitton's monogram, sparking a legal conflict over trademark infringement. At that time, the divide between Louis Vuitton, the luxury powerhouse, and Supreme, a scrappy skate brand, couldn't have been wider. But by the time of their 2017 collaboration, both brands had transcended their origins, making this partnership a symbol of how streetwear had ascended to the ranks of high fashion.

Kim Jones, Louis Vuitton's Men's Artistic Director at the time, was the ideal designer to bridge these two worlds. According to *GQ,* one of his earliest jobs involved unpacking boxes for the company that imported Supreme to the United States, giving him an understanding of the streetwear market and presenting an opportunity for a full-circle moment of his own. Jones took Louis Vuitton's signature luxury and blended it seamlessly with Supreme's loud, rebellious energy.

The standout pieces included bright-red leather bomber jackets and sneakers with the LV logo boldly embossed into the fabric, alongside Supreme's iconic red box logo. These jackets, crafted with the meticulous quality Louis Vuitton is known for, were paired with oversized hoodies and monogrammed leather bags. The collaboration also featured sneaker designs where swaths of the LV monogram were applied across the panels, creating an elevated take on Supreme's recognizable aesthetic.

Debuted at Louis Vuitton's Spring/Summer 2018 runway show, the collaboration's presentation was just as groundbreaking as the designs themselves. It was the first-ever 360-degree runway show, staged inside a circular set that allowed the audience to experience the collection from every angle. The innovative format mirrored the collaboration's ethos—blurring the lines between art, fashion, and technology. The buzz surrounding the collection was immense, with fans lining up for hours to get their hands on pieces, cementing Louis Vuitton x Supreme as one of the most coveted fashion releases of the year.

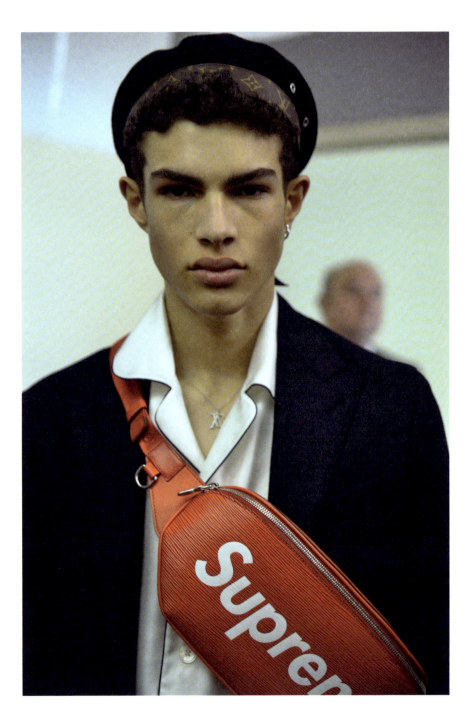

LOUIS VUITTON X SUPREME

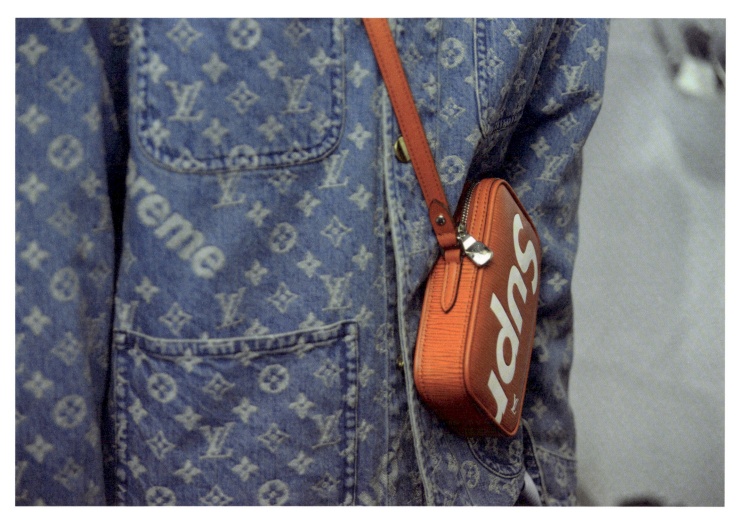

STREETWEAR HAD ASCENDED TO THE RANKS OF HIGH FASHION, MAKING THIS PARTNERSHIP A SYMBOL OF THAT SHIFT.

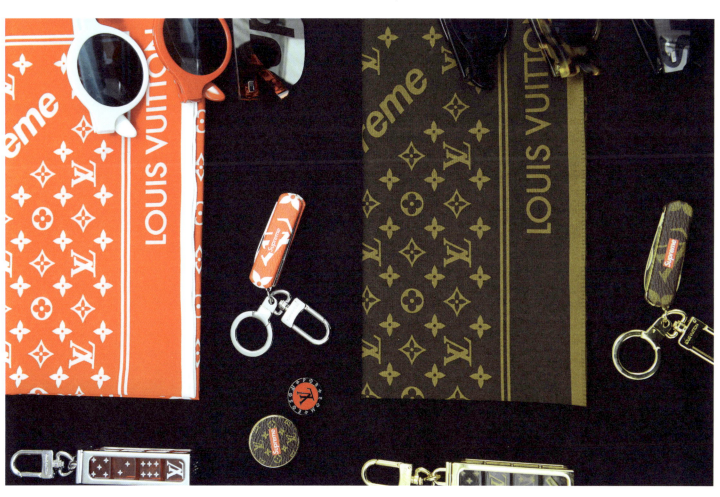

A Bold Fusion of Streetwear and High Fashion

STÜSSY X **DRIES VAN NOTEN**

Stüssy and Dries Van Noten blend luxe fabrics with casual street style, creating a collection that merges surf culture and Belgian avant-garde design.

The Stüssy x Dries Van Noten collaboration, launched in 2022, was a standout fusion of streetwear and high fashion, combining Stüssy's laid-back surf culture vibes with Dries Van Noten's avant-garde Belgian design sensibilities. The collection featured a mix of oversized jackets, vibrant print shirts, and relaxed trousers, all crafted with luxurious fabrics like silk and velvet, and paired with the signature casual elements of streetwear like graphic tees and hoodies. This blend of high-end fabrics and street-ready aesthetics made the collection both refined and accessible, appealing to a wide range of fashion enthusiasts.

The collaboration was part of Stüssy's broader strategy of partnering with high-end designers, having previously worked with names like Virgil Abloh, Herschel Supply Co., and Nike, pushing streetwear into the luxury space. Dries Van Noten, famed for his eclectic prints and experimental tailoring, has also collaborated with brands like Undercover, continuously blurring the lines between high fashion and street culture.

Highsnobiety played a pivotal role in bringing Dries Van Noten and Stüssy together in 2022, introducing the two brands for this groundbreaking partnership. The collaboration's ambition to reflect an era of California cool was cemented with the inclusion of Red Hot Chili Peppers' legend Flea in the campaign. A$AP Nast also teased the collection on his Instagram, building anticipation among fans. Their involvement helped solidify the partnership's impact, making the Stüssy x Dries Van Noten collection one of the most talked-about releases of the year.

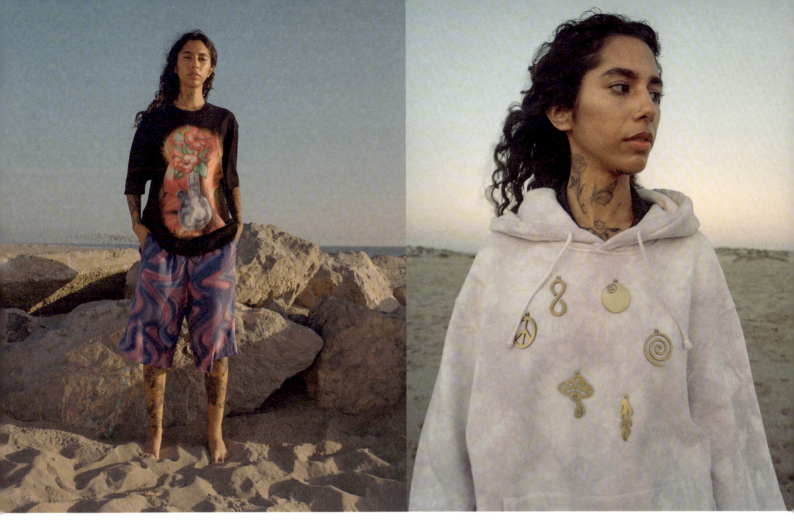

A STANDOUT FUSION OF STREETWEAR AND HIGH FASHION, COMBINING SURF CULTURE WITH AVANT-GARDE DESIGN.

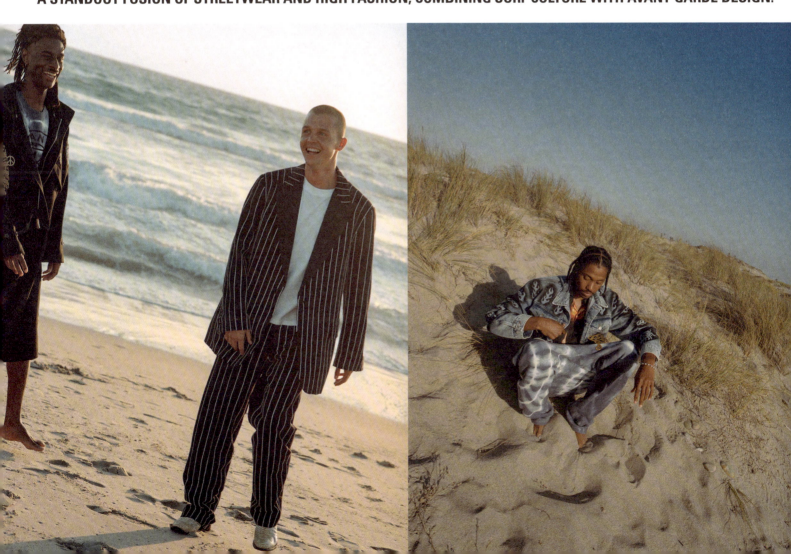

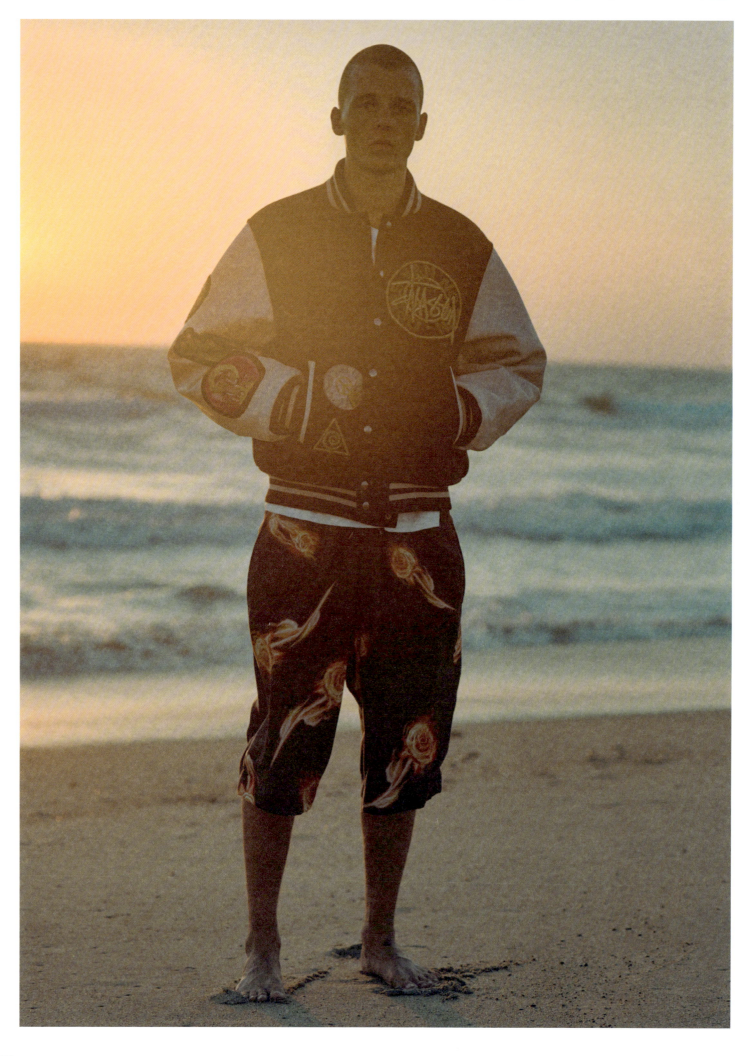

STÜSSY X DRIES VAN NOTEN

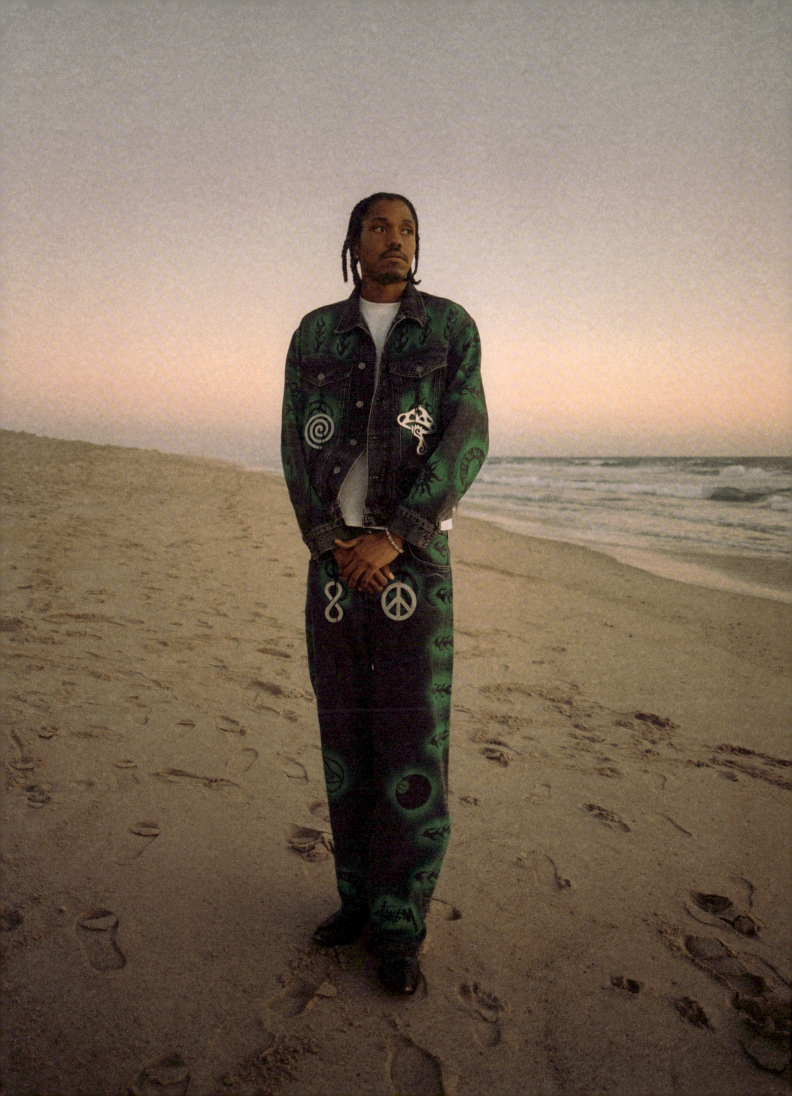

Where the American West Meets a Hip-Hop Classic

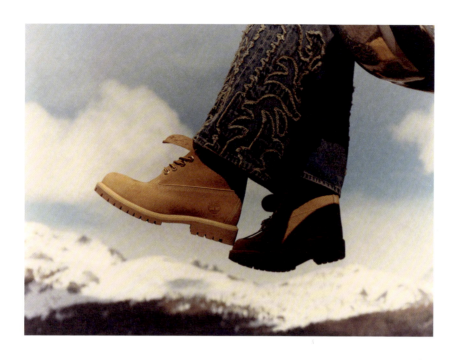

LOUIS VUITTON X **TIMBERLAND**

Pharrell Williams brings his unique blend of streetwear and high fashion to Louis Vuitton with a rugged, refined workwear collection, including a reimagined Timberland collaboration and the return of iconic pieces.

Pharrell Williams has always been ahead of the curve when it comes to blending staples of hip-hop and streetwear with high fashion. From the oversized Vivienne Westwood hat that sparked a thousand memes at the 2014 Grammys to collaborations with adidas and Chanel, the musician and style icon has never been afraid to push boundaries. (Who can forget the dress he wore on the 2019 cover of *GQ's* "New Masculinity" issue?) So it was no surprise when he was named Men's Creative Director for Louis Vuitton in 2023, or that his Fall/Winter 2024 Workwear Capsule—a beautiful combination of rugged American workwear with high-end craftsmanship—launched to huge success.

The collection showcases Pharrell's love for practicality, influenced largely by the leatherwork found in the American West, where style serves a purpose. Oversized trucker jackets, sculptural coats, and utility pants come with luxe touches like pearls, turquoise buttons, and leather appliqué, blending durability with sophistication. Louis Vuitton classics like the Keepall Toolbox are reconfigured to be multi-pocketed and function-forward. The standout? A collection of work boots with Timberland.

Like Stüssy, Supreme, and Off-White™ before him, Pharrell Williams reasserts Timberlands as not only a '90s hip-hop standard worn by artists like Biggie and Nas, but a contemporary everyday classic. Pharrell reimagines the shoe in five different styles—from ankle boots to ranger boots, to subtly oversized versions of their classic cuts, all with rugged, rubber lug outsoles and luxury leather finishes. (On runways, the shoes were sometimes seen unlaced or undone, a nod to the casual street style made famous by artists like Aaliyah, Rihanna, and Wu-Tang.) And if the historical throughline wasn't explicit, the design of the collection's LV 6-inch boot makes it so. Crafted in waterproof Italian leather and embossed with 18K-gold LV initials, the shoe is also engraved with a sentiment Pharrell shared at the debut of his first LV line: *THE SUN IS SHINING ON US.*

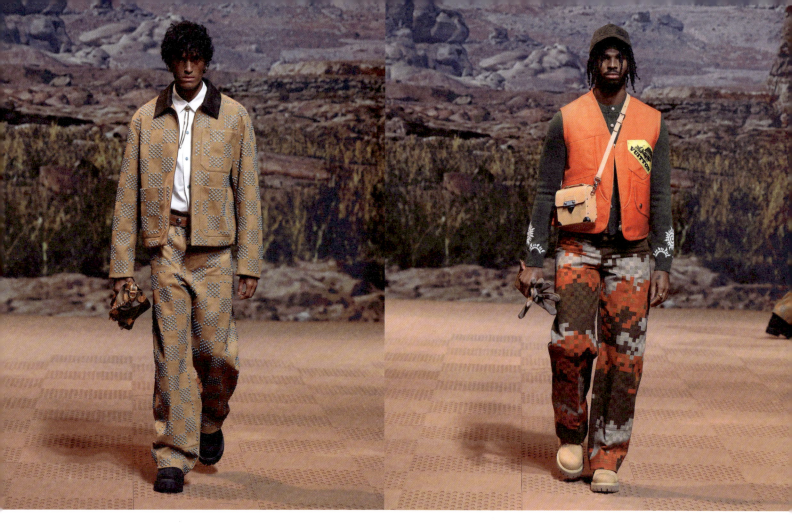

PHARRELL WILLIAMS BLENDS HIP-HOP STAPLES WITH HIGH FASHION, PUSHING BOUNDARIES FROM OVERSIZED

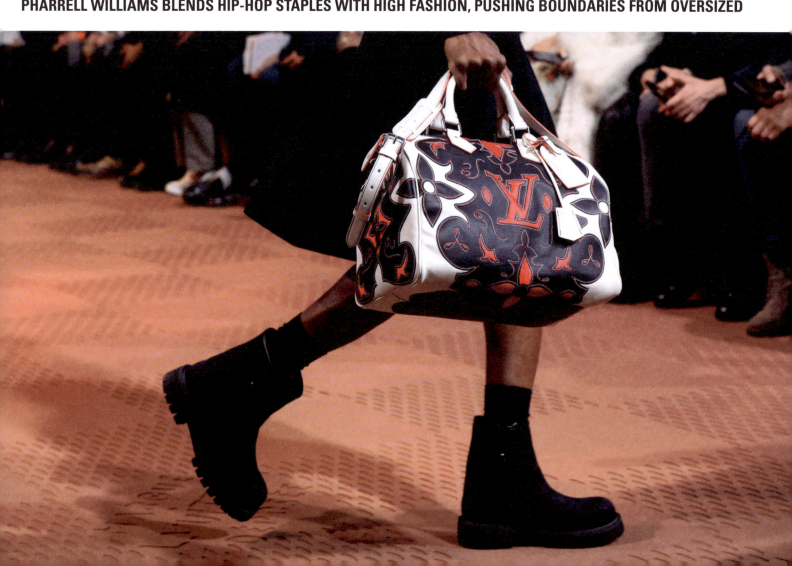

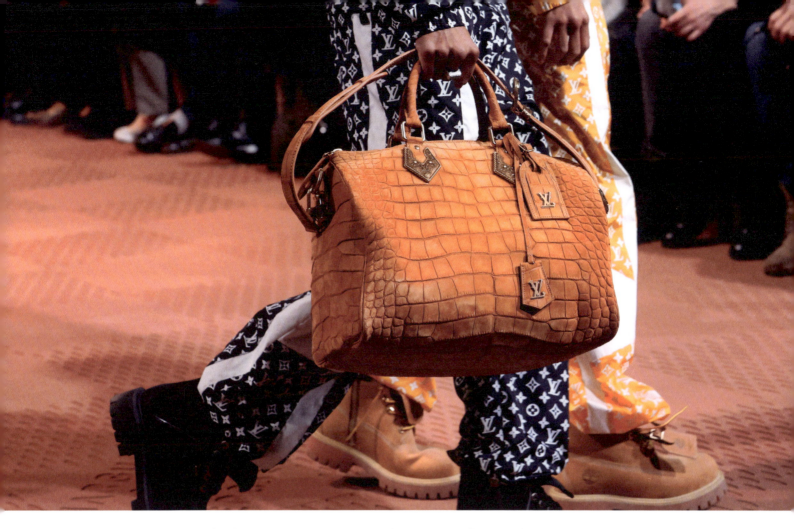

HATS TO DRESSES, LEADING TO HIS SUCCESSFUL LV WORKWEAR COLLECTION.

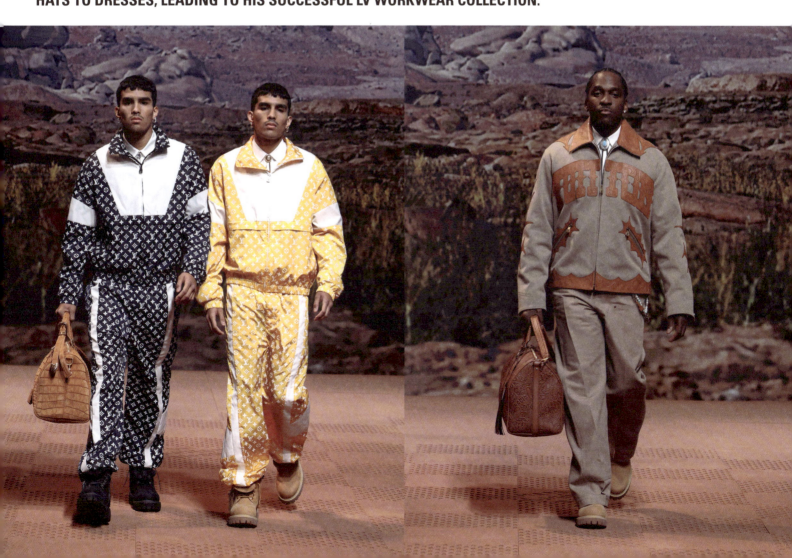

Music Listening Meets Style and Innovation

APPLE **X** **BEATS**

Beats has consistently pushed the boundaries of sound, style, and innovation—starting with its iconic headphones and culminating in the cultural sensation of the Beats Pill speaker.

Beats has come a long way since 2006, when rap innovator Dr. Dre and longtime record exec Jimmy Iovine set out to disrupt the headphone market with a brand that blended sleek design and serious sound. What started as a mission to deliver deep bass and stylish headphones quickly grew into a cultural phenomenon; the branding spoke to celebrities, athletes, and fashionistas who saw style as an extension of music fandom. In 2014, the acquisition of Beats by Apple for $3 billion signaled a massive intent to scale, with technological innovation and forward-thinking design leading the way.

The Beats by Dr. Dre headphones quickly became a fashion statement and status symbol, thanks in part to their popularity among celebrities like Lady Gaga, LeBron James, and Justin Bieber. (Known for its resonant sound, especially in low registers and bass, Beats especially resonated with fans of hip-hop and pop music.) Apple's acquisition also enabled seamless integration with Apple devices, introducing innovations like wireless audio and noise-canceling features, while maintaining the Beats' bold look.

Then came the release of the Beats Pill, a compact Bluetooth speaker designed for portability, water resistance, and long battery life for on-the-go listening. One of its key innovations is the ability to connect multiple Pill speakers for a synchronized sound experience, thanks to its "Party Mode," which allows users to pair multiple units together, amplifying the sound for larger spaces or social gatherings. The speaker's chic design and vibrant colors quickly made it a cultural icon, further boosted by its presence in high-profile music videos like Nicki Minaj's *"Anaconda."*

With its ability to pair with other units, the Pill tapped into the growing trend of social listening, making it a fashionable accessory for parties and road trips alike. Today, Beats continues to innovate with products like the Beats Studio Pro, Beats Solo Buds, and an ever-evolving, updated version of the Beats Pill.

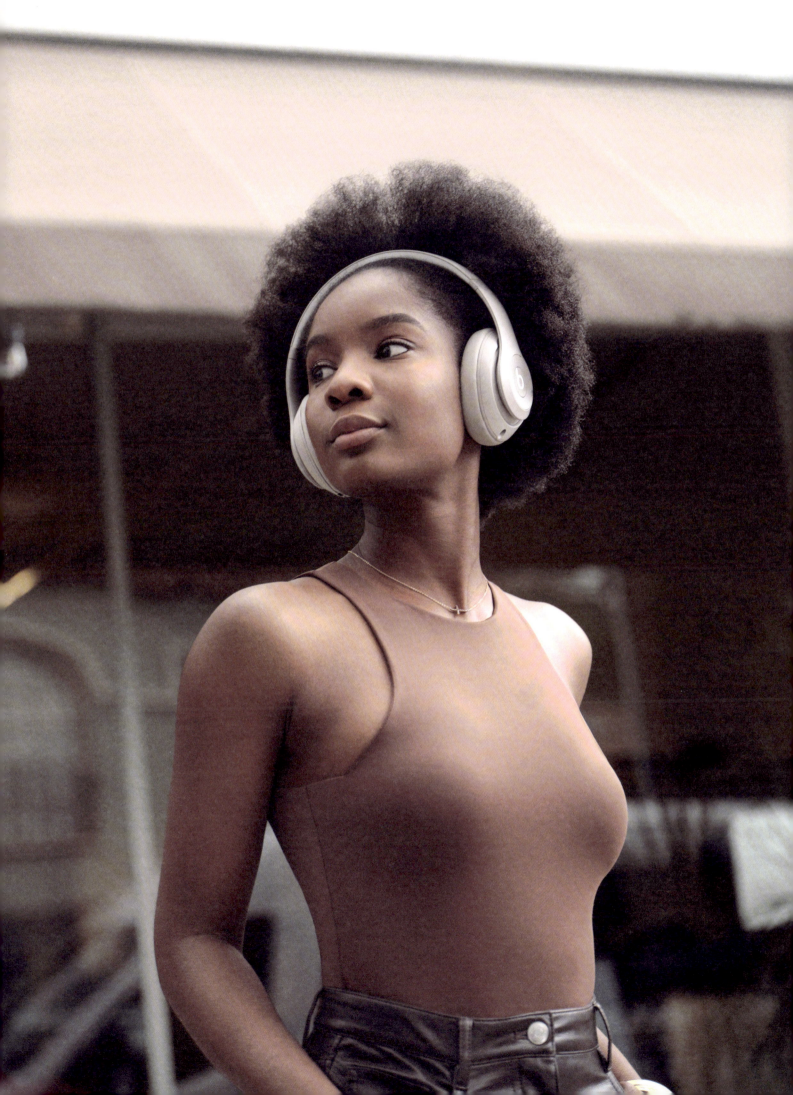

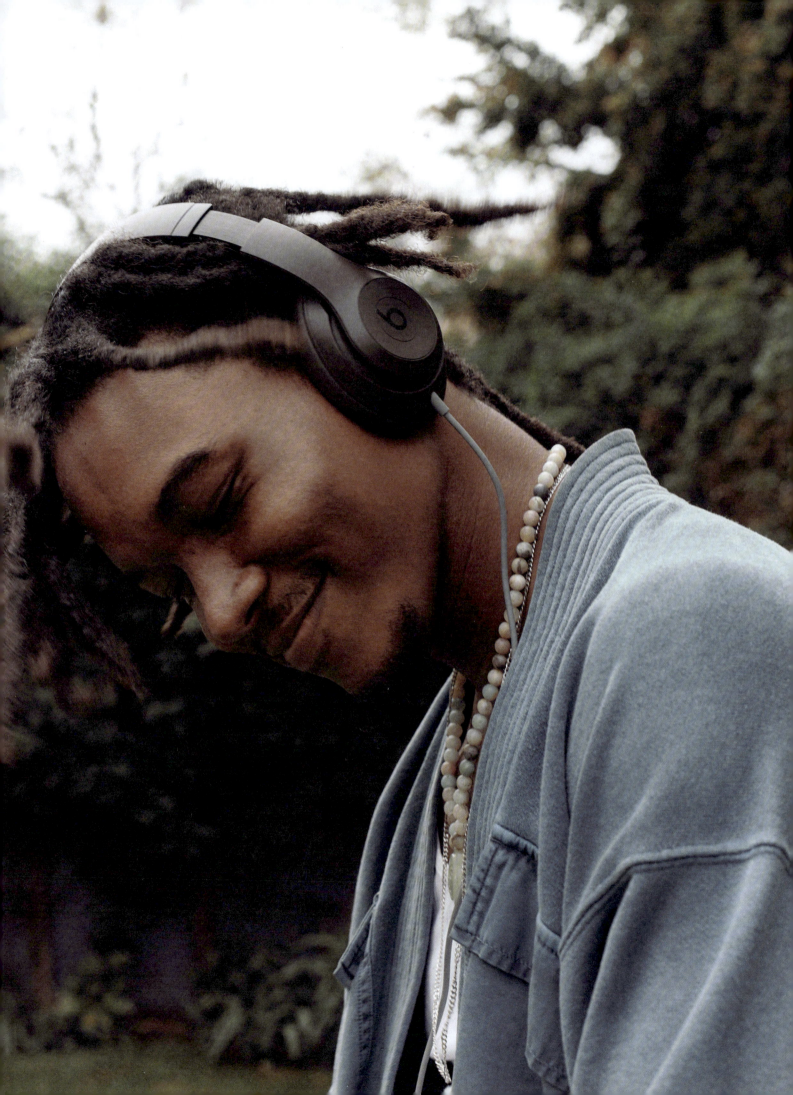

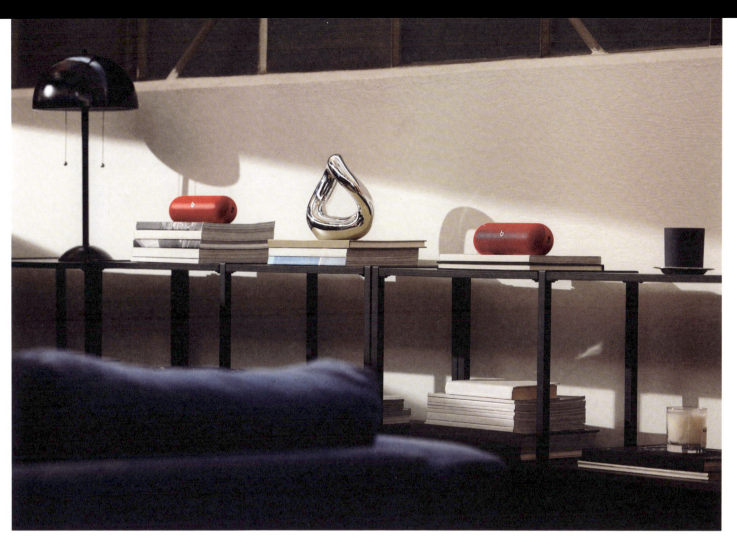

WITH ITS ABILITY TO PAIR WITH OTHER UNITS, THE PILL TAPPED INTO THE GROWING TREND OF SOCIAL LISTENING.

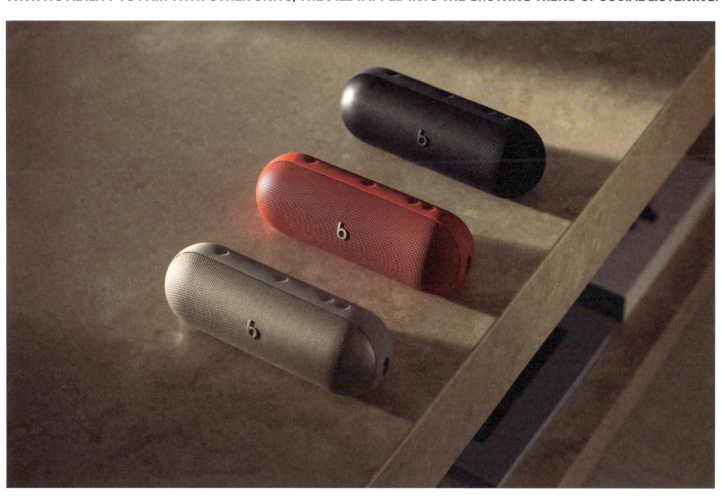

A Longstanding Collaboration Gets a Playful Restart

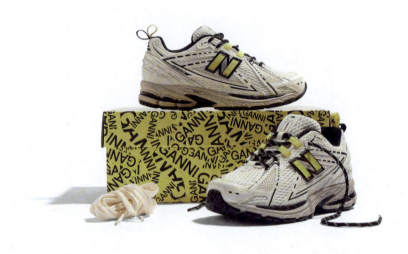

GANNI X **NEW BALANCE**

Debuting on Copenhagen runways, the refreshed versions of the 1906R and RC30 featured eco-friendly designs, vibrant colorways, and a playful marketing campaign featuring the work of *New York Times* cartoonist Suerynn Lee.

Since their first collaboration in 2022, GANNI and New Balance have launched several highly anticipated, sold-out sneaker collections, merging GANNI's distinctive style with New Balance's athletic heritage and sustainability efforts. In August 2023, they unveiled their latest collaboration, which included refreshed versions of the New Balance 1906R and RC30 sneakers and debuted at GANNI's Spring/Summer 2024 runway show during Copenhagen Fashion Week.

The 1906R was introduced in two distinct colorways: "Egret," a subtle off-white, and "Blazing Yellow," a vibrant all-yellow design. The RC30 was presented in a striking "Bumblebee Black and Yellow" combination, consisting of alternating black and yellow leather panels that created a bold visual contrast. Both sneakers were crafted using recycled and vegan materials, aligning with GANNI's commitment to sustainability. This approach marked a departure from traditional designs, offering eco-friendly alternatives without compromising on style or quality.

The marketing campaign for the GANNI and New Balance collaboration, illustrated by *New York Times* cartoonist Suerynn Lee, featured playful and vibrant cartoons that depicted the sneakers in whimsical and dynamic scenes. The illustrations showcased tennis star Coco Gauff and GANNI's creative director, Ditte Reffstrup, engaging with the sneakers in various imaginative settings. These cartoons added a sense of fun and creativity to the campaign, perfectly aligning with the lighthearted and bold aesthetic of the collaboration. The images were used in billboards across major cities like New York, London, and Copenhagen, creating a buzz around the release and solidifying the pair's international appeal.

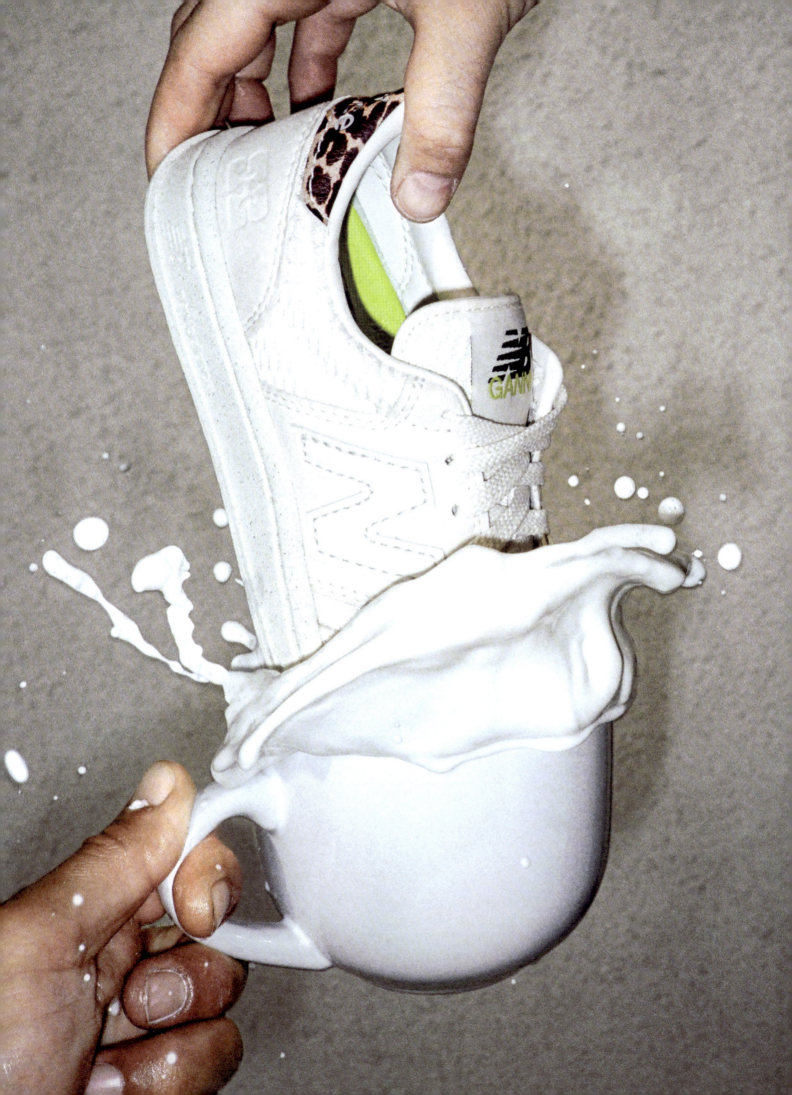

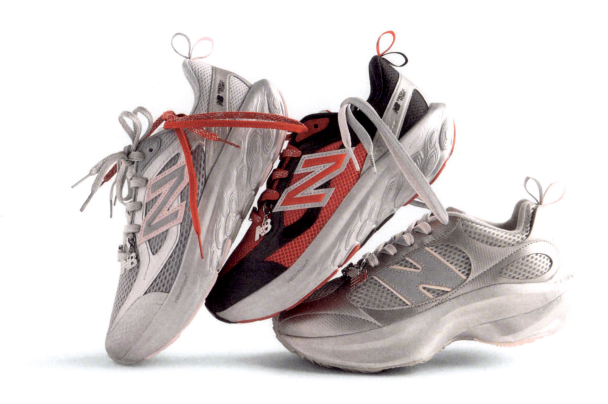

MERGING GANNI'S DISTINCTIVE STYLE WITH NEW BALANCE'S ATHLETIC HERITAGE AND SUSTAINABILITY EFFORTS.

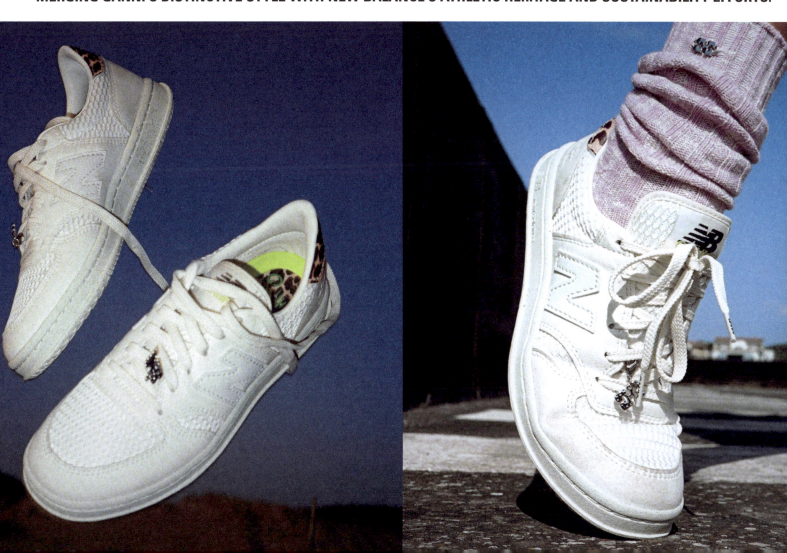

A Statement on Privacy and Surveillance

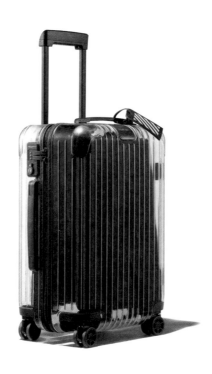

RIMOWA X **OFF-WHITE™**

The 2018 collaboration between RIMOWA and Virgil Abloh's Off-White™ reimagined travel essentials, blending craftsmanship with a daring critique on the erosion of personal privacy and the commodification of belongings.

In June 2018, luxury luggage brand RIMOWA and Virgil Abloh's streetwear label, Off-White™, unveiled a groundbreaking release that reimagined travel essentials with a bold, unsettling twist. The collection, which debuted with a transparent polycarbonate suitcase, made waves for its unapologetic commentary on privacy, surveillance, and the personal nature of belongings. This marked the first collaboration between the two brands, blending RIMOWA's signature craftsmanship with Off-White™'s iconic design language.

The suitcase, based on RIMOWA's Essential model, was stripped of its interior lining to embrace transparency, offering a raw, almost voyeuristic view of one's personal items. Instead of traditional compartments, the case featured Off-White™'s Flex-Divider system, black or white cotton bags, and a transparent amenity kit, complete with a set of orange wheels for added flair. Subtle details, like the brand's distinctive labeling on the locks and telescopic handle, ensured that the suitcase was unmistakably Off-White™.

Abloh's exploration of transparency and surveillance extended beyond just luggage design. His use of branding as an intrusive presence appeared throughout his work, most notably in his iconic "SCULPTURE" bag for IKEA: a humble paper bag stamped with the word SCULPTURE in scare quotes. This and many of his other designs highlighted how even the most mundane of objects can be commodified and transformed into status symbols. This mirrored the commodification of personal data in the digital age, where one's identity and possessions often feel exposed and out of one's control. The theme of visibility and surveillance had previously taken center stage in Abloh's 2017 "Seeing Things" collection for Off-White™, where he merged the idea of being constantly observed with the visibility of personal belongings. Featuring graphics reminiscent of CCTV camera angles, the collection explored the tension between exposure and control, reinforcing his commentary on privacy in a hyper-connected world.

For the RIMOWA collaboration, Abloh described the project as an exploration of the emotional connection people have with their personal belongings, an ethos reflected in the design's irony and artistic flair. The collection didn't just offer a suitcase—it made a statement.

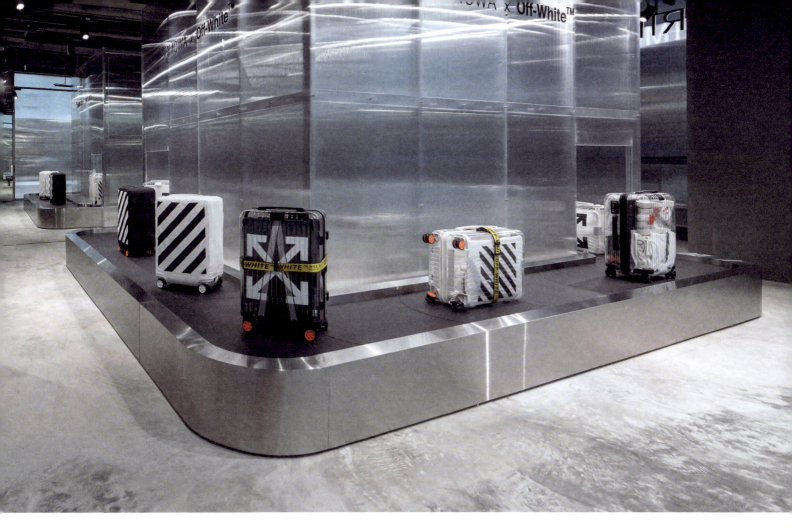

THE COLLECTION, WHICH DEBUTED WITH A TRANSPARENT SUITCASE, MADE WAVES FOR ITS COMMENTARY ON PRIVACY.

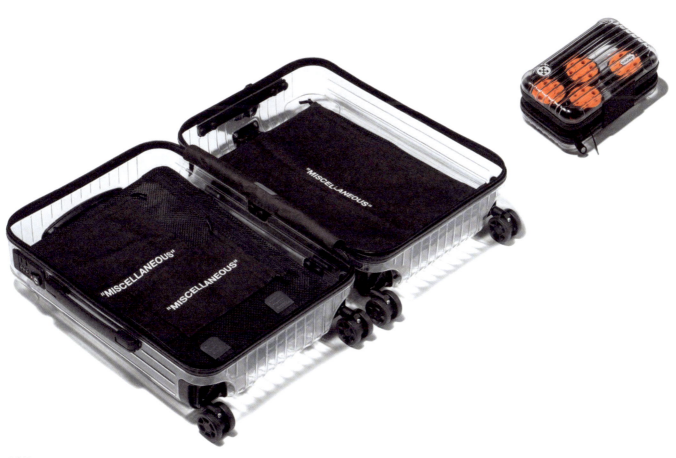

AURALEE x New Balance Unite for a Luxe 990v4 Revamp

AURALEE X **NEW BALANCE**

The Japanese brand's minimalist aesthetic meets New Balance's classic design in a limited-edition release featuring premium materials, sophisticated colorways, and enhanced comfort.

The Japanese brand AURALEE's aesthetic is minimalist and sophisticated, focusing on high-quality fabrics, clean lines, and a refined color palette of neutral tones. Emphasizing comfort and luxury, AURALEE uses natural materials like cotton, wool, and cashmere, while prioritizing perfect fit and subtle elegance. The designs are modern yet timeless, offering versatile pieces that are elevated enough for formal occasions but remain effortless for everyday wear. AURALEE's style is understated but makes a quiet, sophisticated statement. It's no surprise then that AURALEE's collaboration with New Balance in 2022 focused on refining the silhouette of the sneaker brand's 550 shoe to give it a cozier, more luxurious feel. This partnership marked the start of a series of collaborations that seamlessly blended AURALEE's understated design philosophy with New Balance's classic footwear.

In December 2024, AURALEE and New Balance unveiled their latest collaboration: the 990v4 Made in USA. This iteration featured a premium mix of materials and a subdued, tonal palette that incorporated a splash of color at the base, adding vibrancy to the minimalist design. The updated 990v4 showcased AURALEE's commitment to quality and subtlety, with an upper that combined soft nubuck, breathable mesh, and suede, resulting in a sophisticated and layered look. Meanwhile, the midsole incorporated New Balance's ENCAP technology for enhanced cushioning. The two colorways—Dusty Blue with a yellow-accented midsole and Taupe with a blue-accented midsole—exemplified AURALEE's signature muted tones.

The limited-edition release generated significant anticipation, with fashion critics praising the collection's balance of practicality and high-end design. The marketing campaign emphasized the universal appeal of the collection, showcasing models from diverse age groups wearing the pieces in everyday settings, reinforcing the idea that fashion can be both functional and accessible without compromising on style.

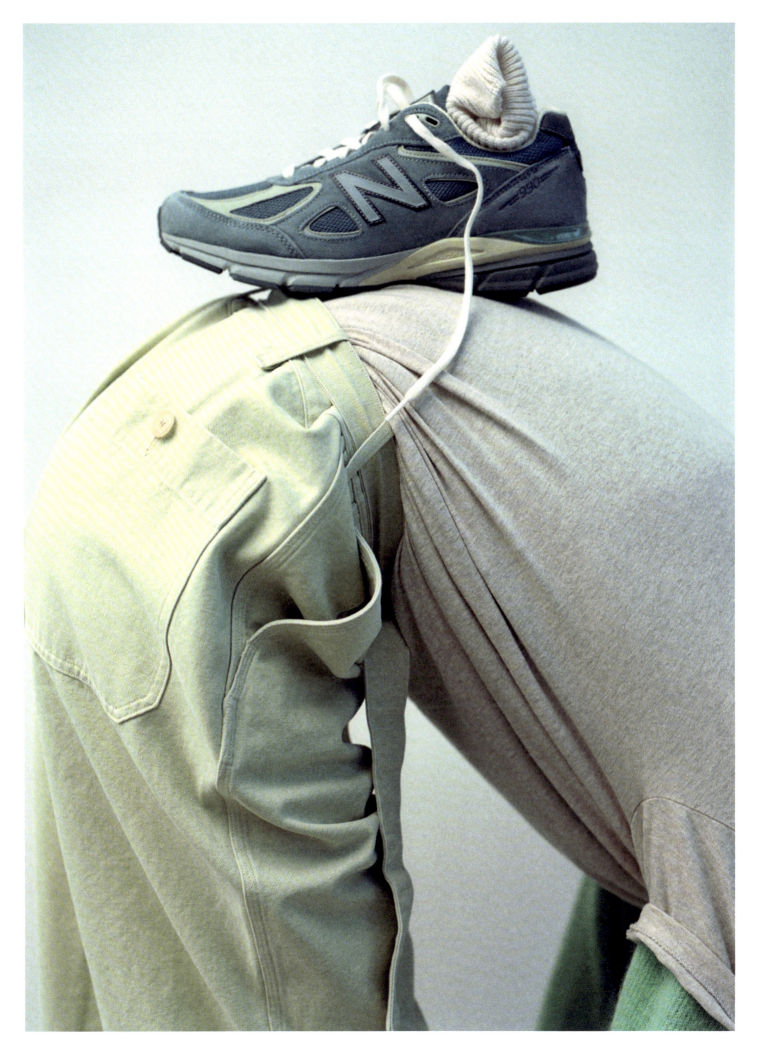

A Merging of Boston and New York

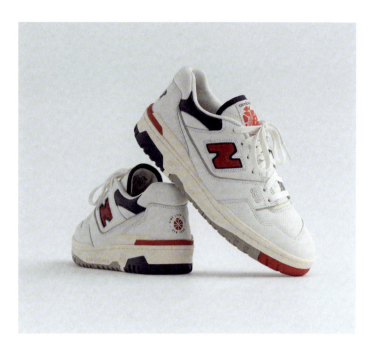

AIMÉ LEON DORE X **NEW BALANCE**

The brands celebrate five years of a meaningful partnership by revisiting the iconic New Balance 997, combining refined craftsmanship with the spirit of NYC's handball culture.

In the campaign video for the collaboration between Aimé Leon Dore and New Balance, the British actor Ray Winstone (of *The Gentlemen,* among others) reflects on how finding the perfect match—whether it's in relationships or collaborations—is rare, meaningful, and requires a high level of trust. His narration captures the essence of the collaboration as a harmonious and special union, highlighting the strength of their long-lasting creative relationship and underscoring the emotional connection behind it. The partnership has become a standout in the sneaker world, blending New York street style with New England craftsmanship—Winstone notes, cheekily, that it's rare to see the two rival cities of Boston and New York "break bread."

Celebrating their five-year partnership in 2024, the two brands revisited the iconic New Balance 997 silhouette, delivering a refined, colorful take on the classic model. This release marked a full-circle moment, bringing back the original design elements that defined their first collaboration while adding a modern, elevated sensibility and a sophisticated color palette. The 997 features a multicolored mix of suede, mesh, and leather overlays, paying homage to the brand's shared heritage while embracing craftsmanship and comfort. The updated version of the 997 draws from the classic color blocking, introducing leather overlays, textured synthetic eyestays, and a floral graphic sockliner. The shoe's ENCAP midsole provides cushioned support, while the custom packaging and woven Aimé Leon Dore labels add a premium touch to the design.

Beyond the sneaker itself, the collaboration is a nod to Aimé Leon Dore's NYC roots, incorporating the spirit of handball—a sport deeply tied to the city's cultural fabric—into the design. The fast-paced sport where players use their hands to hit a small rubber ball against a wall has become a favorite among sporty New Yorkers, thanks to widespread access to handball courts in the city's public parks. The updated 997, designed for speed and agility, intentionally captures the spirit of handball, both functionally and aesthetically. With its rich mixture of inspirations and its fresh urban look, this collection solidifies Aimé Leon Dore and New Balance as intra-city collaborators redefining the boundaries between streetwear and high-end craftsmanship, five years strong.

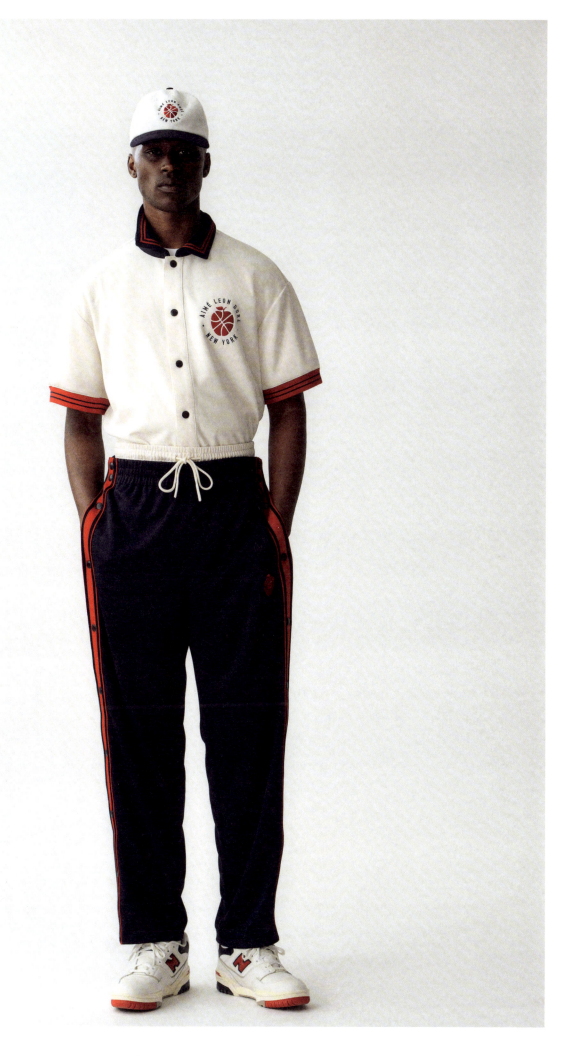

AIMÉ LEON DORE X NEW BALANCE

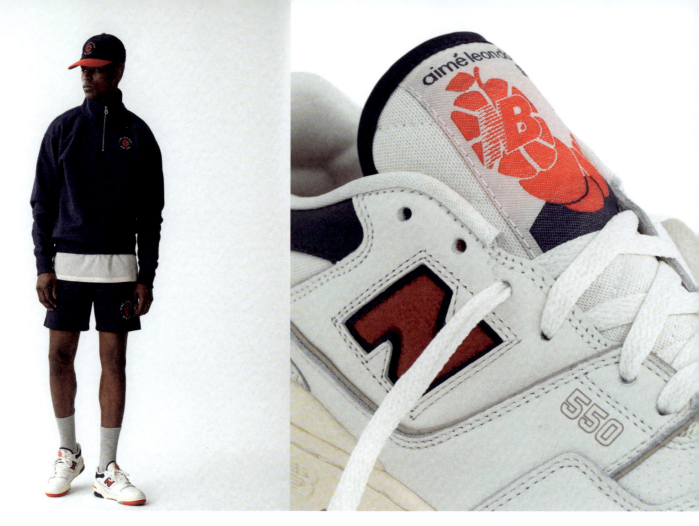

BEYOND THE SNEAKER ITSELF, THE COLLABORATION IS A NOD TO AIMÉ LEON DORE'S NYC ROOTS.

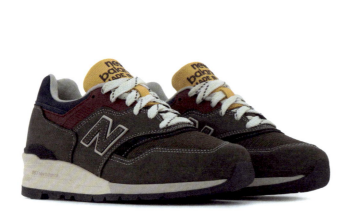

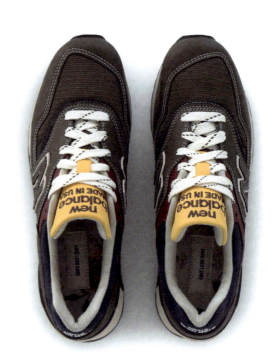

AIMÉ LEON DORE X NEW BALANCE

Harmonizing Style and Intentionality

BEAMS **X** **ARC'TERYX**

Inspired by the Japanese philosophy of *nagomi,* this collaboration blends high-performance gear with a serene, minimalist design approach for a capsule collection that embodies balance and elegance.

The Japanese philosophy of *nagomi* centers on harmony, balance, and tranquility, emphasizing a peaceful coexistence between elements like people, nature, and design. It encourages simplicity in design, where form, function, and aesthetics seamlessly converge. *Nagomi* values understated beauty, often reflecting the Japanese concept of *wabi-sabi,* which appreciates imperfection and the natural cycle of change. In fashion, it results in thoughtful, subtle pieces that integrate easily into daily life, avoiding extremes to create a timeless, unified experience.

Inspired by these centuries-old philosophies, the BEAMS x Arc'teryx collaboration harmoniously blends Arc'teryx's technical outdoor expertise and BEAMS' refined approach to Japanese streetwear. The collection features a range of essential pieces that embody both elegance and utility, but a standout product is the *Beta AR jacket,* a weather-resistant outerwear piece constructed from Arc'teryx's renowned GORE-TEX fabric, ensuring durability and protection. Its muted tones evoke a sense of calm while the sleek, minimalist design allows it to fit effortlessly into both urban and natural environments.

The collaboration's *jackets* are engineered for movement and comfort without sacrificing style, with a subtle patchwork detail that nods to the collection's theme of embracing balance and imperfection. The patchwork elements create a unique texture, drawing on a *wabi-sabi* aesthetic to highlight the transience of movement. Accessories like the *Alpha SV jacket* and backpacks round out the collection, each piece thoughtfully designed with functional details like waterproof zippers, breathable mesh lining, and ergonomic fits. Other outdoor pieces include the weather-resistant Beta jacket and the versatile Squamish Hoody, both designed with a unique patchwork pattern and durable fabrics, and finished with refined elements like the iconic Arc'teryx logo embroidered in a striking sunset gradient. The collaboration was a success largely due to its thoughtful fusion of craftsmanship, practicality, and the grounding principle that people are meant to honor their environment.

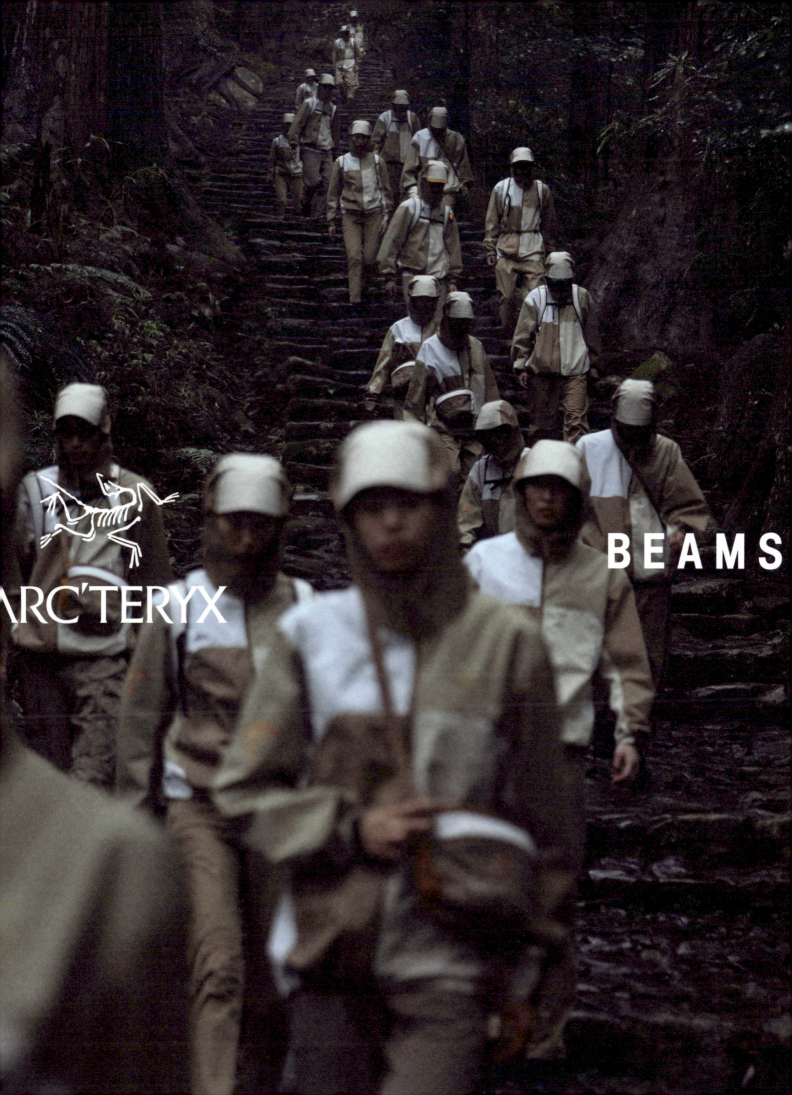

THE COLLABORATION WAS A SUCCESS LARGELY DUE TO ITS THOUGHTFUL FUSION OF CRAFTSMANSHIP.

Novel Ideas: Kitsch, Novelty, and the Power of Surprise

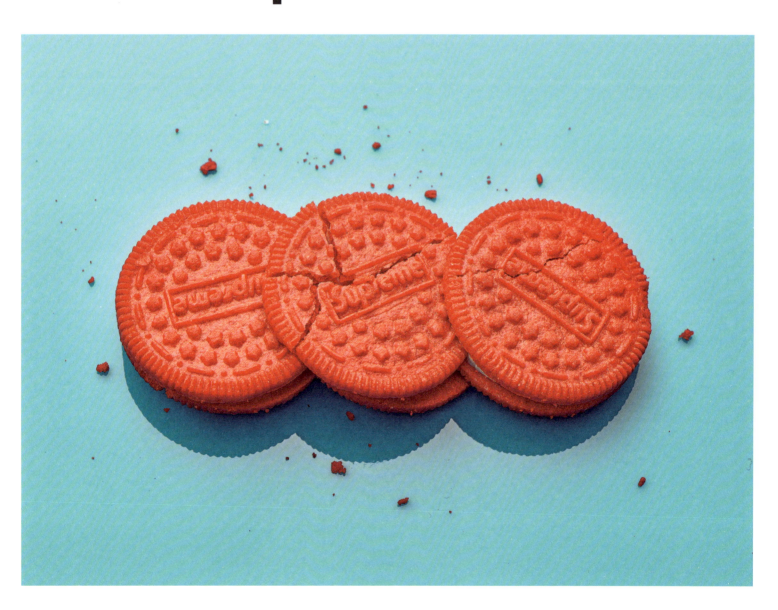

Supreme x Oreo

118

In 2020, the *New York Times* published an article about a seemingly unassuming cultural staple: the Oreo cookie. For over a century, Oreo has remained a favorite snack in households across the globe, its classic black-and-white design etched into the collective memory. In 2012, Oreo's parent company Mondelez International celebrated the cookie's 100th anniversary by introducing a new flavor: Birthday Cake. The cookies mostly looked like the familiar Oreos, except the signature white cream filling was speckled with sprinkles and more closely emulated cake frosting rather than the usual vanilla-esque sweetness of the originals. The flavor hit shelves for a limited time and became a sought-after item not just for Oreo enthusiasts, but curious consumers wanting to taste the difference for themselves.

In the last 50 years, the company has introduced over 85 varieties of flavors to the mix. There were Blueberry Pie Oreos, Churro Oreos, Tiramisu Oreo Thins, and even China-exclusive flavors like Hot Chicken Wing Oreos and Wasabi Oreos. While Nielsen data revealed that sales for the novelty flavors went up by 12%, they also had the effect of boosting business for the original flavor by 22%. In this way, novelty flavors act as brand ambassadors, drawing in new consumers while reminding loyalists of what made Oreo timeless in the first place.

It's no surprise that Oreo has extended this practice beyond flavors and into full-on licensed collaborations. In 2017 and 2018, during the Easter season, Mondelez partnered with Just Born candy company to make Oreo-ified versions of its classic marshmallow Peeps treats, pairing pink and purple cream filling with an outer cookie depicting Peeps' signature chick silhouettes. More recently, Mondelez made a polarizing Oreo bar features a matcha-infused white chocolate coating—a striking departure from the milk chocolate original. The mouth-watering jade-green bar quickly became one of the brands top-selling flavors in Japan. The bar's success helped lift the brand, and by 2014, Kit Kat had snatched the top sales position from homegrown confectionery Meiji.

Kit Kat also benefited from a very successful marketing campaign with the Japanese post office, where the brand played on the candy bar's phonetic similarity to the Japanese phrase *kitto katsu*. The saying, which roughly translates as "victory is assured," is a way to wish someone good luck before a difficult task—and sounds very similar to *kitto kato,* the Japanese name for a Kit Kat bar. The campaign's word play delighted Japanese viewers and transformed the bar from just a sweet treat into an edible good luck charm. Since then, the company has released other flavors like red bean, sweet potato, Hojicha tea, and even a pricey gold leaf-wrapped premium dark chocolate that retailed for $16 a bar. In 2014, the company opened the Kit Kat Chocolatory, a high-end boutique specializing in recipes by Japanese chef Yasumasa Takagi, which has generated more than 2 billion yen in sales. Takagi expanded the palate to include chili, ginger, passion fruit, plum, and even the quintessential Japanese rice spirit, sake, which combined sake powder with white chocolate.

This phenomenon, where novelty reinvigorates familiarity, is not limited to snacks. Across industries, from streetwear to high fashion, from beverages to fast food, the power of novelty and kitsch has reshaped consumer expectations. These elements, once considered fringe, are now central to how brands create cultural phenomena, generate buzz, and reframe perceptions. By reimagining the prosaic and embracing

ACROSS INDUSTRIES, THE POWER OF NOVELTY AND KITSCH HAS RESHAPED CONSUMER EXPECTATIONS.

cookie flavor with another one of its popular brands: the gummy Sour Patch Kids candy. It also made waves when it teamed up with Coca-Cola on a cookie with a fizzy, popping red cookie layer meant to emulate the soda. Coca-Cola returned the favor with an Oreo-flavored Coke Zero drink, which mostly tasted like regular Coke, except for a slight chocolatey finish.

More recently, Oreo realized that novelty flavors were not the only way to get people excited about buying their cookies. By embracing licensing partnerships with franchises like Star Wars and Pokémon, Oreo turned opening a pack of Oreos into a trading card-like frenzy. It isn't enough that the novelty collaborations are limited—but each package contains different characters of varying rarity. For the Star Wars collaboration, opening the package revealed either red cream "Dark Side" filling or blue cream "Light Side" filling, with different characters appearing for each color. Meanwhile, the Pokémon Oreos are illustrated with 16 different kinds of characters from the series, with the rarest being the diminutive Mew. After the release in 2021, unopened packages began flooding resale sites like eBay, with some lucky Mew-finders going as far as encasing the rare cookie in plastic airtight casing and asking for thousands of dollars for a pristine disc. Over in Japan, the birthplace of Pokémon, novelty flavors certainly aren't anything new.

In 1973, Kit Kats were first introduced to the Japanese market. In the year 2000, Nestlé began experimenting with Kit Kat flavors more suited to local tastes. The first one was strawberry, and it hit the shelves just in time for Japan's strawberry season. In 2004, the company followed with a bold, new flavor: Matcha. Inspired by the popular Japanese green tea, the absurd, companies have managed to turn commonplace objects into coveted items, blurring the lines between consumer products and cultural artifacts.

Supreme's collaboration with Oreo in 2020 serves as the ultimate example of how novelty can drive cultural relevance. When the streetwear giant announced its partnership with the cookie brand, the collaboration seemed like a tongue-in-cheek prank. Supreme's bold red-and-white branding was stamped onto red Oreo cookies with the iconic white filling, creating a surreal marriage of high-demand exclusivity and mass-market availability. Retailing at just $8 for a pack of three, the cookies were affordable by Supreme's standards, and they sold out instantly—with resale platforms like eBay seeing single packs go for hundreds, even thousands of dollars.

This collaboration epitomized Supreme's ability to make the everyday much more interesting. It wasn't just a logo on a cookie—it was a cultural statement, a reminder that anything Supreme touches, no matter how banal, becomes desirable. Supreme's success lies in its ethos, which melds exclusivity with accessibility. By re-contextualizing a grocery store staple as a collector's item, Supreme expanded its audience while maintaining its core identity as a tastemaker. The Oreo collab underscored an essential truth: novelty, when executed with self-awareness and cultural fluency, can amplify a brand's identity rather than dilute it.

Supreme's strategy also tapped into a deeper commentary on consumer culture. By turning a commonplace snack into a status symbol, Supreme reminded its audience of the absurdity—and thrill—of modern consumerism. This wasn't just

a cookie; it was a symbol of the power of branding, a playful middle finger to traditional notions of luxury and value. Supreme has built its empire on this unique formula of irreverent exclusivity, creating a lane for mundane must-have items. Collaborations with unexpected partners—from Ziploc storage bags, to Band-Aid bandages, and even Honda motorbikes—demonstrate its ability to stay elastic while maintaining its authenticity. The Oreo collaboration wasn't the first time Supreme elevated a mass-market product into a cultural artifact, and it was far from the last.

Supreme's success lies in its ability to blend streetwear's rebellious spirit with the world's shared cultural touchstones. In 2016, Supreme infamously made a literal brick emblazoned with its logo. The bricks were 8 inches long, 4 inches wide, weighed about 2.5 pounds, and retailed for $30. They not only sold out in seconds, but commanded a resale price of hundreds of dollars. One collector in Corpus Christi, Texas, was reportedly obsessed enough to try to build a house out of them, only realizing, after accruing 1,800 of the absurd item, that not enough actually existed to complete the task. Another user on Reddit, tamaral36, went one step further and calculated that, assuming you *could* get your hands on enough Supreme bricks to build a home, it would cost a staggering $4,704,000 for the bricks alone.

The brick was just the latest in a long line of novelty items the brand has manufactured. Every season contains several, like a pair of red foam nunchucks from its Spring/Summer 2010 collection, all the way to its more recent Fall/Winter 2024 collection, where it released a Japanese-inspired food model, or *sampuru,* of a New York delicacy: the chopped cheese sandwich. The inedible replica of the uptown deli staple was made of polyurethane, epoxy resin, and PVC

clunky design and association with nurses and suburban dads. Yet in the past decade, Crocs have become a surprising fashion staple, embraced by influencers, celebrities, and designers alike. How did this transformation happen? The answer lies in a deliberate embrace of novelty and collaboration.

The turning point came in September 2016, when Scottish fashion designer Christopher Kane unveiled marble-printed Crocs as part of his runway collection. Kane paired the unassuming shoes with high-fashion ensembles, creating a jarring yet intriguing contrast that forced audiences to reconsider Crocs' aesthetic potential. By placing Crocs in a context that no one expected, Kane injected irony and subversion into the brand's narrative. The collaboration came from a genuine appreciation for the footwear, as Kane wore Crocs in his spare time. While the fashion world had a polarizing response to the footwear, which sold for $375 a pair—much more than your typical Crocs—Kane was unabashed about his love for the brand and shrugged off any criticism of the shoes. In an interview with *WWD* later that year, Kane explained that he "knew people were going to react in that way, but it wasn't about being controversial. The fact is Crocs is a huge successful business on its own, they don't need me to make them even more successful. Obviously people do like them, and that's a different customer that I want to grab. I want to include everyone and not be a snob."

It was a bold move that signaled Crocs could be both ironic and aspirational. And that's a realm that longtime Balenciaga creative director Demna Gvasalia (now known under the mononym *Demna*) has long trafficked in. In October 2017, Balenciaga debuted its own collaboration with Crocs, taking its recognizable upper and fully leaning into the absurdity of Crocs'

IT WASN'T JUST A LOGO ON A COOKIE—IT WAS A CULTURAL STATEMENT, A REMINDER THAT ANYTHING SUPREME

and came with a 9" ceramic plate wrapped in logo wax paper. It retailed for $148, which is roughly equivalent to about 10 chopped cheese sandwiches at the local bodega.

The beauty of Supreme's ability to take seemingly anything and make it covetable stems from the soft power the brand has cultivated over its 30-year history. Arguably one of the novelty items it's made with the most lasting cultural legacy is something it usually gives away for free: the horizontal red box logo sticker, which has become a symbol for the brand's transformative power, but also a shorthand for its ability to make just about anything a collaboration. In the brand's infancy in the mid-1990s, the simple sticker was slapped on everything from subway stops, mailboxes, payphones (remember those?), and of course, outdoor advertisements. The bold color and visually striking logo provided a great contrast to the black-and-white Calvin Klein ads prominently featuring model Kate Moss, creating an instant way of building awareness for the brand while also inadvertently putting it on the same level as a high-end fashion campaign.

While Supreme, using a distinct blend of absurdity and cultural commentary, has taught us that collaborations can elevate everyday objects into highly prized artifacts, Crocs has shown us how collaborations can change consumer sentiments and influence shifts in trend and taste—and even redefine the notion of what is considered "good" design. Founded in 2002 by Scott Seamans, Lyndon "Duke" Hanson, and George Boedeker Jr., Crocs was built more on comfort and pragmatism than being on the cutting edge of style. In fact, one of its first marketing campaigns in 2005 touted the message "Ugly Can Be Beautiful." Once relegated to the fringes of fashion, Crocs were mocked for their

design, amplifying its exaggerated proportions and turning the shoe into a luxury item retailing at $850. Critics were divided—was it a joke or genius?—but one thing was clear: Crocs were no longer a punchline. They were a conversation starter.

Crocs' journey from reviled to revered wasn't accidental—it was the result of intentional partnerships with influential designers and tastemakers, as well as a healthy dose of self-awareness. The brand started by embracing its 2005 message that, indeed, ugly could be beautiful. In the world of streetwear and sneakers, Crocs partnered with Michael Cherman of Market, a tongue-in-cheek label known for humorous reinterpretations of high-fashion brands and psychedelic graphics for several kitschy collaborations. The first was a 2019 reinterpretation of the classic clog fully covered in verdant green turf, giving the shoes a fuzzy texture. It followed that up with a licensed partnership with the Grateful Dead, who at the time were experiencing a resurgence fueled by a trend embracing hippie style, as well as a new awareness of their music thanks to John Mayer, who began touring with original members Bob Weir, Mickey Hart, and Bill Kreutzmann as Dead & Company. Market even went as far as making unsanctioned Crocs collaborations in shock-drop releases and at events like Complexcon, a three-day convention by Complex that specializes in limited-edition products sold exclusively within its walls. One year Market created a mysterious booth styled after a lawyer's office, in which it sold general-release Crocs Clogs with a custom 3D-printed Jibbitz-like attachment in the shape of a Nike Swoosh. The unofficial collaboration was a fun nod to Market's tendency for pushing the envelope in terms of illegal bootlegs,

Opposite top left + right: Christopher Kane Spring/Summer 2017, London
Opposite bottom: Supreme Brick

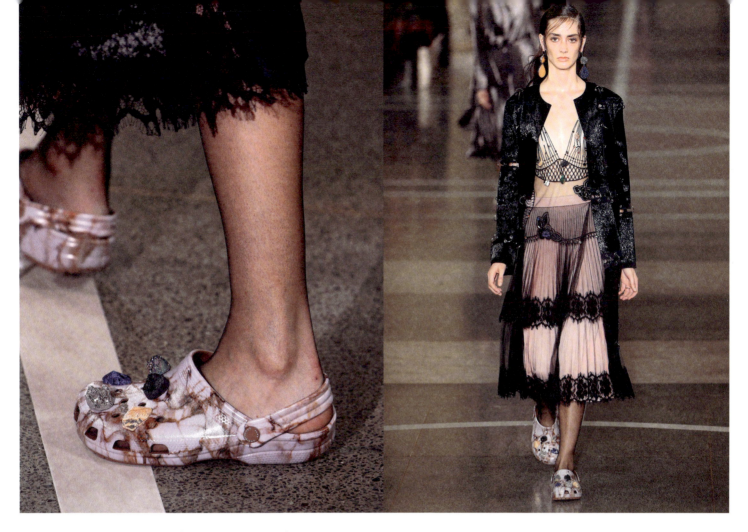

TOUCHES, NO MATTER HOW BANAL, BECOMES DESIRABLE. SUPREME'S SUCCESS LIES IN ITS ETHOS.

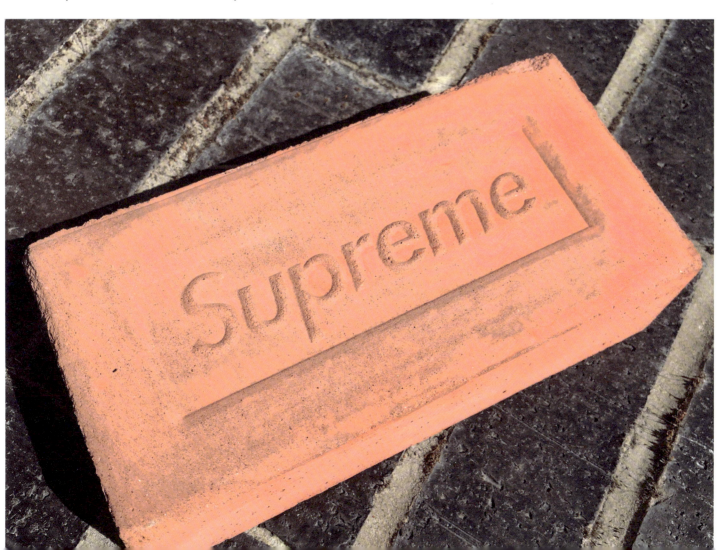

and it sold out long before either company could send a cease-and-desist.

Meanwhile, Crocs tapped footwear designer Salehe Bembury for an unprecedented partnership that allowed him to design a new silhouette from the ground up. His sculptural designs implemented a fingerprint motif that gave an innovative luster to the molded shoes, ushering in a new era of accessibly priced Crocs that looked less like the orthopedic clogs associated with nurses and suburban mallgoers, but the kind of covetable silhouettes sneakerheads and fashion enthusiasts readily flocked to. Bembury's Pollex Clog was an instant hit, and cemented Crocs as a legitimate player in the world of hype footwear, proving that even the most polarizing items can be reframed through the right partnerships.

Not only was Crocs embracing new design philosophies and making footwear more palatable to fashion-conscious consumers, it also went all-in on its own kitschiness, embracing what made them unique rather than trying to conform to traditional notions of style. In 2019, it released a collaborative shoe in the shape of Lightning McQueen from the Pixar film *Cars,* turning the lovable character into a pair of kids' shoes—and adults began to demand pairs in their sizes. Crocs answered with a limited-edition release that quickly sold out, and the adult-sized Lightning McQueen Crocs became an aftermarket commodity. Similar collaborations followed, featuring characters like Shrek, and even restaurants like McDonald's hopped on the trend. Here, the over-the-top perceived ugliness of the shoes is exactly what made them desirable. These partnerships allowed the brand to redefine its identity, turning its perceived flaws into strengths. Sales skyrocketed, and by 2021, Crocs had not only shed their stigma but emerged as one of the most profitable footwear brands in the world.

Much like Crocs, UGG has undergone a transformation that few would have predicted a decade ago. Once synonymous with suburban moms and early 2000s pop culture, UGG boots were widely considered a fashion faux pas, and in many ways are still considered the footwear equivalent of a Starbucks Pumpkin Spice Latte. Despite these challenges, the brand has been able to shift its perception among consumers and critics alike. UGGs have found new life in the realms of high fashion and streetwear, leveraging collaborations to rewrite the brand narrative while proudly flaunting their own kitschiness.

The shearling-lined boots trace their history back to Australia where "ugg boots" are, to this day, a generic term for warm sheepskin boots. Originally worn by farmers and laborers for long days in the cold, ugg-style boots quickly grew a following among Australian surfers who used them to warm up their feet after riding the waves. In the 1960s, the popular style of boot spread to other countries through their respective surfing cultures. s In the late '70s, future UGG co-founder Brian Smith, an Australian surfer, noticed the boots' popularity among surfers in California, but was disappointed by existing versions on the U.S. market. And so he, along with his friend Doug Jenson, started their journey to make the perfect ugg-style boot for the American market. In 1978, Smith and Jensen founded the UGG brand and established a strong foothold in the Southern California market, gaining even more recognition when the cozy footwear ended up on the feet of the American Olympic team during the 1994 Winter Olympics. A year later, the brand was acquired by its current owner, Deckers Brands, for $14.6 million.

UGG continued to grow and experience popularity among women especially, getting an extra boost in 2003 when Oprah Winfrey gave away 350 pairs to her studio audience as part of her "Oprah's Favorite Things" segment. UGG's trajectory as the go-to comfort boot of famous females ranged from Beyoncé, Kate Moss, Sarah Jessica Parker, and Jennifer Lopez. Ironically, it was also eagerly adopted by male celebrities, particularly anti-fashion icons like Adam Sandler

UGGS HAVE FOUND NEW LIFE IN THE REALMS OF HIGH FASHION AND STREETWEAR, LEVERAGING COLLABORATIONS

and Shia LaBeouf. It wasn't until 2010 that UGG debuted its first fashion collaboration, a five-piece capsule collection featuring elaborate studded patterns and animal print uppers courtesy of Jimmy Choo. The partnership also had a high-fashion price tag of around $800, significantly more than the usual UGG price of $175—already a premium for the average consumer.

By 2011, UGG began to actively court the male consumer, first with a campaign featuring star American football quarterback Tom Brady. The choice of celebrity was met with mixed reviews, interpreted as the brand both playing it too safe and aligning itself with talent that didn't necessarily resonate with a style-conscious men's audience. However, a few years later images began to surface of Pharrell Williams wearing a pair of the brand's 2013 collaboration with cult Japanese designer Junya Watanabe, featuring patchwork plaid flannel and Fair Isle patterns on the upper of its Classic Boot, but it wouldn't be until 2017 that UGG began to explore fashion collaborations in earnest.

That year, UGG debuted a capsule collection with 3.1 Phillip Lim, tapping the designer for silhouettes that combined traditionally masculine outdoor shapes like the ridged duck boot with classic UGG shapes. The addition of a front zipper and a more minimal interpretation of the Classic Boot created an unexpected juxtaposition, showing that UGG boots could be pulled off in a more tailored context. This was followed up with a more maximalist approach from designer Jeremy Scott—whose previous collaborations with adidas encapsulated an entire era of genre-defying sneakers. Scott's designs for adidas turned high-top sneakers into wearable teddy bears, pushing notions of tackiness and taste with details like oversized bone-shaped

Top left: UGG x Jimmy Choo
Opposite, top left: Beyoncé, 2004; top right: Bella Hadid, 2022
Opposite, bottom left: Sarah Jessica Parker, 2003; bottom right: Jeremy Scott attends the i-D x Jeremy Scott party presented by UGG in London, 2017

TO REWRITE THE BRAND NARRATIVE WHILE PROUDLY FLAUNTING THEIR OWN KITSCHINESS.

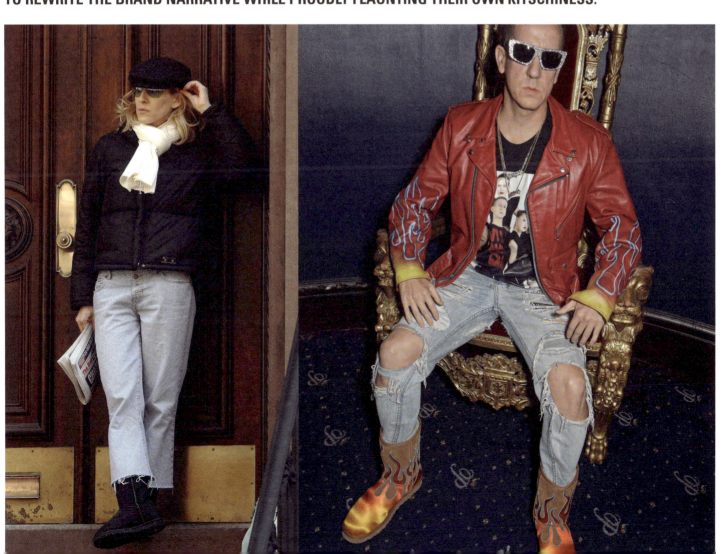

lace locks and exaggerated wings that covered the entire upper of a shoe. The controversial designs weren't for everybody—and that was exactly the point. It's an aesthetic he expanded on during his tenure as the creative director of Moschino from 2013 to 2023, where Scott not only brought in licensed partnerships with Looney Tunes, Spongebob Squarepants, and Disney, but he also pushed the envelope by imitating, and subverting, the instantly recognizable marks of Budweiser, McDonald's, Kellog's, and Barbie—a clear nod to the "logo-hacking" pioneered by rebellious streetwear brands.

For his collaboration with UGG, Scott reimagined the boots with bold flames, crystal embellishments, and over-the-top designs that felt equal parts kitschy and chic. He also enlisted Jasmine Sanders and rapper Lil Yachty to model his collaboration, imbuing it with a modern sense of youthful relevancy. The partnership felt natural because of Scott's own appreciation of UGG boots, influenced by the nostalgia of early 2000s paparazzi photos depicting stars like Britney Spears and Kate Hudson wearing the boots while grabbing Starbucks coffee. The brand continued its streak with partnerships that spanned a range of cultural spaces. Collaborations with brands like BAPE, Palace, and NEIGHBORHOOD added streetwear credibility, while projects with Telfar, Tremaine Emory of Denim Tears and Josué Thomas of Gallery Dept. courted a new audience of plugged-in cool guys. UGG's ability to work with a diverse group of creatives allowed it to reach new audiences while staying true to its identity as a comfort-first brand.

When it comes to products that are truly emblematic of pop culture, few come as close as soda pop itself. Beverages might seem like an unlikely platform for creative

that Raf Simons actually drinks a lot of Coca-Cola. As depicted in the 2014 documentary *Dior and I,* which documents Simons' first couture collection during his tenure as Dior's creative director, Simons is often seen with a can of Coke Zero not too far from him. It's a habit he took with him when he moved to New York to briefly take the creative reins at Calvin Klein.

Another famous fashion designer who loved Coca-Cola was Karl Lagerfeld, who once admitted in an interview with *Harper's Bazaar* that: "I drink Diet Coke from the minute I get up to the minute I go to bed. I can even drink it in the middle

ON THE FLIPSIDE, COLLABORATIONS DO MORE THAN JUST GIVE MASS LABELS CREDIBILITY IN THE WORLDS OF HIGH

collaborations, but they've become fertile ground for some of the most memorable brand partnerships. BAPE set the stage in 2001 with its Pepsi collaboration, which featured three different camo-print soda cans and bottles. Unopened versions of the collab still fetch a high price on the aftermarket. This partnership blended BAPE's streetwear aesthetic with a mass-market product, introducing the brand to a wider audience while reinforcing its association with youth culture.

In 2003, Coca-Cola tapped fashion designers Elvis Pompilio, Veronique Branquinho, Walter Van Beirendonck, Bernhard Willhelm, and Raf Simons to design custom Coke Light cans as part of the Coke Light Fashion Edition label. Limited to 250 pieces each, Simons' version referenced the Frankie Claeys-designed graphic from his 1998 "Black Palms" collection, but is considered a part of his seminal Spring/Summer 2003 "Consumed" collection, one of his most memorable seasons. The connection is also ironic because with "Consumed," Simons purposely explored the ideas of advertising, commodification, and consumerism itself. As the show notes for "Consumed" explain: "Today's living environment is about consuming as well as being consumed; some suggest this could lead to an apocalyptic end, while others, particularly younger generations, take this reality as their cue to create new, more viable and flexible personas."

Arguably one of the most important men's fashion collections to ever exist, it reimagines late capitalism through the lens of a post-apocalyptic wardrobe. One of the more prominent accessories were black-painted soda cans that hung around models' necks, a tongue-in-cheek synergy with Simons' timely collaboration with Coke. Even more interesting is the fact

of the night and I can sleep. I don't drink coffee, I don't drink tea, I drink nothing else."

So it wasn't surprising to see Lagerfeld partner with Diet Coke for a series of collaborative bottles in 2010, followed by another edition in 2011. Juxtaposing his signature silhouette alongside colorful bottles, it even featured a campaign shot by Lagerfeld himself, featuring models Coco Rocha, Heidi Mount, and Jeneil Williams. These partnerships weren't just about branding—they were about turning everyday objects into collectible items. They showed how something as simple as a soda can or bottle could be reimagined through the lens of design, becoming a vehicle for self-expression and cultural commentary.

Evian's foray into fashion collaborations represents the pinnacle of turning the ordinary into the extraordinary. Since 2008, the bottled water brand has worked with designers like Christian Lacroix, Jean-Paul Gaultier, Coperni, and Virgil Abloh to create limited-edition bottles that blend functionality with artistry. These collaborations elevate Evian from a hydration product to a lifestyle statement. Evian's designer bottles aren't just about aesthetics—they're about signaling the brand's alignment with luxury and innovation. By partnering with figures from the fashion world, Evian reinforces its position as a premium product while expanding its cultural reach. Each bottle becomes more than a vessel—it's a piece of art that communicates the brand's values.

On the flipside, collaborations do more than just give mass labels credibility in the worlds of high fashion or streetwear—they can reshape how a brand is viewed by the mainstream. Once the domain of rugged outdoorsmen, Stanley

Top: Raf Simons, Panamarenko, Wim Delvoye, Walter Van Beirendonck, Elvis Pompilio, Limited Edition Coke Light 2003–2005
Opposite: Kith Treats, Miami Design District

tumblers have found a surprising new audience: suburban moms and influencers. The shift began with exclusive collaborations, such as bright pink Target-exclusive designs, which introduced new colors and styles to appeal to a more design-conscious demographic.

Former Crocs executive Terence Reilly played a key role in Stanley's transformation, leveraging the power of TikTok to turn the tumblers into viral sensations. Influencers showcased their practicality and aesthetic appeal, sparking a wave of consumer interest. Certain designs began reselling for double their retail value, solidifying Stanley tumblers as a surprising grail item. It also symbolized a shift in status symbols. No longer restricted to the car you drive, the purse you carry, or the sneakers you wear, even the tumbler you drink from—whether kept in a car's cup holder or at an office desk—could now make a statement. Stanley's success demonstrates how a brand can reinvent itself by embracing collaboration and cultural relevance. By tapping into trends around functionality and design, Stanley transformed its utilitarian image into one of aspirational femininity, proving that even the most unexpected items can become tomorrow's must-have purchase.

In 1934, the breakfast cereal Wheaties began including pictures of notable athletes on its packaging to showcase why it touted itself as "The Breakfast of Champions." The first athlete to appear on the box was baseball great Lou Gehrig, and since then the roster of sports legends to grace the front of the box has expanded to include Michael Jordan, Arthur Ashe, Ken Griffey Jr., Serena Williams, Mia Hamm, and even professional wrestler "Stone Cold" Steve Austin. But much like what has happened to the sneaker industry, the cultural relevance of

"The Fiegster" combines Frosted Flakes, Cocoa Puffs, mini marshmallows, and crushed Oreos.

"Some kids can't afford to buy an article of clothing every other week or every month, so they can leave with a taste," says Fieg in a *Business of Fashion* article about why he chose to open Kith Treats. The success of the cereal bar led to the inclusion of a Kith Treats in every Kith store, but also some standalone locations, like an outpost in Tokyo years before Kith opened a proper store in the country. A year later, Kith partnered with Cap'n Crunch on a full collection featuring the cereal mascot wearing a

FASHION OR STREETWEAR—THEY CAN RESHAPE HOW A BRAND IS VIEWED BY THE MAINSTREAM.

athletes has been superseded by other movements like streetwear, fashion, and hip-hop. Even more telling, in 2008 Olympic champion swimmer Michael Phelps instead chose to appear on the box of Frosted Flakes cereal, a more sugary alternative to Wheaties that the athlete preferred to eat himself.

Streetwear thrives on the unexpected, and one of the most surprising cultural intersections has been the marriage of streetwear and breakfast cereal. What started as a curious novelty has snowballed into a full-fledged phenomenon, with brands like Kith and AMBUSH, artists like KAWS, and pop culture icons like Travis Scott collaborating with cereal brands like Reese's Puffs and Cap'n Crunch. These projects showed that in the world of collaborations, even the simplest products—like a box of cereal—can become canvases for hype.

In 2015, Ronnie Fieg renovated his Brooklyn flagship store and debuted a new endeavor: Kith Treats. A cereal-centric spin on the ice cream parlor, Fieg's cereal bar offered 24 different cereals and 25 different toppings, ranging from Lucky Charms marshmallows to crushed Oreo cookies. The eatery served the cereal in a specially-branded Nike shoebox with compartments for an exclusively-designed milk bottle and gave customers the opportunity to mix and match their favorite cereals and either consume them in a bowl of milk or blended into a shake. Fieg even got inspiration for pre-made mixes by tapping some of his high-profile friends to create menu items based off of their orders. LeBron James's "The King's Treat" features Cinnamon Toast Crunch with granola and crushed Snickers bars, artist Daniel Arsham's "The Snark" mixes together Rice Krispies, Cocoa Puffs, and Cookie Crisp, and Fieg's own

collaborative capsule line of exclusive merchandise, and a Saturday morning cartoon-style advertisement evoking childhood nostalgia with Kith's edge. There was also an exclusive Cap'n Kith cereal—a mix of Cap'n Crunch, Chocolatey Crunch, and mini marshmallow bites. Limited to an edition of 500 boxes, of course, it was sold in a special box and individually numbered.

When Travis Scott collaborated with Reese's Puffs in 2019, the partnership felt inevitable. Scott, known for his Astroworld-themed marketing and larger-than-life collaborations, brought his trademark energy to the cereal aisle. The box design featured a cosmic, psychedelic aesthetic that mirrored the visuals from his music videos and live performances. But it wasn't just the packaging that caught fans' attention—it was the rollout.

Scott released the collaboration alongside exclusive merchandise, including branded cereal bowls and spoons, turning a box of Reese's Puffs into a coveted collector's item. Like much of his work, the Travis Scott x Reese's Puffs partnership became an instant sellout, with boxes hitting resale platforms for upwards of $50. For Scott, it was another example of his ability to blend music, art, and commerce into a cohesive cultural experience.

As *Complex* described, the collaboration "proved that even a box of cereal can become a piece of cultural currency when the right name is attached to it."

Cereal, like sneakers and streetwear, touches on the consumer's shared obsession with nostalgia; for many, cereal remains a symbol of childhood simplicity. This sentimentality made it ripe for reinterpretation by brands that thrive on remixing cultural artifacts.

2021 also saw the artist Brian "KAWS" Donnelly collaborate with General Mills to reimagine the packaging for Reese's Puffs. The boxes featured his signature "XX" motifs and instantly recognizable characters, transforming a grocery store staple into a collectible object. For KAWS, it wasn't just about lending his designs to a cereal box; it was about making art accessible in the most unconventional way. The limited-edition boxes sold out quickly, and many appeared on resale platforms for prices upward of $100— proof that fans valued the cultural cachet of owning a KAWS-designed box as much as, if not more than, the cereal itself.

The cultural significance of cereal collaborations lies in their ability to tap into nostalgia while recontextualizing an everyday product as a luxury item. Cereal is inherently democratic—it's cheap, accessible, and universally familiar. By pairing it with high-fashion aesthetics or streetwear credibility, collaborators create a jarring but effective juxtaposition that sparks interest and drives demand. Moreover, cereal collaborations leverage the power of storytelling. Each project is an opportunity to tell a unique narrative, whether it's KAWS turning Reese's Puffs into art, Travis Scott embedding his larger-than-life persona into a breakfast staple, or Kith transforming Cap'n Crunch into a lifestyle brand. These stories deliver nostalgia and build brand sentiment one spoonful of sugar at a time, giving fans something they didn't know they wanted until it existed.

When done right, novelty partnerships can also add a layer of hype to the ubiquitous. McDonald's has long been a symbol of accessible taste, but its recent embrace of collaboration culture has taken the brand to new heights. In 2020, McDonald's teamed up with the ad agency Wieden+Kennedy to launch the "Famous Orders" campaign, featuring celebrity-curated meals

In 2017, when the popular animated show *Rick and Morty* premiered the first episode of its third season, there was much ado made about McDonald's Szechuan Sauce, where main character Rick Sanchez reveals that his main motivation for the season would be nothing more than to acquire the long-defunct condiment again. Originally created in 1998 as part of a tie-in to the Disney film *Mulan,* the passing mention in the widely influential series prompted almost 50,000 fans to sign a petition asking McDonald's to bring it back. In response, the McDonald's test kitchen made four jugs, sending one to *Rick and Morty* co-creator Justin Roiland, and the other three to lucky fans. Eventually, McDonald's capitulated to fan demand and decided to bring back the novelty sauce for one day only on October 7. Fans lined up overnight for a chance to try the resurrected sauce, but unfortunately there wasn't nearly enough to meet demand, in part because profiteering resellers snapped up as much as possible to put on the resale market. Even though McDonald's apologized for the shortfall and ended up making 20 million more packets available for purchase in 2018, it was an example of how even the most well-meaning, seemingly innocuous collaboration can end up leaving a bad taste in many consumers' mouths.

But perhaps the most groundbreaking meeting of the minds happened in 2022 when McDonald's partnered with Cactus Plant Flea Market to make what was essentially an adult version of its famous Happy Meal. The off-kilter partnership showed the power of a mass brand to turn a niche, art-house creative into a household name. Up until that point, Cactus Plant Flea Market and its relatively low-key creator Cynthia Lu remained more popular in the kinds of circles where pop art, streetwear, cult fashion, and sneakers converge. Led by a

LONG A SYMBOL OF ACCESSIBLE TASTE, MCDONALD'S HAS MASTERED THE ART OF MAKING ITSELF CULTURALLY

from Travis Scott, BTS, and Saweetie. It leveraged each collaborator's star power while simultaneously making them more relatable to their fans. Not everyone can be a global superstar like Travis Scott, but certainly thousands more can go to their local McDonald's and have what he's having. The BTS meal, for example, included two signature sauces, Sweet Chili and Cajun (with custom packaging printed both in English and Korean and a color scheme tied back to the K-pop band's purple and pink visuals) and a global marketing push that resonated with the band's massive fanbase.

McDonald's has mastered the art of making itself culturally relevant through collaborations that blend nostalgia, accessibility, and kitsch. It followed up the "Famous Orders" campaign with the equally genius "As Featured In…" campaign. This time, though, the brand decided to leverage its own star power. Combing through decades of pop culture references, it elevated the humble brown paper bag into a leading role, proudly putting "As Featured In" on the side of its famous takeaway packaging and touting its impressive filmography, from *Space Jam* to *Coming to America* to brief appearances in an episode of *Seinfeld* and beyond. It even transformed participating restaurants into McDonald's parodies, like McDowell's from *Coming to America* and WcDonald's, a fictional restaurant from the 1980s anime series *Cat's Eye*, referencing how the restaurant has often been indirectly referenced in many popular Japanese anime franchises. Taking things one step further, it partnered with London-based streetwear brand PALACE Skateboards—known for its witty messaging and fun approach to collaborations—to create a special line of merchandise that was only available to customers who scanned a code on the "As Featured In" packaging.

longtime creative consigliere for Pharrell, Lu's brand (CPFM for short) gained a following among cultural diehards like NIGO, Pusha T, Travis Scott, and KAWS alike. In fact, it was this organic community of supporters that led to the genre-bending partnership. Pusha T famously co-wrote with his brother the earworm-inducing "I'm Lovin' It" jingle for McDonald's back in 2003, an act that in and of itself subverted the artist's usual oeuvre of lyrics about selling cocaine. Decades later, Pusha T helped make the introduction between CPFM and McDonald's.

Smartly, McDonald's allowed Lu to have free rein over how the partnership came to fruition, resulting in a blend of childhood nostalgia and quirky, avant-garde aesthetics. The DIY, handmade appeal of the brand shone through not just in the advertising—which combined throwback claymation with live-action mascots—but also in the collectible toys. Collectors quickly fell in love with the cheerful, claymation-inspired plastic figurines, which took four of McDonald's most iconic characters and distorted them through the artist's signature lumpy, warped aesthetic which occupies a liminal space between childhood drawing and fever dream. In addition to its memorable figurines, CPFM supplemented the rollout with pre-orders for coordinating merchandise and additional toys on its own platforms. The meals weren't just a viral hit, but also showed how these kinds of collaborations place wholly relatable consumer experiences on a luxurious pedestal. Far from simple marketing strategies, they're cultural statements that challenge perceptions, spark conversations, and redefine what consumers value. As brands continue to explore the intersection of creativity, culture, and commerce, the message is clear: With the right lens, anything can become a phenomenon.

Opposite, top: Travis Scott x McDonald's
Opposite, bottom: Palace x McDonald's Skateboards

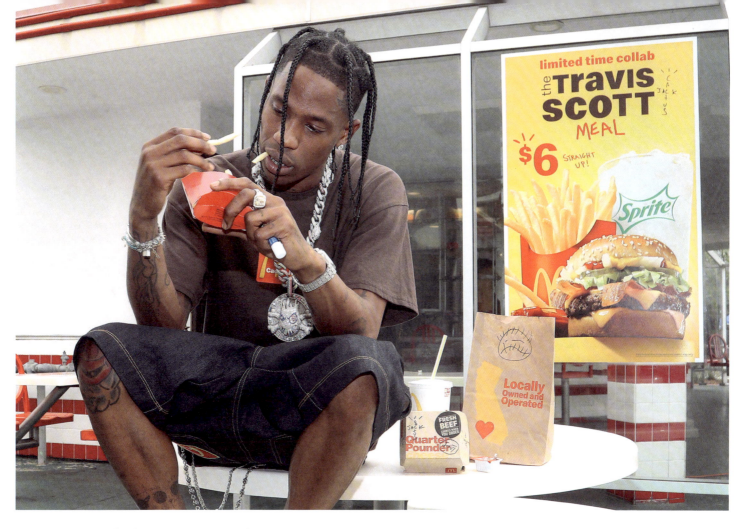

RELEVANT THROUGH COLLABORATIONS THAT BLEND NOSTALGIA, ACCESSIBILITY, AND KITSCH.

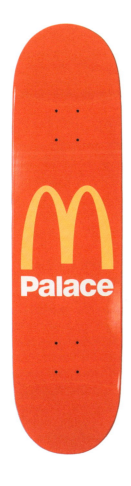
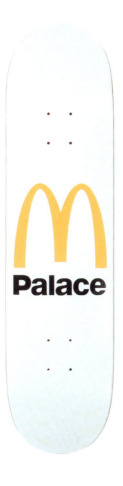
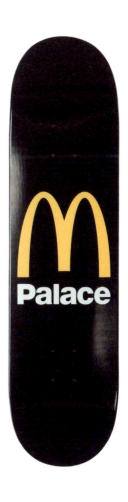

A Social Media Spark Leads to Doughnut-Shaped Sponges

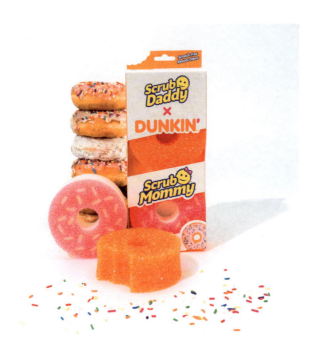

DUNKIN' **X** **SCRUB DADDY**

The product's fun design and clever marketing around National Doughnut Day turned a social media joke into a viral success, selling out in less than two weeks.

In a move that seamlessly blended culinary delight with household practicality, Dunkin' and Scrub Daddy joined forces in June 2024 to celebrate National Doughnut Day with a limited-edition line of doughnut-shaped sponges. Hilariously, the collaboration between Dunkin' and Scrub Daddy began with a playful exchange on social media that sparked the idea for a unique partnership. It all started when Dunkin' posted a lighthearted tweet featuring one of their signature doughnuts, playfully questioning what other items could be "dunked" in their coffee. Scrub Daddy, known for its fun and interactive social media presence, responded to the tweet, suggesting that their sponges would be just the item.

The humorous back-and-forth caught the attention of fans on both sides, quickly gaining traction and leading to a larger conversation about how the two brands could join forces in a more creative way. This exchange led to the development of the limited-edition doughnut-shaped sponges, transitioning a social media joke into a tangible product offering. The collection featured two sponge variants: the Scrub Daddy and the dual-sided Scrub Mommy. Both sponges were crafted to resemble delectable doughnuts, complete with a central "hole," enhancing their utility for cleaning long-handled utensils.

The marketing campaign capitalized on the whimsical nature of the product, with the sponges featuring vibrant colors and designs reminiscent of Dunkin's iconic doughnuts. The promotion highlighted how these charming, doughnut-shaped sponges could add a sense of delight and novelty to everyday chores.

When Coffee and Sneakers Meet on the Go

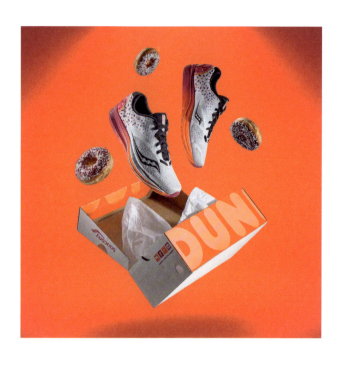

DUNKIN' X **SAUCONY**

Dunkin' Donuts and Saucony's 2019 collaboration dropped just in time for the Boston Marathon, reimagining the Kinvara 10 running shoe with Dunkin's signature flavors.

We've all heard it before—"America Runs on Dunkin'"—the catchy slogan is practically hardwired into every American's brain. But in 2019, the footwear company Saucony took the slogan and ran with it—literally. That was the year Dunkin' and Saucony, both Boston-based brands, teamed up to drop a sneaker collection just in time for the Boston Marathon, blending Dunkin's sweet flavors with Saucony's performance-driven design.

The standout of the collaboration was the Saucony Kinvara 10, a celebrated running shoe in its own right, having won multiple awards for its lightweight design and responsive cushioning. Known for its "fast feel" and versatile performance, the retro-inspired running sneaker was reimagined in Dunkin's strawberry flavor, iced in a pale pink, and speckled with pink with sprinkles. The shoes came in a bold orange, pink, and brown box to mirror the packaging of the food chain's packaging, with a playful "Coffee and Donuts" embroidery on the tongue as a cheeky nod to the partnership's roots. A children's version of the shoes was also released, marketed as "Munchkins"—a wink-and-nod reference to Dunkin's donut holes of the same name. Because why not? And it didn't stop at sneakers. The collection also included limited-edition Dunkin' hoodies and socks, each in the same vibrant colors that made the sneakers pop.

Crucially, the pairing came right as Dunkin' was rebranding itself—officially dropping "Donuts" from its name. The rebrand was a bold move that reflected the company's evolution into a broader lifestyle brand, one that could suggest a possibly healthier lifestyle that went hand-in-hand with sugary treats. More than just a playful collaboration, the sneaker pairing was a clever example of how a donut brand could shift into new gear while also making sneakers just as much a part of the daily routine as that morning cup of coffee.

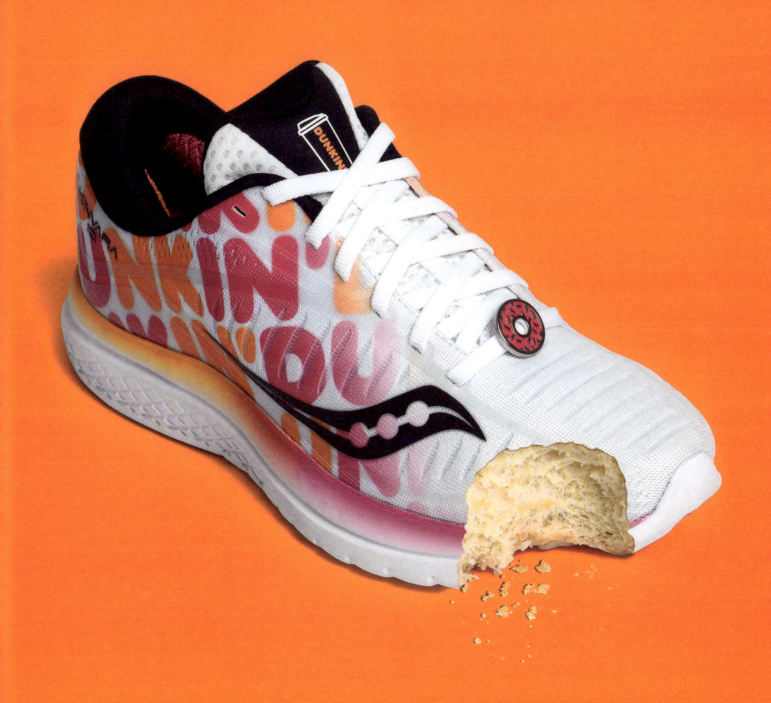

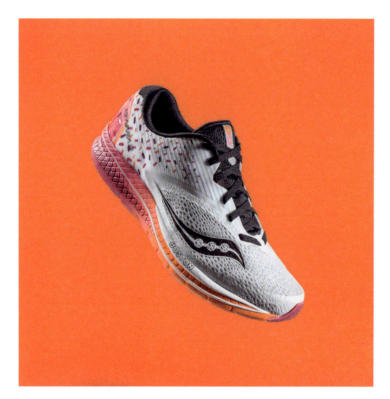

A SNEAKER COLLECTION, BLENDING DUNKIN'S SWEET FLAVORS WITH SAUCONY'S PERFORMANCE-DRIVEN DESIGN.

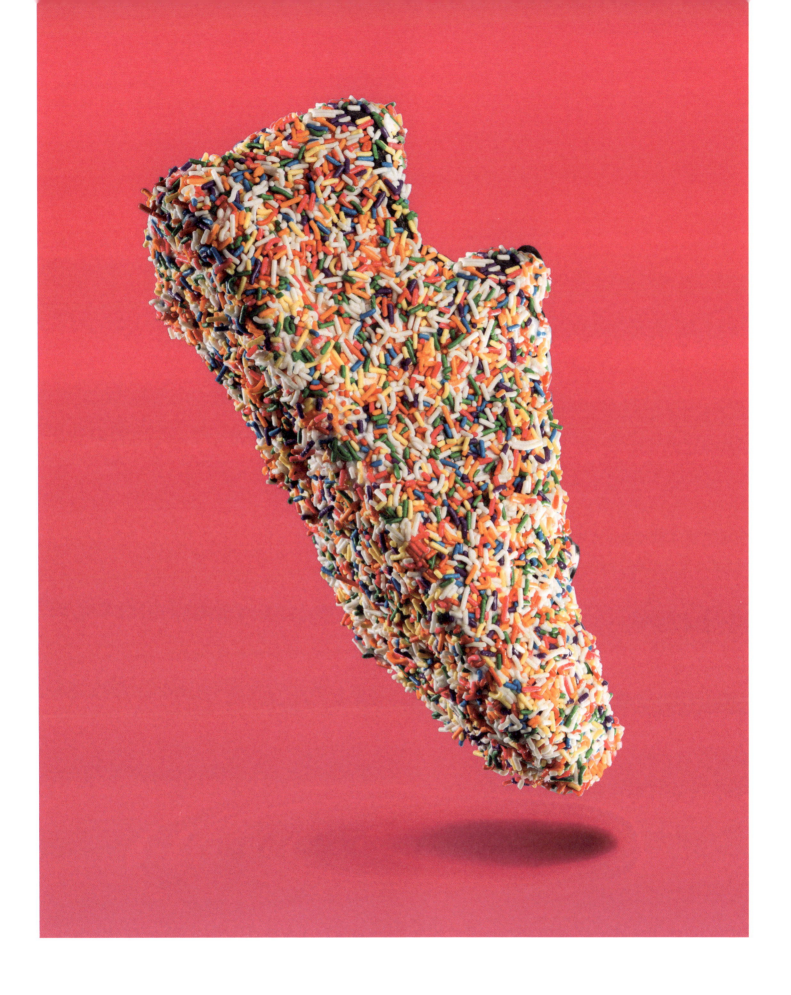

133 DUNKIN' X SAUCONY

A Cosmic, Sentimental Fusion of Music and Fashion

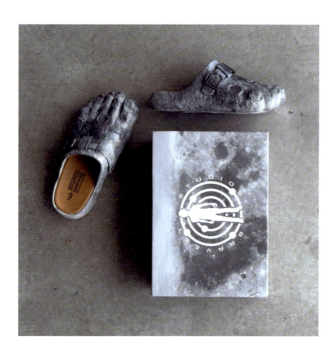

BRAVEST **X** **KID CUDI**

Following a string of successful streetwear collaborations, Kid Cudi teamed up with Bravest Studios for a limited-edition footwear release celebrating the 15th anniversary of his iconic album *Man on the Moon.*

Kid Cudi has long been a notable figure in the world of streetwear, with collaborations that include iconic brands like BAPE, where he released a limited-edition collection featuring hoodies, t-shirts, and sneakers inspired by his cosmic aesthetic. He also worked with Nike in 2010 on a special edition of the Air Force 1, further cementing his role in the sneaker world. Additionally, Kid Cudi has teamed up with New Era for custom baseball caps, and Alo Yoga for a collection that merged his laid-back personal style with athleisure. Through these partnerships, Cudi has consistently shaped streetwear culture, blending his music's themes with bold, wearable designs, making him a key figure in the intersection of fashion and music.

In December 2024, Bravest Studios and Kid Cudi unveiled the "Moon Clog," a footwear collaboration commemorating the 15th anniversary of his seminal album, *Man on the Moon.* This release marked their second joint effort, following the success of their Summer 2024 green clogs. Drawing inspiration from lunar landscapes, the Moon Clogs feature a textured gray exterior that emulates the moon's surface. An adjustable buckle strap enhances both the fit and aesthetic, while high-quality faux leather insoles and footbeds provide comfort. The non-slip outsole ensures practicality, making them suitable for daily wear. Each pair is presented in a multi-panel collector's box, further reflecting the collaboration's artistic vision.

The design process was deeply influenced by Kid Cudi's artistic journey and the themes of his debut album. In addition to the clog's lunar motifs, orange insoles bearing Kid Cudi's insignia add a personal touch, reinforcing the collaboration's authenticity. The shoes not only offered fans a tangible connection to Kid Cudi's musical legacy, they also showcased Bravest Studios' commitment to merging art and fashion.

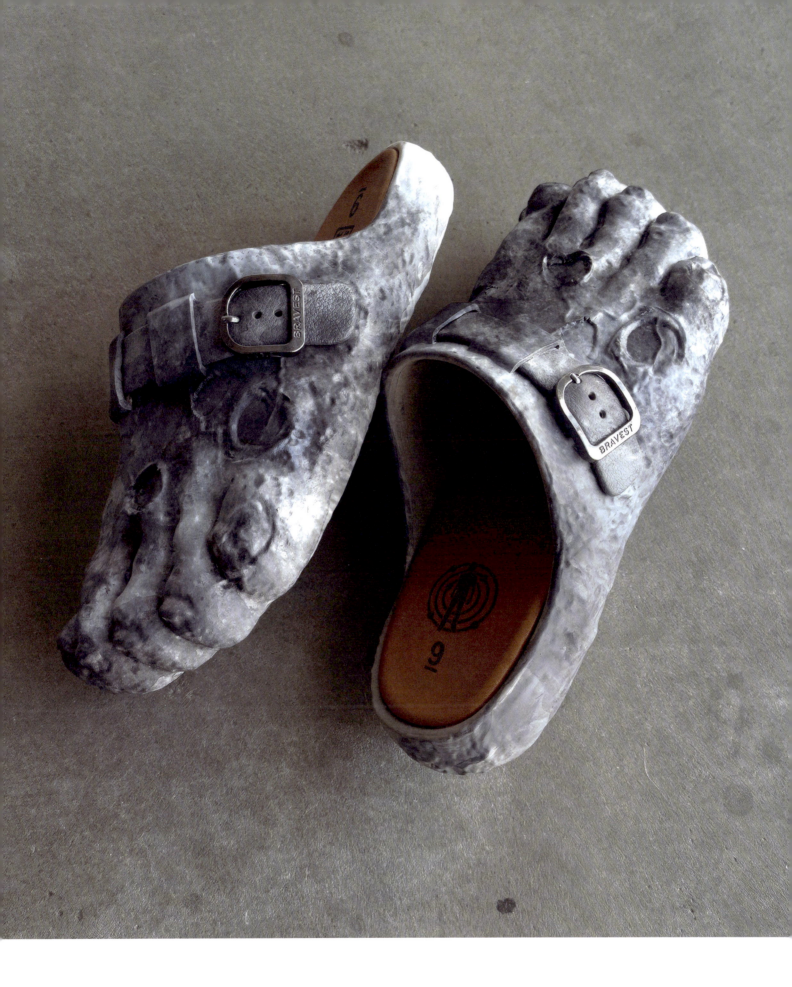

135　　　　　　　　　　　　　　　　　　　　　　　BRAVEST X KID CUDI

The Fast-Food Footwear Flex

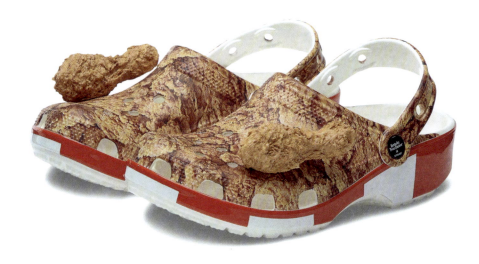

CROCS X **KFC**

KFC's quirky collaboration with Crocs—featuring platform clogs with rubber fried chicken Jibbitz and a spicy aroma—became an unlikely viral sensation. Selling out in minutes, the partnership was equal parts absurd and genius, sparking debates and fueling a new era of fashion-meets-fast-food stunts.

KFC is no stranger to orchestrating elaborate stunts, having created everything from their own Extra Crispy Sunscreen to various unusual items that smell like chicken (e.g., firewood and Valentine's Day cards). But their collaboration with Crocs might take the cake: the collection debuted with a unique pair of sky-high platform Crocs decked out in KFC's signature red-and-white patterned packaging and, most notably, a pair of rubber fried-chicken-drumstick Jibbitz accessories attached to the straps. (Yes, they reportedly smelled like chicken, too.) The reveal came during New York Fashion Week with a viral campaign featuring South Korean influencer and fashionista Me Love Me A Lot and with a *Paper Magazine* cover and brand takeover, immediately generating a mixture of disbelief, fascination, and perhaps most surprisingly, obsessive excitement. Soon thereafter, other high-profile influencers, like Kim Kardashian, posted about receiving their very own pair of the Crocs, sparking an online frenzy. When Crocs put a more classic version of the KFC x Crocs up for sale the day after their debut, they sold out in under 30 minutes. Even more unexpectedly, the collaboration sparked heated debates on social media about its true cultural significance, with some fans considering it an ironic fashion statement and others hailing it as a stroke of genius.

The collaboration isn't as bizarre as it might seem at face level. Crocs, known for its bold, offbeat design and an unshakable place in the world of casual comfort, has increasingly leaned into creative partnerships. From Justin Bieber to Post Malone, the brand has mastered the art of tapping into niche, often unexpected cultural moments. KFC, with its deep roots in American fast food and its penchant for quirky, attention-grabbing advertising, was gunning for a viral, meme-ified hit. For KFC, it was a chance to tap into younger, more social media-savvy audiences, while Crocs was able to capitalize on the sheer absurdity of the pairing. The result was a product that was both a tongue-in-cheek commentary on consumer culture and a surprisingly wearable piece of footwear.

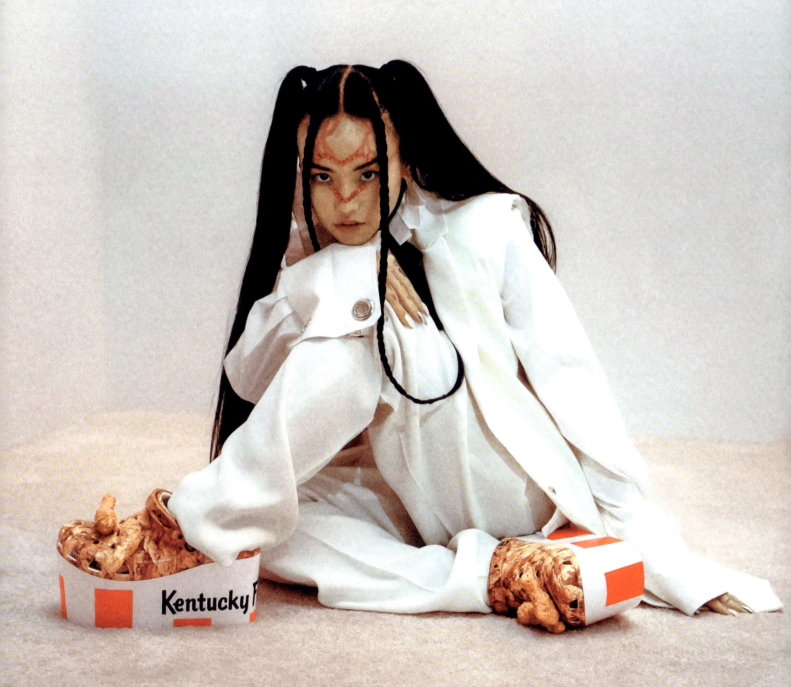

Reimagining Comfort with Style

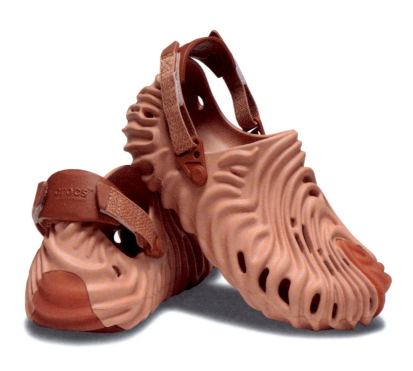

CROCS **X** **SALEHE BEMBURY**

In a groundbreaking collaboration, designer Salehe Bembury reimagines Crocs with the Pollex Clog, transforming the iconic foam clog into a sculptural work of art. With bold textures, nature-inspired design, and a new luxury edge, this partnership elevates Crocs into the realm of high fashion.

In 2021, Crocs, a company long known for favoring comfort over aesthetics, turned heads by partnering with designer Salehe Bembury. Best known for his work at Yeezy and Versace, Bembury brought his distinctive touch to the iconic shoe, transforming it from polarizing, utilitarian footwear into a high-fashion statement. The result was the Salehe Bembury x Crocs Pollex Clog, a bold reimagining of the classic Crocs silhouette with a unique, sculptural design that fused Bembury's love of nature with Crocs' focus on feel.

The collaboration was born from a shared desire to break convention. Crocs, a brand that once faced ridicule for its chunky, foam-based design, has evolved into a symbol of casualwear and unapologetic self-expression with a surprisingly wide fanbase, particularly in streetwear circles. Salehe Bembury, a designer known for his organic, nature-inspired aesthetic, stated in a press release that he sought to redesign the clog not just for style, but as a form of "artistic expression." His vision included exaggerated curves and bold textures, along with earthy colors that nodded to the natural world—a stark contrast to Crocs' original look but entirely in line with Bembury's unique design philosophy.

The Pollex Clog was met with rave reviews. Sneakerheads and fashion insiders were impressed by how Bembury infused the shoe with a sense of high design. The shoes, with their layered textures and unconventional shape, managed to be both wearable and visually striking. The addition of the distinctive, fingerprint-like indentations on the shoe's upper became an immediate visual trademark of the collaboration. Critics also praised Bembury for elevating the Crocs brand from a functional, "dad" shoe to a piece of forward-thinking design.

The Pollex Clog was a leap into the realm of luxury streetwear, reflecting the brand's increasing influence in the fashion world. People started to see Crocs as a canvas for creative designers, not just a symbol of practicality. For Bembury, it was another triumph in his quest to merge nature and design, showing that even the most unassuming footwear can become a work of art.

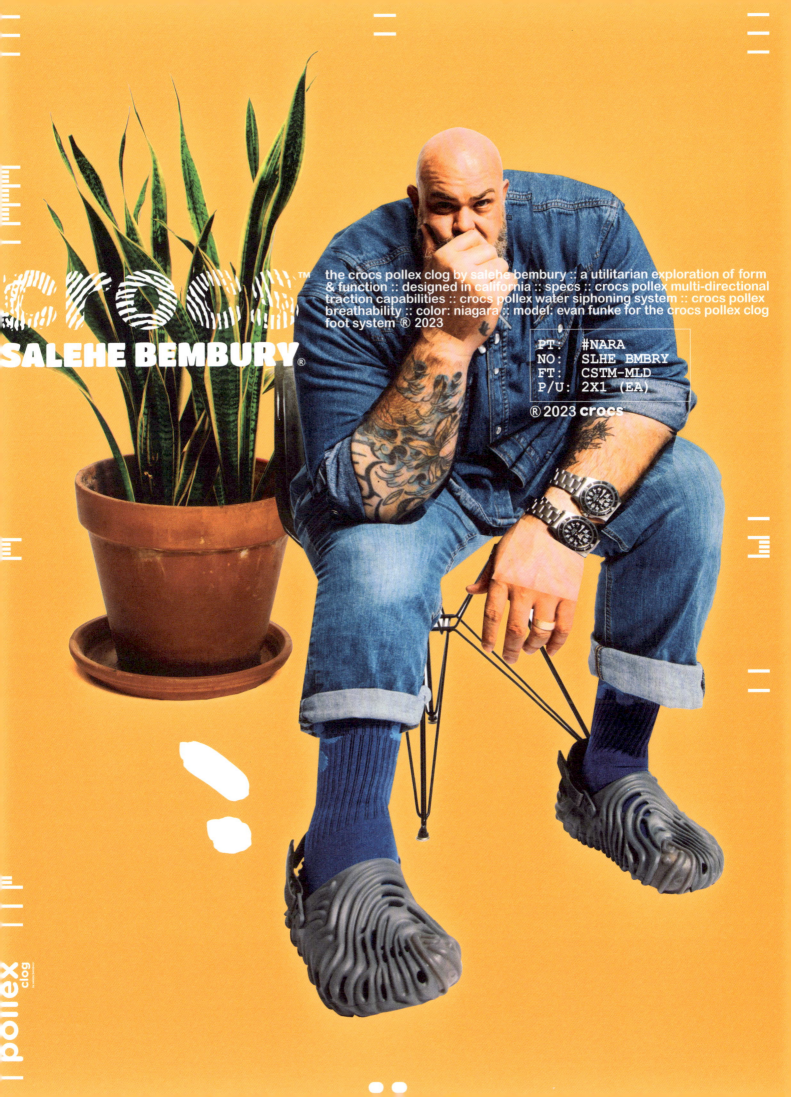

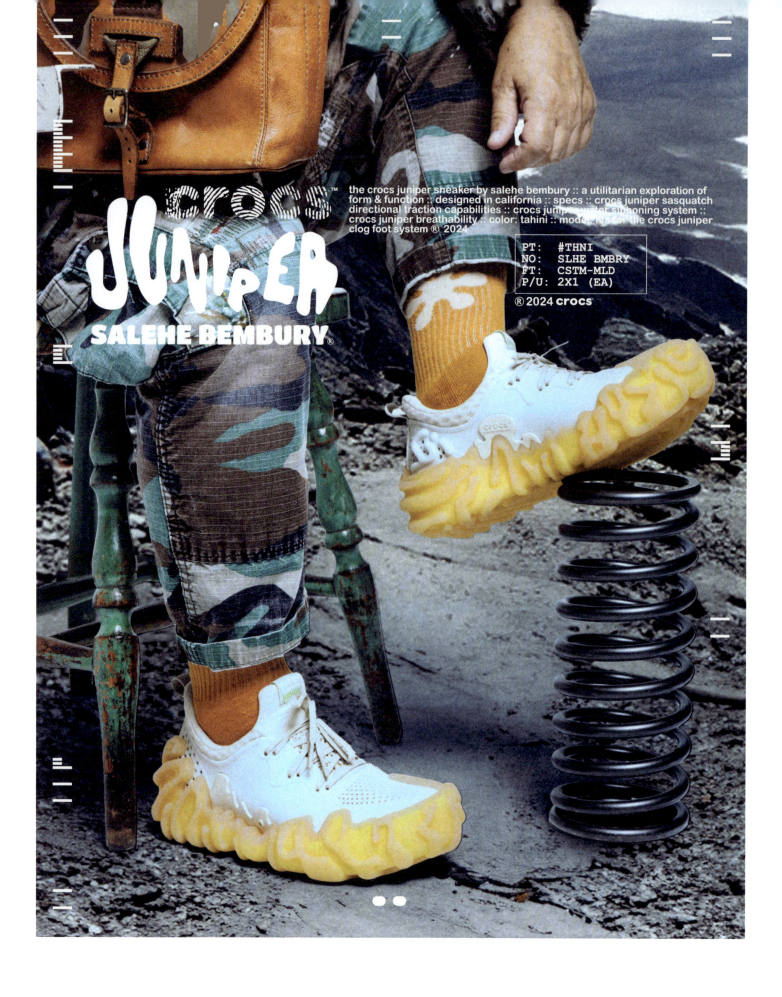

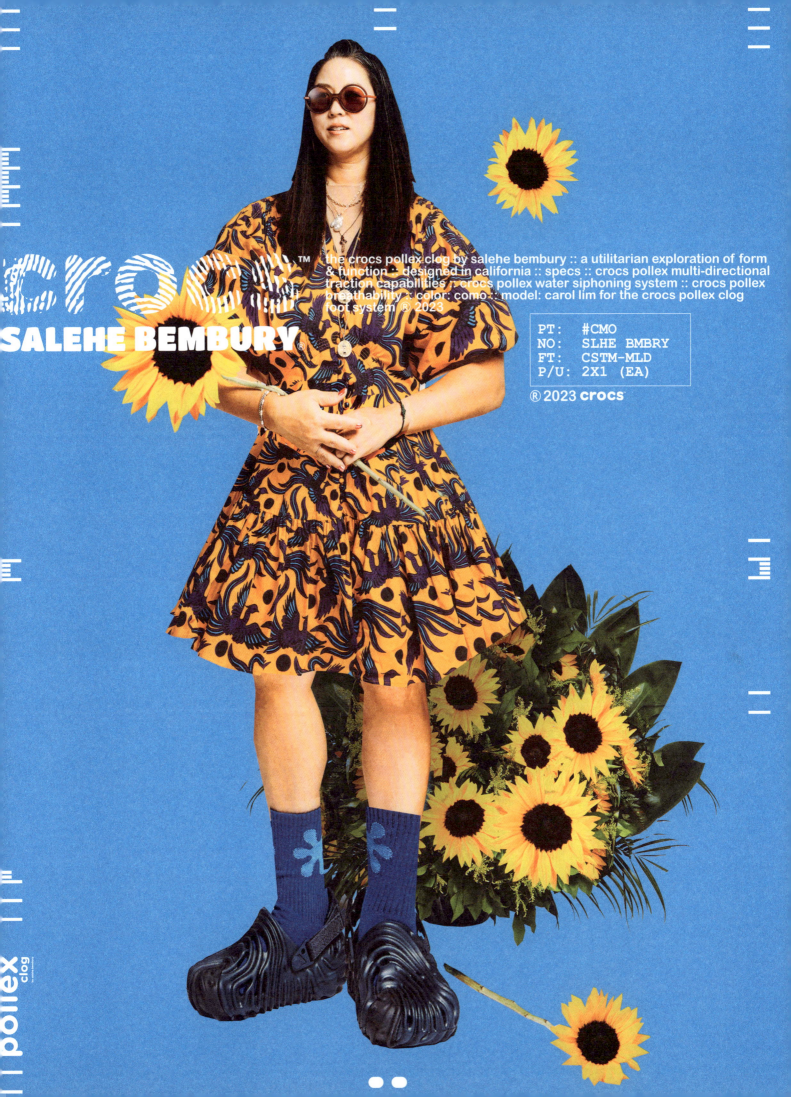

A Colorful Fusion of Pop Art and Luxury

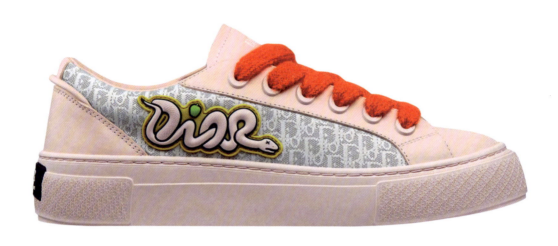

DIOR X **KAWS**

Kim Jones and KAWS reunite for a vibrant menswear collection, this time centered around a serpentine motif. With playful twists on Dior's heritage and streetwear influences, the collaboration merges high fashion with graphic art in a strikingly fresh way.

The Dior x KAWS capsule collection is the latest chapter in the ongoing collaboration between Dior Men Artistic Director Kim Jones and the New York-based artist. Their initial collaboration in 2018 began with KAWS designing a massive sculpture made of thousands of pink and white flowers, which was placed at the center of the runway for Jones's debut Dior collection for Summer 2019. This set the stage for KAWS's line of reinterpretations of Dior's iconic Bee motif, but for 2025, the focus shifted to something more dynamic and mischievous: the snake.

Pop art has long been a bridge between the worlds of fashion and fine art, with figures like Andy Warhol and Roy Lichtenstein influencing collections across the fashion spectrum. Jones, who himself has previously worked with artists like Kenny Scharf and Daniel Arsham, long admired KAWS's ability to inject energy into his work, and was excited to bring the artist's influence back into the fold. "KAWS is incredible as a person and an artist," Jones said in a statement to *WWD*. "It was a pleasure working with him for the summer 2019 collection and now I thought it might be good to bring back a KAWS element." Drawing from KAWS's signature pop-art style, the snake, symbolizing transformation and fluidity, became the collection's focal point, appearing on every single item—from pastel-pink varsity jackets and bright-red cardigans to cream and black track jackets and pants.

Dior's signature Oblique monogram was reworked with squirming snakes weaving through the branding, while the "CD" logo was reimagined as a bold, serpentine form, giving the collection a playful, yet high-fashion edge. The collection also featured quilted coats and button-up shirts, where the snake motif stretched across the fabric in intricate designs. For Jones, this collaboration is another step in the ongoing relationship between art and fashion, where wearable, graphic art goes luxury.

A Cozy Staple Given a Cult-Worthy Reinvention

Y/PROJECT

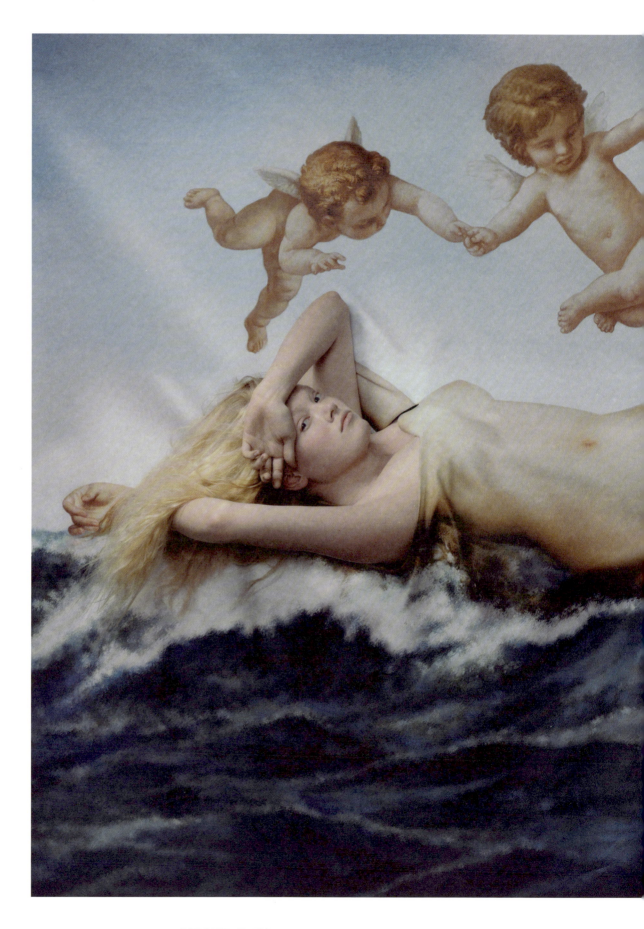

Y/PROJECT X UGG

Glenn Martens reimagines UGG's classic sheepskin boot with high-fashion sculptural shapes, merging art history with avant-garde design.

UGG

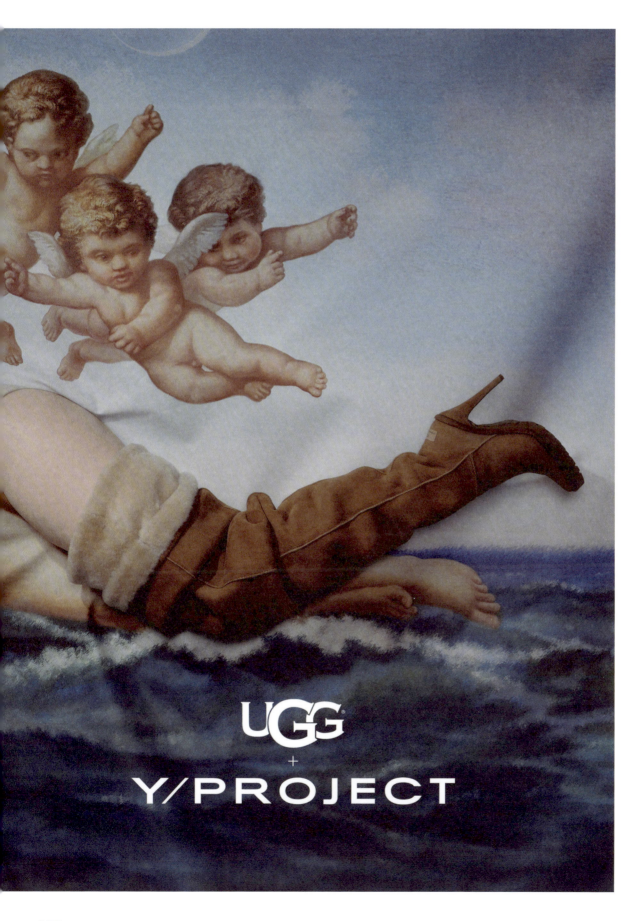

Y/PROJECT X UGG

Glenn Martens, the designer behind Y/Project, reimagined UGG's iconic sheepskin boots with a bold twist, blending high-fashion flair with cozy Americana. Unveiled at Paris Fashion Week in January 2018, the collaboration was an unexpected mix of Martens' experimental, deconstructed style and UGG's laid-back comfort. Martens took the classic boot, redefined its proportions with sculptural shapes, and turned it into a sleek, thigh-high statement piece.

The campaign itself drew inspiration from classical art, particularly Botticelli's *The Birth of Venus*. "The Classic boot is one of the most recognisable shoes in history. It is a statement. The starting inspiration would be *The Birth of Venus*," Martens explained. He framed the collection as "the birth of something classic, the birth of this collaboration, surfing on waves, twisting the expected, triggering the eye in an eclectic mishmash of different codes." Martens' creative direction culminated in a much-discussed ad campaign featuring scantily clad models whose heads, limbs, and torsos protruded from various famous Renaissance paintings, their bodies covering and merging with the figures in the originals. This literal fusing of reality and art was, in itself, quite striking, but what made the images unforgettable were the Y/Project x UGG boots and sandals adorning the feet of every model.

And although the collection as a whole caught the fashion world's eye, the boots were the real showstoppers: the towering platform boots with chunky soles that highlighted the sheepskin, along with knee-high boots sporting double layers for a dramatic effect. Unexpected textures, oversized buckles, and straps made each pair a bold statement piece. Celebrities like Rihanna and Bella Hadid were quick to embrace the collaboration, with Rih photographed running errands in the platform UGGs. When she said the boots "reminded me of something familiar and comforting," she made the shoes a must for collectors everywhere. They became so popular that fashion magazines began devoting entire articles on the many ways to style them, turning the once-humble UGG into a high-fashion, cult-status must-have.

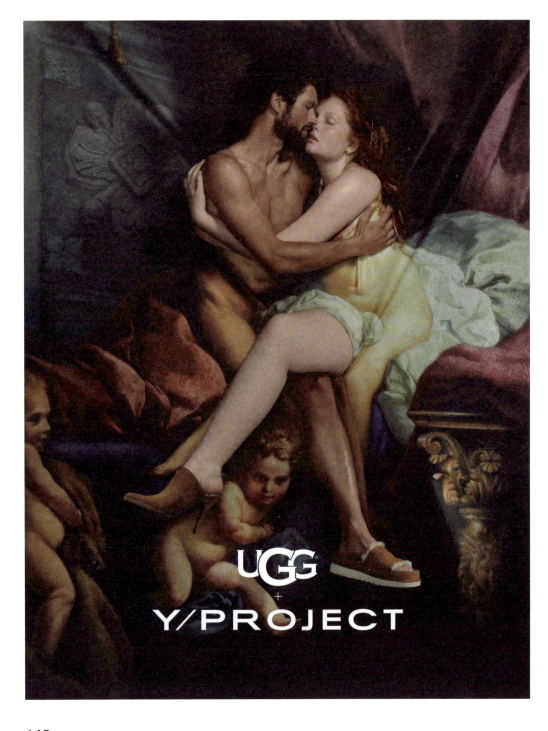

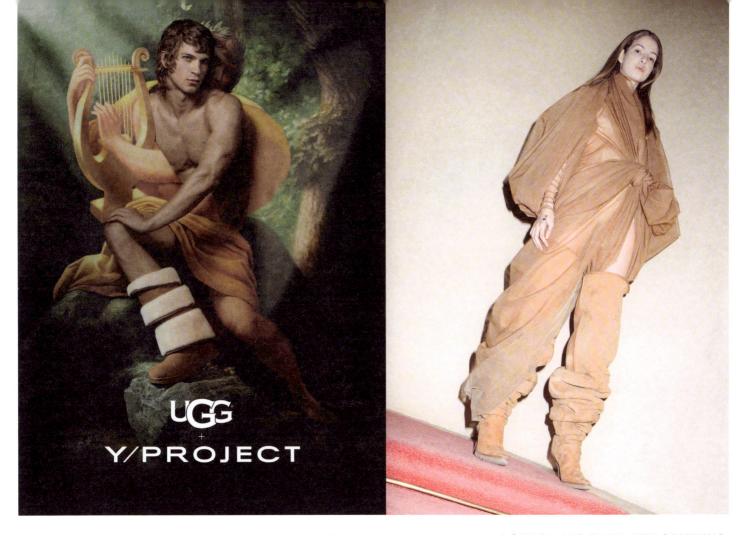

THE CAMPAIGN DREW INSPIRATION FROM CLASSICAL ART, PARTICULARLY BOTTICELLI'S *THE BIRTH OF VENUS.*

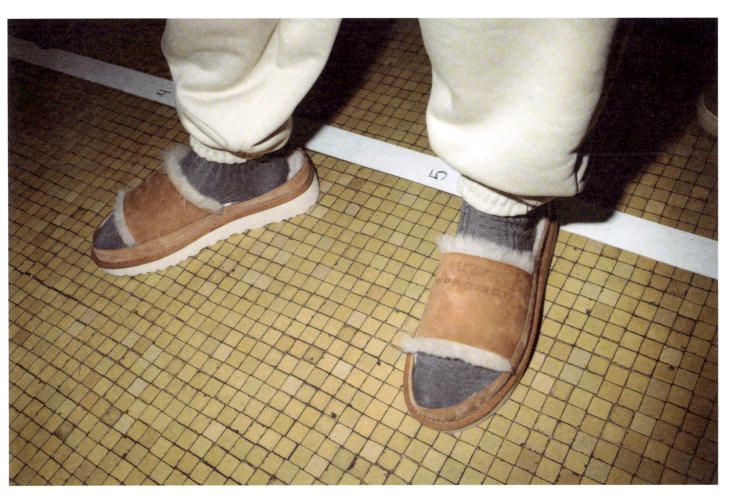

From Pop to Pop Culture: Art's Crossovers with Streetwear, Fashion, and Consumer Products

150

The modern manifestation of the snake eating its own tail is a 45-second Burger King commercial featuring footage of Andy Warhol awkwardly chowing down on a hamburger. Aired in 2019 during one of advertising's most infamous and competitive time slots—Super Bowl Sunday—it repurposes very real footage of Warhol from Danish filmmaker Jørgen Leth's 1982 film *66 Scenes from America,* a series of vignettes where Warhol indeed spends four-and-a-half minutes silently eating a Whopper. The Burger King commercial ends while Warhol is mid-chew, listlessly looking off somewhere beyond the camera before the hashtag #EatLikeAndy splashes across the screen. The work's journey from outsider art to the pinnacle of mass consumption is a microcosm for how Warhol himself was the architect of this meta moment, where art commenting on mass culture then becomes subsumed by it.

In the 1960s, Andy Warhol transformed the art world forever. His vision was as much about breaking down barriers between "high" and "low" culture as it was about celebrating consumerism. Warhol's most famous pieces—Duchamp-esque illustrations of Campbell's soup cans, colorful diptychs of Marilyn Monroe, and stacked boxes of Brillo soap pads—weren't about elevating utilitarian objects to the level of fine art. They were about interrogating the notion of what "fine art" even meant. Warhol didn't just redefine art; he redefined the artist. The Factory, his New York studio, became an incubator for creativity, commerce, and a new kind of celebrity. It was less a studio and more a cultural nexus—a place where painters, musicians, actors, and socialites came together. Warhol's ability to embrace collaboration and production at scale turned the Factory into an assembly line for art, mirroring the industrial processes that inspired his work.

York's downtown scene in the late 1970s and early 1980s, Haring was a protégé of Warhol, but his approach to art was more populist. While Warhol leaned into celebrity culture, Haring took to the streets—literally. His chalk drawings on black advertising panels weren't just about expression—they were about inclusion. Haring's work spoke to everyone: the Wall Street banker commuting to work, the graffiti artist dreaming of legitimacy, the child marveling at a world of vibrant figures in motion. In the process, Haring's distinctive style—bold lines, cartoonish silhouettes, vivid colors, and universally understood symbols—became part of the city's fabric.

Haring's ethos was simple: art should belong to everyone. This belief culminated in the 1986 opening of the Pop Shop, a retail space where fans could buy affordable art pieces like T-shirts, buttons, and posters. The Pop Shop wasn't just a store; it was an experiment in accessibility. Haring saw it as an extension of his public art, a way to bring his work to people who couldn't afford original pieces. It took art off the pedestal and made it less precious, creating in the process a new kind of hybrid between meticulous art piece and ready-made product. It challenged traditional ideas about ownership and exclusivity in art, giving birth to a new kind of collector who trafficked in a gray area between accessibility and prestige.

Warhol may have staked his claim to the Campbell's soup can, but Haring opted to reinterpret the Coca-Cola bottle. A fitting obsession, given the brand's bold colors, recognizable branding, and utter ubiquity, sold everywhere from vending machines and grocery stores to gas stations and bodegas. Haring repainted a series of Coca-Cola bottles that became sought-after collectibles in their own right,

ANDY WARHOL AND KEITH HARING LAID THE FOUNDATION FOR THE INTERSECTION OF ART AND COMMERCE.

Modern-day influencers can probably trace their roots back to Warhol, too. Despite often being misattributed as saying that in the future, everyone will be famous for 15 minutes (in actuality, the phrase *"quart-d'heure de popularité"*—fifteen minutes of popularity—dates as far back as 1821 to Charles Lacretelle's *Histoire de l'Assemblée),* what Warhol did understand was the power of being not just a creator, but a product. This idea of the artist-as-brand was one of the most prescient things about him. The cool, enigmatic, aloof, and yet extremely media-savvy persona he crafted was as much a part of his art practice as the works that came out of The Factory. As Natasha Degen writes in her book *Merchants of Style: Art and Fashion After Warhol,* what made people and companies want to associate themselves with Warhol was that he made himself into a "generic signifier for art," occupying this ambiguous space between culture, commerce, and the cognoscenti where his mere presence conferred legitimacy. This is not unlike the effect streetwear luminaries like Hiroshi Fujiwara, NIGO, and Virgil Abloh would have many decades later in making everything from sneaker boxes to cereal boxes all the more covetable and collectible.

Warhol's ability to commercialize art and turn the artist into an innovative commodity—a form of cultural credibility that could be bought into or collaborated with—set a precedent for many of today's most successful artists. Figures like Jeff Koons, Takashi Murakami, Daniel Arsham, and even Pharrell Williams owe a debt to Warhol's blueprint of art as both culture and commerce.

If Warhol created the blueprint for the modern artist, Keith Haring built out the concept. Emerging from New

even doing an entire vending machine at one point—and it wouldn't be until long after his untimely death in 1990 that any of these collaborations were officially sanctioned by the Coca-Cola Company. But Haring's ability to translate fine art into consumer goods showed that art didn't have to be rarefied to be valuable. And much like Warhol, Haring understood that the real power of art lies not just in its creation but in its ability to connect with people on a mass scale.

Warhol and Haring laid the foundation for the intersection of art and commerce, creating a cultural continuum that continues to evolve. Both artists saw consumer products as potential vessels for artistic expression. And while Warhol elevated commercial objects to fine art, Haring brought fine art into the realm of the everyday. Together, they showed that art could live beyond galleries and museums, reaching an audience that rarely, if ever, set foot in either. This approach didn't just democratize art; it expanded the market. Suddenly, the "art consumer" wasn't limited to wealthy collectors or gallery-goers. The kid who bought a Keith Haring button from the Pop Shop or a Warhol-inspired print from MoMA's gift shop became part of the cultural conversation.

Fast forward to today, and this dynamic has reached new heights. Artists like Takashi Murakami, KAWS, and Daniel Arsham have taken Warhol and Haring's playbook and adapted it for a 21st-century audience. These creators work at the intersection of fine art, fashion, and consumer goods, collaborating with brands like Louis Vuitton, Nike, and Supreme to produce pieces that are as much status symbols as they are artworks.

Jeff Koons emerged as another master at creating schlock value. Whereas Warhol recontextualized soup cans and Brillo boxes, and Haring brought art into public spaces and everyday objects, Koons took things a step further. His works weren't just about pop culture—they were about scale, spectacle, and kitsch.

Koons's sculptures, such as Balloon Dog and Balloon Rabbit, are among his most recognizable. The stainless-steel creations are polished to a mirror finish, and at face value are a fairly simple statement about taking the ephemeral and giving it a sense of permanence. Unlike Haring's democratic Pop Shop or Warhol's embrace of mass production, Koons tends to create work that is accessible in its imagery, but often fetches prices that only the ultra-wealthy can afford. In 2013, his Balloon Dog (Orange) sold at auction for $58.4 million, and six years later his work Balloon Rabbit sold for $91.1 million.

Where Haring sought to democratize art, Koons embraced exclusivity. Taking the idea of Warhol's use of the studio as a production factory, Koons popularized the practice of art fabrication to create many of his works, editioning them so they could simultaneously occupy several gallery spaces, but severely limiting the production so value could be created through scarcity. Koons's "Banality" series of Hummel figurine-inspired sculptures in 1988 made its debut in three different galleries: in New York, Chicago, and Cologne at the same time.

His collaborations with brands reflect this same ethos. For example, Koons's work on two iterations of BMW's Art Car project in 2010 and 2022 were a collision of pop art, industrial design, and automotive culture, further blurring the line between

If Warhol, Haring, and Koons defined the American approach to pop art and consumerism, Takashi Murakami globalized it. Born in Tokyo, Murakami studied traditional Japanese art before pivoting to a style that merged the old with the hyper-modern. Murakami grew up amidst the rise of consumerism and pop culture phenomena like manga and anime. His "superflat" theory posits that these elements, far from being inferior to fine art, are part of the same cultural continuum. Superflat is as much a critique of Japan's hyper-consumerist society as it is a celebration of its cultural exports. Drawing from anime, manga, and the post-war *kawaii* aesthetic, Murakami creates vibrant works that blur the line between fine art, anime culture, and commercial design.

Murakami's works are instantly recognizable: bright, cartoonish flowers; Japanese motifs like cherry blossoms, reimagined; and wide-eyed anime characters that skew from seductive to *kawaii*. His real genius, though, lies in his ability to commercialize his art without losing credibility. Launched in 2001, his Kaikai Kiki studio functions as both a production house and a talent incubator, managing younger artists like MADSAKI and legitimizing cross-cultural talents like Virgil Abloh in the art world. In addition, it produces art objects like prints, collectible toys, and trading cards based on Murakami's works and apparel. It also served as a production studio for Murakami's 2013 film *Jellyfish Eyes,* and launched Murakami's WEB3 endeavors featuring NFTs themed after his floral works. The studio also lets Murakami explore other industries like Coffee Zingaro, a Showa era-inspired coffee shop housed in Nakano Broadway, a sprawling Japanese antique mall known mostly for its vintage watch vendors and shops selling esoteric anime merch. He also recently became a partner in

KAWS' APPROACH EXPANDED THE ART COLLECTOR DEMOGRAPHIC TO INCLUDE SNEAKERHEADS, STREETWEAR

fine art and consumer goods. In 2014, he partnered with H&M on a massive takeover of its Fifth Avenue flagship in New York with images of one of his balloon dog sculptures. It was to celebrate his collaboration with the Swedish fast-fashion company, consisting of a singular bag that cost $49.50 and featured a six-inch image of his sculpture on the front. It remains an affordable outlier for an artist who mainly traffics in high-ticket items. Even his prints and editioned small-sale sculptures tend to have a much more expensive asking price. Three years later in 2017, Koons made a proper return to luxury by partnering with Louis Vuitton to create a collection of bags and accessories featuring reproductions of famous artworks by Leonardo Da Vinci, Vincent van Gogh, and Claude Monet. Each piece was adorned with Koons's signature and nameplate, turning luxury items into portable art exhibitions.

Although many have tried to imitate his approach, what sets Koons apart is his focus on the immaculate. Every piece, from his sculptures to his Louis Vuitton collaborations, is crafted with a hyper-attention to detail; this meticulousness connects him to contemporary artists like Takashi Murakami and KAWS, who similarly merge fine art precision with controversial pop culture subjects. The idea that a balloon dog or a porcelain Michael Jackson statue could be considered high art opened doors for a new generation of artists who sought to challenge traditional boundaries. Together, they form a bridge in the evolution of art's crossover with consumer culture. Whereas Haring brought pop art to the streets, Koons brought it to the luxury market. Both challenged the idea of what art could be and where it could exist.

Kijayakutei, the spiritual successor to Dairakutei Kitaguchi, a small restaurant known for its gyoza that he had frequented for 20 years. When COVID hit, the business owners decided to close up shop, but Murakami worked with them to revive his beloved dumpling purveyor through the lens of Kaikai Kiki.

Murakami's collaborations with brands and musicians propelled his reach into the mainstream consciousness. His partnership with Louis Vuitton in 2003 reimagined the luxury brand's monogram with kaleidoscopic colors and anime-inspired designs. This wasn't merely a marketing stunt; it was a cultural moment that signaled the art world's embrace of consumer goods, and its re-release two decades after still generated plenty of hype and sales—proving that the work has staying power. His artwork for Kanye West's *Graduation* album cover in 2007 solidified his status as a cultural icon, and subsequent projects with Nike, Porter, and Uniqlo showcased his adaptability and cemented his status as a cultural powerhouse.

Brooklyn-based artist KAWS took Murakami's model and pushed it further, creating a universe where art, toys, and streetwear intersect seamlessly. Starting as a graffiti artist, KAWS became known for his reimagined pop culture characters—Mickey Mouse, the Simpsons, Snoopy—which he transformed almost beyond recognition, giving them his signature "X" eyes and exaggerated features.

While Murakami celebrated consumer culture, KAWS critiqued it—and eventually found himself becoming a reluctant participant. Starting out in Jersey City, KAWS made a name for himself by subverting advertisements in a process he called "interventions." He would paint over

Opposite, top: KAWS:HOLIDAY 'Companion' inflatable sculpture by artist Kaws on display in Shanghai, 2024
Opposite, bottom: Artist Jeff Koons poses next to his work at the National Museum in Naples, 2003

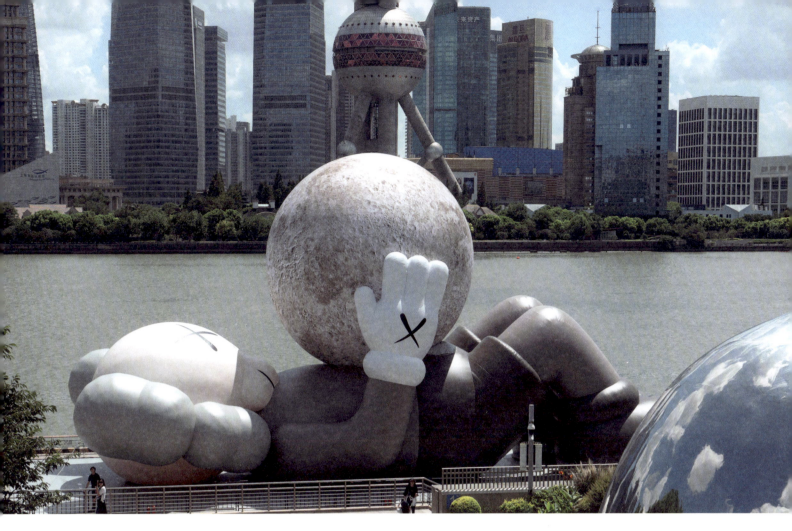

ENTHUSIASTS, AND FANS OF POP CULTURE, PROVING THAT ART WAS COURTING AN ENTIRELY NEW AUDIENCE.

billboards and bus shelters, replacing corporate imagery with his own characters. These interventions were witty, disruptive, and undeniably artful.

KAWS' ability to translate his street art into other mediums like his clothing label OriginalFake propelled him to international fame. His vinyl toy collaborations with Japanese brands like Medicom Toy and the streetwear label Bounty Hunter coincided with the beginning of the urban vinyl movement and its championing of collectible vinyl statues. KAWS' figures, such as his recurring "Companion" character, took the sterile, cutesy nostalgia of Disney mascots and infused it with a deep uncanniness. These instantly recognizable collectibles were limited in quantity, driving demand among art collectors and streetwear enthusiasts alike, until eventually they became cultural icons.

But KAWS also sparked a broader conversation about accessibility in art. By creating pieces that ranged from $200 toys to million-dollar paintings, he made his work attainable to different audiences. His influence can be seen in artists like Hebru Brantley, who similarly blend pop culture references with fine art sensibilities.

KAWS' approach expanded the art collector demographic to include sneakerheads, streetwear enthusiasts, and fans of pop culture, proving that art was courting an entirely new audience.

As KAWS' reputation grew, so did the scale of his work. He moved from vinyl toys to massive public installations, such as his 120-foot "Companion" inflatable at Hong Kong's Victoria Harbour and his own balloon at the Macy's Thanksgiving Day Parade. Collaborations with brands like Supreme, Nike, and Dior further expanded his reach. His Air Jordan 4 sneakers, released in 2017, became one of the most sought-after sneaker collaborations of all time.

Artists like KAWS found natural partners in brands like Medicom Toy, whose Bearbrick collectibles became a canvas for collaborations with the world's leading creatives. Since their inception, Medicom Toy's Bearbrick figures have become one of the most ubiquitous symbols of art-meets-consumerism. Introduced in 2001, these plastic bear-shaped collectibles are essentially blank canvases for artists, brands, and designers. Over the years, Bearbricks have featured collaborations with a list of visionaries that includes Karl Lagerfeld, Travis Scott, KAWS, Pharrell Williams, and even the estates of Andy Warhol and Jean-Michel Basquiat. As its reputation grew, Medicom's Bearbricks evolved into a modern-day art collectible, blending streetwear aesthetics with fine art pedigrees.

Similarly, Hong Kong's AllRightsReserved has emerged as a leader in bridging art and commerce. Their limited-edition collectibles with artists like KAWS and Joan Cornellà echo the early urban vinyl figure movement, pioneered by artists like Michael Lau and companies like Kidrobot. Lau, often called the "godfather of designer toys," created hand-painted vinyl figures that captured the DIY ethos of street art with a high-design polish. Lau's figures, which debuted in the late 1990s, fused graffiti and streetwear aesthetics with action figure sensibilities. Meanwhile Kidrobot founder Paul Budnitz's collaborations with artists like The Gorillaz, MF Doom, Frank Kozik and Tara McPherson brought street art into the collectibles market. Kidrobot found even more success when it expanded into "blind box" toys, where rare collectibles were packaged in box sets among more common ones, and customers never knew what they were getting until the package was opened. Naturally, this contributed to an aftermarket price bump for the rarest figures.

These toys, once niche, have since exploded into a global phenomenon. In 2010 Wang Ning founded Pop Mart as one of China's premiere purveyors of modern designer toys. Blending affordability with desirability, Pop Mart specializes in

IT'S NO LONGER JUST ABOUT OWNING A PIECE OF ART; IT'S ABOUT PARTICIPATING IN A CULTURE.

the sale of "blind box" figures. Pop Mart has introduced characters like Labubu, Molly, and Dimoo to a mainstream audience. Through unlikely fans like K-Pop star Lisa of Blackpink, characters like Labubu have become more popular than ever.

But despite the resurgence in collectible toys and art-adjacent products, the value of bona fide art certainly has not gone anywhere. The throughline connecting prototypical pop artists like Warhol to artists like KAWS, Jeff Koons, Tom Sachs, and Daniel Arsham is their ability to translate fine art into cultural capital. Each, in their own way, has challenged traditional ideas about where art belongs and who it's for.

Daniel Arsham and Tom Sachs exemplify how contemporary artists can straddle multiple worlds. Arsham's "Future Relics" series, which reimagines everyday objects as eroded artifacts, taps into themes of time, permanence, and a collective nostalgia. Collaborations with adidas, Dior, and Porsche have allowed his aesthetic to reach new audiences, while his large-scale installations and exhibitions maintain his credibility in the fine art world.

Tom Sachs, on the other hand, approaches art with a tongue-in-cheek sense of irony. His collaborations with Nike—notably the Mars Yard sneakers—merge his fascination with space exploration and craftsmanship. Sachs' DIY ethos and focus on detail make his work as appealing to collectors as it is to sneakerheads.

Both artists understand the importance of narrative. Whether it's Arsham's speculative archaeology or Sachs' satirical take on consumerism, their works resonate because they tell stories—stories that connect with audiences

Top: Takashi Murakami, 2002
Opposite: Daniel Arsham Studio

across mediums. Together they have reshaped the art world, paving the way for the collaborations, movements, and markets that dominate today. From streetwear to luxury fashion, they have shown that art isn't just about what hangs on a wall—it's about how it moves through the world. It's no longer just about owning a piece of art; it's about participating in a culture that prizes creativity, accessibility, and innovation. What began as a rebellion against exclusivity has become a thriving global market, where art exists not just on walls but on our feet, on our shelves, and in our phones. And in this

biggest names in modern art. But he is also a proponent of distilling an artist's message into aphorisms tailor-made for the age of social media, which is why his "-ISMS" series of books is brilliant on its own merits. Pocket-sized collections of affirmations from artists and important cultural figures, Warsh's books of Arsham-isms, Basquiat-isms, Haring-isms, and Futura-isms (among many, many others), demonstrate his understanding of how mass consumers may not fully understand how to process art, but they can always find new ways of engaging with it.

On the other side of the spectrum, Isimeme "Easy" Otabor has become a paragon of the post-Virgil Abloh collector and curator. Born and raised in Chicago, Illinois, Otabor is a self-taught collector and now the owner of his own Gallery Anthony. He began his career working with Virgil Abloh and Don Crawley at their RSVP Gallery boutique in the mid-2000s, where he learned about the intersection between art, commerce, and the growing crossover between sneakers, streetwear, and high culture.

His position as the gallery's head operator and buyer afforded him the opportunity to travel to global hotspots like Paris, Milan, and Tokyo, witnessing a burgeoning movement of convergence firsthand. He not only quickly befriended artists like Tom Sachs, Theaster Gates, and Takashi Murakami, but he also became an early proponent of artists like Matt McCormick and Yue Wu, with the former being tapped to create an album cover for artist Don Toliver through Otabor, who went on to serve as both a creative and cultural consigliere to Travis Scott and his affiliates.

And if running his own gallery and providing creative counsel to music world royalty weren't enough, Otabor also has his own clothing line, Infinite Archives. A trailblazing

THIS DEMOCRATIZATION HAS NOT ONLY EXPANDED THE MARKET—IT HAS REDEFINED WHO GETS TO PARTICIPATE

new era, the consumer is not just a buyer but a curator, collector, and collaborator in their own right.

Behind many of these shifts are figures like Larry Warsh, a collector and curator instrumental in redefining how contemporary art is marketed and consumed. Warsh's involvement with artists like Basquiat and Haring in their early careers demonstrates his foresight in recognizing the intersection of art and popular culture. His efforts to make art accessible, whether through books, exhibitions, or collaborations, mirror the larger trends shaping the art world today. Warsh's role in the art world extends beyond collecting; he has actively shaped how art is consumed. By supporting artists like Basquiat and Haring early in their careers, Warsh helped redefine the modern art market.

A native of Astor Place, Warsh first began to covet Keith Haring's pieces when he encountered them in the subway, on pieces of black paper that were once used to cover unsold ad space. In fact, he tried to carefully peel one off of the wall it was on, and although he failed that initial attempt, it set the stage for a collection that sold at Sotheby's and was valued at $10 million. Warsh's collections span works by Haring, Jean-Michel Basquiat, Kenny Scharf, KAWS, and Ai Weiwei. He also has amassed several of Basquiat's notebooks, which he has described as "Napoleonic battle sketches." They are important not just because of the notes they contain, but the way in which they document Basquiat's entire creative process.

Warsh has positioned himself as somewhere between a soothsayer and tastemaker. His impressive collection of artists demonstrates a penchant for predicting some of the

project that aims to blend history with product storytelling, Infinite Archives' releases are hyper-specific and home in on one particular era each year, telling a unique story with each drop. Meanwhile, his gallery has not only hosted newer exhibits by Barbara Kruger, Arthur Jafa, and Tom Sachs, it has become a springboard for emerging artists like Nina Chanel Abney, Adeshola Makinde, Eri Wakiyama, and tattooist Dr. Woo. Otabor's masterful juxtaposition of contemporary masters, legitimizing a new crop of talent, is a unique approach that works only because of the cultural authenticity he brings to the table. As a result, he is creating a more inclusive space that successfully connects local and global artists to a larger community, enriching the landscape in the process.

Art has long been a source of inspiration for fashion, and collaborations that involve artists often yield some of the most visually arresting products. When brands and artists join forces, the result is often more than just merchandise—it's wearable art.

Consider the longstanding relationship between Louis Vuitton and contemporary artists, a trend spearheaded by Marc Jacobs during his time as Creative Director at the storied French fashion house. From Takashi Murakami's colorful monogram designs to Yayoi Kusama's polka-dotted creations, these collaborations transformed Louis Vuitton's accessories into canvases for artistic expression. They also introduced these artists to a broader audience, bridging the worlds of high art and high fashion.

Another standout example is the Dior x KAWS partnership, which brought the street artist's signature

Top: Gaetano Pesce x Bottega Veneta

"Companion" figure to the world of luxury menswear. Memorable as Kim Jones's debut collection during his legendary tenure as Dior's Artistic Director of Menswear, Dior x KAWS incorporated the artist's playful yet thought-provoking motifs into Dior's tailored silhouettes. Blurring the line between streetwear and couture, the collection gave us pieces that were as collectible as they were wearable. Not only that, but Jones was inspired by Mr. Dior's own love for art, citing the fact that Dior owned a gallery and operated as an art dealer in the 1930s before his clothing business took off. Jones strove to work with artists whom he thought Mr. Dior would be a fan of today. Considering Dior's early exhibitions included the works of Picasso, Braque, Giorgio de Chirico, as well as Surrealism from Cocteau, Fini, and Ernst, one can see why Jones would have followed up KAWS with a series of artist collabs that ran the gamut, from contemporaries like Hajime Sorayama and Kenny Scharf to the likes of Amoako Boafo and Peter Doig.

Art and commerce have always danced a complicated pas de deux, but the past few decades have seen this partnership evolve into something thrillingly new. Where once the art world was happily ensconced in its ivory tower, the 1980s began cracking open that exclusivity, and contemporary artists and brands have since bridged the gap between high art and consumer culture. Today, sneakers can be sculptures, vinyl toys can command five figures, and art events like Art Basel attract the same attention as a Hollywood premiere.

In fact, events like Art Basel have become emblematic of how the art market has evolved. Once the domain of elite collectors, these fairs now attract a younger, more diverse crowd, drawn by the Instagrammable spectacle of works

The cheeky sneakers sold out in minutes and instantly became a hot commodity on resale sites like StockX, demanding up to $3,000. Not to be outdone, MSCHF incited further consternation with the black-and-red "Satan Shoes" released in 2021 with similarly controversial artist Lil Nas X. Done as a marketing tie-in for Lil Nas X's music video for "Montero (Call Me By Your Name)," in which the artist portrays himself giving a lapdance to Satan, the shoes not only drew the ire of religious groups and conservative celebrities, but even Nike itself, which sued MSCHF for copyright infringement on the custom pairs.

Interestingly, as MSCHF continued to lampoon sneaker and streetwear culture, it accidentally became a part of it. Many of MSCHF's projects were launched on its app in the form of regular "drops" that were associated with timed releases in sneakers and streetwear. The products varied from digital apps like a virtual tontine with a very real monetary payout, to a blind-boxed Lamborghini contest in which customers paid a flat rate for varying scales of toy Lamborghini cars—with the grand prize being that one customer got the real deal. Later releases included Birkenstock sandals made from repurposed Hermés Birkin bags—dubbed "Birkinstocks" with retail prices ranging from $34,000 to $76,000. By 2022, MSCHF went from parodying luxury brands to officially collaborating with them. To celebrate the 160th anniversary of Tiffany & Co., MSCHF created an edition of 100 "Ultimate Participation Trophies" made out of sterling silver and stainless steel, with equestrian themes inspired by the Woodlawn Vase, the first trophy designed by Tiffany & Co. and still given out during the Preakness Stakes. The message seemed to communicate that if wanton spending was a competition—this was the grand prize.

IN IT. IN THIS NEW ERA, ART BELONGS TO EVERYONE, AND CULTURE ITSELF BECOMES THE ULTIMATE CANVAS.

like "The Comedian"—Maurizio Cattelan's infamous duct-taped banana—or immersive installations by brands like Bottega Veneta, Nike, and LVMH.

These events are no longer just about selling art; they're about cultural moments. With collaborations like Gufram x A$AP Rocky's "Shroom" furniture or Gaetano Pesce's colorful chairs for Bottega Veneta making the journey from the runway in Milan to an artist's booth in Miami, we see how art, fashion, and design intersect to create products that are as much status symbols as they are creative works.

This evolution is not without its drawbacks: similar to how Paris Fashion Week has become overrun with dilettantes and branded parties, Art Basel Miami Beach has devolved into a seemingly never-ending sponsored party punctuated by long waits in traffic. Newer entities like MSCHF have restored a bit of that original novelty to the event, thanks to self-aware, cheeky installations like an ATM that turns checking one's balance into a literal competition—ranking bank balances for all fair attendees to see.

Founded in 2016 by Gabriel Whaley, MSCHF began as a creative collective performing cultural commentary that muddled the lines between viral internet pranks, performance art, and late capitalist consumerism. In fact, speaking of blurred lines, one of its most popular items is the "Blur" series of 3D-printed collectibles meant to resemble digitally clouded stacks of money in various currencies. It parodied the high resale value of Nike sneakers with the 2019 "Jesus Shoes," a pair of Air Max 97s injected with water from the Jordan River that was blessed by a priest, and then affixed with a crucifix on the laces.

Eventually, MSCHF began releasing its own series of bags and sneakers that both subverted and bootlegged other designs. Its sneakers ranged from distorted, lawsuit-inducing reinterpretations of Vans Old Skools dubbed the "Wavy Babys" to the "Super Normal," a very commercial sneaker that looks like a trippy version of a Nike Air Force 1. In 2022, MSCHF released a shoe called the AC1, which literally looked like a medical cast—pushing the boundaries of good taste but also continuing to comment on what exactly their fanbase was willing to buy, and how much of consumer culture was about creating products that could go viral. Perhaps the best example of this is MSCHF's "Big Red Boot," a molded shoe that took the form of cartoon boots one would more likely see on characters like Mickey Mouse or Astro Boy. Appearing on the feet of influencers and TikTok stars, the shoes were universally reviled but also undeniable. They became the truest parody of the sneaker culture that MSCHF was making fun of in the first place—simply having them was more important than wearing them, and after posting proof of ownership online, many buyers felt as hollow as the shoe itself.

From Keith Haring's Pop Shop to MSCHF's subversion of viral moments, the crossover between art, streetwear, and consumer goods reflects a fundamental shift in how we value creativity. Art is no longer confined to galleries or museums—it's worn, collected, and memed. This democratization has not only expanded the market—it has redefined who gets to participate in it. In this new era, art belongs to everyone, and culture itself becomes the ultimate canvas.

OVO x NFL Capsules Reflect the Long Shared History of Music and Sports

OVO **X** **NFL**

This collaboration's second drop was released ahead of Super Bowl LVIII, featuring co-branded gear for select teams and fueled by a star-studded campaign of football and rap icons.

A longtime and famous sports fan, Drake's known to be a basketball guy—he even serves as the global ambassador for the Toronto Raptors, curating events and designing merchandise for the team since 2013. Over the years Drake has forged close ties with athletes like LeBron James and Kevin Durant, and his OVO brand, co-founded with Oliver El-Khatib and Noah "40" Shebib, has partnered with teams like Toronto FC and, more recently, the NFL. The partnership, which first launched in 2024, was built on OVO's ties to music, sports, and streetwear culture, as well as the NFL's growing interest in tapping into the cult followings of music celebrities. (Just wait 'til they drop a collab with Taylor Swift.)

OVO's newest NFL capsule dropped just before the 2025 Super Bowl. The line targeted specific demographics with a range of co-branded sportswear essentials, such as Sideline jackets, graphic tees, and team-specific gear for the Buffalo Bills, Chicago Bears, Las Vegas Raiders, and more.

The collection's varsity-inspired aesthetic prominently features both the OVO owl insignia and the logos of select NFL teams, with pieces (including New Era fitteds) tailored to each team's specific colors. For example, the Chicago Bears apparel comes in their signature orange, while items for the San Francisco 49ers feature the team colors of red and gold.

The items, including heavyweight turtlenecks, fleece jackets, and hats, cater to both style and function, with athletes like former NFL receiver Brandon Marshall and former legendary quarterback Joe Montana modeling them in the campaign. While the NFL brought players into the campaign, Drake's involvement meant promoting the lines through his massive social media presence, with additional features from celebrities like Lil Wayne and Benny the Butcher. The buzz surrounding the collection—a success built off the longstanding relationship between rap culture and sports—is expected to extend beyond this collection with future releases.

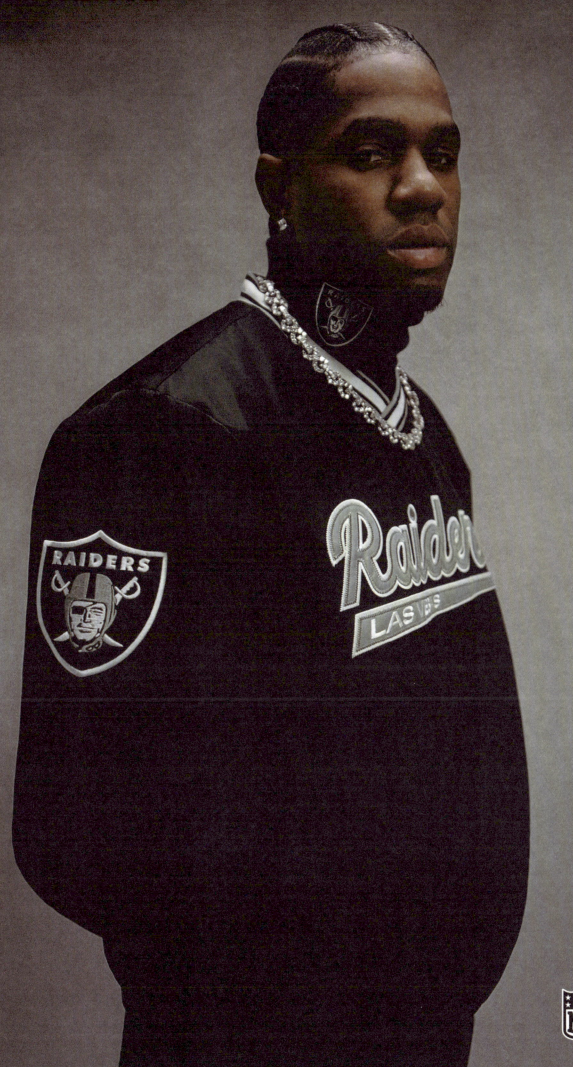

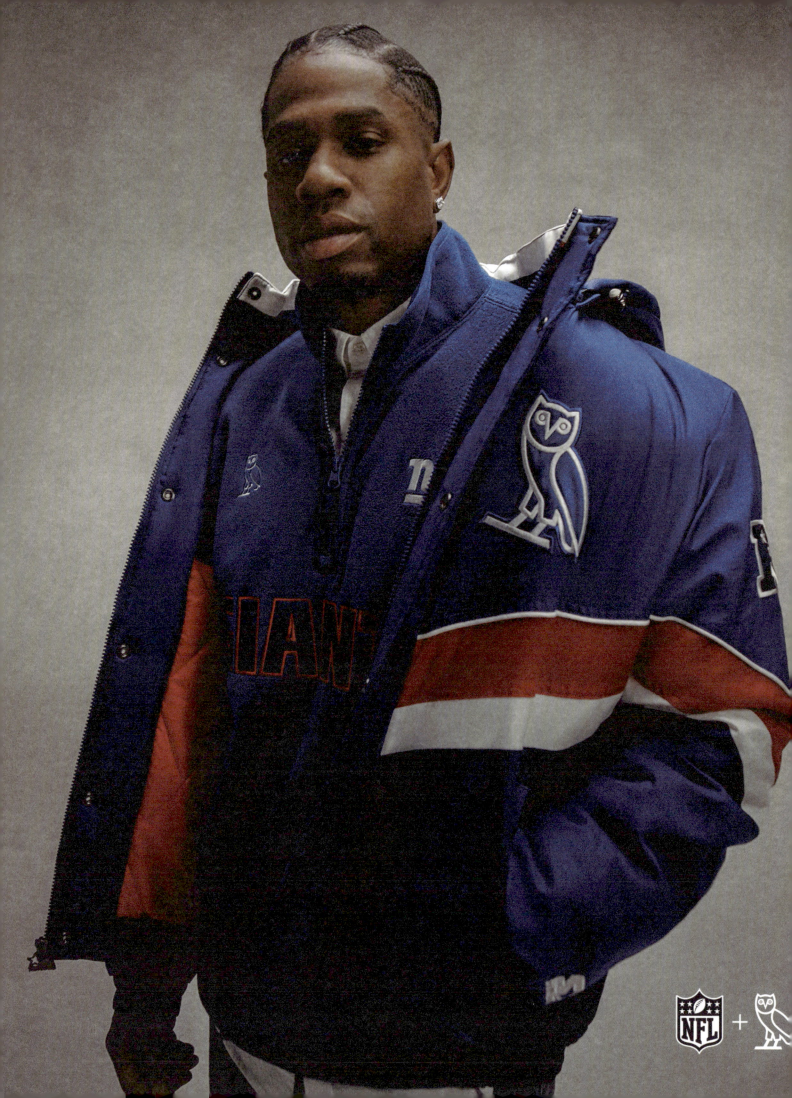

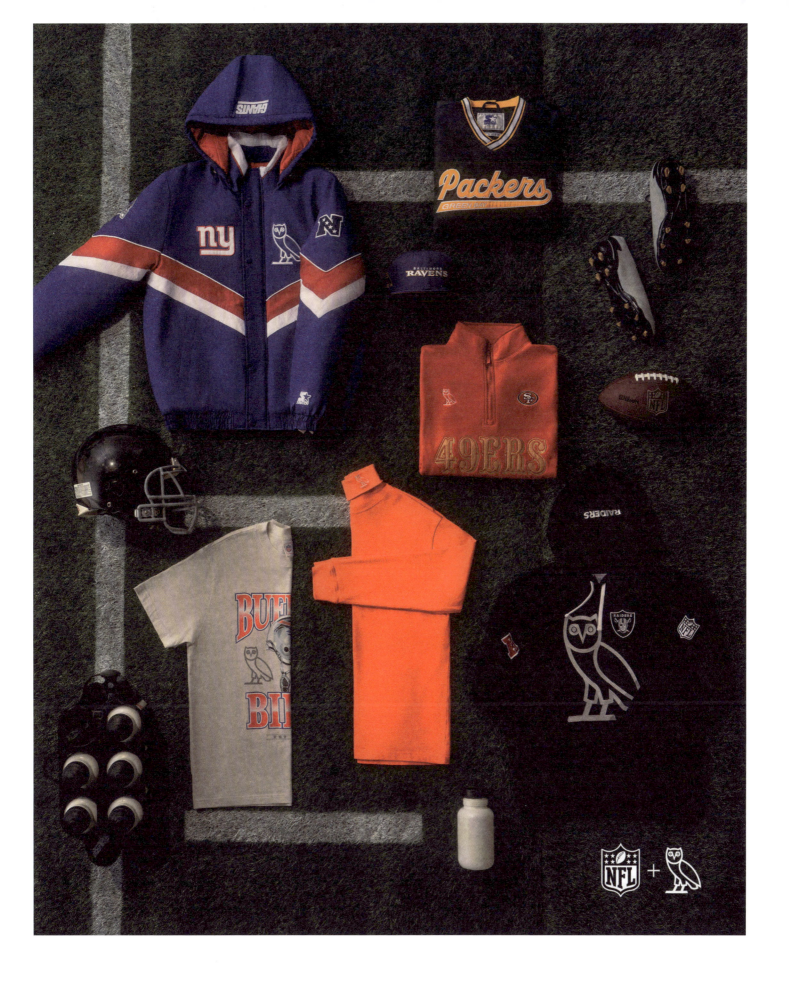

A Powerful Conversation on Black Culture and Identity

DENIM TEARS X **LEVI'S**

The third installment of the Denim Tears x Levi's partnership weaves personal histories, Afrofuturist biker iconography, and cultural references to explore race, legacy, and subculture.

Denim Tears and Levi's might seem like a natural pairing—two brands that have long defined American workwear—but the collaboration between these fashion staples runs much deeper, offering a nuanced commentary on culture, history, and identity. Debuting in 2021, the collection came to life through the vision of Denim Tears' founder Tremaine Emory, whose past roles include creative director at Supreme and consultant for Nike and adidas—and who has used the Levi's partnership as a narrative device—exploring the intersections of fashion, race, and the legacies of systemic inequality.

The collaboration has centered around reimagining Levi's most iconic pieces—the 501 jeans and trucker jackets—through Emory's striking graphics and deeply personal storytelling. Earlier collaborations mined the dark history of slavery in America, with a Kara Walker-inspired transformation of Black histories resurfaced through contemporary design. That collection featured denim pieces adorned with cotton plant motifs, an unmistakable reference to the brutal history of slavery in the United States and to the ways in which American capitalism is built on the backs of marginalized communities.

This third collaboration, released in 2023, felt like a culmination of Emory's growing influence and vision. It was an ode to the Black biker community and the subcultures that they've inspired. The 501 Western Stitch Denim Shirt and Black Riders Rucksack were emblazoned with iconography that hat-tips to the secret symbolism and folk art of the biker community through an Afrofuturist lens. With references to cowboy culture, rodeo style, and Indigenous clothing, he envisioned these pieces as something an outlaw or drifter might wear, complete with the stories they carried. With embroidery adding a layer of meaning that turned each garment into a statement or cultural artifact, the line balanced the weight of historical significance and a modern, wearable sensibility. By continuing to work with Levi's, Emory further solidified fashion's power as a tool for social dialogue, making the collection not just about aesthetics, but about creating space for necessary conversations around race, influence, and legacy.

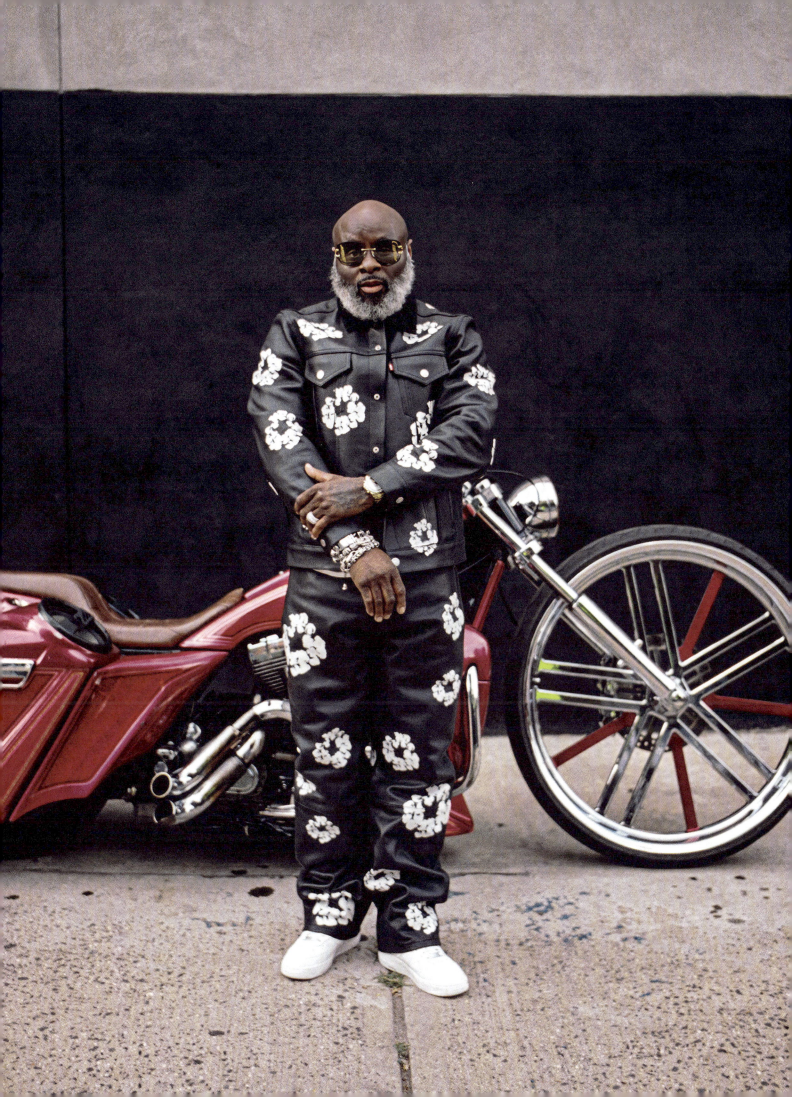

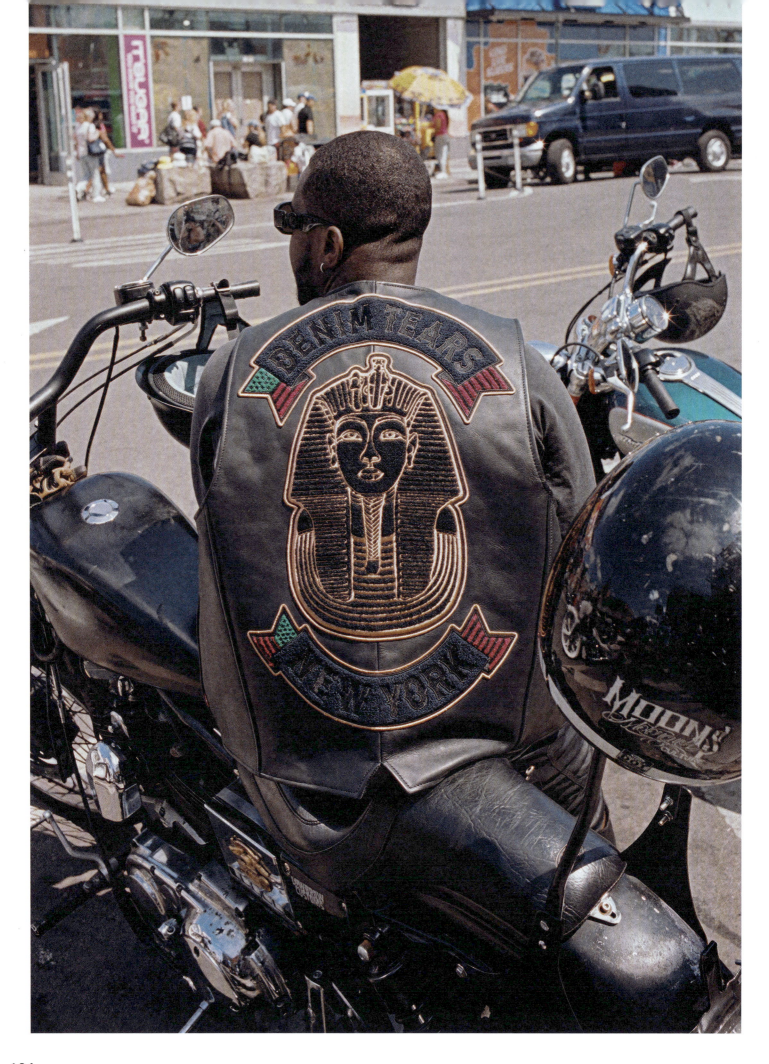

IT WAS AN ODE TO THE BLACK BIKER COMMUNITY AND THE SUBCULTURES THAT THEY'VE INSPIRED.

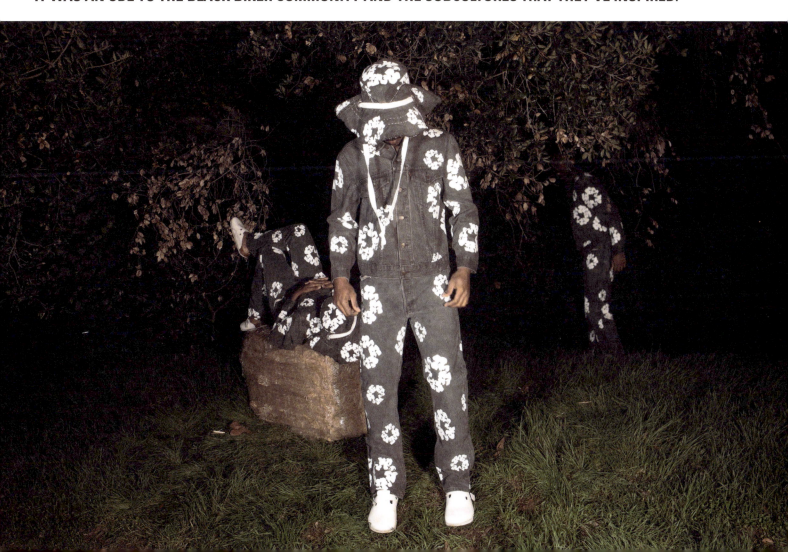

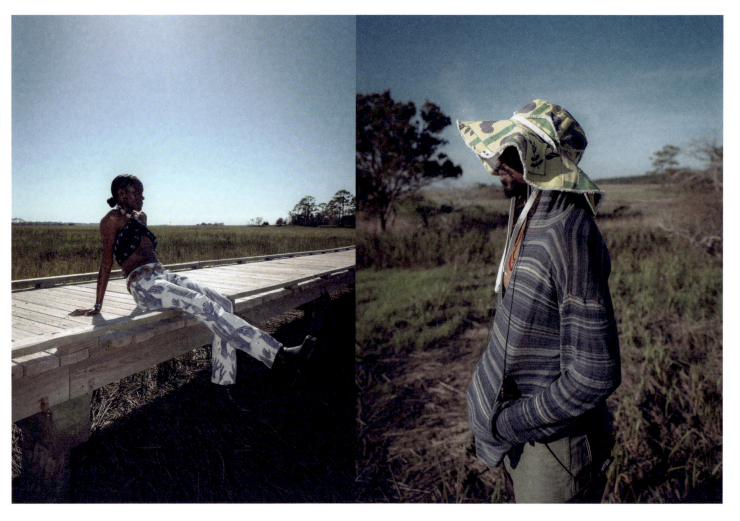

THE LINE BALANCED THE WEIGHT OF HISTORICAL SIGNIFICANCE AND A MODERN, WEARABLE SENSIBILITY.

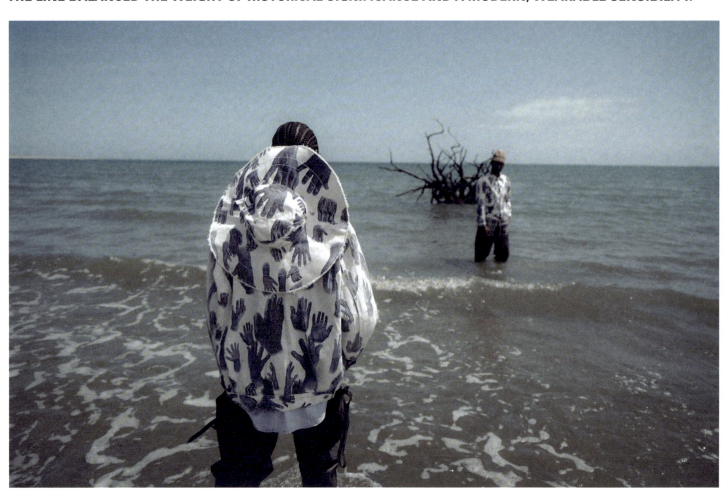

166　　　　　　　　　　　DENIM TEARS X LEVI'S

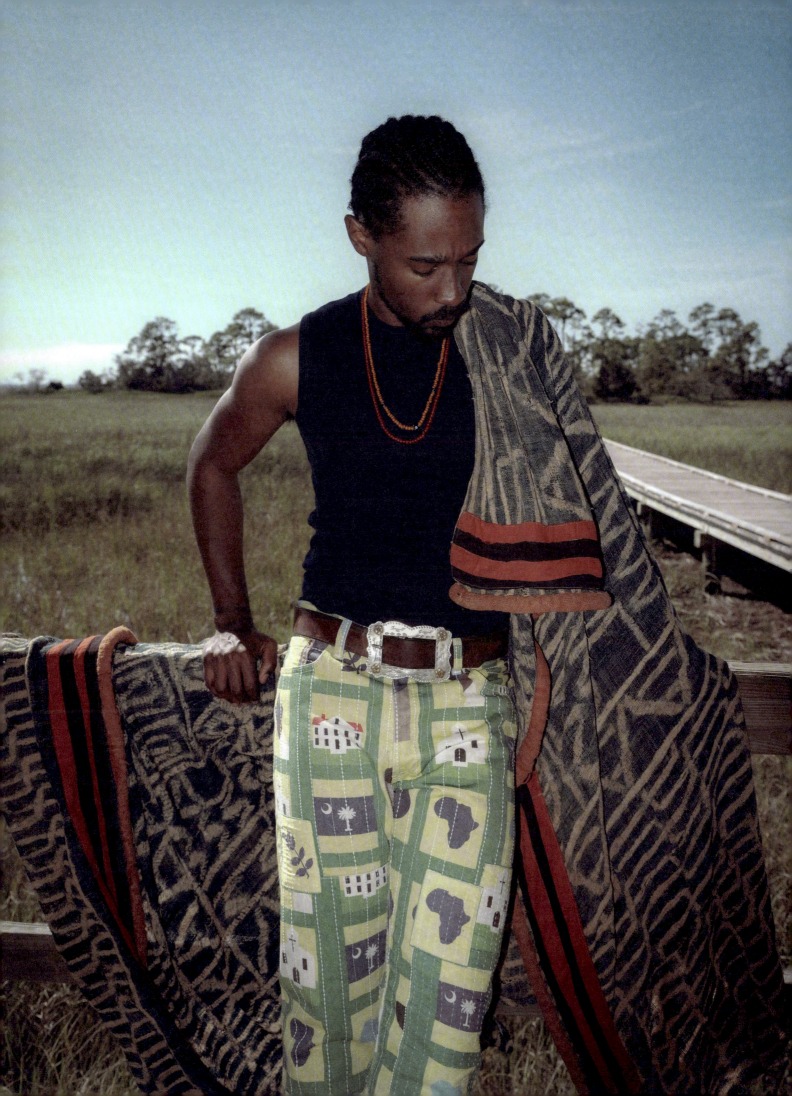

A Nostalgic Streetwear Collection Celebrating the Art of Film Photography

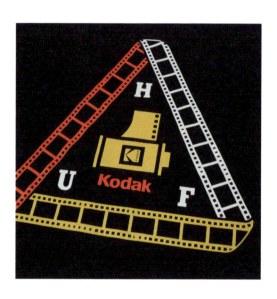

HUF X **KODAK**

Merging retro-inspired designs with modern streetwear, the collaboration offers graphic tees, accessories, and a custom Kodak camera. The result is the ultimate tribute to the resurgence of analog photography.

Nostalgia is woven into the fabric of photography itself, and Kodak, with its rich legacy, has long evoked the sentiment of an analog world where moments were fleeting and memories harder to preserve. In recent years, that nostalgia has been brought to life through various campaigns and collaborations—often developed by Kodak's network of licensees—that celebrate the brand's iconic film heritage. These include retro-styled cameras that combine vintage aesthetics with modern technology and heartfelt initiatives to commemorate the past, all of which reinforce the enduring appeal of analog photography in the digital age. Through their work with artists and influencers, these collaborators have introduced classic Kodak imagery to a new generation, often through digitally staged shoots that contrast today's visual culture with analog sensibilities.

The HUF x Kodak collaboration fits seamlessly into this movement, tapping into the resurgence of '90s style and the youth's growing fascination with film photography's tactile charm. HUF's minimalist, edgy pieces are particularly well suited to partnerships, acting as a blank canvas for a long list of artists and skate culture-focused brands who have put their own unique spin on HUF's oversized tees, hoodies, and caps. One standout piece from the Kodak x HUF collaboration is the Imagine What tee, which features a collage of grainy film images framed by Kodak's iconic 400 ISO branding. Another highlight is the Rear View tee, which combines a minimalist front with oversized Kodak graphics on the back, nodding to the bold typography that defined Kodak's past. The Dark Room Jacquard knit sweater incorporates Kodak symbols and the HUF wordmark into a repeating all-over intarsia, reminiscent of the precision and texture of a photographic darkroom.

Beyond apparel, the collection includes accessories like the Collage Side Bag, covered in vibrant, high-saturation film photos, and a Cruiser Deck that mirrors this design. A unique addition to the collection is the Kodak Ektar H35N, a pocket-sized half-frame camera that captures twice as many photos as a standard film camera. This camera features a glossy, HUF-green panel and branded accessories, bridging the world of fashion and functional photography.

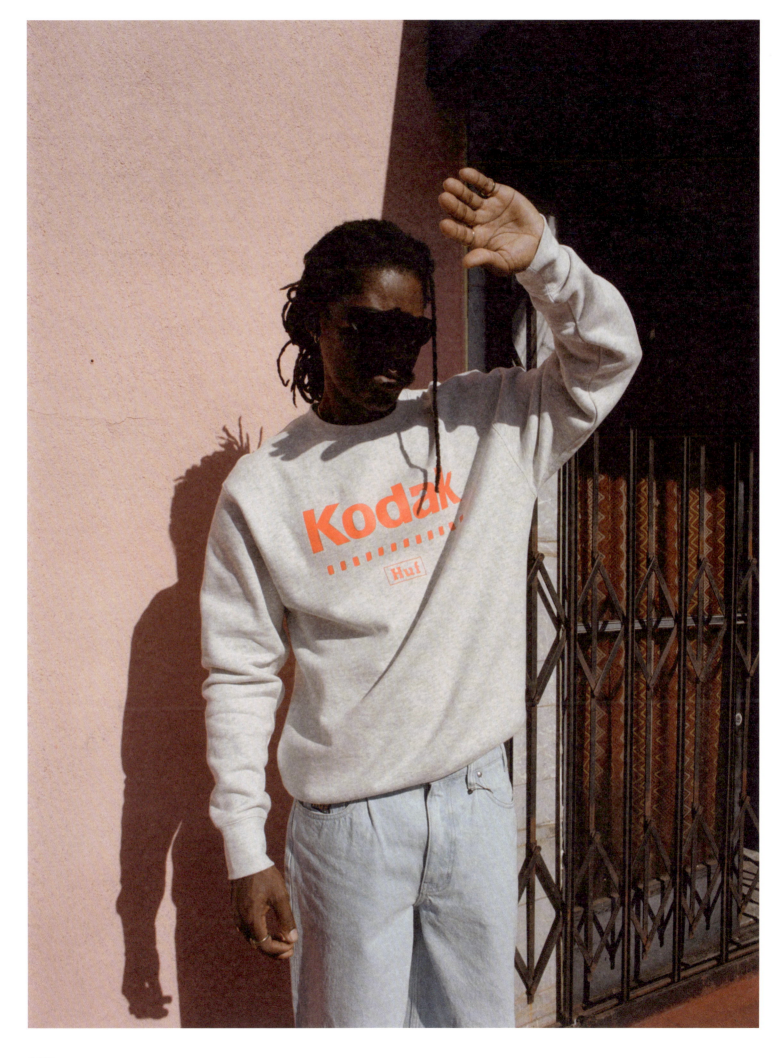

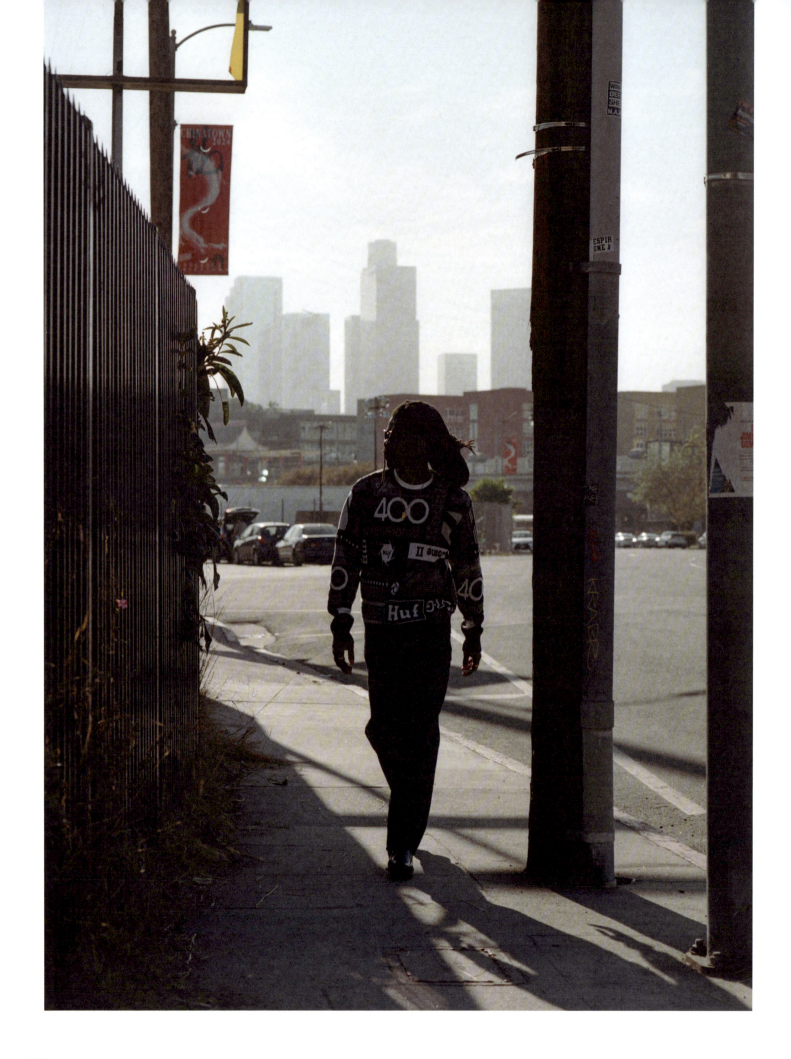

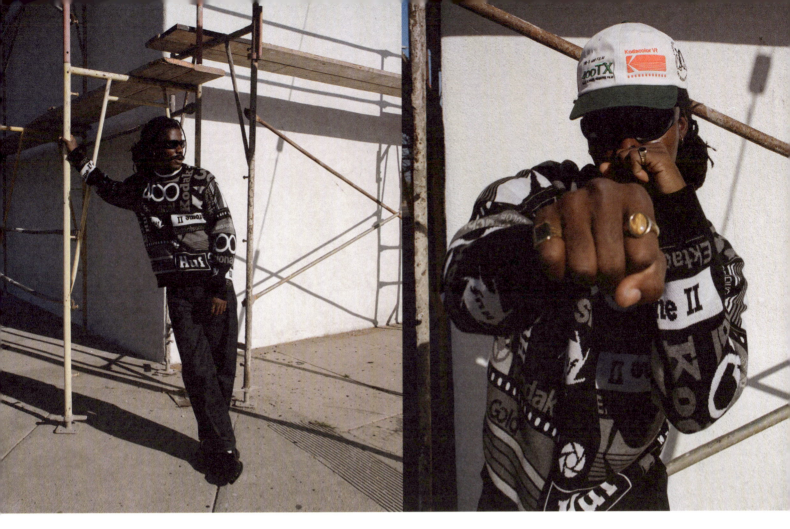

COLLABORATIONS WHICH REINFORCE THE ENDURING APPEAL OF ANALOG PHOTOGRAPHY IN THE DIGITAL AGE.

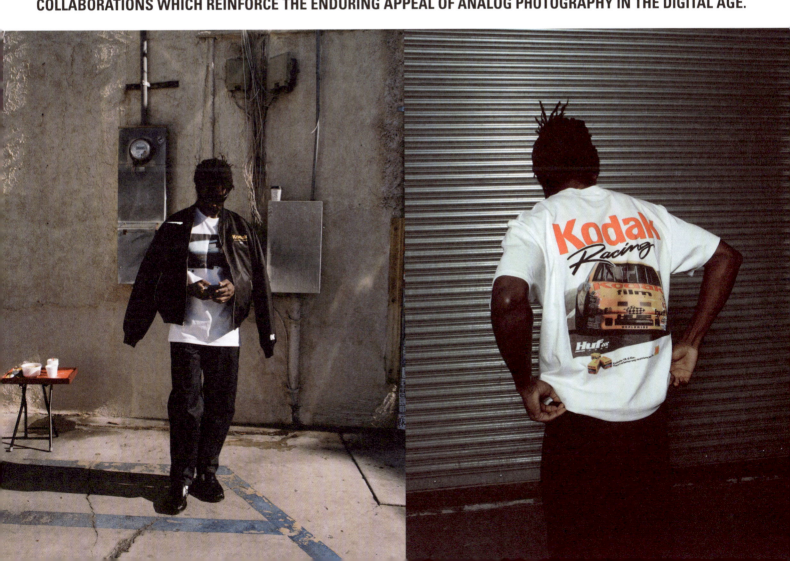

Redefining Streetwear Through Contemporary Luxury

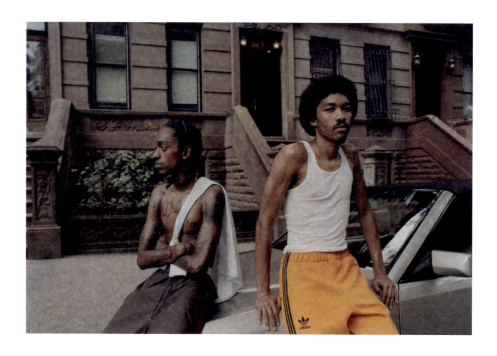

ADIDAS ORIGINALS X **WALES BONNER**

This collaboration, designed by Grace Wales Bonner, blends athletic heritage with intellectual sophistication, remixing street style through African diasporic influences, sharp tailoring, and luxury sneakers.

The adidas Originals x Wales Bonner collaboration is a masterclass in blending athletic legacy with intellectual sophistication. Grace Wales Bonner, whose work often explores Afro-Atlantic identity and diasporic culture, redefines streetwear with her most recent collaboration with the athletics brand—not by simply adding elegant touches, but by elevating the very conversation around what street style can mean. Her insight goes deeper than the average high-fashion sportswear moment, with designs that map out complex cultural narratives through casual wear.

Here, Wales Bonner's eye is both vibrant and considered, using the rich culture of hip-hop's origins and remixing it into something new. Floral-printed vests, reworked tracksuits, and sharply tailored outerwear speak to the designer's nuanced approach to globalized culture. Her designs are at once regional and international, nostalgic and contemporary. The prints themselves subtly reference textiles and patterns from the African diaspora, adding depth and historical nuance, both hallmarks of Bonner's vision.

Sweats and hoodies—objects once synonymous with the rebelliousness of urban youth—are given new life with sharp tailoring and refined details that suggest the Savile Row sensibility that Wales Bonner is known for. But footwear is where she really flexes: the adidas Originals Superstar, now rendered in luxurious, crocodile-embossed leather, is a far cry from the sneaker's classic, white leather origins. The Samba– originally designed for indoor soccer in 1949–also gets a serious makeover, with one particularly popular version that uses a plush pony-hair upper, dyed to look like leopard print. The casual versatility of the line has been praised by fashion bibles *Vogue* and *GQ,* with the *Guardian* describing the collaboration as evolving the idea of "luxury streetwear."

Shot by Renell Medrano in Harlem—with skaters as models—the campaign's imagery feels like a love letter to the neighborhood, with its mix of street smarts, style, and cultural swagger. The juxtaposition of skate culture with hip-hop's influence underscores the ongoing evolution of urban fashion. And for the designer, who has been expanding the boundaries of contemporary menswear, this collection solidifies her place as one of fashion's most visionary voices. (It was hardly a coincidence that she won Menswear Designer of the Year at the Fashion Awards in Britain the same year Originals x Wales Bonner hit the shelves.) This is more than just a collab; it's a cultural statement, a nuanced exploration of identity and design that will resonate for seasons to come.

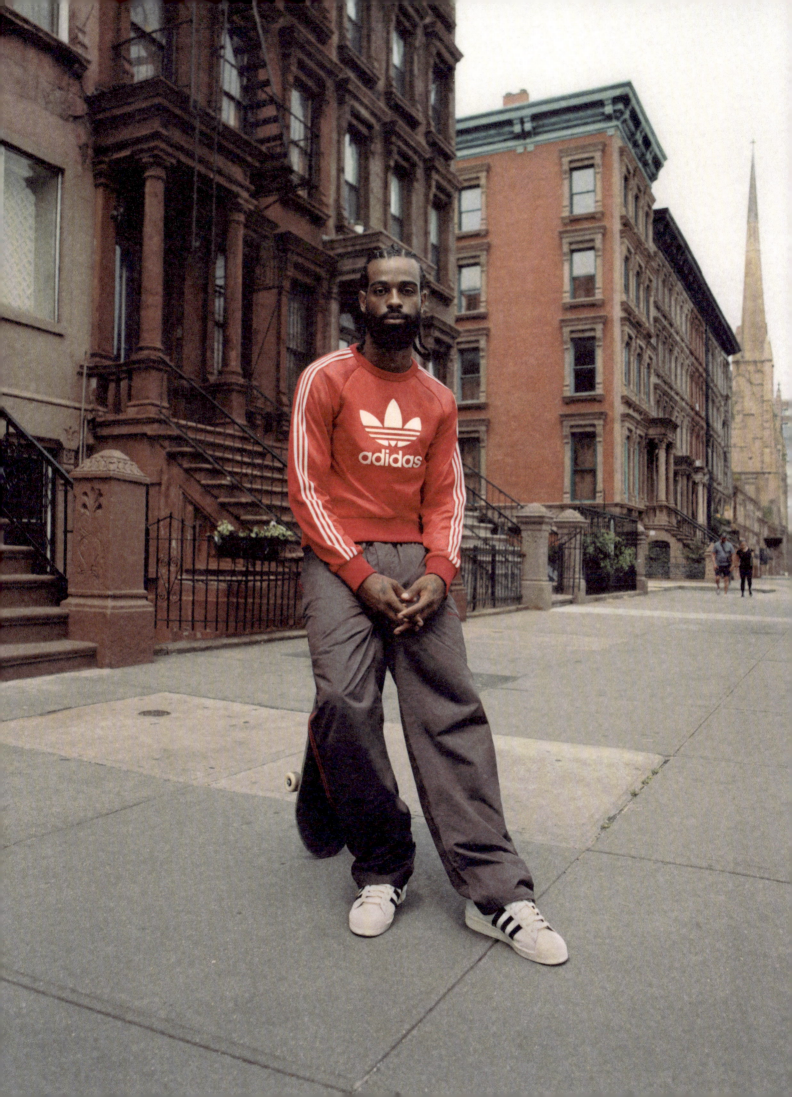

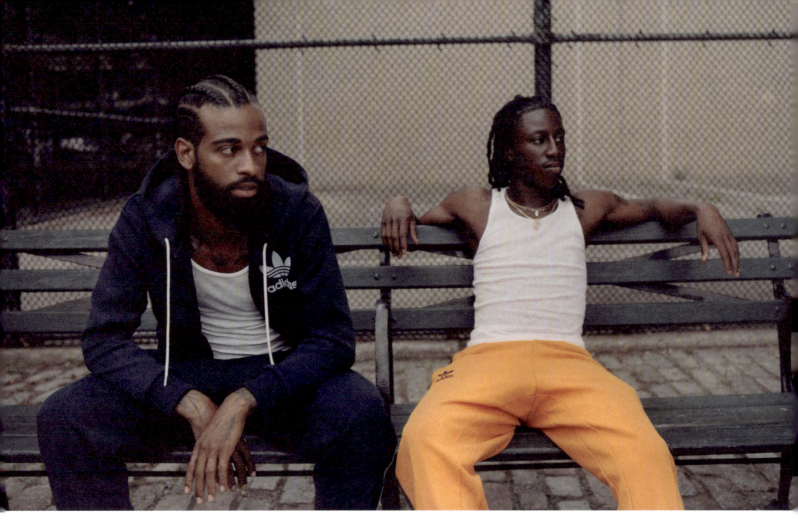

GRACE WALES BONNER, WHOSE WORK OFTEN EXPLORES AFRO-ATLANTIC IDENTITY AND DIASPORIC CULTURE,

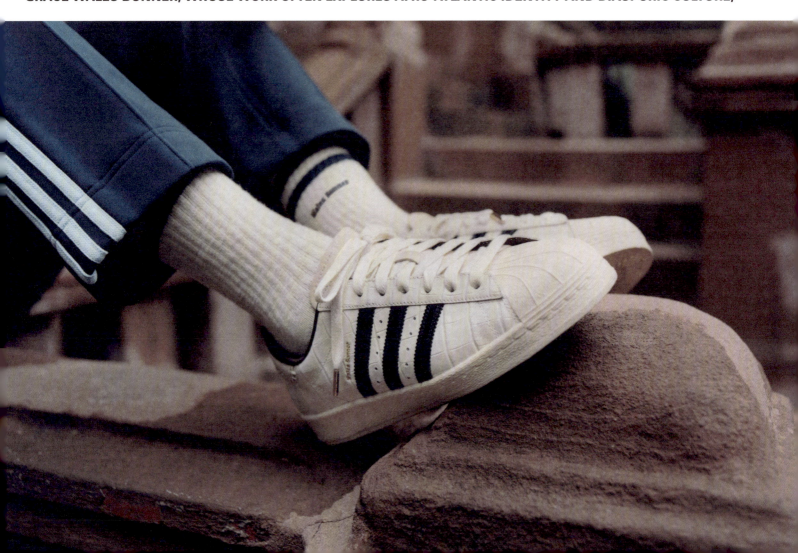

REDEFINES STREETWEAR WITH HER MOST RECENT COLLABORATION WITH THE ATHLETICS BRAND.

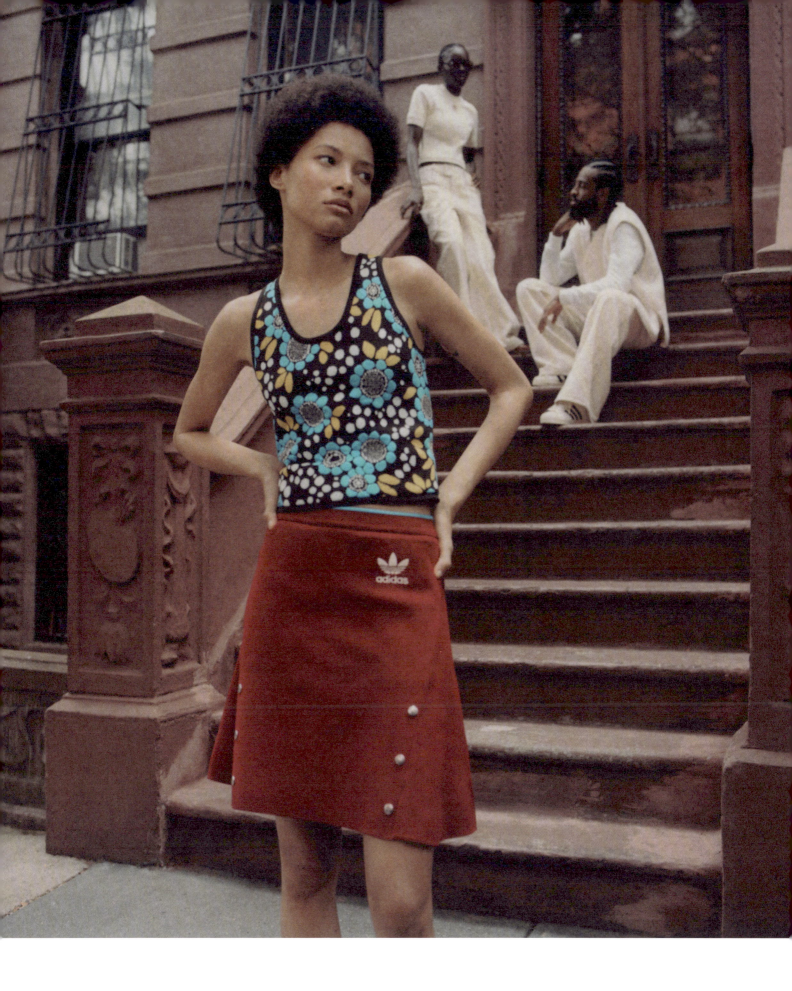

177 ADIDAS ORIGINALS X WALES BONNER

GRACE WALES BONNER'S DESIGNS ARE AT ONCE REGIONAL AND INTERNATIONAL, NOSTALGIC AND CONTEMPORARY.

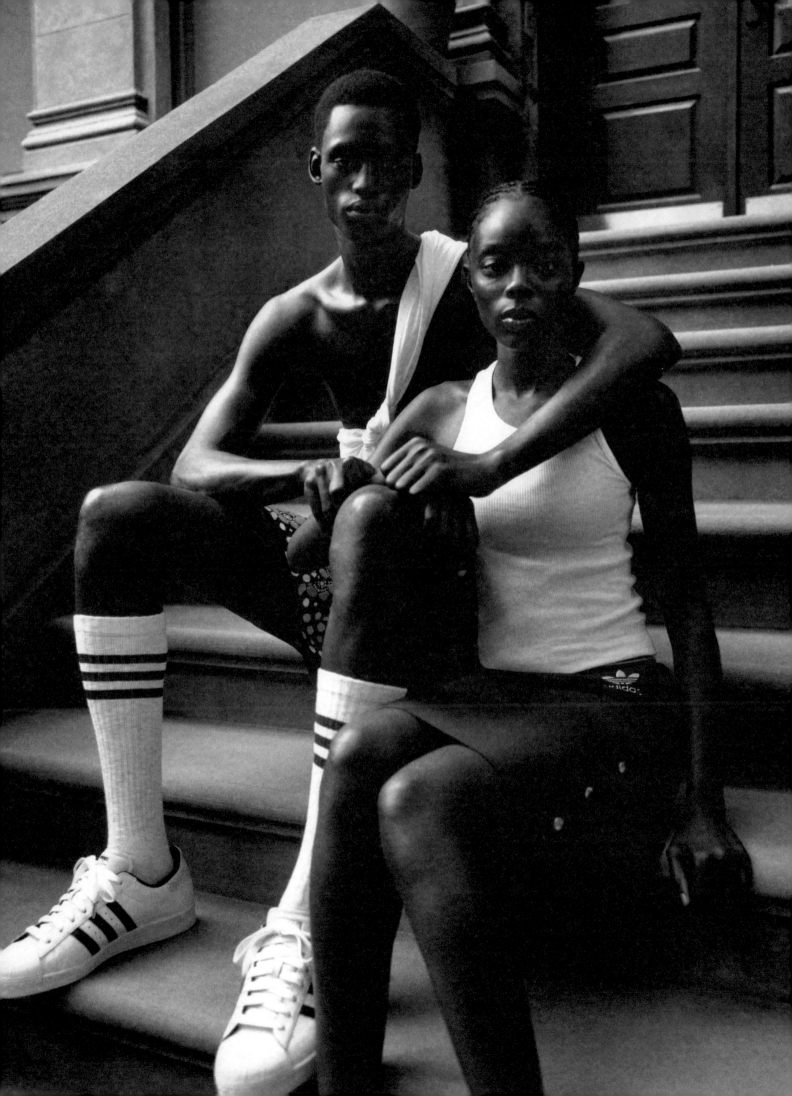

A Surf-Side Elevation of the Iconic Slide Shoe

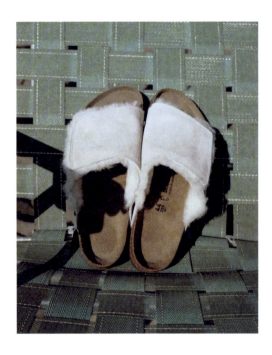

STÜSSY X **BIRKENSTOCK**

From a laid-back poolside essential to a streetwear icon, the Stüssy x Birkenstock partnership blends comfort with cutting-edge style. Their 2020 collaboration reimagined the classic Boston clog, while their latest release, the Solana sandal, brings cozy vibes to the forefront of modern street culture.

The slide shoe has become a streetwear must-have, effortlessly blending comfort with style and giving off a cool, confident vibe. What was once relegated to poolside lounging is now an everyday essential, thanks to heavy hitters like adidas, Nike, and Birkenstock. One of the most iconic examples? Birkenstock's Arizona slide, which has seen a major resurgence in recent years—often paired with everything from athleisure to high-end streetwear. These slides, with their simple yet bold designs and signature footbed, are all about that laid-back luxury. And it's no surprise that Stüssy, the streetwear giant known for its effortless fashion, wanted in on the action. When they teamed up with Birkenstock, it was a natural fit—combining Stüssy's surf-inspired aesthetic with Birkenstock's casual design. The result? A perfect mix of relaxation and edge that turned the slide from humble summer accessory to streetwear icon.

Stüssy's partnership with Birkenstock began in 2020, with their first collection focused on the iconic Boston clog, which was reimagined in three distinct colorways—Bone, Caramel, and Dusty Pink. The shoes featured premium suede uppers, providing a luxurious yet casual feel. Stüssy's signature logo was embossed on the footbed, subtly nodding to its streetwear roots while maintaining Birkenstock's classic design elements. The collaboration was a hit, combining high-end craftsmanship with street-savvy style, making it an instant favorite among sneakerheads and trendsetters. The shoes sold out quickly, becoming a coveted item on the resale market and cementing the partnership as a huge success.

Their third collaboration, which dropped in November 2023, introduced the Solana sandal—an upgrade to Birkenstock's signature one-strap Kyoto style. This iteration was designed for both indoor and outdoor use, with a cozy shearling lining for winter warmth. The shoe featured the shoemaker's classic cork footbed for ultimate comfort, but Stüssy's influence is evident in the clean, minimal lines of the oversized suede upper, and in the brand's signature logo, debossed into the outer strap. The colorways—Bone, Caramel, and Washed Green—exude a calm, earthy aesthetic, perfect for the laid-back yet trend-forward aesthetics of modern street culture.

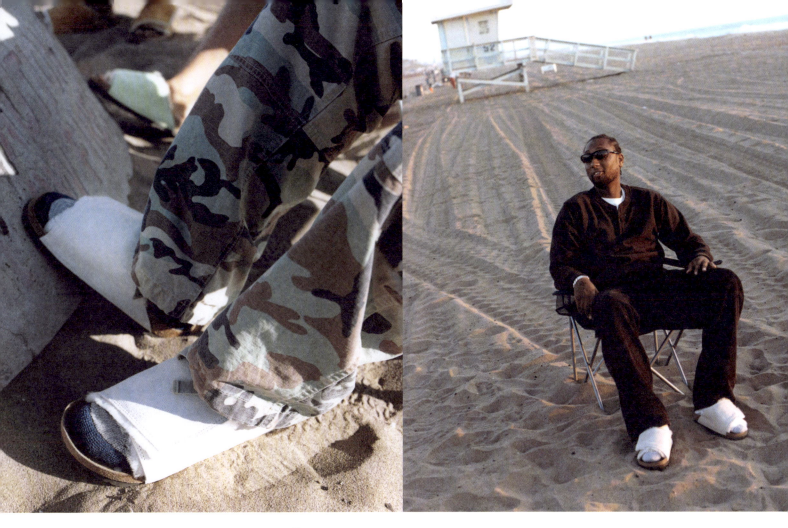

IT WAS A NATURAL FIT—COMBINING STÜSSY'S SURF-INSPIRED AESTHETIC WITH BIRKENSTOCK'S CASUAL DESIGN.

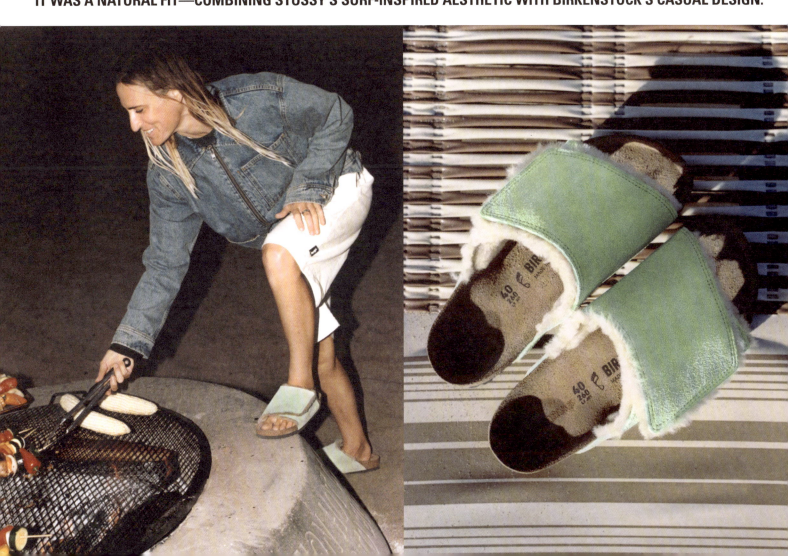

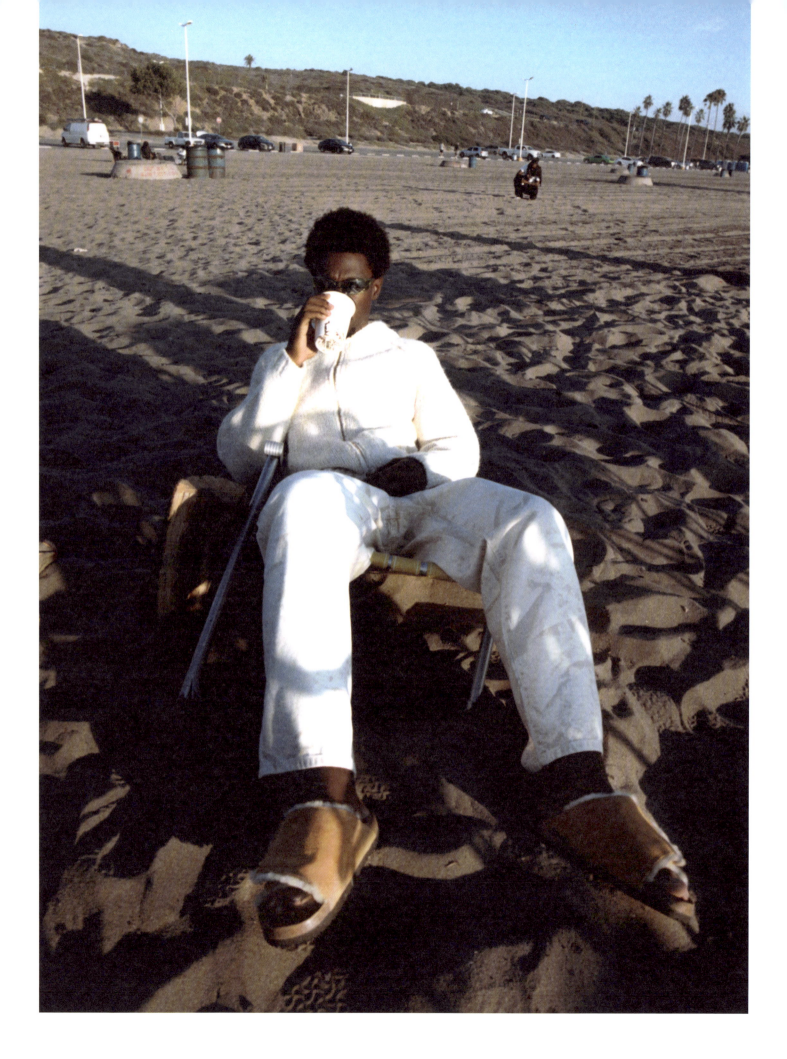

A PERFECT MIX THAT TURNED THE SLIDE FROM HUMBLE SUMMER ACCESSORY TO STREETWEAR ICON.

Where Performance Meets NYC Street Style

SANDY LIANG X **SALOMON**

Sandy Liang brings her signature urban sensibility to Salomon's performance-driven gear, merging bold, tech-forward designs with oversized, cozy silhouettes.

Even on gray winter days, slogging through the city on the subway and through the slush, everyone deserves a little brightness. For Liang, known for her feminine, utilitarian style, the partnership with Salomon offered a way to reinterpret outdoor gear for urban environments. Salomon, a brand synonymous with technical innovation and performance, wanted to expand its appeal beyond athletes and adventurers by tapping into street culture. Their collaboration allowed both brands to push boundaries, creating a product that merged fashion and function for a new kind of luxury.

 The result was a collection that married Salomon's innovative approach to athletic wear with Liang's signature cozy, oversized, and distinctly New York-inspired style. Highlights of the collection included a reworked version of Salomon's iconic XT-6 sneaker, featuring bold color-blocking and a sleek, modern silhouette, alongside other outdoor staples like puffer jackets and utility vests. The designs were infused with elements that were undeniably urban—playful yet practical, with a nod to both retro and contemporary outdoor aesthetics.

 The response to the collaboration was overwhelmingly positive, with sneakerheads and fashion insiders praising the collection for its unique blend of high performance and elevated style. The updated XT-6 sneaker, in particular, became an instant hit, thanks to its rugged, tech-forward design. By combining Salomon's precise engineering with Sandy Liang's fashion-forward, wear-anywhere approach, the collection as a whole felt as much at home in the rugged outdoors as it did on the bustling streets of New York, breaking down the barriers between luxury, sport, and practicality.

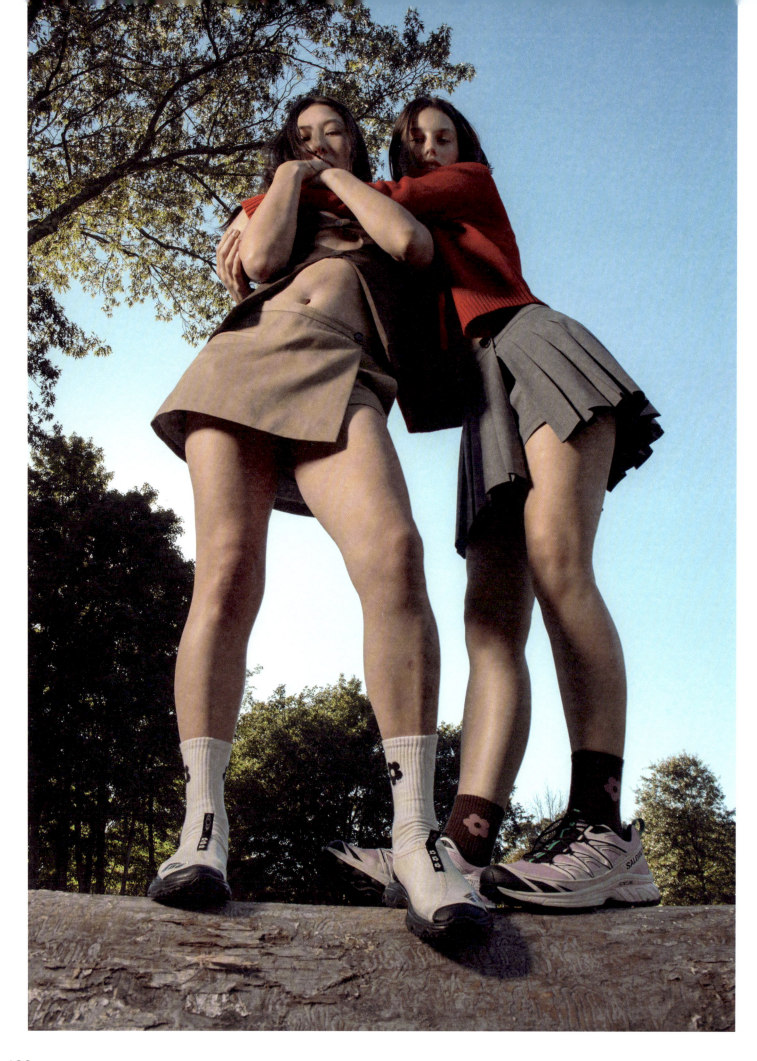

SANDY LIANG X SALOMON

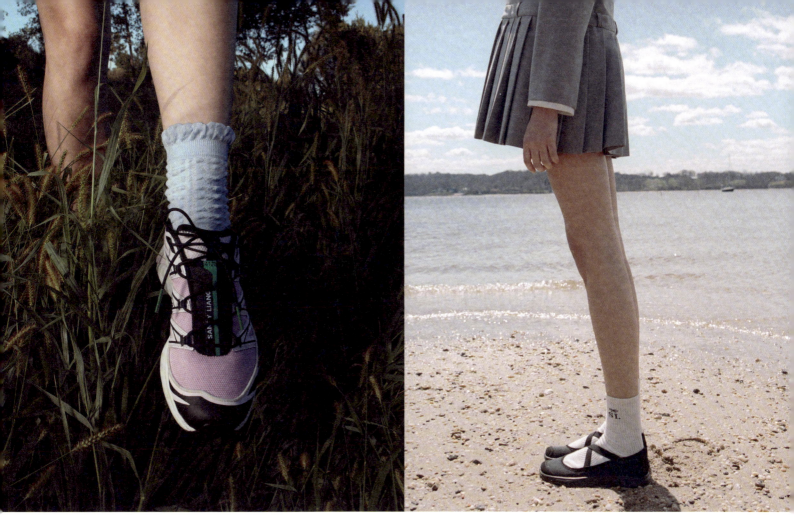

A COLLECTION WITH SANDY LIANG'S SIGNATURE COZY, OVERSIZED, AND DISTINCTLY NEW YORK-INSPIRED STYLE.

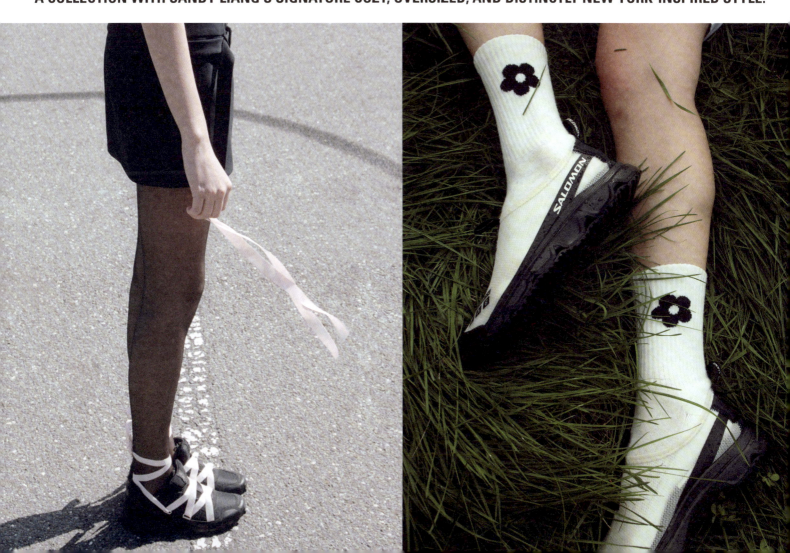

Two French-Born Brands Create a Trail-Running Masterpiece

HOKA X **SATISFY**

Two brands merge performance and style with a refined update to HOKA's iconic trail shoe, offering new aesthetics and cutting-edge functionality for trail runners and fashion-forward adventurers alike.

When HOKA and SATISFY teamed up, it was a major moment for fans of both brands, who are all about blending performance with lifestyle. Their collaboration kicked off in 2023, driven by a shared passion for trail running. SATISFY, the Paris-based brand known for its premium, high-performance gear, brings a refined, fashion-forward approach to the outdoor space, focusing on both style and technical excellence. HOKA, on the other hand, has built a reputation for innovative footwear that prioritizes comfort, cushioning, and durability, often pushing the boundaries of what's possible in performance footwear. Together, the two brands created something special—the Mafate Speed 4 Lite STSFY. This shoe takes HOKA's iconic Mafate Speed series to the next level, combining cutting-edge style with top-tier performance.

The Mafate Speed 4 Lite STSFY is a technical masterpiece designed with the rugged outdoors in mind. The shoe, whose design was inspired by topographic maps, boasts a transparent, lightweight upper crafted from soft microfiber, ripstop nylon, and engineered mesh, providing both durability and breathability for trail runners. A two-part ProFly™ midsole delivers responsive cushioning and stability, essential for tackling tough terrain. The collaboration brings a new, elevated aesthetic to the trail running world, with colorways like Sulfur and Rubber, all designed to appeal to both function-driven runners and fashion-conscious adventurers.

The shoes' design reflects SATISFY's vision of blending refined aesthetics with HOKA's trail performance credentials. With understated, earth-tone colorways like Coffee and Bone, the shoes maintain their high-performance capabilities while offering a more subtle, minimalist look. This marriage of ruggedness and refinement resonates with a broad audience—from elite athletes to fashion-forward runners. The marketing campaign, titled "Highs & Lows," showcased the dynamic spirit of the collaboration, with point-of-view shots and drone footage from the French Alps, capturing the shoe's performance in the raw, extreme conditions of the mountains. This captivating visual storytelling reinforces the technical prowess of the Mafate Speed 4 Lite STSFY while highlighting the collaboration's blend of high-end fashion and trail-running precision.

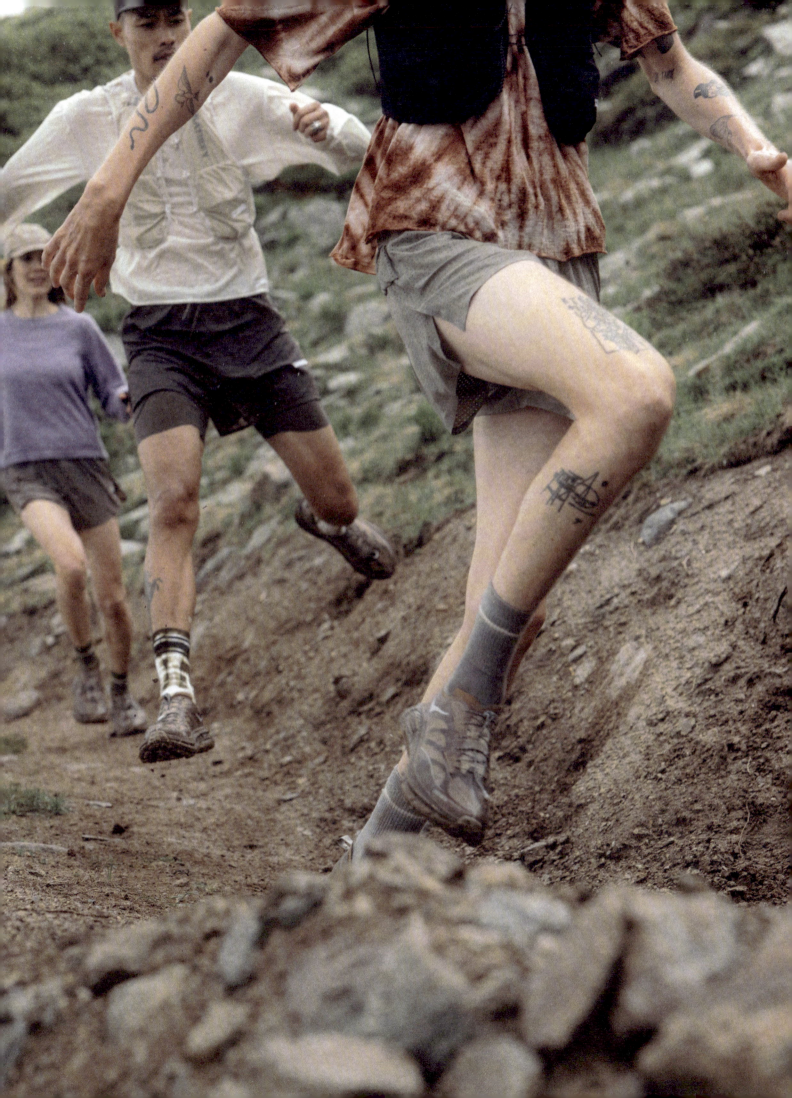

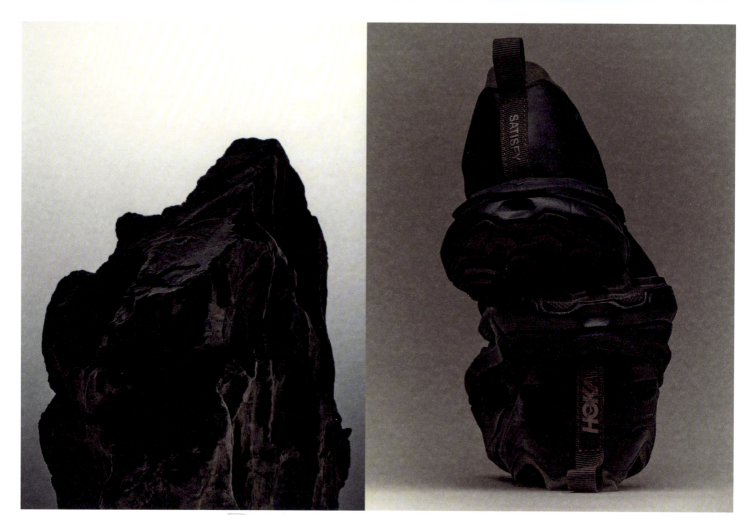

A MAJOR MOMENT FOR FANS OF BOTH BRANDS, WHO ARE ALL ABOUT BLENDING PERFORMANCE WITH LIFESTYLE.

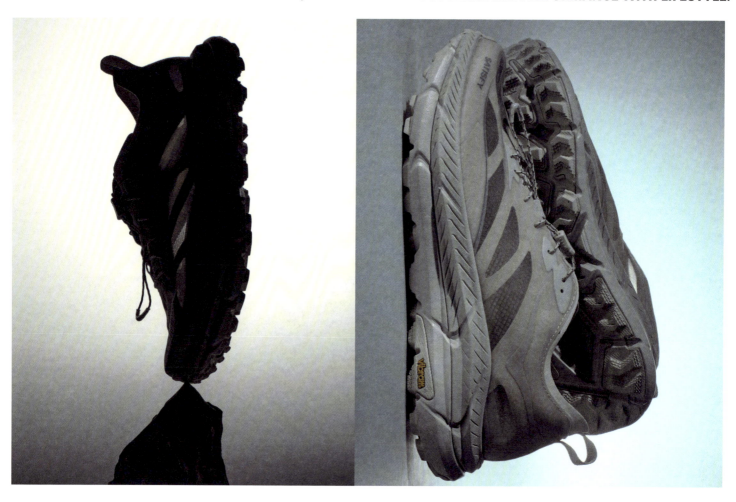

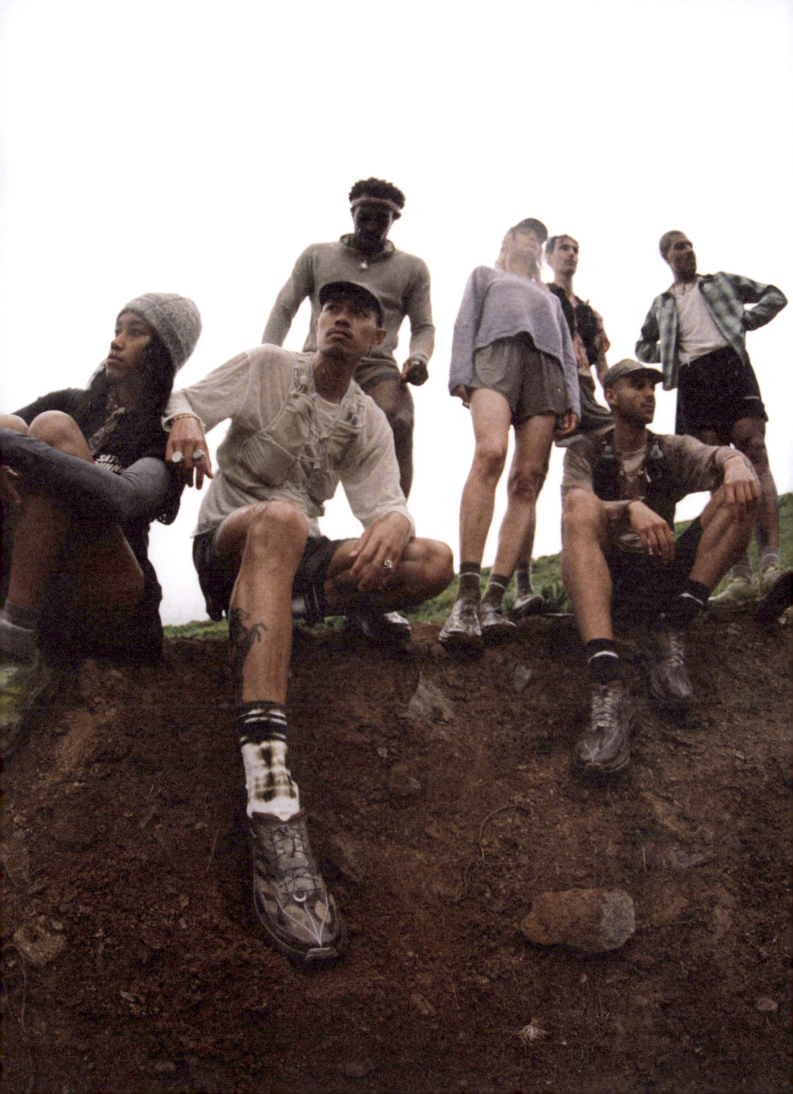

Two California Greats Build a Collection of Outdoors Must-Haves

STÜSSY **X** **MOUNTAIN HARDWEAR**

Building on their successful debut, Stüssy and Mountain Hardwear's 2024 collection brings together high-performance expedition gear and stylish streetwear, designed for outdoor enthusiasts who want both functionality and style on the slopes.

Stüssy and Mountain Hardwear first teamed up in 2023, blending Stüssy's laid-back California vibe with Mountain Hardwear's wild, rugged outdoor California expertise. That first collaboration focused on injecting West Coast streetwear style into Mountain Hardwear's technical outdoor gear. Intent on combining durability with streetwear flair, the pieces featured vibrant colors with down vests, fleece clothing, t-shirts, and hats in bright orange, yellow, and blue. A one-off sleeping bag collaboration featured a yellow and black insulated sac branded with both Stüssy and Mountain Hardware's logos.

Building on the previous year's success, the 2024 collection focused on expedition-quality gear designed for both functionality and style. It includes GORE-TEX bibs, waterproof shells, and insulated jackets, offering essential protection from the elements. The multi-pocket outerwear and weather-resistant trousers are designed for durability, while carefully curated accessories like CORDURA backpacks, beanies, and caps continue to underscore the collection's commitment to practicality and preparedness. The 2024 capsule introduced a more subdued color palette, with dark greens, sky blues, and muted tones, creating a calmer, more versatile wardrobe for true outdoorsy types. However, bold citrus accents—like orange long-sleeve T-shirts and beanies—still make an appearance for those wanting to stand out or improve visibility in snowy environments.

The design elements of the ski wear, in particular, showcased the collab's ethos of functionality meets style: the khaki green-and-black-paneled snow pants were equipped with multiple pockets, a waterproof composition, and adorned with the collaborative logo on the leg. Other pieces in the collection included long-sleeve T-shirts, insulated puffer jackets, beanies, and a stitched ski/carpenter jacket, all designed to perform on the slopes while maintaining a streetwear aesthetic.

STÜSSY X MOUNTAIN HARDWEAR

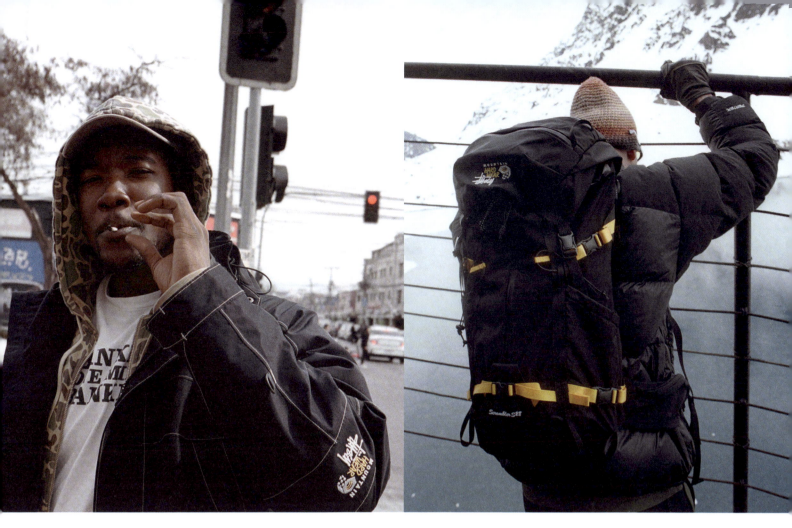

THE COLLECTION FOCUSED ON EXPEDITION-QUALITY GEAR DESIGNED FOR BOTH FUNCTIONALITY AND STYLE.

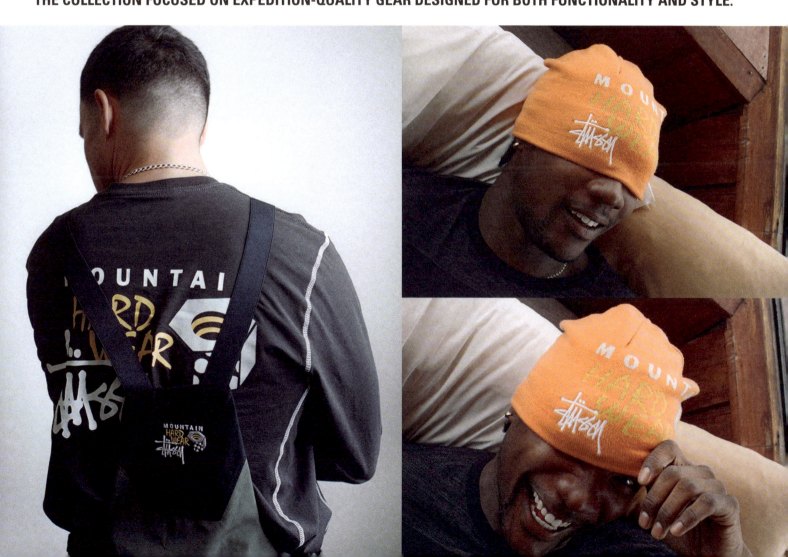

The High-Fashion Pool Clog Returns in a Bold New Collaboration

BALENCIAGA

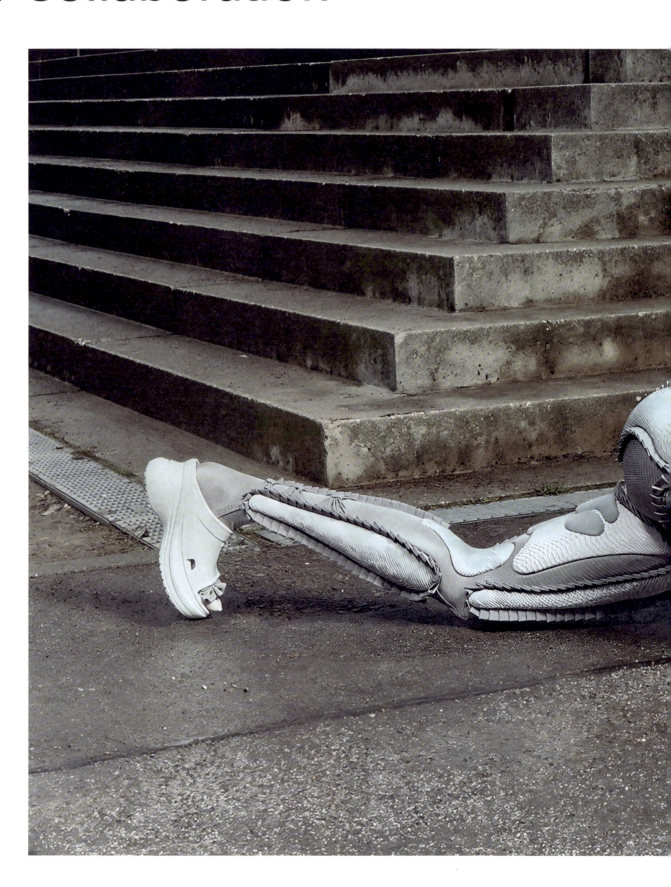

196 BALENCIAGA X CROCS

This unexpected partnership hit a new mark with the debut of the Crocs Pool style: blending platform soles and vibrant colors, the Crocs Pool collab marked another step in Balenciaga's journey to transform utilitarian footwear into high-fashion statement pieces.

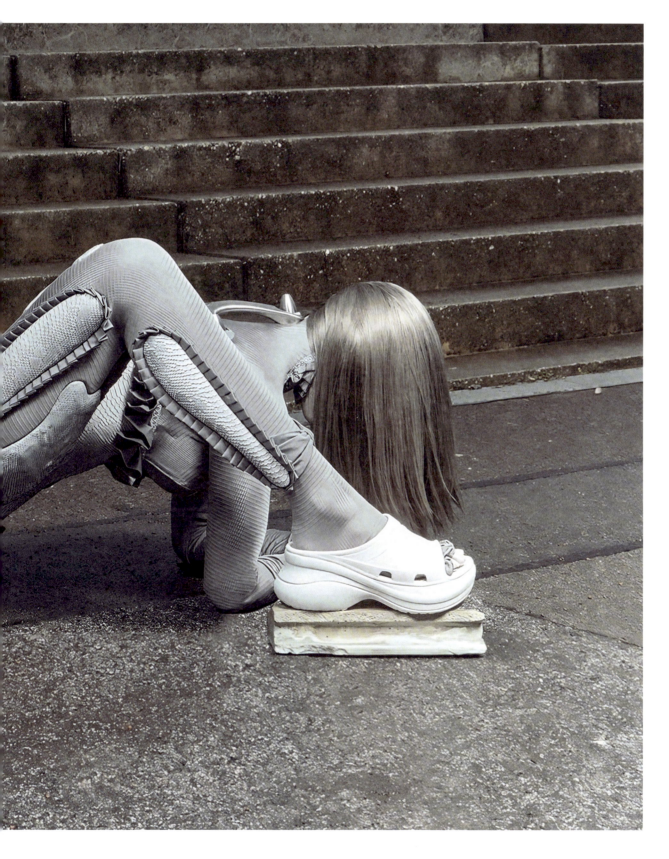

CROCS

197 BALENCIAGA X CROCS

Balenciaga's signature shoes have long been defined by their bold, unconventional designs that challenge traditional fashion norms. The brand's most iconic footwear includes the Triple S sneaker, known for its chunky, multi-layered sole, which embodies the "ugly sneaker" trend, and the Speed Trainer, a sleek, sock-like sneaker made from knit material with a high-fashion edge. Additionally, Balenciaga's Knife boots feature sharp, pointed toes and sleek silhouettes, making them a striking and distinctive choice in luxury footwear.

Given their love of unusual shapes, it was no surprise when Balenciaga first teamed up with Crocs in 2017, with the hopes of merging high fashion with casual footwear. The partnership has since delivered bold designs like platform Crocs clogs, high-heeled sandals, and mule styles, with each release reimagining the classic Crocs silhouette. Creative director Demna has infused the designs with a unique, avant-garde edge, often incorporating exaggerated forms and unexpected materials. While the reaction to the often-mocked utility shoe was polarized, Balenciaga enthusiasts like Kanye West, Kim Kardashian, and Cardi B quickly embraced the shoe, elevating their popularity.

In 2021, Balenciaga's creative team pushed the partnership to include "Crocs Boots" and "Crocs Madame Mules," both equally eccentric, maintaining their commitment to reimagining utilitarian items through a high-fashion lens. For Balenciaga's Spring 2022 collection, their collaboration took the standard Crocs silhouette and elevated it with a rounded platform sole and a choice of bold colors including pink, black, green, white, and yellow. The sandals are stamped with the iconic Balenciaga logo, blending the recognizably casual style of Crocs with a campy, high-fashion aesthetic.

The collaboration's success lies in blending cultural identities: Crocs' working-class, utilitarian origins and Balenciaga's high-fashion, extravagant approach. Since their original release, the platform-style Crocs have become a symbol of Gvasalia's knack for creating "ugly chic" pieces—luxury items that embrace the unconventional and celebrate clunky, sometimes downright unusual designs. This collection, which features a simple yet high-concept take on the classic pool clog, takes those ideals one step further into a kooky, future modernity.

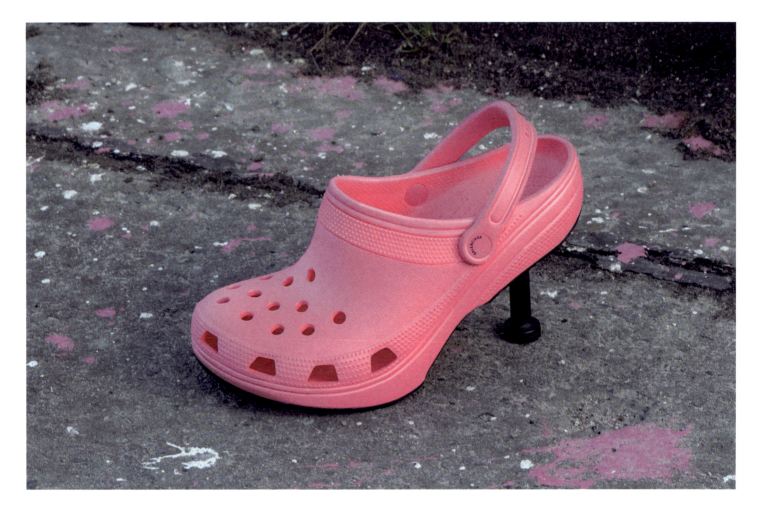

Bold Functionality Meets High-End Aesthetics

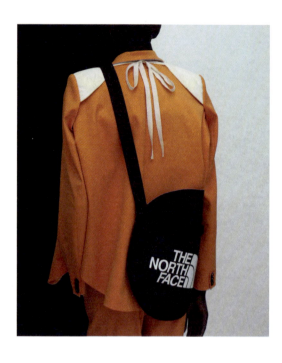

THE NORTH FACE X **MM6 MAISON MARGIELA**

In their 2020 collaboration, The North Face and MM6 Maison Margiela reimagine iconic outerwear with a genderless, fashion-forward twist, blending rugged performance with luxury design, offering a fresh take on technical outerwear.

The North Face is known for its technical innovation and outdoor expertise, making it a surprising fit for luxury design. Still, the brand has collaborated with brands like Gucci and Comme des Garçons—and in 2020 it continued its innovation by partnering with MM6 Maison Margiela: merging rugged functionality with high-end aesthetics, the two brands reimagined iconic outerwear through a fashion-forward lens. The collaboration took the functionality of iconic North Face outerwear and infused it with Margiela's conceptual design, offering a bold, genderless twist that paid homage to Margiela's 1998 collection, famous for its circular garments that lay flat when unworn.

The collection featured reworked outerwear, including iconic pieces like the Denali jacket, Himalayan coat, and Nuptse puffer, which were all updated with elements like Margiela's famed circular patterns, as well as modular designs that mirror the Expedition System from The North Face. First developed in 1988, the Expedition System was revolutionary for its detachable, layered pieces designed for extreme weather conditions. MM6 took this concept further, giving it a new, conceptual dimension. The clothing is made from recycled down insulation, aligning with the growing trend of sustainable fashion while maintaining the technical precision that The North Face is known for. Bold solid colors of purple, orange, and blue added a pop of brightness—a hallmark of The North Face's personality-driven designs.

A standout in the collection is the reimagined Tabi Expedition Mitt, which pays tribute to Margiela's signature Tabi gloves—long, split-finger gloves that have become a winter fashion staple. In this collaboration, the gloves are constructed in warm, winter-friendly textiles, incorporating both Margiela's conceptual touch and The North Face's utilitarian functionality. Additionally, accessories like a circle backpack and clutch were inspired by The North Face's Base Camp Duffel, further highlighting the circular design theme throughout the collection.

The collection debuted at London Fashion Week in February 2020, quickly gaining attention for its inventive take on outerwear. North Face added an element of coziness and comfort to Maison Margiela's typically avant-garde designs. The Nuptse scarf was a prime example: a puffy, almost blanket-sized scarf that managed to look both incredibly cozy and undeniably Fashion.

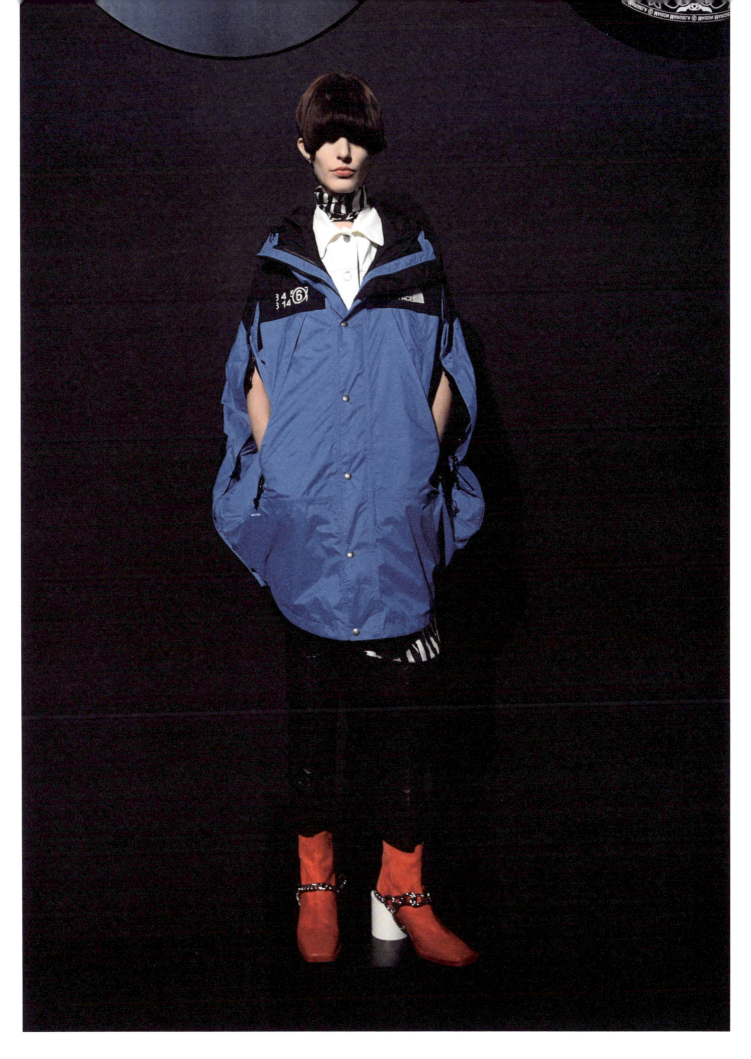

201 THE NORTH FACE X MM6 MAISON MARGIELA

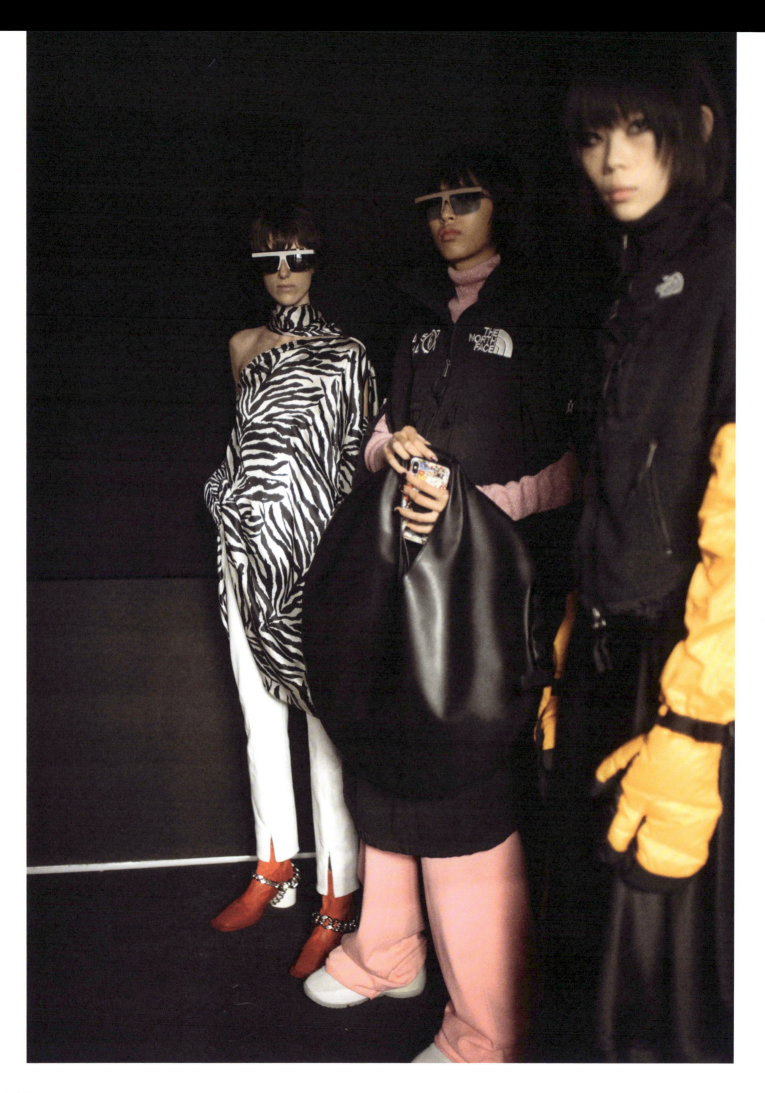

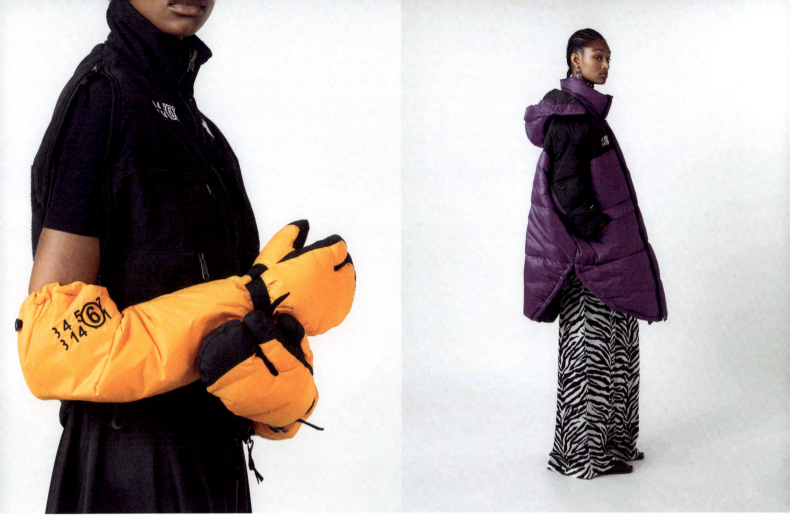

BLENDING RUGGED PERFORMANCE WITH LUXURY DESIGN, OFFERING A FRESH TAKE ON TECHNICAL OUTERWEAR.

Where Fashion Meets Streetwear Via Innovative Collaboration

MONCLER

Through boundary-pushing collaborations with designers like Hiroshi Fujiwara, Craig Green, and Rick Owens, the brand has transformed its approach to outerwear.

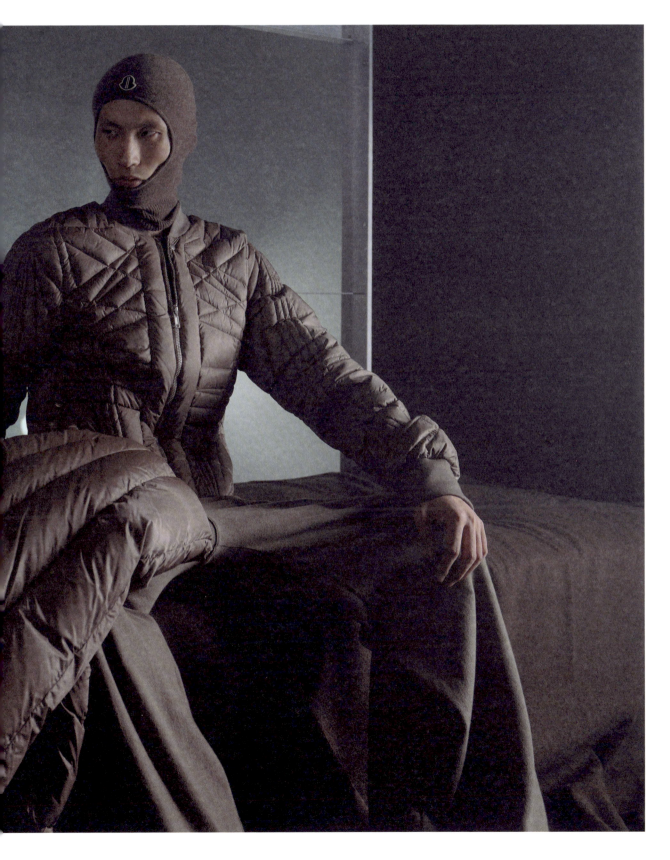

GENIUS

MONCLER GENIUS

Moncler Genius, launched in 2018, quickly disrupted the luxury outerwear world by inviting designers to reimagine the brand's iconic down jackets. CEO Remo Ruffini's vision was to blur the lines between high fashion, streetwear, and art, creating a space where all three could coexist. Collaborations with names like Hiroshi Fujiwara, Craig Green, Pierpaolo Piccioli, and Rick Owens have consistently pushed boundaries—Fujiwara brought streetwear flair, Green experimented with sculptural shapes, Piccioli fused elegance with performance, and Owens redefined outerwear with bold, oversized silhouettes. The brand's innovative spinoff elevated its collaborations through immersive, interactive events that blended fashion, art, and culture. The initiative kicked off with the 2018 Moncler Genius exhibition in Milan, showcasing collections from designers like Hiroshi Fujiwara and Pierpaolo Piccioli in an environment where each designer's vision was brought to life through custom installations. In 2021, the brand created an interactive pop-up for Simone Rocha's collection in London, celebrating delicate craftsmanship in an ethereal space. In 2020, Moncler extended its reach to Beijing with an art-driven event that allowed guests to engage with the collections, while in 2022, the brand merged fashion with adventure through the "Ski" experience, giving guests a chance to experience the ski collections in real-world conditions. Two years later, in 2024, Moncler took the concept to Shanghai Fashion Week with "The City of Genius," offering a multi-layered experience that connected with a global audience.

While the events showcased Moncler's dedication to artistic storytelling, they also reinforced the practical functionality and superior craftsmanship of their jackets. For the capsules, each jacket was crafted from premium Italian materials, fusing traditional techniques with experimental elements and resulting in pieces that celebrated function with style. This balance of heritage and innovation has cemented Moncler Genius's status as an ever-evolving staple in outerwear.

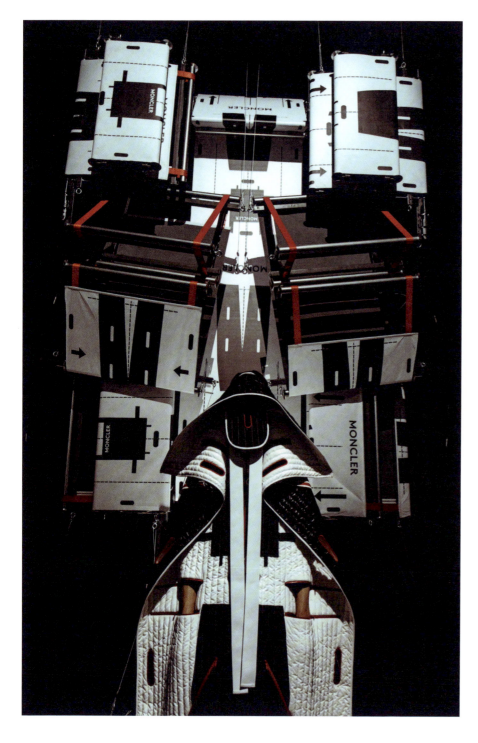

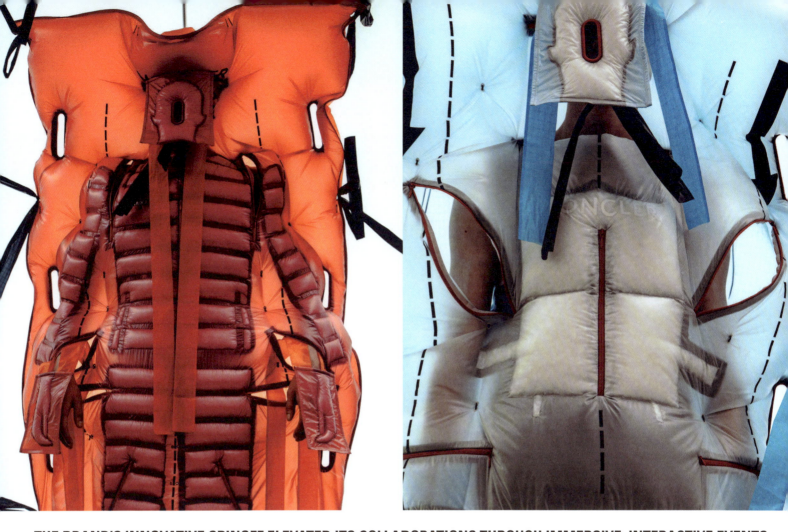

THE BRAND'S INNOVATIVE SPINOFF ELEVATED ITS COLLABORATIONS THROUGH IMMERSIVE, INTERACTIVE EVENTS.

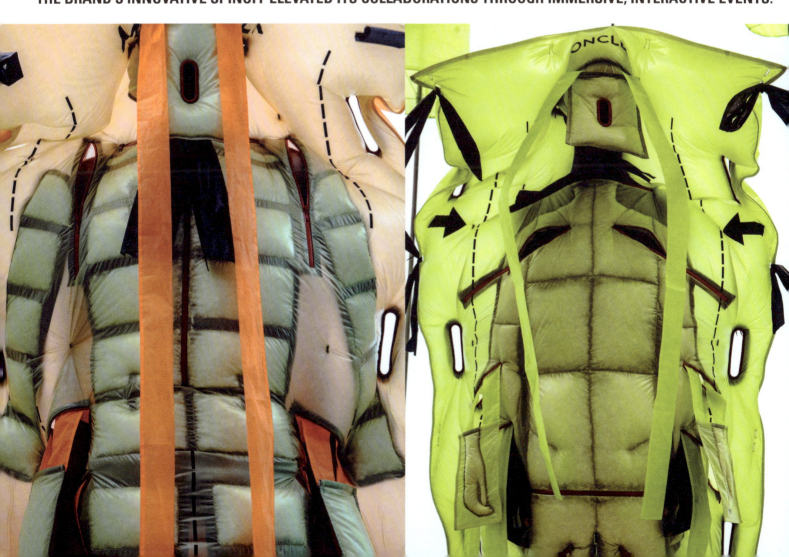

MONCLER + JIL SANDER

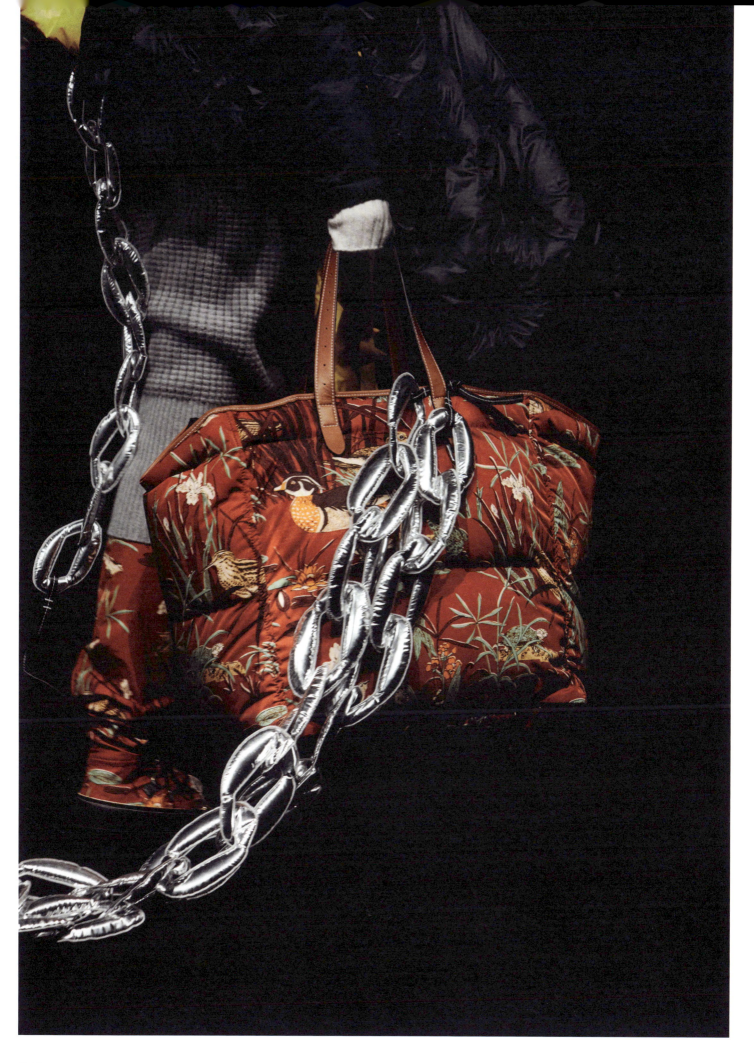

MONCLER GENIUS DISRUPTED LUXURY OUTERWEAR BY BLURRING LINES BETWEEN HIGH FASHION, STREETWEAR,

AND ART. COLLABORATIONS PUSHED BOUNDARIES WITH INNOVATIVE EVENTS.

Where Japanese Classics Meet British Heritage

UNIQLO X **JW ANDERSON**

Since their first collaboration in 2017, UNIQLO and JW Anderson have blended functional basics with bold British design, creating timeless yet modern collections that are accessible to all. The partnership has been widely praised for its balance of practicality and high-end design.

UNIQLO has made a name for itself by collaborating with top designers, combining its focus on high-quality, functional basics with fresh, high-fashion perspectives. Since the early 2000s, the brand has worked with a diverse set of designers like Jil Sander, Christophe Lemaire, and most recently, JW Anderson. These partnerships have allowed UNIQLO to offer limited-edition collections that add a creative twist to its core LifeWear philosophy—simple, versatile, and affordable clothing. Each collaboration brings something new, whether it's innovative fabrics, updated silhouettes, or elevated details, all while staying true to UNIQLO's commitment to comfort and accessibility. This strategy has helped the brand stand out globally, making high-fashion pieces available to a wide audience.

UNIQLO and JW Anderson first teamed up in 2017 to merge sleek Japanese design with bold British fashion. The collaboration resulted in a 33-piece range of menswear and womenswear that blended traditional British heritage with UNIQLO's functional basics. Anderson's goal was to democratize fashion by creating high-quality, stylish pieces accessible to all.

He believed that the collection would resonate with anyone looking for well-crafted, versatile pieces, noting that the key was to reduce each item to its essence, focusing on materials, fit, and functionality. The pieces featured traditional British fabrics and patterns, like tweed and herringbone, reinterpreted with UNIQLO's advanced fabrics such as merino wool and HEATTECH for warmth.

The collection also took British staples like belted trench coats and quilted jackets and gave them a modern twist. Many of the pieces incorporated JW Anderson's signature touches, like tartan linings and anchor-logo patches, resulting in pieces that were both timeless and contemporary. Accessories like striped scarves, bags, and beanies rounded out the collection. The response was overwhelmingly positive, with fashion critics praising the collection's balance of practicality, high-end design, and emphasis on a perfect fit, from the oversized knit dresses to the styling of the coats. What's more, the marketing campaign showcased an inclusive range of models, emphasizing that great style is for everyone.

UNIQLO X JW ANDERSON

Anime Futurism Turns Fashion

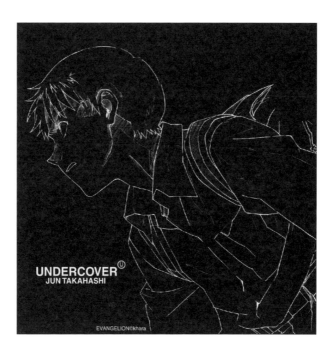

UNDERCOVER X **EVANGELION**

With bold graphics, oversized silhouettes, and unmistakable references to the cybernetic world of Evangelion, the collaboration was an artful mix of edgy street aesthetics and dystopian futurism.

When Jun Takahashi, the designer behind the Japanese fashion label Undercover, announced a collaboration with the iconic anime series *Neon Genesis Evangelion* in 2021, it felt like the perfect fusion of two cultural powerhouses. Takahashi, who has long admired *Evangelion*—a series that has shaped Japanese youth culture since its 1995 debut—found a natural connection between the anime's dark, introspective themes and his own approach to fashion. The show, known for its exploration of psychological complexity, dystopian futures, and its intricate mechanical creatures, or *mechas,* resonates with Takahashi's fusion of streetwear and high fashion, often mixing the beautiful with the unsettling.

The *mechas* in *Evangelion,* massive humanoid robots piloted by humans, symbolize a tragic union of humanity and technology. While the *mechas* are designed for combat, they are also human—cybernetic creations where biological and mechanical elements coexist. This concept of "mechanical people" echoes Takahashi's approach to fashion, where his designs blend the human body with deconstructed, industrial elements, challenging the boundaries between the organic and the synthetic.

The *Undercover* x *Evangelion* collection brought the anime's existential themes to life through oversized jackets, graphic tees, and hoodies emblazoned with bold interpretations of *Evangelion* imagery. Several design elements also mirrored the iconic EVA Units 01 and 02, central *mecha* characters in *Evangelion.* Unit-01's deep purple and green color scheme was reflected in a standout oversized jacket featuring bold, contrasting patches, while the fiery red and white palette of Unit-02 was echoed in a similarly striking bomber jacket with a glowing robotic hood, both capturing the *mechas'* distinctive and powerful presence. With its distressed finishes, oversized silhouettes, and rebellious prints the line balanced the show's futuristic, sci-fi aesthetic and Takahashi's signature streetwear edge.

Fans of *Evangelion* praised the collaboration for staying true to the anime's philosophical depth while creating wearable pieces that spoke to its cultural impact. Takahashi's work translated the *mechas'* metal-clad human form into wearable fashion—an exploration of technology and humanity that feels more urgent than ever before.

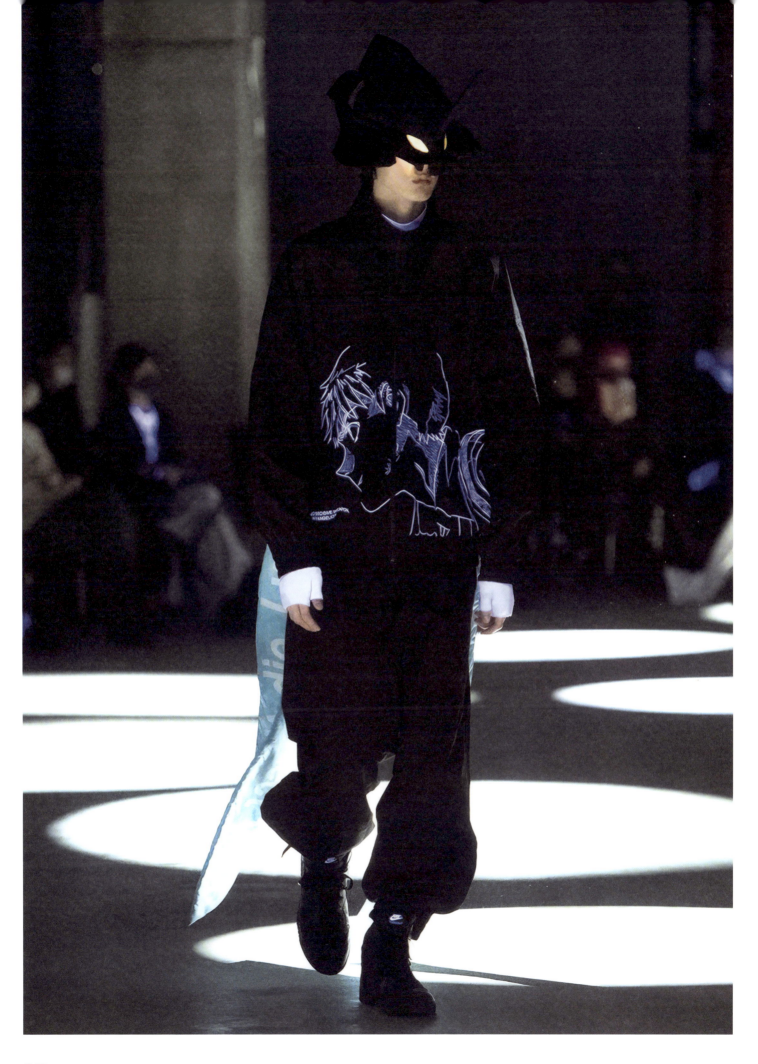

UNDERCOVER X EVANGELION

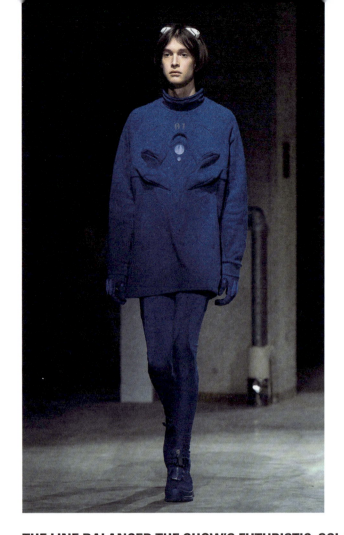

THE LINE BALANCED THE SHOW'S FUTURISTIC, SCI-FI AESTHETIC AND TAKAHASHI'S SIGNATURE STREETWEAR EDGE.

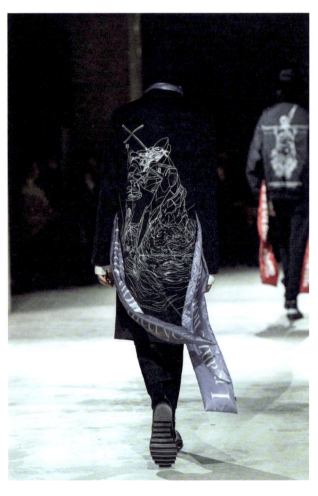

UNDERCOVER X EVANGELION

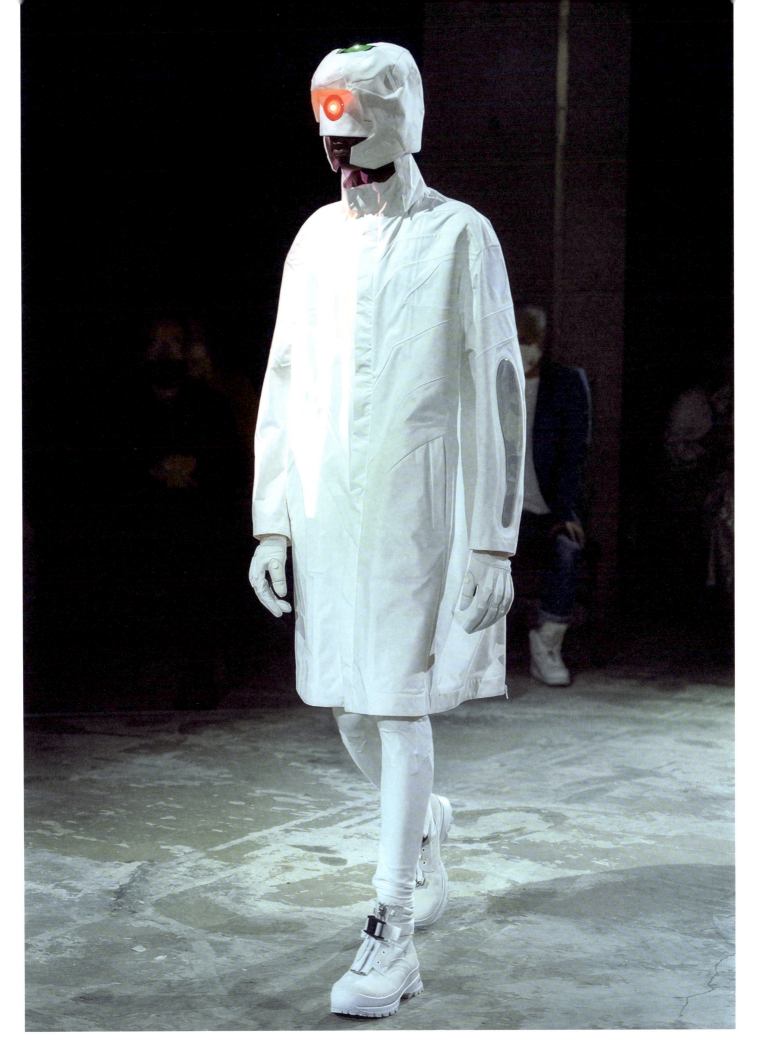

"X" Marks the Spot: The Recipe for a Perfect Collab

Stüssy x Carhartt x Tommy Boy Jacket

In many ways, "collaboration" has become a buzzword synonymous with limited-edition hype and manufactured exclusivity. Yet, its origins tell a different story—one rooted in cultural intersections, mutual respect, and shared innovation. Before brand names were stacked with "x" symbols in every product category, collaboration was an intentional act of synthesis, a way of blending visions to create something greater than the sum of its parts.

But what separates a meaningful collaboration from a fleeting marketing stunt? It's the ability to deliver the unexpected—a product or concept that feels essential the moment it appears. The best collaborations don't just create products; they tell stories, redefine categories, and, in the process, capture the zeitgeist in an undeniably alluring way.

To understand how collaborations came to dominate streetwear and consumer culture, we must travel back to the 1980s, a pivotal decade for creative experimentation. During this era, Tokyo's Harajuku district became an accidental hub for innovation, where young designers like Hiroshi Fujiwara fused global influences into something distinctly new. Fujiwara, widely regarded as the godfather of Japanese streetwear, exemplified the collaborative ethos of the time.

Hiroshi Fujiwara was born in 1964 in Ise—a city known more for its vast Shinto shrine dedicated to the sun goddess Amaterasu than for being on the bleeding edge of style, music, and culture. By the time he turned 18, Fujiwara moved to Tokyo, and immediately immersed himself in the city's burgeoning street fashion scene.

Japanese street fashion at the time was heavily influenced by what writer W. David Marx refers to as American "arbitrage," the act of importing modes and styles from other countries and adapting them to the Japanese market. For a while now, the American Casual way of dressing (Amekaji, in local parlance) had favored Levi's jeans, casual, Brooks Brothers-inspired oxford button-down shirts, and slick leather jackets from storied manufacturers like Schott out of New York City.

Local Japanese brands cribbed those aesthetics and put their own spin on them, resulting in labels like the rockabilly-influenced Cream Soda and then later in the '80s, Nobuhiko Kitamura's seminal Hysteric Glamour, which came to define the rebellious, underground style that continues to characterize Tokyo's Harajuku shopping district. But as Fujiwara discovered and appreciated American style and its influences, like punk rock, from afar, it was his first trip to New York City in the early 1980s that fundamentally changed the way he looked at fashion, trends, and the consumer's relationship with product.

A longtime fan of the film *Breakfast at Tiffany's*, one of the first places Fujiwara wanted to visit was one of the brand's flagship stores in New York City. When he got there, he began a recurring ritual in which he'd buy several of the label's leather-bound day planners—essential notebooks that came in handy in a time before smartphones and online calendars. But while he was perusing the storied jewelry brand's many wares, he discovered a series of luxurious Montblanc Meisterstück pens co-branded with Tiffany's logo. He also discovered several Rolex watches that boasted the "Tiffany & Co." branding on the bottom half of the dial.

Curious as to why a reputable brand like Tiffany wouldn't just make its own pens and watches (in fact, Tiffany has a long history of selling fine Swiss timepieces, even being the first United States retailer to carry Patek Philippe in 1851), Fujiwara asked an employee about the provenance of these seemingly collaborative items. The reply he got was something along the lines of: "If Montblanc makes the best pens in the world, and Rolex makes the best watches in the world, why try to do it better rather than just work with them directly?"

That notion set the stage for the early days of collaboration culture in streetwear. Why would upstart brands that were new to making products try to compete with some of the best manufacturers in the world when they could just enlist them to make new twists on old favorites? As the saying goes: If you can't beat them, join them. So that's what Hiroshi Fujiwara did.

By the early 1990s, Harajuku had become a global epicenter for youth-driven creativity. Brands like NEIGHBORHOOD, WTAPS, and Bounty Hunter thrived in this vibrant ecosystem, using collaboration not only as a creative tool but also as a survival strategy. When resources were scarce, partnerships allowed these brands to share audiences, expand their reach, and amplify their messages. Eventually, Fujiwara shuttered his GOODENOUGH streetwear brand to focus solely on a multidisciplinary label called fragment design (sometimes stylized as FRGMT). It's a brand that's notable for only ever making collaborative products with other entities.

One of the most celebrated collaborations from this era was between Jun Takahashi's UNDERCOVER and Nigo's BAPE, starting with the seminal boutique NOWHERE. Juxtaposing Takahashi's punk sensibilities with Nigo's playful pop-culture references, their joint projects demonstrated the transformative power of creative partnerships. Their work wasn't just about selling clothes; it was about building cultural capital

THE BEST COLLABORATIONS DON'T JUST CREATE PRODUCTS; THEY TELL STORIES AND CAPTURE THE ZEITGEIST.

and creating pieces that resonated with the youth of Tokyo and beyond.

Around the same time, Fujiwara's "if you can't beat them, join them" approach to collaboration manifested in a highly regarded sub-label for storied Japanese bag manufacturer PORTER. The HEAD PORTER line of functional bags with a vintage, military-inspired twist remained a longtime staple for the brand, which went on to do many collaborations in its own right. Fujiwara also launched a line with denim brand Levi's called FENOM, a Japanese-market exclusive collection that tapped into the country's demand for details like selvedge denim and historically accurate reproductions of past jeans.

As Japan's streetwear scene flourished, similar dynamics were unfolding in the United States. Shawn Stüssy's eponymous brand was among the first to integrate collaboration into its DNA. Drawing inspiration from surf culture, punk, reggae, hip-hop, and skateboarding, Stüssy positioned itself as a cultural hodgepodge, partnering with like-minded brands and individuals to expand its influence.

One of Stüssy's earliest collaborations was with Carhartt, a brand synonymous with workwear. Together, they transformed the utilitarian Detroit jacket into a canvas for street culture, emblazoning it with embroidered logos from seminal hip-hop music label Tommy Boy Records and stitching a knowing "STAFF" ID onto the chest in Stüssy's signature handstyle. Only 800 of the jackets were made—and the kicker? They were never for sale, only given out to close friends and family of the brand, a precursor to the common practice of "F&F" exclusives that function as a high-value cultural-currency thank you

to a brand's early adopters. The result was a product that bridged fashion and music, redefining what collaboration could achieve.

While Stüssy was pioneering collaborations in streetwear, Nike was revolutionizing the sneaker industry. By the mid-1980s, Nike's Air Jordan line had already become a cultural phenomenon. They captured a new segment of the market by combining the power of sports and storytelling, and in doing so, created a new kind of consumer: one as interested in engaging with culture as much as product. The Air Jordan series of sneakers didn't just appeal to basketball fans, they became a staple in skateboarding and hip-hop, too.

In 2000, Nike and Stüssy made waves when they announced they were teaming up—this was the first time ever the sneaker company had partnered with a clothing brand. A meeting of the minds between Fraser Cooke (who would go on to lead collaborative projects at Nike) and Michael Koppelman (founder of streetwear distributor Gimme Five and the man responsible for helping build the presence of Stüssy and Supreme in Europe), the first Nike x Stüssy silhouette was the Huarache, a cult running model inspired by breathable handmade Mexican sandals of the same name. It was designed by Tinker Hatfield, the visionary behind several of Nike's most iconic footwear models, most notably the Jordan 3, a black-and-cement colored mid-top whose signature elephant print instantly catapulted it to legend status among sneaker lovers. (The Jordan 3 was also rumored to be the shoe that convinced Jordan to stay with Nike at a time when his endorsement contract was up for negotiation.)

A year later the two brands teamed up once more to launch a fresh take on the Nike Dunk. Their design laid the groundwork for the luxury-meets-accessibility aesthetic that

HTM wasn't just a series of sneakers; it was a blueprint for how collaborations could merge storytelling with design, turning every release into an event that consumers would eagerly line up for. In this way, they began to manifest a real sense of community around the product. Further, the three stakeholders represent the three key ingredients in what makes a truly great collaboration: Hiroshi Fujiwara's authenticity, cultural fluency, and enthusiasm for great product; Tinker Hatfield's inherent knowledge of innovation and forward-thinking design; and Mark Parker's knack for understanding the importance of cultural relevance and its relationship to a brand's positioning with consumers. Part of what made Mark Parker integral to Nike's heyday is that he not only understood the business side of what makes a brand great, but also saw the unquantifiable value in creating niche products that drive excitement and become part of the zeitgeist.

At the same time, Nike had established its skateboarding line, Nike SB, and it was gaining traction thanks in part to collaborations with brands like Supreme, but also through the efforts of Robbie Jeffers, the former manager of Stüssy's skate team, and Nike's Sandy Bodecker. Both men brought serious credibility and authenticity to the sub-line. Curating a roster of some of the era's best skateboarders, like Paul Rodriguez, Gino Iannucci, Reese Forbes, Danny Supa, and Richard Mulder, each team member was given their own signature shoe in the same manner as any star athlete. Just as the 1980's Air Jordan 1 was readily adopted by the skate community for its comfort, this time the Nike Dunk was refitted to meet the needs of skateboarding. It was a full-circle storytelling moment that came to define an era of collaborative shoes.

HTM WASN'T JUST A SERIES OF SNEAKERS; IT WAS A BLUEPRINT FOR HOW COLLABORATIONS COULD MERGE STORY-

would come to define many future collaborations. Mixing a tonal black-and-tan upper with an ostrich leather Swoosh, the upscale details were something people had never seen before on a sports shoe. Couple that with an extremely limited run, and it was an instant hit.

Nowadays, scarcity is a hallmark of collaboration culture, driving demand and making products feel more special. Limited releases often create a sense of urgency, with fans scrambling to secure items before they sell out. This phenomenon, amplified by social media, has turned collaborations into cultural events. But back in those days, before the internet, scarcity wasn't a marketing strategy—it was authentic to the nature of the brand. It didn't make sense for a relatively niche label like Stüssy to manufacture a ton of pairs, since the intended audience was finite.

By the time Hiroshi Fujiwara partnered with Nike for the HTM line in 2002, Nike noticed there was a budding movement around using sneakers as a canvas to tell compelling stories. Sure, seeing athletes like Michael Jordan and Kobe Bryant dazzle audiences on the court was still one way to sell a ton of shoes—but there was something entirely new about elevating the humble sneaker into a cultural artifact. The HTM collaboration—featuring Fujiwara, Hatfield, and then-Nike CEO Mark Parker—marked a new chapter in sneaker culture. The sub-label's initials simply stood for the first names of the collaborators: Hiroshi, Tinker, and Mark. These limited-edition releases melded Nike's most iconic and innovative designs with premium materials and filtered them through a new lens of connoisseur-like appreciation, rather than performance.

While Nike had seemingly figured out this winning formula, streetwear and other niche labels had been making similar partnerships around the world. Shawn Stüssy, Hiroshi Fujiwara, and contemporaries like A Bathing Ape's NIGO and James Jebbia of Supreme had made collaborative products an essential part of their brand DNA, and in the process built dedicated communities for their labels—with plenty of cross-pollination between their respective universes along the way. In those days, someone wearing a Supreme box logo hoodie with selvedge denim from a label like Hiroki Nakamura's visvim and a pair of HTM x Nike sneakers signified a very specific type of customer. One who was plugged in enough to know about these brands, but also monied enough that they could get on a plane to Tokyo or New York and buy the products.

That all changed when the internet came around and not only connected these underground communities but increased their ranks exponentially. The first places to bring legions of in-the-know enthusiasts together were internet message boards, online forums where people gathered to talk about the latest releases in sneakers, streetwear, and fashion. In September 1999, an Australian named Wayne Berkowitz founded Superfuture while living in Tokyo. It became a hotbed for conversations around raw denim, cult streetwear labels, and eventually avant-garde designers like Rick Owens. Three months later, in December 1999, Nelson Cabral established NikeTalk, a forum that discussed all things sneaker-related—but, as you can probably guess, mostly revolved around footwear with the recognizable Swoosh on it.

Despite the relative accessibility of forum culture, there was a definite sense of exclusivity in the conversations.

Opposite, top left: Stüssy x Nike Air Huarache "Desert Oak"; opposite, top right: John Dettman in Goleta, California, 1987
Opposite, bottom: Japanese fashion designer Nigo, 2004

TELLING WITH DESIGN, TURNING EVERY RELEASE INTO AN EVENT THAT CONSUMERS WOULD EAGERLY LINE UP FOR.

Knowledgeable veterans who were fluent in the sense of humor and jargon of the online community were respected, and neophytes who hadn't taken the time to lurk and do research before asking seemingly obvious questions were shunned. As much as these places served as an early resource for discovering the latest in sneakers and streetwear, they trafficked mainly in an insular discourse that kept the community feeling gated. Ironically, it meant that the products being discussed within these online walls retained a fair amount of their mystique and hype.

But almost as a reaction to the clubby feel of forums, the proliferation of online blogs took this new way of discussing products to a mass audience. Niche slang like "jawns" referring to gear and "collab" as a contraction of "collaboration" became the vernacular of publications like *Highsnobiety* when it was first published in 2005. Most notably, a new shorthand for "collaboration" began to emerge: the now-ubiquitous "x" symbol. With this, a sneaker like the riot-inducing collaboration between Nike SB and Staple would be simplified to read almost like an equation: "Nike x Staple Pigeon Dunk."

As it turns out, the "x" is the perfect symbol to represent the x-factor in what makes a great collaboration. It succinctly visualizes the exponential power of two partners working together to create something truly greater than the sum of its parts. It can be interpreted as both a cross-hybridization between companies but also the underlying transcendence that happens when a great brand puts its signature flourish on a previously existing product, creating a newfound desirability.

The rise of the internet in the early 2000s played a crucial role in shaping collaboration culture, but also democratized access to it. Consumers could participate in

tions can be a pathway to growth, offering access to resources, audiences, and expertise. For larger brands, partnerships can reinvigorate their image, introducing fresh perspectives and tapping into new cultural trends in a way that reminds consumers of their own heritage. And for emerging brands, collaborations offer a pathway to visibility and relevance. Partnering with established names can provide credibility, expand reach, and open doors to new audiences.

That said, it's about more than just strategy and planning. A truly successful collaboration hinges on both

AT THEIR BEST, COLLABORATIONS ARE POWERFUL STORYTELLING TOOLS. THEY ALLOW BRANDS TO EXPLORE NEW

global cultural moments regardless of their location, while smaller brands gained visibility through online platforms. The internet became a powerful tool for amplifying the impact of collaborations.

Despite their popularity, collaborations are not without challenges. Critics often point to oversaturation, with some brands diluting their identity through excessive partnerships. Others argue that many collaborations prioritize hype over substance, resulting in products that lack originality or lasting impact.

Successful collaborations require careful alignment of values and creative visions. Without this, partnerships risk becoming hollow exercises in branding, eroding consumer trust and diminishing the cultural significance of collaboration itself. At their best, collaborations are powerful storytelling tools. They allow brands to explore new narratives, engage with diverse audiences, and create products that resonate on a deeper level. From Nike's early collaborations with brands like Supreme and designers such as Hiroshi Fujiwara to groundbreaking partnerships like the Dior x Air Jordan 1, these alliances demonstrate the power of blending unique perspectives and heritage into a single product, while telling a story of cross-cultural influences and mutual appreciation.

Yet behind the creativity lies a complex business ecosystem. Collaborations require meticulous planning, from licensing agreements to production logistics. They also command a deep understanding of consumer behavior, as brands must anticipate demand and manage scarcity to maintain exclusivity. For smaller brands, collabora-

a visionary approach and seamless execution. If there's one brand that exemplifies this mixture best, it's the empire Ronnie Fieg has built with Kith. Founded in 2011, Kith now has 16 flagship stores around the world, and has become synonymous with conceptual retail and boundary-pushing collaborations. Much of Kith's success can be credited to Fieg's rare combination of skills—a gift for storytelling, sharp business acumen, and a natural ability to connect with his customers. He has a knack for knowing when his audience is ready for a shift in silhouettes, and which parts of a brand's history resonate most with consumers.

Fieg began his career in collaborations at New York footwear retailer David Z, where he started working at age 13 as a stock boy. Eventually he was given the opportunity to design three pairs of limited-edition ASICS sneakers, with a run of 252 pairs each. The so-called "252" pack ended up getting covered in *The Wall Street Journal,* and sold out in 24 hours. That led to other collaborations with partners like New Balance, Puma, Saucony, adidas, and non-sneaker footwear like Timberland and Sebago. By the time he set out on his own with Kith, he already had over 50 successful collaborations under his belt. Kith itself is an extension of the "friends and family" notion that characterized early collaborative items. Referencing the old-fashioned phrase "kith and kin," Fieg sought to build a community around the brand first, not simply selling products, but selling his story and something to belong to.

Kith storytelling hits all the right notes, starting with nostalgia and Fieg's own humble upbringing in Queens. In many ways, he emulated the success stories of other figures, like Ralph Lauren, telling the tale of a kid who dreamed of making

Top: Rami Almordaah, AKA @Ramitheicon, shows off the Dior x Air Jordan 1
Opposite, top right: adidas x Pharrell Williams Humanrace

something of himself, and ended up following through on that promise. It's a thread that has allowed him to tell stories beyond sneakers, like how partnering with retailers like Bergdorf Goodman and Hirshleifers was a form of personal wish fulfillment. The internet and social media became a useful tool for helping Kith punch well above its weight, creating experiential pop-ups in Aspen for partners like Samsung and curating extravagant trips full of Fieg's famous friends like Joe La Puma from *Complex*, former NFL player Victor Cruz, jeweler Greg Yuna, and Teddy Santis of Aimé Leon Dore. Fieg slowly built an aspirational world that scaled with the brand's success. As the Kith community grew, so did the scope of its stores and partnerships.

When Kith launched its collaboration with Versace in 2019, it went beyond simply releasing the product; it included temporary takeovers with New York hotspots like Cha Cha Matcha and Sadelle's, featuring exclusive co-branded food items. Similarly, Kith used its 2019 collaboration with Coca-Cola to pave the way for a Hawaii store, opening a pop-up, complete with vintage Coca-Cola machines and exclusive merchandise, before eventually opening a flagship in 2021. For its 2024 collaboration with Giorgio Armani, Kith took over an Upper East Side townhouse and outfitted the rooms with the collection, turning the partnership into an immersive experience that resonated with consumers on multiple levels. The takeaway here is how emerging brands like Kith have managed to expand their cachet and make a meaningful impact on the business by combining collaboration with masterful storytelling. By crafting narratives that differentiate them from competitors, and by placing an emphasis on shared values to convey a cohesive vision, Kith has been able to court an impressively diverse range of partnerships.

creativity and commerce collide, and they often predict the direction of consumer trends. When Japanese clothing label Uniqlo tapped French designers Christophe Lemaire and Sarah Linh-Tran of the quintessentially minimal label Lemaire to create the Uniqlo U line of forward-thinking everyday apparel, it charted a course towards gender-inclusive, casually elegant clothing. Although there are still specific men's and women's collections, the generous proportions of the label and its campaigns, which style the items across different genders, speak to how individual items can be re-contextualized by the wearer.

NARRATIVES, ENGAGE WITH DIVERSE AUDIENCES, AND CREATE PRODUCTS THAT RESONATE ON A DEEPER LEVEL.

At the core of every successful collaboration is the chemistry between creative minds. Whether it's a designer and a brand, two companies, or even cross-industry pairings, the best partnerships stem from shared respect and complementary skills. Take Pharrell Williams and adidas: their work on the "Humanrace" collection is a study in how a designer's philosophy can align with a brand's identity. Pharrell's focus on inclusivity and individuality mirrors adidas's commitment to making a global cultural impact (dating back to their first partnership with Run DMC in the 1980s). This synergy allowed the partnership to feel organic and authentic.

While the financial upside of collaborations is significant, the true power lies in their ability to forge emotional connections with consumers. A great collaboration doesn't just combine logos or styles; it creates a narrative that resonates deeply with people's aspirations, memories, and cultural touchpoints. Consider the vast yet controversial collaborative portfolio of Kanye West. From his longtime partnership with adidas on the YEEZY line to projects like his capsule collections for A.P.C., West leveraged his own artistic vision and storytelling prowess to create a mythology around the products that makes them feel less like sneakers and more like cultural artifacts. It's more telling that despite the change in sentiment about West as a celebrity, he has still managed to create a suite of memorable products that remain in demand.

Perhaps the most fascinating aspect of collaboration is its ability to reflect and shape culture. By merging disparate worlds, partnerships create new cultural languages and challenge established norms. They show us what's possible when

Similarly, adidas' ongoing partnerships with designer Stella McCartney and the non-profit organization Parley for the Oceans put a focus on recycled materials and eco-conscious designs, addressing a growing demand for sustainability. In the same vein, Nike's collaboration with artist Tom Sachs resulted in utilitarian sneakers with a wabi-sabi, rough-around-the-edges appeal, reflective of the artist's work in making homegrown reproductions of everything from lunar modules to stereos. That aesthetic informed the "Space Hippie" line of sneakers, inspired by the NASA practice of "in situ" training, in which astronauts and engineers were limited to only using the materials around them to create necessary tools. The lo-fi look of the sneakers instantly appealed to consumers, and in another nod to innovation, were shipped in the shoeboxes they were packaged in, not only preventing unnecessary waste, but also discouraging resale profiteering.

So what makes a collaboration truly great? First, there must be a clear alignment of values and goals between the partners. This ensures the product feels cohesive rather than forced. Next, the collaboration should offer something genuinely new—a fresh perspective, innovative design, or an unexpected combination of elements. Of course, not every collaboration is a success, and failures can provide valuable lessons. Some partnerships fall flat because they lack authenticity or appear overly commercial. Others fail because they misjudge their audience or fail to deliver on expectations.

The lesson here is that collaboration must prioritize substance over hype. While exclusivity and scarcity can drive initial interest, lasting success depends on the quality of

the product and the strength of the story behind it. A poorly executed partnership risks not only disappointing consumers but also damaging the reputations of all parties involved.

Collaborations thrive on the chemistry between brands and the cultures they represent. The best partnerships aren't just about combining aesthetics; they create a kind of cultural alchemy that resonates far beyond the products themselves. One of the most powerful aspects of collaboration is its ability to bridge generational gaps. By pairing heritage brands with contemporary designers or creators, collaborations create a dialogue between the past and present. This intergenerational appeal is especially evident in sneakers. Building off the success of the HTM line and the Nike SB label, Nike has continued to innovate in its partnerships. It was one of the first labels to work with avant-garde designers like Rei Kawakubo of COMME des GARÇONS, Chitose Abe of sacai, and Cynthia Lu of Cactus Plant Flea Market. Meanwhile, it has partnered with sneaker-centric figures like Sean Wotherspoon and the late DJ Clark Kent, as well as hugely popular streamers like Kai Cenat and even the makers of the video game *Fortnite,* where characters can wear digital versions of its shoes, hopefully inspiring players to purchase a pair IRL. Other brands have followed suit, like New Balance partnering with Teddy Santis of Aimé Leon Dore to reinterpret some of its most classic silhouettes, and empowering newer designers like Salehe Bembury and Joe Freshgoods to create models that give New Balance even more credibility in the sneaker community, making them relevant to new audiences while honoring their roots.

The most impactful collaborations don't just bring brands together—they create a platform for communities.

consumers value novel experiences, authenticity, and cultural relevance just as much. When Fear of God founder Jerry Lorenzo collaborated with Ermenegildo Zegna in 2020, it wasn't just an exercise in re-contextualizing luxury tailoring with Lorenzo's signature casual, oversized silhouettes. It was also a story about getting dressed up filtered through the Black experience. One of the inspirations behind the collection is a 1941 photo by Russell Lee titled "Sunday Best." The photo depicts five Black youth standing on top of a car in Chicago's South Side, each of them looking resplendent in topcoats, double-breasted suits, ties, perfectly cuffed trousers, and fedoras. Not only did it show that traditional suiting could coexist with modern sensibilities, it also paved the way for a new era of hybrid dressing.

Elsewhere, in 2025 Lorenzo started collaborating with American apparel retailer PacSun on the Fear of God Essentials sub-label. The lower-priced, more accessible line introduced Fear of God's elevated designs to a broader audience while maintaining its aspirational appeal. As a result, Essentials drops have become a moment in their own right, and still generate high sellthroughs, with certain pieces gaining considerable value in the aftermarket. By positioning itself as a bridge between luxury and accessibility, Fear of God expanded its reach without diluting its brand identity.

One of the defining characteristics of groundbreaking collaborations is a willingness to take risks. The most memorable partnerships are those that challenge conventions, break boundaries, and introduce ideas no one saw coming. Risk-taking is the fuel that drives collaborations from good to iconic. By the mid-2000s, collaborations were the lingua franca of sneakers and limited-edition streetwear, and the lines

PERHAPS THE MOST FASCINATING ASPECT OF COLLABORATION IS ITS ABILITY TO REFLECT AND SHAPE CULTURE.

A collaboration becomes a cultural milestone when it resonates deeply with its audience, often by reflecting their values, interests, and aspirations. After all, one of the most overlooked benefits of collaboration is its ability to educate. When two distinct entities come together, they often introduce their audiences to new perspectives, aesthetics, or ideas. They reveal new ways to approach product design, marketing, and distribution.

For Tremaine Emory, founder of the label Denim Tears and former creative director of Supreme, his label is part of a multidisciplinary art practice that stems from his varied interests across cultures. With Denim Tears, Emory is particularly interested in telling the stories of the Black American experience and the African-American diaspora. His signature Levi's collaboration features a cotton wreath motif, printed (or in rare cases, embroidered via chainstitch) all over the iconic 501 jean, a reference to the crops that enslaved people were forced to harvest in the US South.

In 2022, he collaborated with UGG on a series of footwear inspired by his great-grandmother's Black Seminole heritage. The beaded shoes incorporated handicraft techniques associated with Indigenous peoples of the Southeastern United States, and proceeds from the partnership went toward the Backstreet Cultural Museum in New Orleans, which was in dire need of repairs after Hurricane Ida, as well as to the Guardians Institute, similarly dedicated to the preservation of West African indigenous traditions.

Collaborations have also redefined what luxury means in the modern era. Where luxury was once synonymous with exclusivity and inaccessibility, today's

between streetwear and high-fashion had become practically indistinguishable. It was very clear that the industry needed a big shift to move things in a fresh direction.

So when Kim Jones, then the artistic director of Louis Vuitton men's, announced a collaborative collection with Supreme in 2017, it was a seismic moment in the fashion world. Supreme x Louis Vuitton wasn't just about the products; it was about the cultural statement. By bringing together two seemingly opposite brands, the collaboration challenged traditional notions of luxury and accessibility. It also underscored the growing influence of streetwear on mainstream fashion.

Around the same time Demna of VETEMENTS and Balenciaga had been making waves for some risky collaborations of his own. In 2015, he collaborated with shipping company DHL on a capsule collection of tops emblazoned with the company's signature logo and red-and-yellow color scheme. Meant as a cheeky nod to rising shipping costs, the shirts ranged in price from $600 to $840, and it didn't take long for then-CEO of DHL Express Ken Allen to be spotted wearing one of the T-shirts. A few years later, Demna partnered with Crocs on a series of colorful stacked platforms for his Spring 2018 collection for Balenciaga. The towering platform Crocs were met with mixed reactions, but they became an instant conversation starter, highlighting the power of collaborations to disrupt norms and spark debates. What's more, they became an instant hit with consumers, setting the stage for a successful partnership that continued for many years.

Another example is the Moncler Genius project, which, under the guidance of visionary CEO Remo Ruffini, upended the traditional model of brand partnerships.

Instead of one-off collaborations, Moncler invited a rotating cast of designers—ranging from Rick Owens, Craig Green, and Hiroshi Fujiwara—to reimagine its iconic puffer jackets. Straddling the line between avant-garde and mainstream, Genius lives up to its name in the way it has evolved into its own kind of cultural moment. The line's collaborators have expanded to include celebrities like Jay-Z, A$AP Rocky, and Pharrell, alongside former Valentino creative director Pierpaolo Piccioli, cult Japanese designer Kei Ninomiya, and streetwear luminary NIGO—who used his Moncler collaboration as an opportunity to bring in a third partner, Mercedes-Benz, and reimagined the luxurious G-Class SUV with a Moncler nylon roof. This risk paid off, as the Genius project turned Moncler into a dynamic, ever-evolving brand while reinforcing its legacy in outerwear, fashion, and culture. Ruffini's embrace of experimentation and creative risk-taking led to an era of reinvention for the brand.

Moncler Genius showed us that while collaboration culture has its roots in localized subcultures, it has grown into a global phenomenon that transcends borders. Different regions bring unique perspectives to the art of collaboration. In Japan, craftsmanship and attention to detail often take center stage, demonstrated by the canon of Hiroshi Fujiwara, NIGO, and Chitose Abe of sacai. In the United States, collaborations are often driven by cultural movements, blending fashion with music, sports, and art. Stüssy's graphic archive is largely inspired by reggae, punk, new wave, and hip-hop, but also references fashion photography and fashion labels like Issey Miyake and Chanel. Supreme's famous box logo owes its existence to the work of Barbara Kruger, but has similarly mined everything from American motorcycle clubs like the Hell's Angels to the blurred motion

This is why Nike's first foray into skateboarding failed, but its 2002 entry into the scene was wildly successful. Sandy Bodecker saw the value in empowering the skate community. He understood that, despite the fact competitions like the X Games exist—and skateboarding is now in the Olympics—many stalwarts of skate culture are vehemently opposed to calling it a "sport," and certainly no self-respecting skater would consider himself or herself an "athlete." And yet, Bodecker knew that the community's stars, and any skater willing to join Nike's fledgling skateboarding team, should receive the same benefits and level of respect given to world-class athletes with names like LeBron James and Kobe Bryant. This is why the first Nike SB skaters were given their own signature shoes, and why a lot of the early Nike SB collaborations with artists like Futura, De La Soul, and Pushead directly tied back to the kinds of creative entities that were already popular in skateboarding.

Authentically engaging with a community and taking them along for the ride is what Kerner and Pressman refer to as "shared equity" rather than "borrowed equity." It's a result of what happens when all parties in a collaboration clearly bring something to the table, but more importantly, are mutually invested in each other's success. For larger brands, that means supporting smaller labels through scale, marketing, and resources to empower creative campaigns.

The most successful collaborations don't just create fleeting moments—they build legacies. These partnerships leave a lasting impact on the cultural landscape, influencing how future collaborations are approached and inspiring new generations of creators. For example, those early Nike collaborations led to Virgil Abloh's groundbreaking Off-White™ x Nike The Ten,

SO WHAT MAKES A COLLABORATION TRULY GREAT? FIRST, THERE MUST BE A CLEAR ALIGNMENT OF VALUES AND

graphic from the film *Goodfellas* as graphic inspiration. Europe, meanwhile, has a long history of luxury collaborations, with houses like Gucci, Louis Vuitton, and Prada embracing partnerships to expand their creative horizons—all of whom have been previously sampled in streetwear. These regional nuances contribute to the rich tapestry of modern collaboration culture.

International partnerships allow brands to tap into diverse cultural narratives, creating products that resonate on a global scale. But it's important that the partnerships not only feel authentic but are also fair to all parties involved. It's a notion talked about in depth by authors Noah Kerner and Gene Pressman, the former creative director and co-CEO of Barneys New York in its golden era. In 2007, the two co-wrote a book called *Chasing Cool: Standing Out in Today's Cluttered Marketplace,* in which they discuss the concept of "shared equity" in successful collaborations.

"Authenticity" isn't just a synonym for credibility nor is it simply a buzzword for the kind of clout the right celebrity or on-the-cusp underground streetwear label brings to the table. It's something that goes both ways, and functions as a throughline that can connect all partners in a collaboration. The stronger it is, the more any potential partnership makes sense—the weaker it is, the more consumers can easily tell when something feels like a trite cash grab. Many failed collaborations speak to what Kerner and Pressman refer to as "borrowed equity," like a high-end fashion label trying to participate in skateboarding or streetwear and failing spectacularly because there's no real interest in understanding the nuance of a subculture nor telling a story about the shared values the labels might share.

a blueprint for how massive collaborations can feel. For that collection, Abloh took 10 existing Nike silhouettes and put his own spin on each one, riffing on his signature "3% rule," a notion of his design practice that posited the minimum amount that something needed to be changed before it became a completely new product. It merged Nike's penchant for innovation with Abloh's ironic interpretations of cheeky internet culture and an astute understanding of longstanding design codes. It became a benchmark for modern sneaker collaborations—including his equally unprecedented Nike partnership with Louis Vuitton, setting a standard that continues to influence the industry.

The best collaborations don't even have to be scarce to be successful. Uniqlo has managed to put lightning in a bottle on a consistent basis, not only through its continuing partnership with Christophe Lemaire at Uniqlo U, but also through its collaborative labels with British designer JW Anderson, whose capsule collections blend English heritage with Uniqlo's penchant for easy-wearing staples, or with its ever-rotating stable of artists whose work features in its UT line of graphic T-shirts. Not only is the brand able to work with artists like KAWS and Takashi Murakami, they also managed to tap cult label Cactus Plant Flea Market and have them reinterpret the eminently meme-able show *SpongeBob SquarePants* for a collaboration seemingly tailor-made for social media virality. The beauty of collaboration culture lies in its endless possibilities. By bringing together diverse perspectives, brands can create products, stories, and experiences that transcend individual visions. In an era where creativity knows no bounds, the potential for transformative partnerships is limitless.

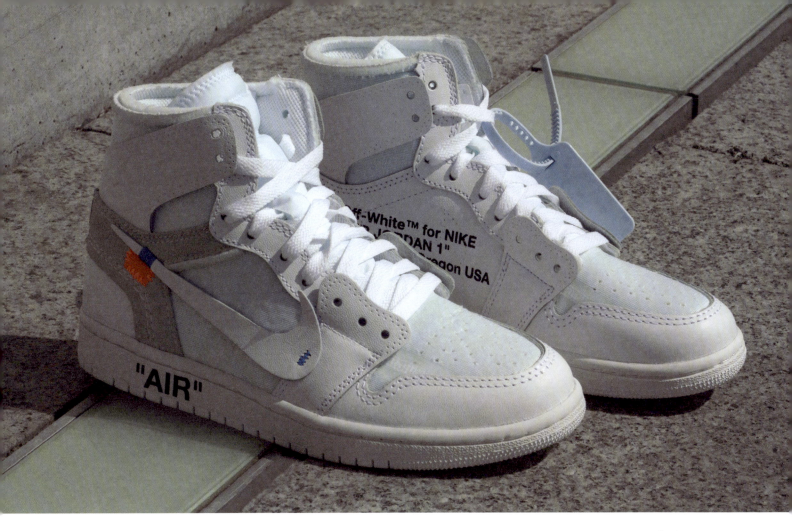

GOALS BETWEEN THE PARTNERS. THIS ENSURES THE PRODUCT FEELS COHESIVE RATHER THAN FORCED.

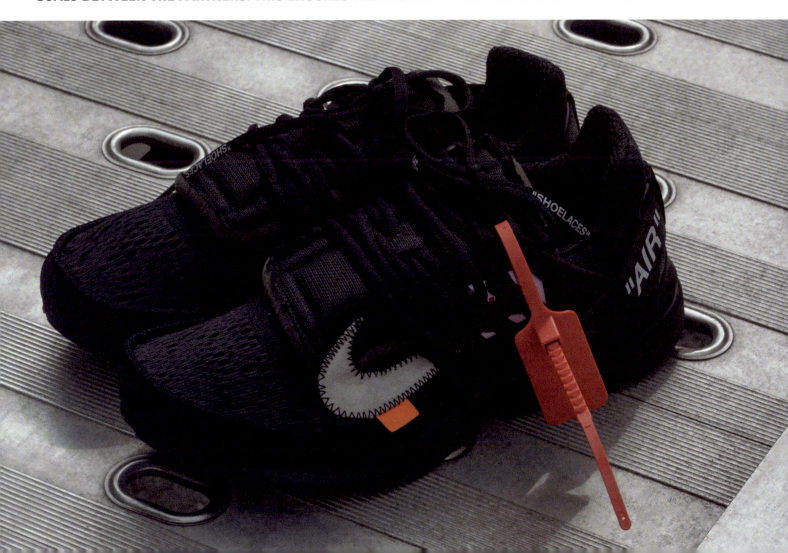

A Sleek, Futuristic Automotive Adventure

MERCEDES-BENZ X **VIRGIL ABLOH**

This groundbreaking collaboration between Mercedes-Benz, Maybach, and the late Virgil Abloh reimagines the future of electric luxury with the unveiling of Project MAYBACH. Blending high fashion, off-road design, and eco-friendly technology, this stunning two-seater coupe pushes the boundaries of what's possible in automotive and fashion innovation.

The collaboration between Mercedes-Benz, Maybach, and Virgil Abloh first took shape as a way to celebrate Abloh's visionary design approach while pushing the boundaries of luxury, eco-conscious design, and automotive innovation. The late Abloh, known for his eclectic blend of high fashion and avant-garde concepts, had previously collaborated with Mercedes-Benz on "Project Geländewagen," which reimagined the iconic G-Class. That success led to the creation of *Project MAYBACH,* a one-of-a-kind electric show car created to celebrate non-traditional design in a car that could still handle the great outdoors.

The result of this partnership was a striking 2-seater, battery-electric coupe that blended Maybach's luxurious elegance with an adventurous, off-road design. Measuring almost six meters in length, the Project MAYBACH features large off-road-friendly wheels, a sleek two-tone color scheme, and solar panels under the front hood to increase range. Sleek, rectangular headlights are housed in angular frames that seamlessly integrate into the body, giving the vehicle a strong,

futuristic presence. A continuous light bar runs across the roof, serving as both a functional top light and a striking visual accent that enhances the car's cutting-edge feel. The promotional campaign for the car further reinforced its futuristic vibe, with images of the vehicle scaling rugged, otherworldly terrain. On the first reveal at the Rubell Museum in Miami during Art Week in December 2021, the response to the car's "electric luxury" was overwhelming, with both the automotive and fashion worlds praising the innovative fusion of style and technology. Abloh's collaboration with Mercedes-Benz went even further, with a limited-edition Maybach S-Class featuring bespoke design details like sand-colored leather interiors and unique MBUX technology. Only 150 units of Project MAYBACH were produced, and they quickly sold out (Jay-Z is among one of the cars' rumored owners). Additionally, Abloh designed a limited collection in partnership with Off-White™, offering exclusive apparel and accessories that mirrored the design elements of the car.

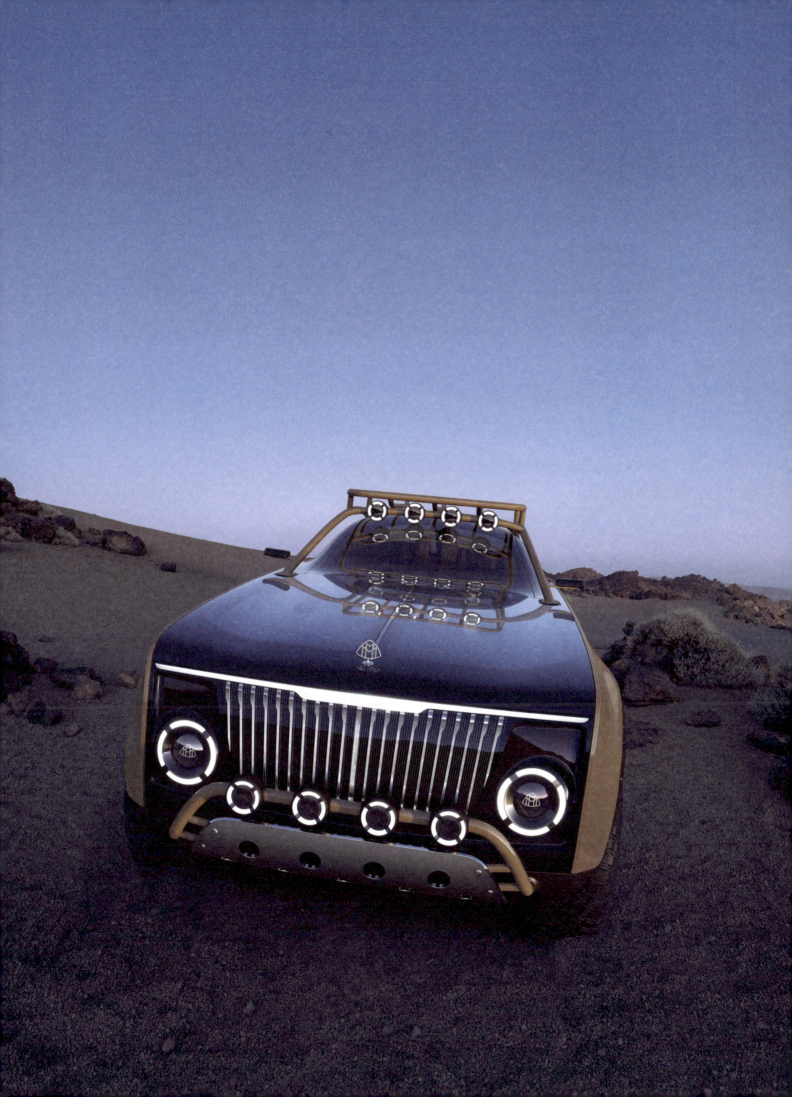

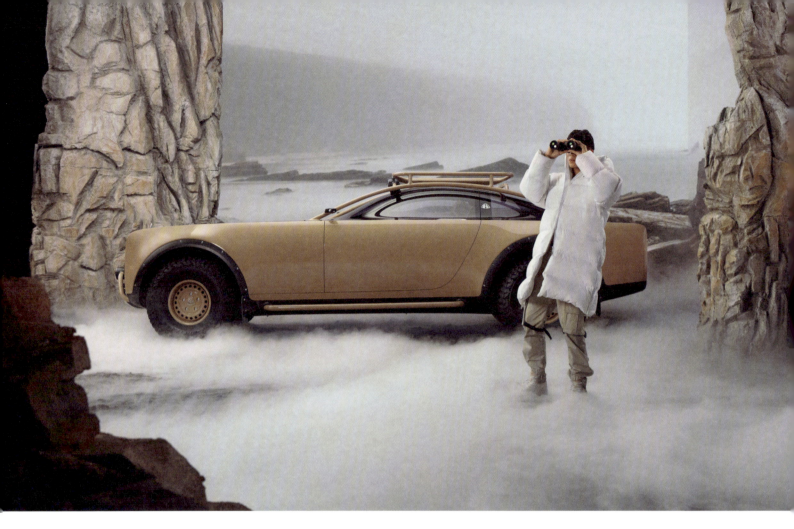

THE COLLABORATION FIRST TOOK SHAPE AS A WAY TO CELEBRATE VIRGIL ABLOH'S VISIONARY DESIGN APPROACH

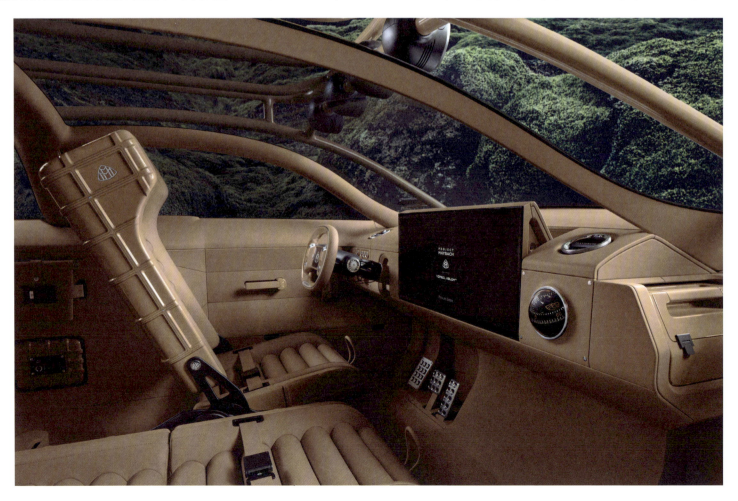

WHILE PUSHING THE BOUNDARIES OF LUXURY, ECO-CONSCIOUS DESIGN, AND AUTOMOTIVE INNOVATION.

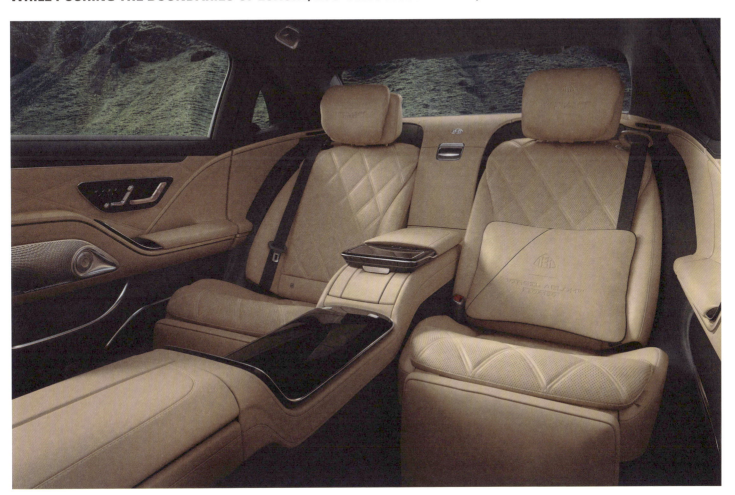

THE AUTOMOTIVE AND FASHION WORLDS PRAISED THE INNOVATIVE FUSION OF STYLE AND TECHNOLOGY.

A Bold Intersection of Streetwear and Performance

PALACE

The iconic streetwear brand Palace and automotive legend Mercedes-Benz come together in a surprising collaboration that transforms the G-Class into a high-performance art car. Merging the worlds of skating and driving, the limited-edition vehicles reimagine luxury through bold graphics, custom details, and a shared spirit of rebellion.

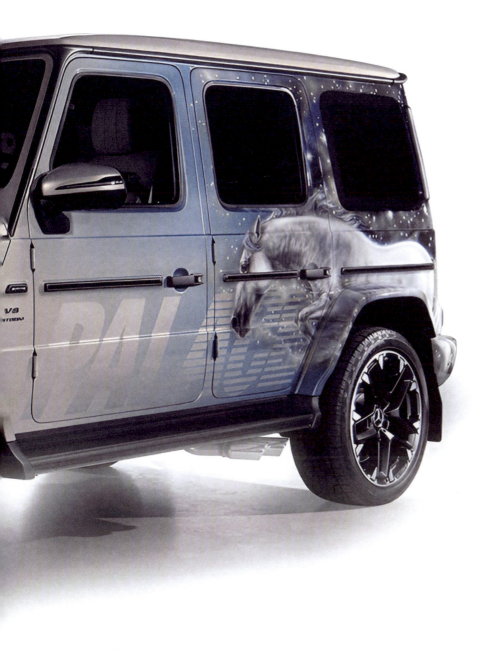

MERCEDES-BENZ

When Palace, the London-based streetwear brand known for its irreverent aesthetic, decided to team up with Mercedes-Benz, the result was a collaboration that was as unexpected as it was thrilling. Founded in 2009, Palace has established itself as a leader in the streetwear world, fusing skate culture with high-fashion sensibilities and earning a reputation for playful subversion, often incorporating humor and nostalgic references into its designs. For Mercedes, this ethos was ideal. Known for their precision engineering and the heritage prestige of their brand, they were eager to reach a younger, more urban demographic—those whose cultural influence extended beyond the traditional high society. Palace, on the other hand, was no stranger to mixing the playful and the prestigious. With past collaborations that included heavy-hitters like adidas and Ralph Lauren, they were practiced in taking the formal and making it feel casual, sometimes even cheeky. The partnership seemed like kismet and resulted in a 23-piece clothing line.

 The collaboration culminated in 2022 with a limited-edition series of Art Cars. Inspired by London, Los Angeles, New York, and Tokyo, the Art Cars reimagine the iconic Mercedes G-Class and other models through the lens of Palace's signature blend of nostalgia, humor, and graphic design. The G-Class, a model already known for its rugged elegance, was transformed with vivid colors, intricate Palace logos, and abstract patterns that seemed to simultaneously mock and embrace the iconography of luxury. The vehicles were fitted with custom interiors, including embroidered seat patterns and exclusive stitching designed by Palace, ensuring that even the smallest elements reflected the brand's unmistakable touch.

 What's most striking about the Art Cars is how they speak to a deeper connection between skaters and drivers, two subcultures that share a passion for speed, precision, and rebellion. Both groups understand the thrill of pushing limits—whether on four wheels or two—and share a sense of freedom and personal expression in their vehicles, whether a car or a skateboard. By turning a Mercedes into a canvas, Palace has crafted a vision of what happens when art and engineering are driven by a shared desire to break the mold.

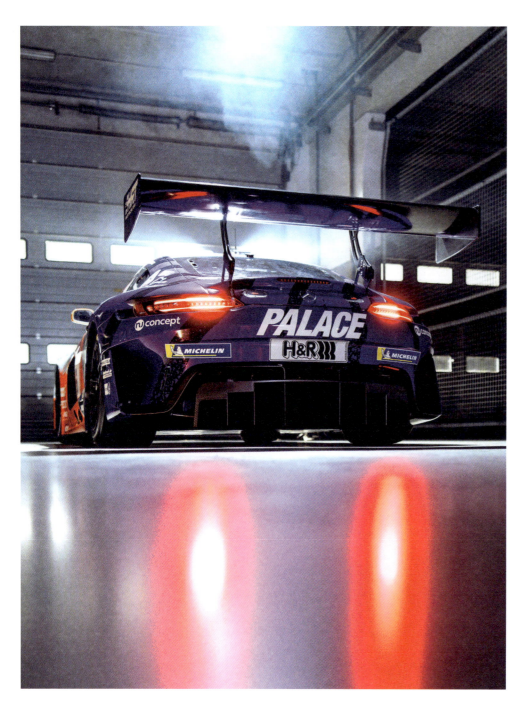

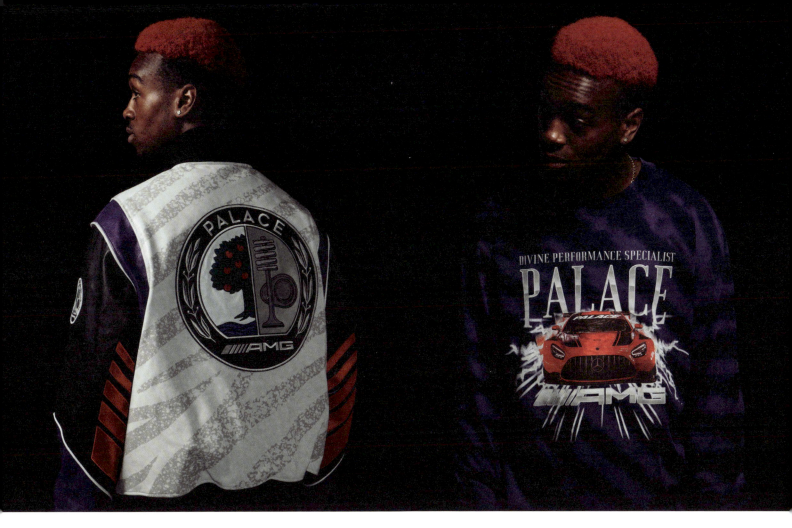

THE LIMITED-EDITION VEHICLES REIMAGINE LUXURY THROUGH BOLD GRAPHICS AND CUSTOM DETAILS.

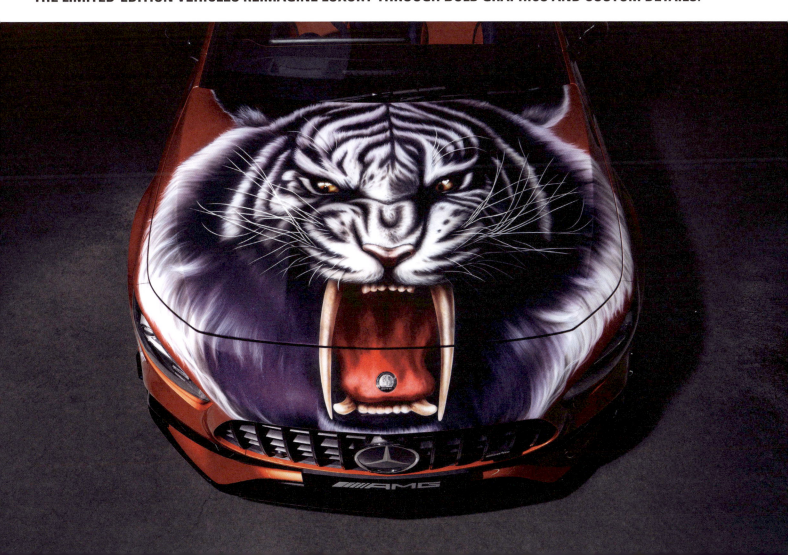

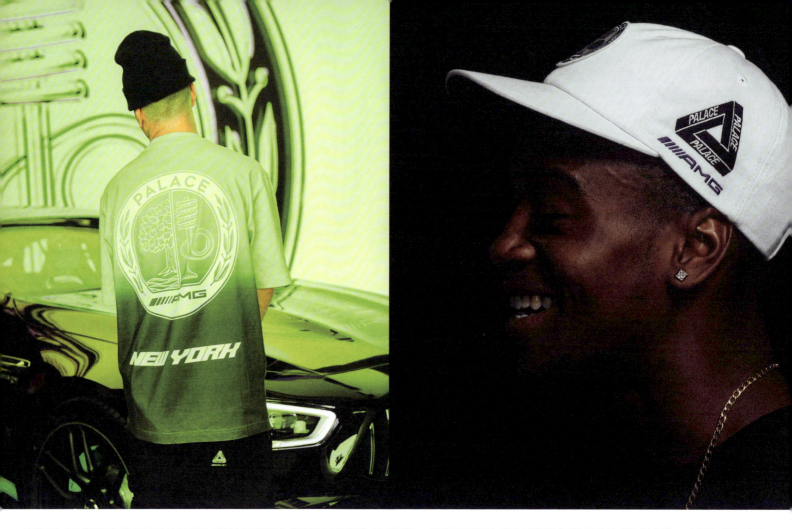

BOTH GROUPS UNDERSTAND THE THRILL OF PUSHING LIMITS—WHETHER ON FOUR WHEELS OR TWO—AND SHARE

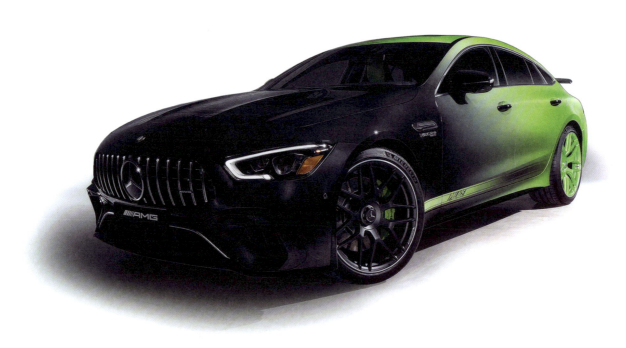

PALACE X MERCEDES-BENZ

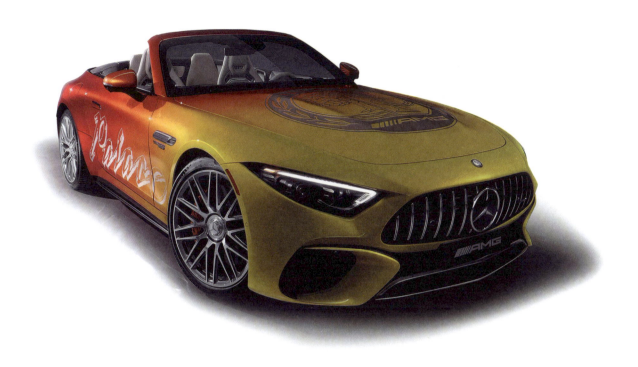

A SENSE OF FREEDOM AND PERSONAL EXPRESSION IN THEIR VEHICLES, WHETHER A CAR OR A SKATEBOARD.

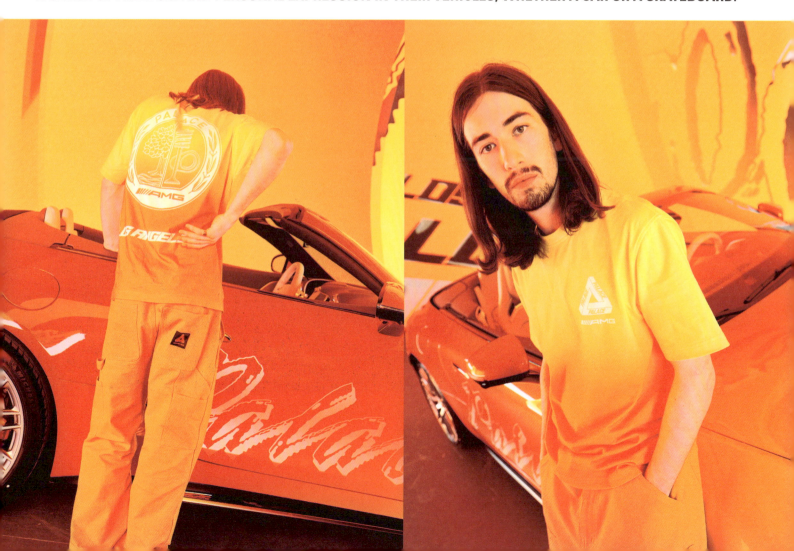

A Custom Porsche 993 Turbo Inspired by the Designer's Roots

AIMÉ LEON DORE

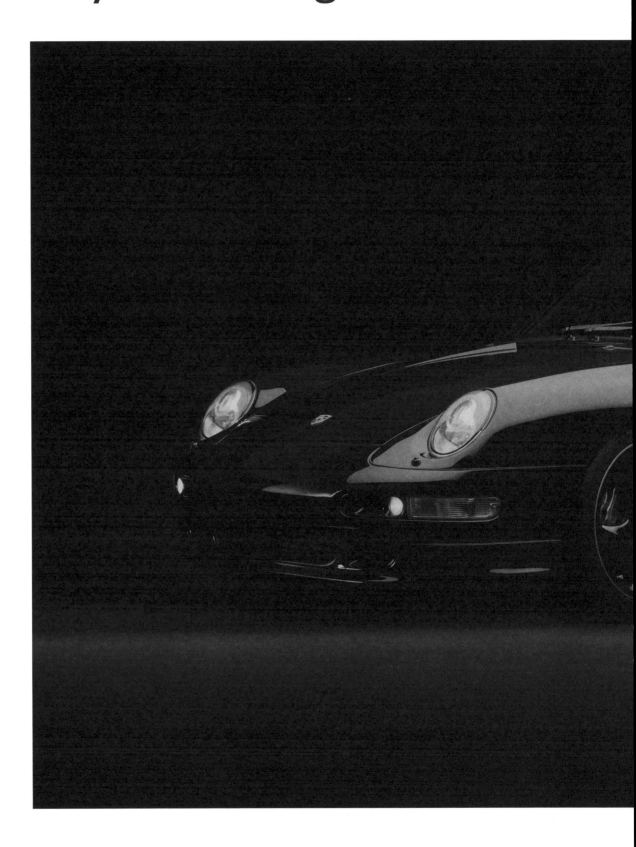

The New York-based brand's latest collaboration with Porsche blends classic automotive design with tailored finishes, featuring a bespoke Turbo and an exclusive capsule collection that pays tribute to Queens, New York.

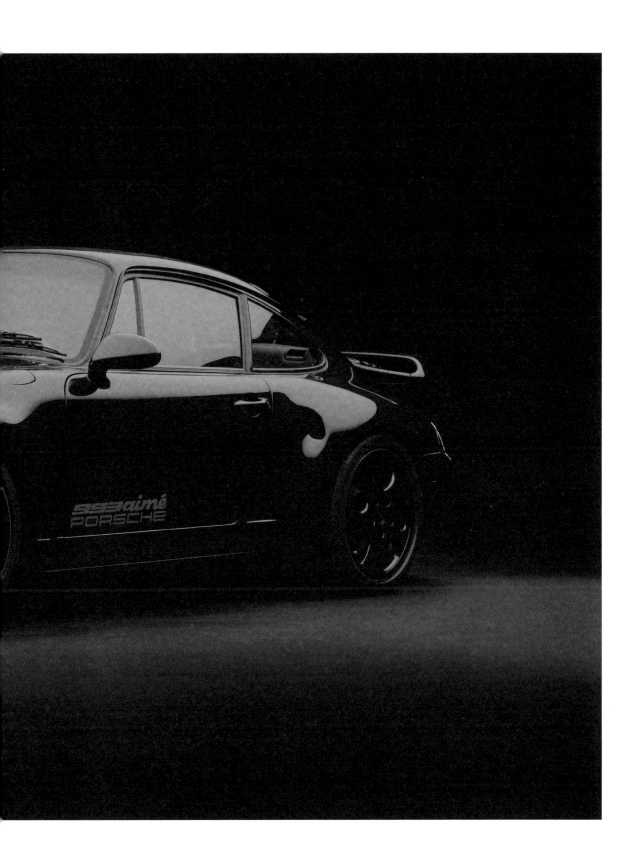

PORSCHE

AIMÉ LEON DORE X PORSCHE

Aimé Leon Dore (ALD), the New York-based fashion and lifestyle brand, has long been celebrated for its seamless fusion of classic and contemporary styles. Their collaboration with Porsche, a brand synonymous with precision engineering and timeless design, began in 2020 with the restoration of a Porsche 964 Carrera 4. This partnership has since blossomed into a series of bespoke restorations, each reflecting the unique sensibilities of both brands.

The latest iteration of this collaboration is a custom Porsche 993 Turbo, unveiled in November 2024. This one-of-a-kind vehicle pays homage to New York City, particularly Queens, the birthplace of ALD. The exterior is finished in Mulberry Green, a signature color developed by ALD over the years. This rich hue is complemented by 18-inch Porsche Turbo Twist rims, also in Mulberry Green with gold accents, and Michelin Pilot Sport PS2 tires. Aerodynamic enhancements include the iconic Turbo S spoiler, front splitter, and exhaust system, all sourced from the 993 Turbo S model. Inside, the car exudes luxury with dark brown leather upholstery, lambswool accents, and hardback seats. The seat backrests are painted in—you guessed it—Mulberry Green, echoing the exterior. In a nod to the Unisphere landmark in Queens, the car features a custom brass gear knob fashioned after the iconic sculpture. This isn't the only Queens reference, though: the door sills feature the inscription, "A team from outta Queens with the American dream," a distinctive reminder of ALD's NYC roots.

To complement the car, ALD released an exclusive capsule collection, including apparel and accessories such as a leather duffle bag, driving gloves, and the coveted Leather Club Jacket. Upon its release, the collaboration was met with acclaim from both automotive enthusiasts and fashion aficionados. Deniz Keskin, Director of Brand Management and Partnerships at Porsche AG, expressed his enthusiasm for the collab, stating, "The 993 is an iconic member of the [Porsche] 911 family and the dream car for so many enthusiasts all around the world. ALD's take is a wonderful way of contributing to that enduring legacy."

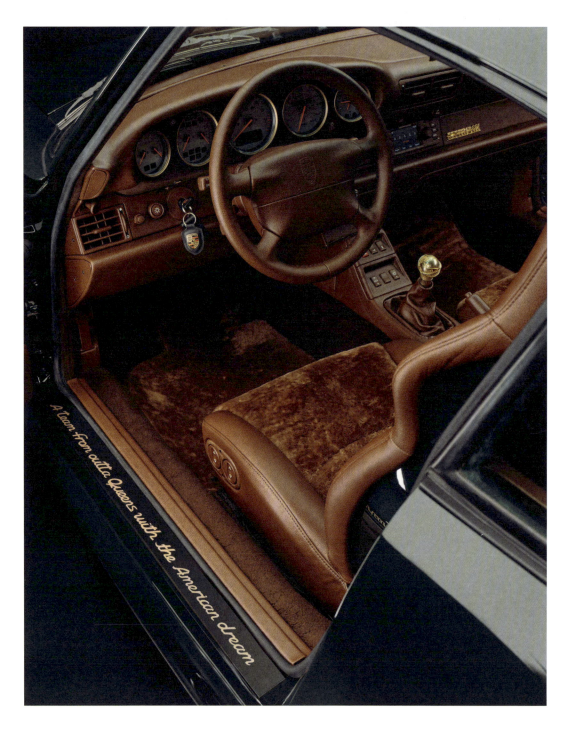

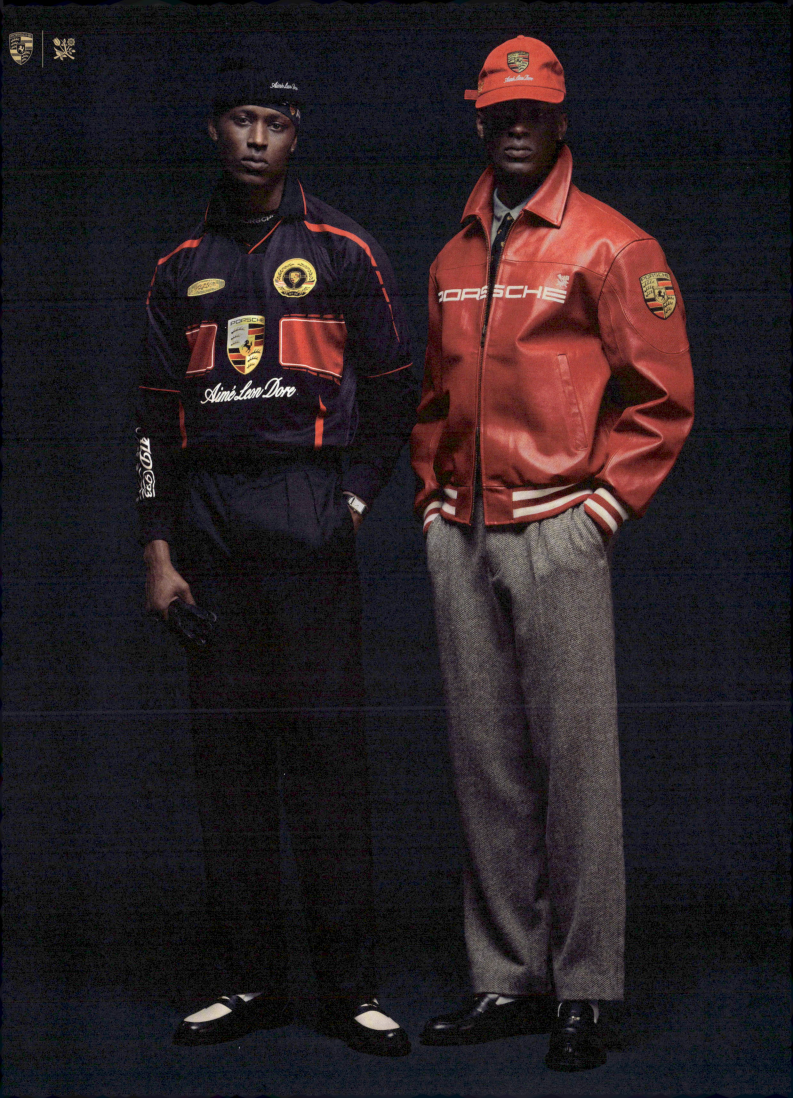

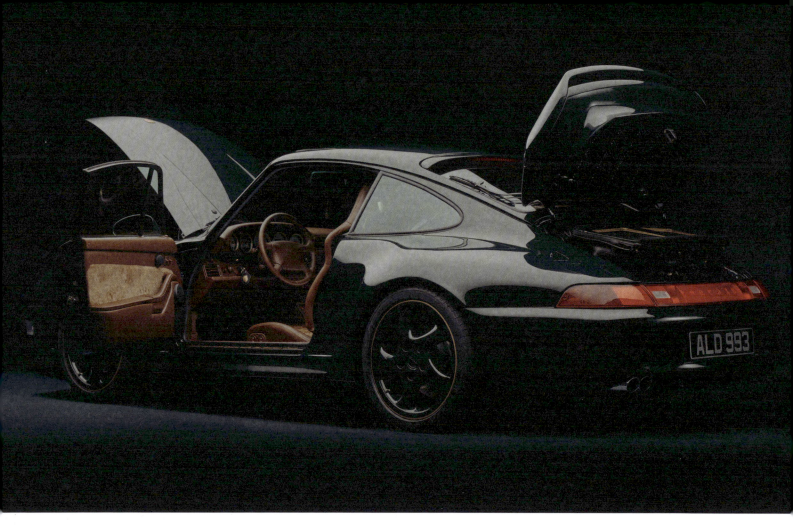

TO COMPLEMENT THE CAR, ALD RELEASED AN EXCLUSIVE CAPSULE COLLECTION, INCLUDING APPAREL AND

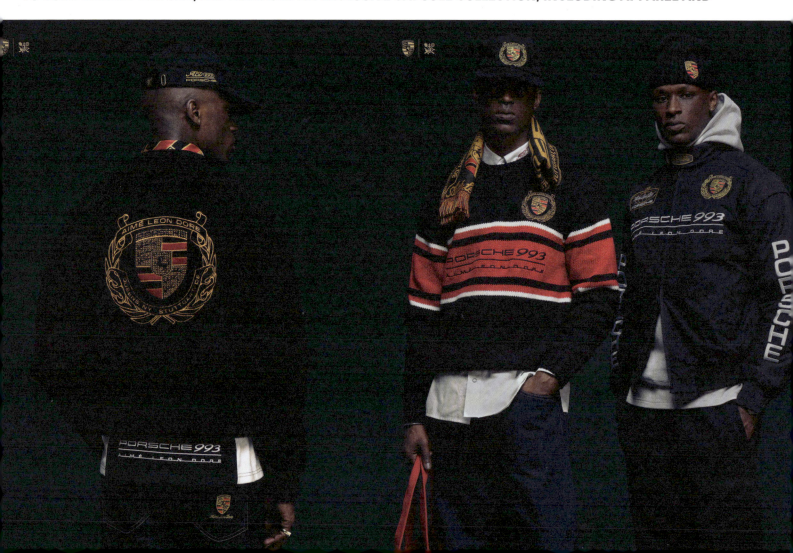

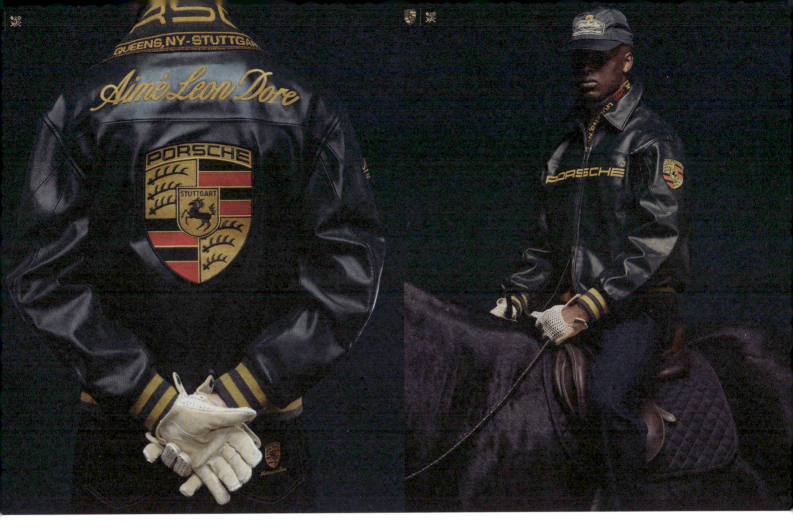

ACCESSORIES SUCH AS A LEATHER DUFFLE BAG, DRIVING GLOVES, AND THE COVETED LEATHER CLUB JACKET.

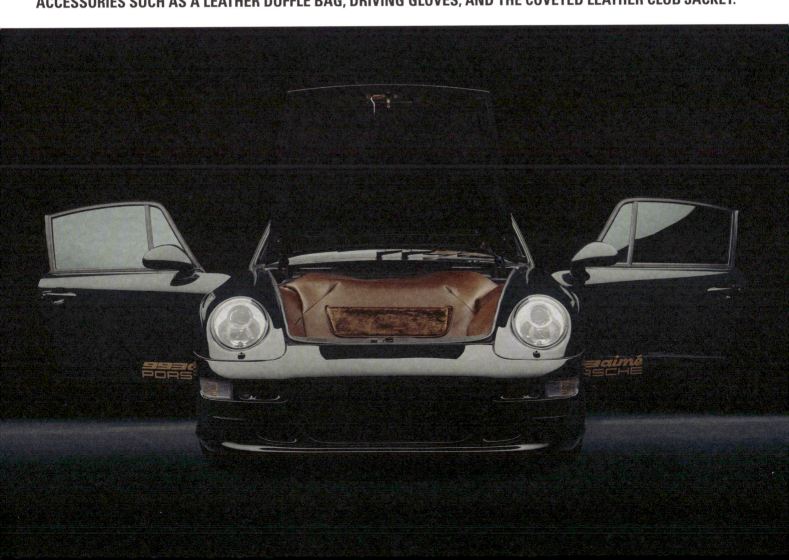

The Designer's Bespoke Defender Blends Color Blocking with an Adventurous Spirit

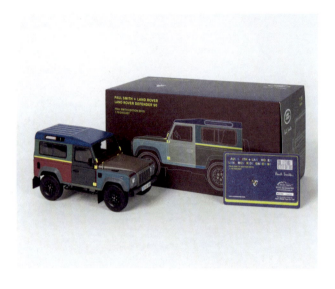

PAUL SMITH **X** **LAND ROVER**

The British designer's custom vehicle transforms the Land Rover Defender with a mix of custom colors, luxurious interiors, and playful details, celebrating the car's final year of production.

The Land Rover Defender is an iconic British 4×4 known for its rugged durability, off-road capabilities, and spirit of adventure. First launched in 1948, its boxy design and reliable performance have made it a favorite among thrill-seekers, military forces, and outdoor enthusiasts around the globe. Among these dedicated fans was designer Paul Smith, who was drawn to the car's rugged charm and versatility. In 2015, after owning several Defenders over the years, Smith decided to take things to the next level: that year he joined forces with Land Rover's Special Vehicle Operations (SVO) team to create a bespoke version of the iconic car, blending his unique aesthetic with the vehicle's legendary design.

The resulting vehicle featured an exterior painted in a camouflage-esque patchwork of 27 individual colors, each carefully selected by Smith. For the palette, he drew inspiration from the British countryside and the historic military Defenders, selecting deep, rich tones, which he then offset with bright accents of cobalt blue and Chartreuse yellow. The end result is as surprising as it is cohesive—a tour de force of color blocking. To achieve his vision, Smith personally provided the SVO team with custom Pantone references, ensuring that each color was mixed specifically for this vehicle. Playful yet refined touches like a hand-painted bee on the roof or the image of a set of keys printed inside the glove compartment reflected Smith's attention to detail and wit. A custom Paul Smith fascia replaced the traditional Defender clock, adding a contemporary flair to the classic design.

The collaboration, unveiled at Smith's Mayfair store in London, served as a fitting tribute to the Defender as it entered its final year of production. The bespoke model also sparked a broader interest in limited-edition Defenders, with Land Rover unveiling three other special models that year. To further celebrate the iconic vehicle, the partnership extended to a collectible, die-cast miniature version, allowing Defender enthusiasts to display a piece of history at home, adding another layer to this distinctly British tribute.

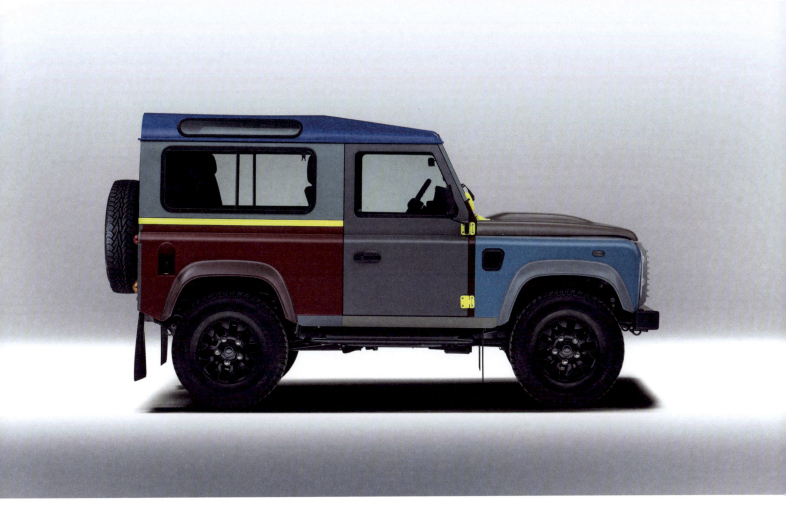

THE END RESULT IS AS SURPRISING AS IT IS COHESIVE — A TOUR DE FORCE OF COLOR BLOCKING.

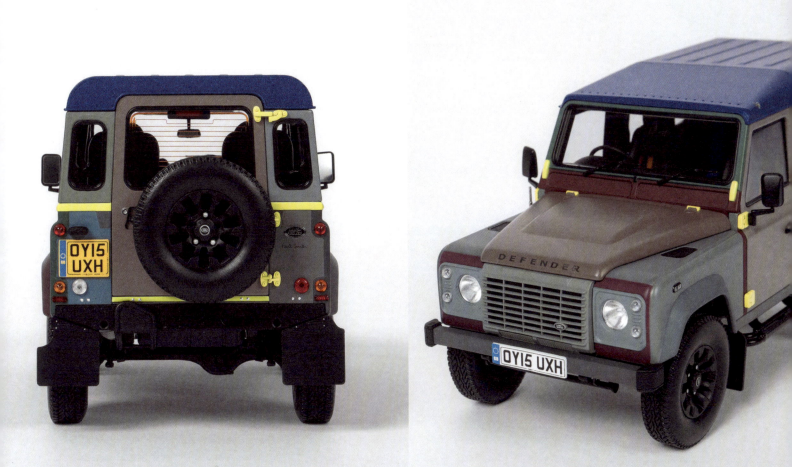

An Artistic Masterpiece in Motion

BMW

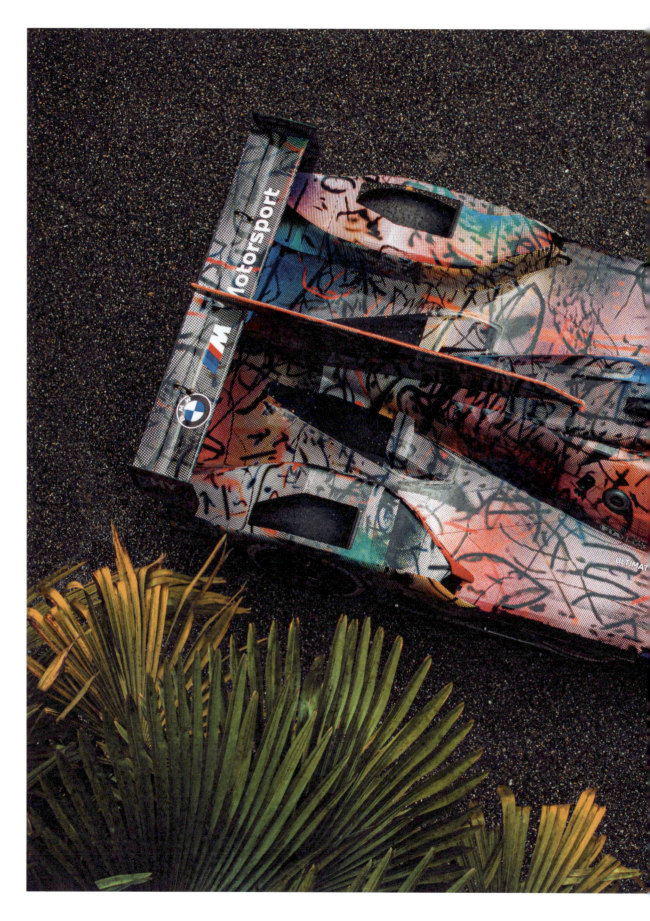

BMW X JULIE MEHRETU

In May 2024, Julie Mehretu's striking design for the BMW M Hybrid V8 debuted at the Centre Pompidou in Paris, merging high-performance with abstract artistry.

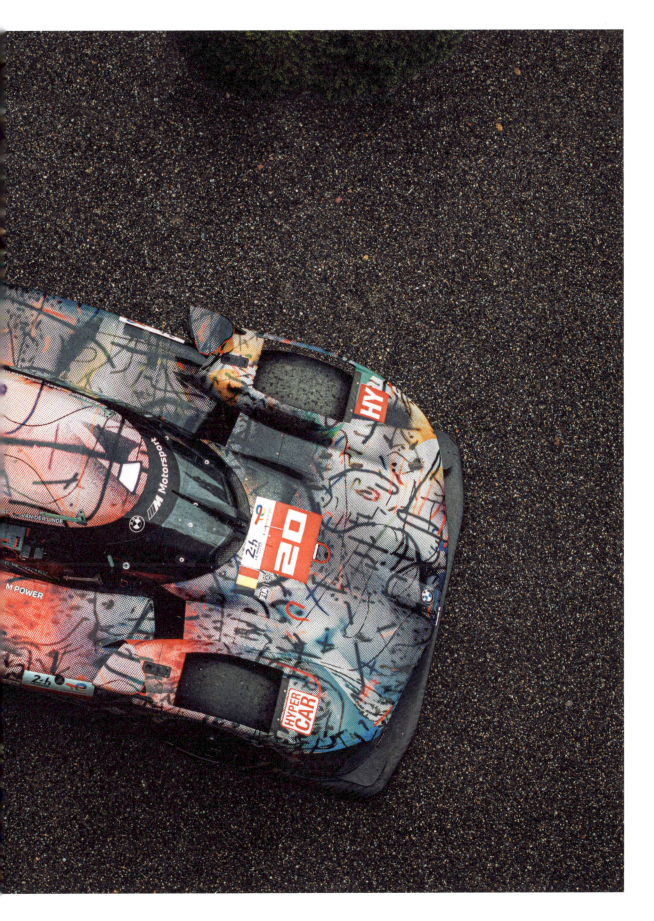

JULIE MEHRETU

BMW's storied Art Car series reached a new milestone with Julie Mehretu as the 20th artist to transform a race car into a canvas. A far cry from traditional sculptures, Mehretu's work on the BMW M Hybrid V8 race car is a dynamic fusion of her abstract artistic vision and BMW's cutting-edge engineering. Known for her large-scale, layered compositions, Mehretu brought her signature abstract forms—geometric lines, swaths of color, and dynamic shapes—to the sleek surface of the M Hybrid V8. More importantly, the collaboration was meant to facilitate a larger commitment to art, bringing art workshops to various locales in Africa and exhibitions at the Zeitz Museum of Contemporary Art in Cape Town, South Africa.

Mehretu's approach uniquely blended performance and art, with the knowledge that the car would eventually be tasked with racing in Le Mans. The design, inspired by her painting *Everywhen* incorporates vibrant colors and a sense of movement that mirrors the car's high-speed capabilities. The wrap, used to ensure the car's aerodynamic integrity and compliance with racing regulations, became the perfect medium to translate her vision into reality. The bold shapes and dramatic color schemes interact with the car's contours in ways that are visually arresting yet purposeful for the high-speed machine.

The car was first unveiled at the Centre Pompidou in Paris, marking the debut of both the car and Mehretu's work on a global stage. The collaboration was then shown at Frieze Seoul, further cementing the international reach and cultural impact of the BMW Art Car series. Mehretu saw the piece as living and breathing through its existence, noting that "the BMW Art Car is only completed once the race is over."

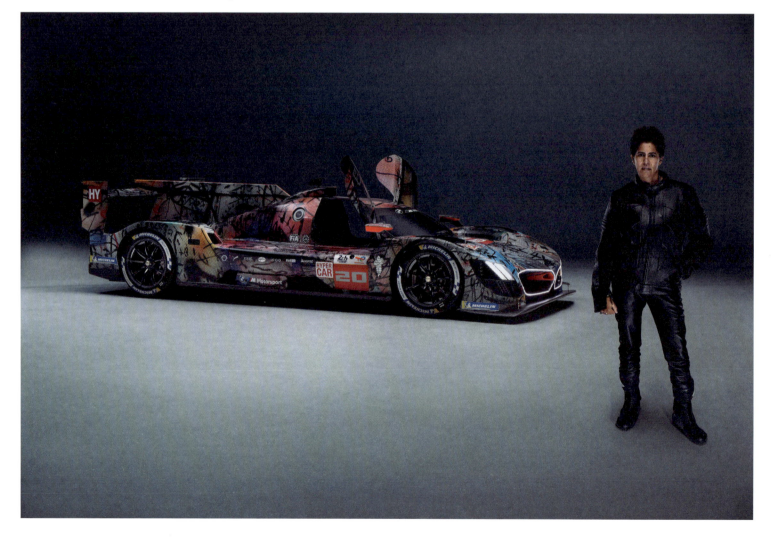

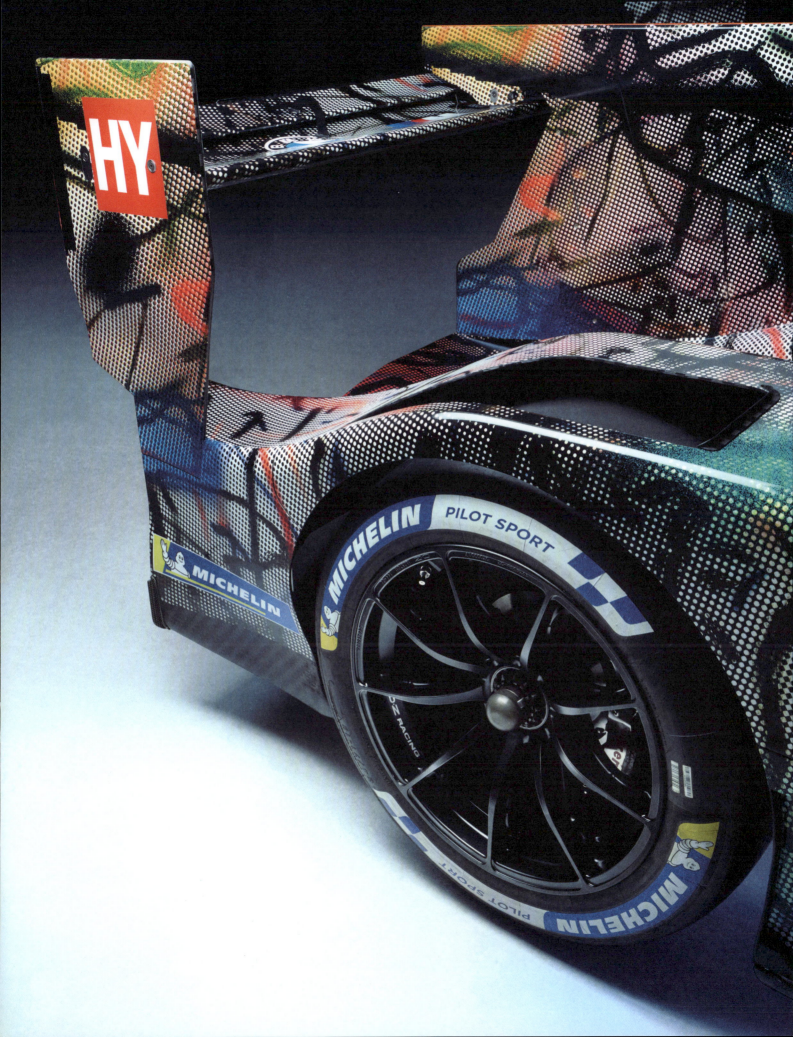

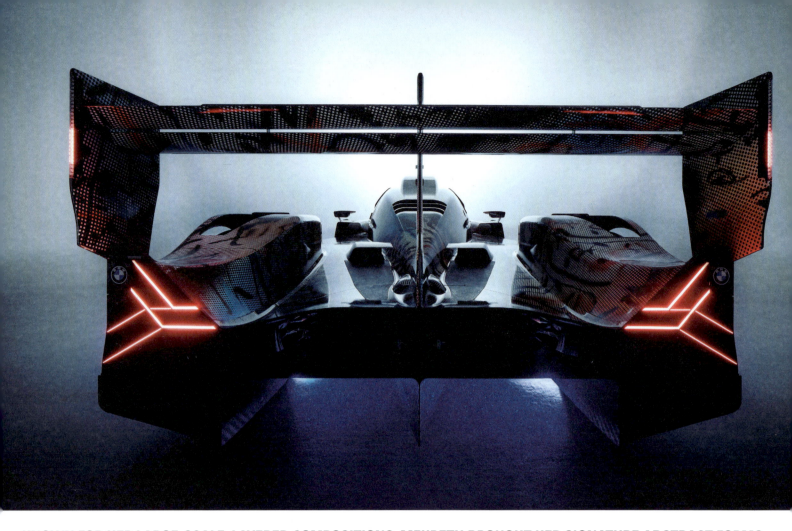

KNOWN FOR HER LARGE-SCALE, LAYERED COMPOSITIONS, MEHRETU BROUGHT HER SIGNATURE ABSTRACT FORMS

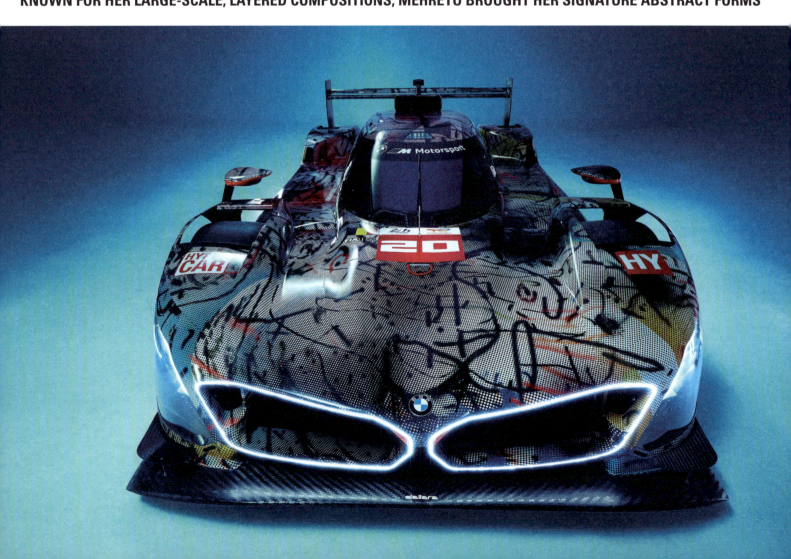

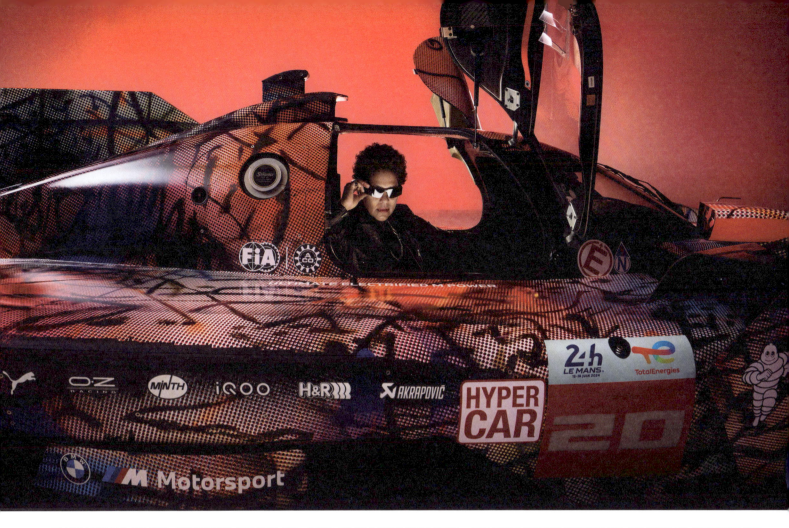

—GEOMETRIC LINES, SWATHS OF COLOR, AND DYNAMIC SHAPES—TO THE SLEEK SURFACE OF THE M HYBRID V8.

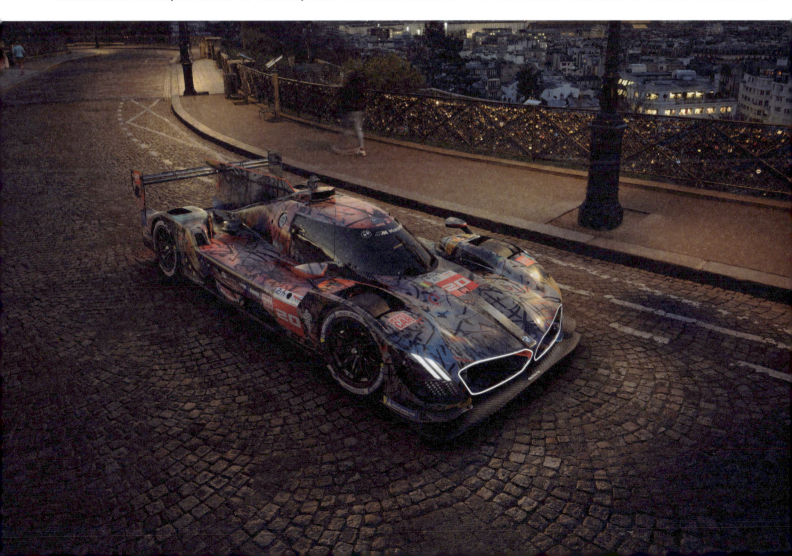

The Ultimate Fusion of Art and Engineering

BMW

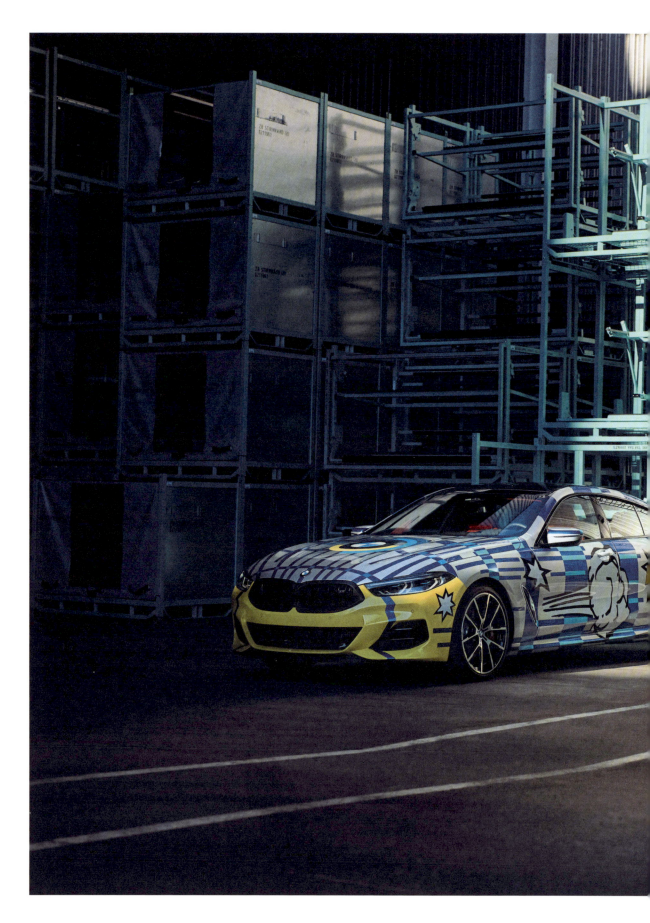

When BMW and Jeff Koons joined forces in 2022 for their second collaboration, the result was more than just a car—it was a limited-edition, rolling work of pop art.

JEFF KOONS

When BMW and Jeff Koons decided to team up, the result was something far more spectacular than just another luxury car. Unveiled in February 2022, their collaboration gave birth to THE 8 X JEFF KOONS, a limited-edition series consisting of 99 BMW M850i xDrive Gran Coupes. Each car became a unique, rolling piece of pop art, fusing Koons's vibrant, explosive color schemes with BMW's cutting-edge engineering.

Koons, known for his bold, graphic style, approached the car like a canvas. Unlike static sculptures, designing a car meant considering not just the visual impact, but also how it would perform. For his collaboration, Koons transformed each car into a mobile piece of art, using up to 11 colors and intricate geometric patterns that flowed seamlessly across the car's exterior while preserving its aerodynamic integrity. The rear design, in particular, draws from Koons's previous BMW Art Car from 2010, with the word "POP!" emblazoned on both sides, capturing the car's essence of speed, power, and artistic energy.

The craftsmanship behind THE 8 X JEFF KOONS is just as impressive as the visual punch it delivers. Each vehicle required hundreds of hours of painstaking paintwork, a process that blended the world of fine art with high-performance automotive design. The meticulous design process ensured the paintwork not only looked striking but also adhered perfectly to the vehicle's performance standards.

As a testament to this collaboration's wider relevance, one of the cars, signed by Koons himself, was auctioned off at Christie's, with proceeds going to a charity for missing and exploited children. The car made its public debut at New York's Rockefeller Plaza, before the limited-edition models made their way to private owners. In every sense, THE 8 X JEFF KOONS is a perfect fusion of art and engineering, proving that a car can be as much a statement of creativity as it is of performance.

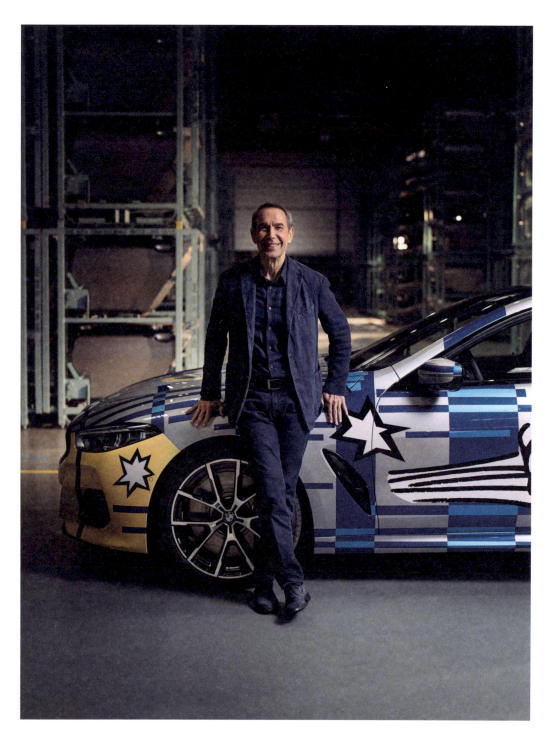

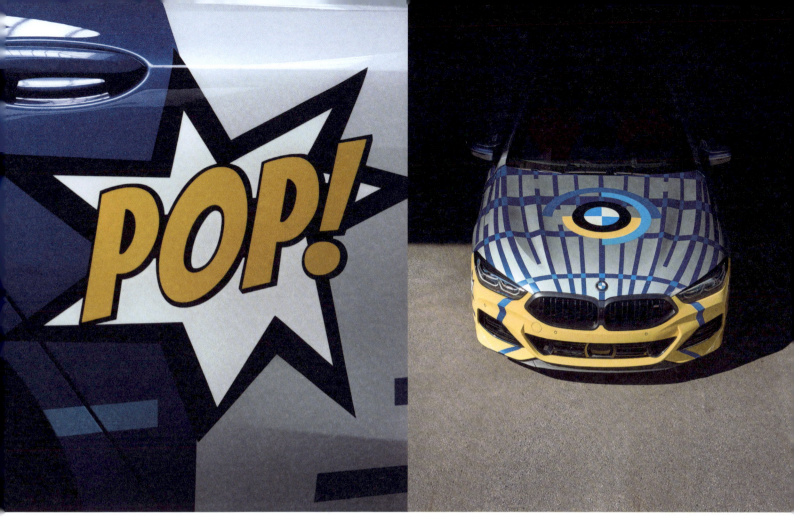

WITH KOONS' VIBRANT, EXPLOSIVE COLOR SCHEMES, EACH CAR BECAME A UNIQUE, ROLLING PIECE OF POP ART.

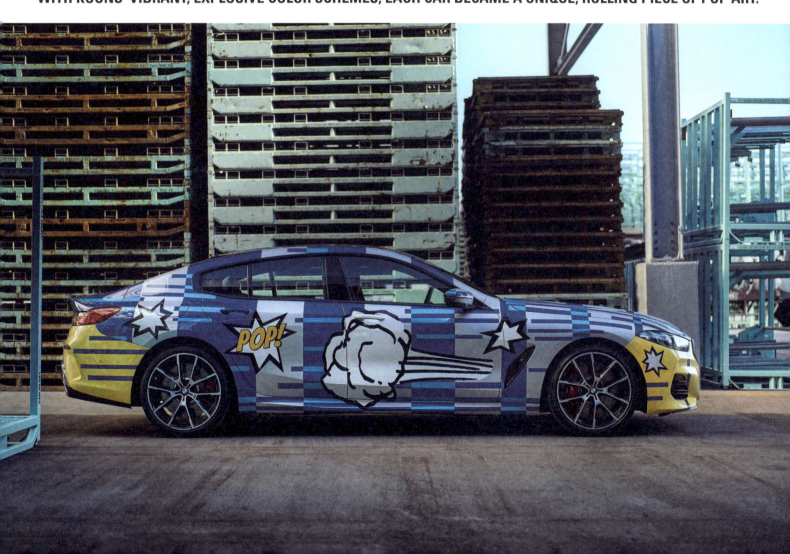

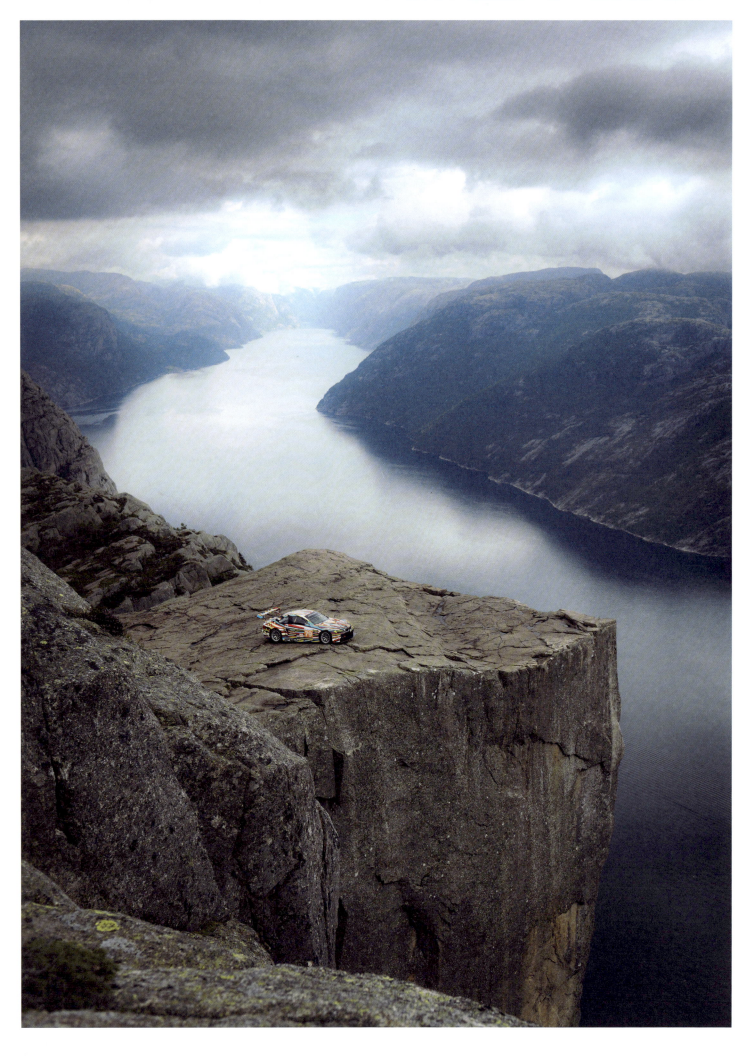

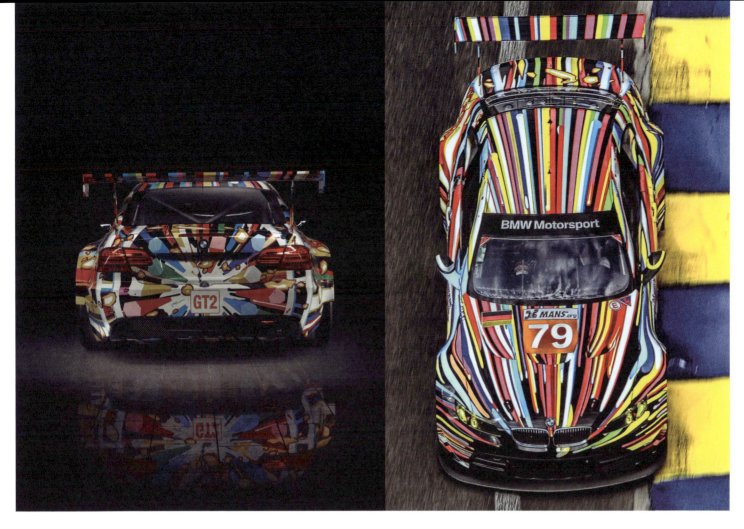

DESIGNING A CAR MEANT CONSIDERING NOT JUST THE VISUAL IMPACT, BUT ALSO HOW IT WOULD PERFORM.

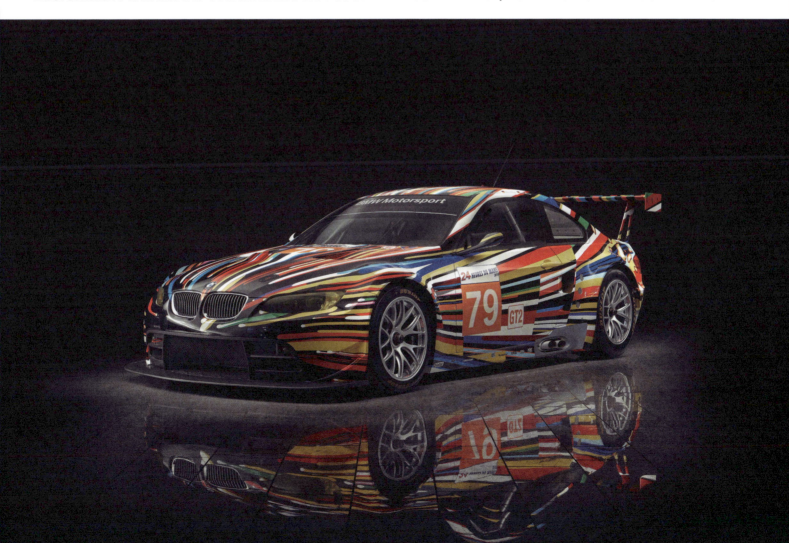

Brewing Up a High-Performance Espresso Machine

PORSCHE **X** **LA MARZOCCO**

This brand collaboration delivers a sleek, powerful espresso machine that combines automotive precision with expert coffee craftsmanship.

If you're someone who starts your day with a shot of espresso and ends it speeding down the freeway, Porsche and La Marzocco made your morning routine a whole lot faster—and a lot more stylish. Launched in October 2024, this collaboration brings together two brands known for quality, innovation, and sleek design. The result: a compact, yet powerful espresso machine that evokes the high-performance characteristics of Porsche sports cars.

Many of the design elements on the reimagined La Marzocco Linea Micra were directly inspired by some of Porsche's most iconic models. Subtle touches like the twist handles for the steam wand and hot water dispenser are reminiscent of the Porsche drive mode switch, and the magnetic drip tray and cup warmer echo the color scheme of the Porsche 911 GT3 with Touring Package. The analog pressure gauges are designed to resemble Porsche speedometers, and the anodized aluminum used in the rotary handles and portafilter exudes a modern, automotive aesthetic. The machine also features black hexagonal socket screws, adding to its sleek, refined look.

Crafted for espresso enthusiasts, the machine combines powerful technology with La Marzocco's signature quality. As a dual-boiler model, it allows for precise control of brewing temperature and steam pressure, ensuring a flawless coffee experience. The Linea Micra's compact size, rapid heat-up time, and easy operation made it a hit. The special edition was introduced at multiple events, including a pop-up café launch in Los Angeles and the Shanghai Coffee Festival, bringing together coffee and car aficionados who crave a high-octane experience.

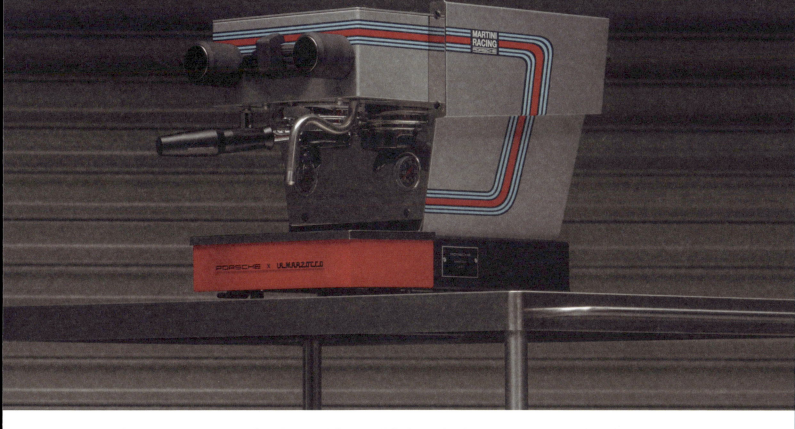

AN ESPRESSO MACHINE THAT EVOKES THE HIGH-PERFORMANCE CHARACTERISTICS OF PORSCHE SPORTS CARS.

A Playful, Affordable Take on the Iconic Moonwatch

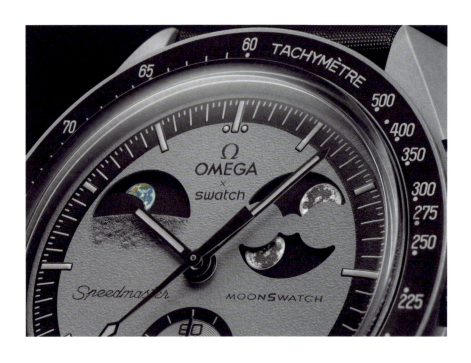

OMEGA **X** **SWATCH**

The MoonSwatch collection blends space exploration heritage with vibrant design, making a piece of history accessible for all.

In 2022, Omega and Swatch surprised the watch world with an unexpected collaboration that fused Omega's iconic Moonwatch with Swatch's colorful, accessible designs. The result was the MoonSwatch, a space-themed collection that reimagined the legendary Omega Speedmaster Moonwatch—worn by astronauts during the Apollo 11 mission—in a more affordable, playful format. The original Omega Speedmaster is a symbol of precision and history, but its high price tag often kept it out of reach. Swatch, known for its affordable and stylish timepieces, became the perfect partner to bring a more budget-friendly version to a wider audience.

The MoonSwatch collection features 11 models, each inspired by a different planet in our solar system. Made from durable, lightweight Bioceramic, these watches combine Omega's precision with Swatch's vibrant, pop-culture aesthetic. While maintaining the signature chronograph look of the original Moonwatch, the watches are reimagined with bold colors and playful details. The space theme is at the heart of the collaboration, with each watch named after a celestial body, from the striking red Mars model to the bold, blue and yellow Saturn. Each of the 11 models is unique, evoking the endless wonders of space.

The watches also incorporate key details like the tachymeter scale and subdials with chronograph features, along with distinctive details like Swatch and Omega branding, circular dial patterns, and luminous elements for a unique, otherworldly aesthetic. Later editions feature a light gray Bioceramic case and a textured gray dial that evokes the lunar surface, complete with a moon phase and patented earth phase function. Its sleek design includes oversized moons with Super-LumiNova, glowing oceans under UV light, and a tribute to Neil Armstrong's footprint on the Moon.

The MoonSwatch collaboration was a smash hit, selling out almost immediately and creating buzz worldwide for blending high-end heritage with playful, accessible design. It brought together two of the most iconic names in the watch industry and made space exploration a little bit closer.

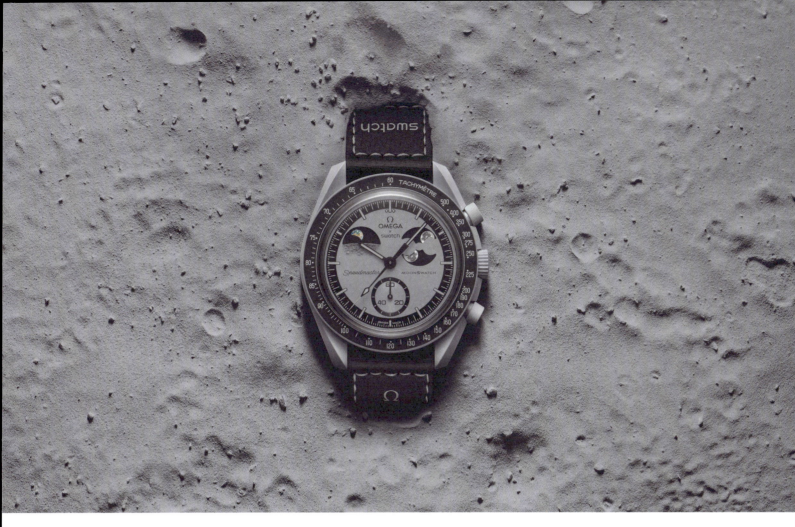

A COLLABORATION THAT FUSED OMEGA'S ICONIC MOONWATCH WITH SWATCH'S COLORFUL, ACCESSIBLE DESIGNS.

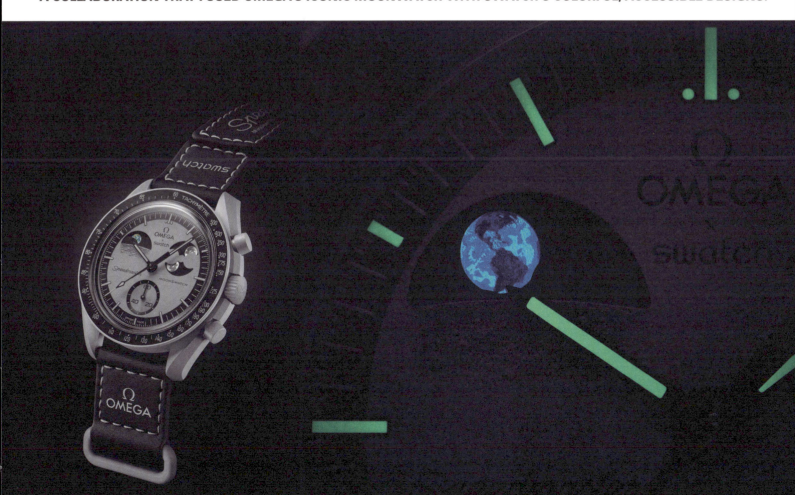

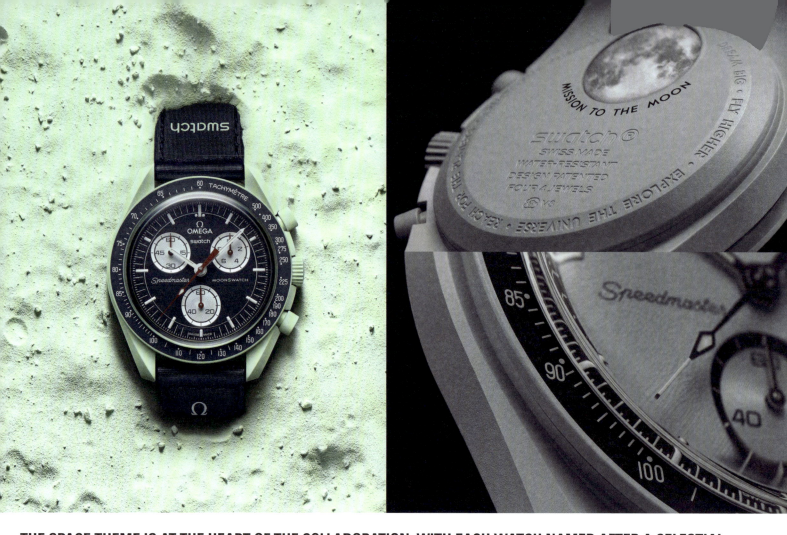

THE SPACE THEME IS AT THE HEART OF THE COLLABORATION, WITH EACH WATCH NAMED AFTER A CELESTIAL

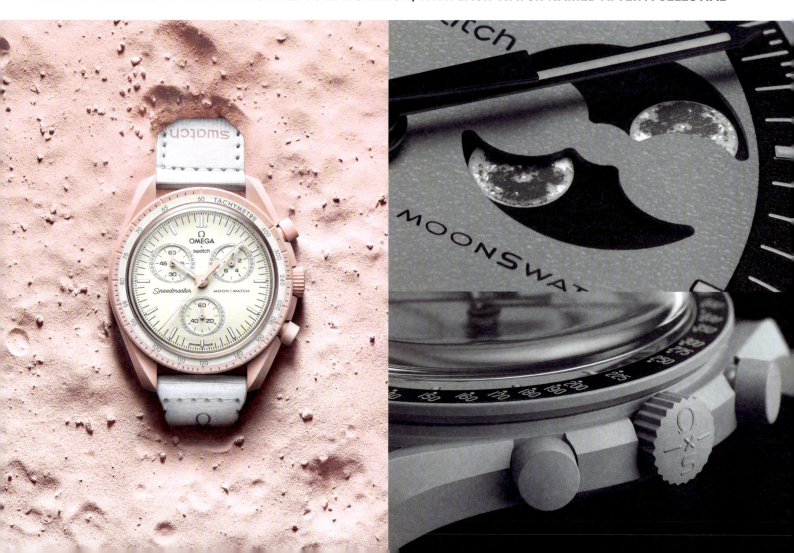

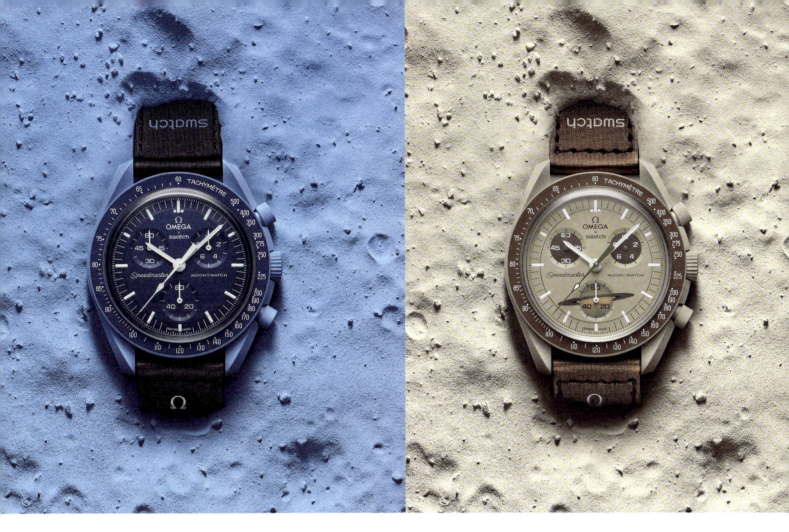

BODY, FROM THE STRIKING RED MARS MODEL TO THE BOLD, BLUE AND YELLOW SATURN.

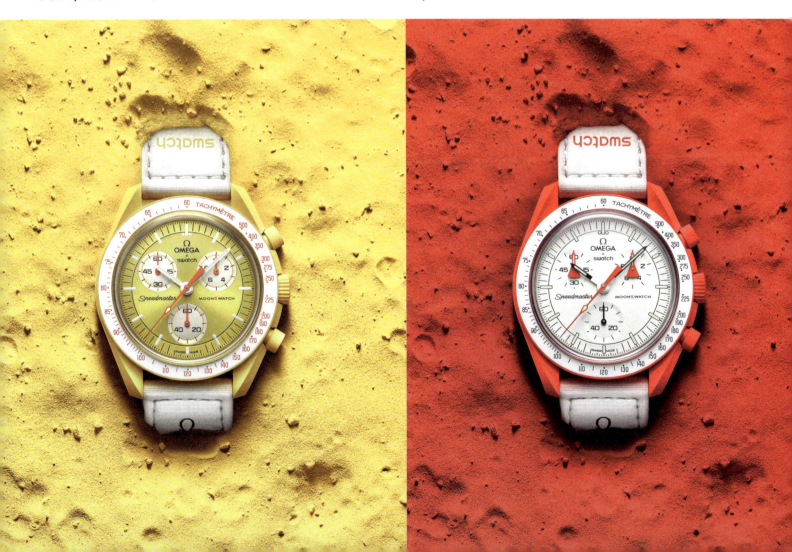

URL to IRL: The Future of Collaboration

270

Louis Vuitton Spring/Summer 2016, Paris

Global superstar Travis Scott is known for his concerts that not only draw the crowds, but feel like a million-person mosh pit. His performances have always toed a volatile line between being a welcome place to expel bottled-up youthful energy, and hardcore punk shows where many audience members expect to come home bloodied after catching a stray elbow to the face. But whereas dynamic punk shows often attract a niche audience who know what to expect, Travis Scott is a bona fide A-list celebrity, and that type of hard-hitting concert isn't meant for the masses. His Astroworld festival went down in infamy in November 2021 after an unfortunate crowd crush incident left eight people dead at the scene, with two more dying in the hospital due to injuries shortly after. But even before then, Scott had a penchant for stoking a crowd's craziest impulses, like an April 2017 birthday performance at New York City venue Terminal 5, where an attendee jumped from a second-level balcony to the cheering crowd below, breaking a leg in the process but earning special recognition from Scott, who gifted him a ring worth thousands of dollars as the fan was wheeled out of the venue on a stretcher. As Scott raps on his hit single "Antidote," indeed: "Anything can happen at the night show."

And although attending one of Scott's live shows is laced with the risk of bodily harm, hundreds of thousands of eager fans still flock to his concerts for the thrill and spectacle of it all. But there was at least one of Scott's performances where almost certainly no one was hurt, and it was arguably his most exciting and innovative performance to date. It didn't necessarily involve intricate stagecraft—although he's certainly pushed those boundaries with animatronic birds, dystopian tribal rock formations, and roller coaster-inspired

into digital costumes that looked surprisingly at home in a video game. This digital tie-in with *Fortnight* was fitting, considering Demna's collection debuted with an interactive custom video game of its own, titled *Afterworld: The Age of Tomorrow*. Players could explore a virtual world, peruse pixelated racks of a virtual Balenciaga flagship store, and gawk at NPCs dressed in the latest collection, turning fashion into a game during a time when traditional fashion shows were not feasible.

The use of a video game as a medium for a fashion show exemplified how brands could adapt to changing circumstances and consumer behaviors by embracing digital platforms. It also highlighted the potential for immersive experiences to showcase products in a way that traditional formats cannot. But it also signaled a shift in how consumers engage with products and celebrities. The democratization of fashion isn't just about accessibly priced collaborations with mass market brands like Uniqlo, Target, and H&M, but also about making brands relatable to different audiences and communities. Louis Vuitton and Dior were able to court sneakerheads and streetwear enthusiasts through their partnerships with Nike, Jordan Brand, Supreme, and Shawn Stüssy, but working with emerging platforms like video games, television shows like *The Simpsons*, and storied production companies like anime powerhouse Studio Ghibli not only endears a brand to an unlikely audience, but serves to add a welcome dose of personality to a label.

For Louis Vuitton creative director Nicolas Ghesquière's Spring/Summer 2016 collection, there were plenty of references to anime shows like *Sailor Moon* and *Neon Genesis Evangelion,* as well as video game franchises like *Final Fantasy*. So it was fitting that Lightning, the fiercely fashionable,

AS WITH ANY COLLABORATION, WHAT SELLS A SUCCESSFUL PARTNERSHIP IS THE AUTHENTICITY OF IT ALL.

stage designs—nor did it involve booking a physical venue. And yet, the five-day performance netted a total of 12.3 million attendees, even though global lockdown mandates had most of the world catching cabin fever indoors. That's right, one of Travis Scott's biggest performances took place virtually in April 2020, when he took over the massively popular multiplayer shooting game *Fortnite* for his "Astronomical" show, a live event that invited the game's global community of players to tune in and turn up for an interactive experience that was replete with its own kind of digital concert merch.

While the game itself has been free-to-play since it was released in 2017, it's created a unique economy around outfits and digital products that allow for a limitless degree of customization, with its community of over 650 million players converting real money into the in-game V-Bucks currency to get limited-edition goodies that range from Nike sneakers to Balenciaga outfits, or, in the case of Travis Scott, exclusive outfits, a digital version of his highly sought-after Jordan sneakers (for much less than the retail price of the physical versions), and a custom "emote" that lets players recreate the viral moment of him shaking a microphone stand over his head. As of 2023, *Fortnite* has managed to generate over $20 billion in revenue in selling these kinds of in-game wearables.

But it's also led to real-life interpretations of in-game gear, like Balenciaga hoodies and tees emblazoned with the game's logo, commanding luxury price tags of over $1,200 for a hoodie. Meanwhile, items inspired by a number of Balenciaga collections including Fall 2021, went on sale as in-game outfits, turning runway grails like the armor-inspired boots and glaives

pink-haired protagonist from *Final Fantasy XIII,* was cast as the face of its "Series 4" campaign. This partnership showcased Louis Vuitton's willingness to embrace digital culture and appeal to a younger, tech-savvy demographic. By featuring a digital character in its campaign, Louis Vuitton challenged traditional notions of brand ambassadorship and highlighted the potential of virtual influencers in fashion marketing.

Beyond static, high-gloss images, the campaign included rich visuals of Lightning modeling the latest collection, and even went as far as having the character conduct an interview with London-based newspaper *The Telegraph* to further flesh out the unique partnership. For his part, Ghesquière not only made his genuine appreciation for video games and anime apparent—lending him a certain geeky, off-beat appeal—he went on to describe Lightning as "the perfect avatar for a global, heroic woman and for a world where social networks and communications are now seamlessly woven into our life."

As with any collaboration, what sells a successful partnership is the authenticity of it all. Ghesquière's genuine love for anime and video games made what could seem like a hokey marketing stunt feel elevated and mutually appreciative. Travis Scott's larger-than-life concerts set the stage for his virtual *Fortnite* takeover and the digital mayhem that ensued.

Even forward-thinking innovators like Hideo Kojima, the Japanese game designer often considered a true *auteur* of video games, has cultivated a unique community of collaborators and confidantes who show up across projects like *Death Stranding*. Kojima's longtime relationship with conceptual apparel designer Errolson Hugh of ACRONYM stems from

a camaraderie built on like-mindedness. Hugh's highly technical garments are intricately considered and engineered with no shortage of utilitarian details. Likewise, Kojima's games are known for subverting tropes and introducing novel mechanics while subconsciously sending players very prescient social commentary that clearly comes from Kojima's unique understanding of global politics and technological shifts. So when the two collaborate on a capsule collection of clothing inspired by one of Kojima's games or when Kojima digitizes Hugh and casts him in a virtual cameo, it essentially amounts to a very layered wink-and-nod.

There has been no shortage of successful collaborations in the gaming community, like 2017's *Gran Turismo* collaboration featuring custom car skins designed by Undefeated, A Bathing Ape, and Anti Social Social Club (whose founder Andrew Buenaflor—better known as "Neek Lurk"—happens to be a car collector), with coordinating IRL apparel collections to match. Meanwhile, *Fortnite* continues to court many fashion collaborators from Ralph Lauren to Nike, whose digital wearables continue to be in high demand in the game. And then there's one of the most unexpected successes in the fashion/video game space, which emerged from *Roblox*, an aesthetically lo-fi game with blocky graphics and LEGO-like characters.

Like *Fortnite*, *Roblox* is a massively popular online multiplayer game. Its audience tends to skew significantly younger, and the game's world is divided into different "Experiences" that each have a specific environment and rules of play. One such Experience is called Dress to Impress, and was designed by a user mononymously known as Gigi who began working on it when she was just 14—which means that

Of course, some companies are cutting out the gaming community entirely and going straight to the source: anyone with a social media account. Technology and fashion have always tried to feed off each other's energy. Both are industries heavily reliant on selling new products by convincing consumers that what they currently have is in dire need of an update. Previously, these partnerships focused on hardware collaborations like 2007's Prada Phone by LG, and Samsung's collaborations with labels like Maison Margiela and Thom Browne. Apple had a good track record of eschewing these seemingly flash-in-the-pan collabs, knowing that its brand cachet in and of itself was enough to sell its industry-leading phones, tablets, and computers. Yet it broke the mold when it made an earnest attempt to break into wearables with the Apple Watch, choosing a collaborative fashion partner in Hermès, a luxury label known for its equally uncompromising standards.

But increasingly, as we saw with *Roblox* and *Fortnite,* the emphasis is less on merging tech and fashion in the real world, and more on helping consumers express themselves in the so-called metaverse. In 2014, independent company Bitstrips launched its cartoonish Bitmoji app, which allowed users to create virtual avatars for use across text messages and social media. It was acquired in 2016 by Snapchat to the tune of $100 million, and its offerings expanded to include digital fashion from brands like Carhartt, Nike, Prada, Off-White™, and Levi's. Using real-world money, users could purchase these brands' digital garments for their avatars to wear. Not to be outdone by the competition, Meta's Mark Zuckerberg tapped his own fashion consigliere Eva Chen on a series of high-profile partnerships with Prada, Thom Browne, and Balenciaga, which

THE USE OF A VIDEO GAME AS A MEDIUM FOR A FASHION SHOW EXEMPLIFIED HOW BRANDS COULD ADAPT

she was around 16 or 17 when it fully launched in November 2023. The game pits players against each other in a fashion competition, where they are all given a theme and 325 seconds to style an outfit. When time runs out, players are judged by their peers in a real-time fashion show, and whoever gets the most votes wins the round.

Dress to Impress was one of the fastest *Roblox* Experiences to reach one billion visits—a number that doubled in less than a year. It became a favorite of popular video game livestreamers like Kai Cenat and Pokimane, YouTubers like James Charles, and even celebrities like Madison Beer, who credited the game with helping her mental health. Its simplicity and community-oriented aspect made it a favorite among numerous communities, and it even launched a collaboration with Charli XCX to help promote her 2024 album *brat,* whose bright-green cover became a viral sensation itself.

The popularity of *Roblox's* Dress to Impress is helped by the fact that one doesn't necessarily need an expensive game console to play it. You could download the *Roblox* app on your phone and, like *Fortnite,* enjoy an entirely free-to-play experience without spending a dime. But like *Fortnite's* V-Bucks, *Roblox* also employs an in-game currency of Robux to augment the user experience and buy premium cosmetics and higher-tier statuses. The success of these platforms is proof that purchases in a digital world are often informed by the very same tastes (and insecurities) that drive physical fashion and luxury shopping IRL: it isn't enough for some people to just be part of a community, some are willing to pay that extra price for something that feels just a bit more exclusive.

meant that users across all of Meta's platforms didn't just get to show off their latest fit pics on Instagram, but could also dress their avatars in similarly high-end duds. The result is a digital landscape where consumers can emulate at least one aspect of the one percent: a fragmented wardrobe. Only instead of their luxury wardrobes living in multiple homes or across several continents, they are split between different social platforms.

As collaboration culture continues to evolve, new trends are emerging that will shape its future. Brands are exploring unconventional formats, embracing technology-driven innovations and redefining what ownership and value mean. RTFKT Studios, a digital fashion and collectibles company, has been at the forefront of merging fashion with technology. One of the more prominent beneficiaries of the COVID-era boom for Non-Fungible Tokens (NFTs), RTFKT stood out by creating collectibles rooted in the aesthetics of sneakers and streetwear, but opting for models that weren't just mock-ups of physical shoes, but fantastical works that took inspiration from superhero armor, high-performance cars, surrealist art, and video game graphics and gave them a wholly new appeal. Their collaboration with 18-year-old artist FEWOCiOUS in February 2021 resulted in the release of virtual sneakers priced between $3,000 and $10,000. The collection sold out within minutes, generating $3.1 million and highlighting the burgeoning market for digital fashion. Collaborations with high-profile artists like Takashi Murakami and sneaker industry figures like Jeff Staple gave them even more credibility in both spaces—so much so that, by December 2021, the company was acquired by Nike for an undisclosed sum.

Opposite, top: RTFKT billboards in Times Square, New York, 2020
Opposite, bottom: Fortnite and Travis Scott present: Astronomical

TO CHANGING CIRCUMSTANCES AND CONSUMER BEHAVIORS BY EMBRACING DIGITAL PLATFORMS.

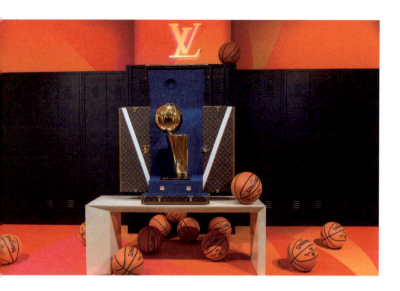

As part of that initial Nike acquisition, RTFKT led the way into so-called "phygital" collaborations, which blend physical and digital products. The RTFKT x Nike partnership, for instance, combines sneakers with NFT technology, creating virtual assets that can be traded or worn in the metaverse, or redeemed for a physical product whose legitimacy could be verified on the blockchain. It set a new stage for what wearables could be, and a potential way for the sneaker resale market to continue to combat fakes.

Moreover, the rise of NFTs presents opportunities for brands to offer exclusive digital assets that consumers

THE RISE OF NFTS PRESENTS OPPORTUNITIES FOR BRANDS TO OFFER EXCLUSIVE DIGITAL ASSETS THAT

can own and trade. These digital collectibles can serve as modern-day status symbols, much like luxury handbags or limited-edition sneakers. By 2022, Nike had launched its . SWOOSH (pronounced "Dot-Swoosh") platform dedicated to the Web3 space, signifying the brand's commitment to embracing blockchain technology to enhance consumer engagement. By incorporating RTFKT's innovations into the platform, such as allowing customers to buy, trade, and wear digital versions of their products, Nike not only added a new, interactive layer to the consumer experience, it also opened new revenue streams through the sale of digital merchandise. Here, the metaverse represents another frontier for collaboration, pointing to a future where collabs are not just about products but about immersive, multidimensional interactions.

On the flipside, Web3 has already seen some volatility. Just three years after being acquired by Nike, RTFKT announced it would be ceasing operations in early 2025, and the .SWOOSH rollout tying physical products to online blockchain transactions has not been a smooth process. Not only is this due to technical hiccups, but likely the regulatory nightmare that is seemingly just beginning to unfold as multiple world governments and private companies contemplate how they could possibly regulate a completely alternate economy. That said, at least once cryptocurrency has not only bounced back from what many thought would be a final crash, it has been surging to new levels. Time will tell how this new movement will pan out, but it's evident there is as much to be terrified of as there is reason for excitement when it comes to implementing a solid Web3 strategy at scale.

Perhaps that's why many traditional luxury companies are looking at alternate ways to expand their footprint into the experiential. While many brands have happily explored new technological frontiers and digital products as a way of building awareness and acquiring a new audience, some have gone in a completely analog direction. LVMH has staked its claim to becoming a pop cultural brand, not just by working with global artists like Pharrell Williams to creatively helm Louis Vuitton's men's output, but also through partnerships with sporting events like the NBA Championships, the FIFA World Cup, and the 2024 Olympics in Paris. The custom Louis Vuitton trophy cases and bespoke trunks holding the Olympic medals propelled the brand to new aspirational heights, aligning its rich heritage with some of humanity's greatest physical achievements. It also elevated the perception of sports as a cultural touchstone, demonstrating how fashion can pay homage to an audience's shared passions.

In the same manner that a post-COVID boom has led to the return of packed sporting events, this has inspired a new era of travel and lifestyle, inspiring brands and hospitality companies alike to work together in new ways. By 2026, Louis Vuitton plans to open its first-ever hotel in Paris. Taking over an old office building on the Champs-Élysées, architects completely concealed the construction site behind what appears to be a giant Louis Vuitton trunk, redefining the storied street in an eminently recognizable way while the world waits to see what's currently transpiring inside. Vuitton is following in the footsteps of labels like Ralph Lauren and Restoration Hardware, two American lifestyle brands who have successfully expanded into the realm of hospitality with lauded restaurants, and in the case of Restoration Hardware, its first hotel opened in the heart of the Meatpacking District in New York City. The purveyor of upscale American housewares has since announced plans to expand the concept into other parts of America and the English Cotswolds, giving the brand an even more luxurious air.

Hotels have always been about more than just a place to sleep—the rise of boutique hotels and membership clubs like Soho House, Ace Hotel, Casa Cipriani, and The Standard proved that travelers are willing to pay a premium for spaces that feel culturally relevant and creatively designed. Streetwear and fashion brands entering this space are rewriting the rules of hospitality. This is the same ethos that informed Kith's expansion into restaurants beyond its successful Kith Treats concept. Building off of previous partnerships with Major Food Group, founder Ronnie Fieg has leveraged his longtime friendship with Jeff Zalaznick to open outposts of its famous Sadelle's restaurant in Miami, Paris, and Toronto, giving foodies and sneakerheads something in common—creating a hyped-up experience in a place where it previously didn't exist.

Similarly in 2021, Pharrell Williams teamed up with David Grutman to open The Goodtime Hotel in Miami, a 266-room Art Deco-style property with plenty of pink pastel accents which perfectly aligns with Pharell's candy-colored aesthetics. It also marked the debut of NIGO's partnership with Blue Bottle Coffee. Consisting of two unique coffee blends and a small capsule collection of apparel, the product release dovetailed with the introduction of a Blue Bottle Cafe inside NIGO's own Human Made Offline Store in Shibuya, Tokyo.

For non-coffee drinkers, one interesting start-up in the caffeinated space is Rocky's Matcha, the brainchild

Top: Louis Vuitton x NBA Trophy Case
Opposite: The Goodtime Hotel, Miami Beach

CONSUMERS CAN OWN AND TRADE. THESE DIGITAL COLLECTIBLES CAN SERVE AS MODERN-DAY STATUS SYMBOLS.

of Rocky Xu, a longtime industry confidante and the collaborative mastermind at Beats by Dre. After speaking with a shaman who advised him to slow down on his coffee intake, Xu began exploring how to make matcha, and eventually used his own industry contacts and previous partnerships with brands like sacai, designers like Kiko Kostadinov, artists like Tom Sachs, and culinary figures like the Ghetto Gastro crew to become the go-to matcha purveyor of the industry cool guy set.

Meanwhile, Sporty & Rich founder Emily Oberg has grown a large online presence with posts that show her, among other things, traveling the world and taking selfies in some of the world's most exclusive hotel rooms. So it isn't surprising to see some of her leisure-fashion label's newest collaborations include capsule collections and events with establishments like the Sunset Tower in Los Angeles, Hotel du Cap-Eden-Roc in Antibes, France, and The Carlyle Hotel in New York City. In elevating the timeless elegance and old-money appeal of these luxurious mainstays, Sporty & Rich infuses them with a new relevance and youthful energy. Importantly—it brings awareness to an audience that, even if they can only currently afford the merch, now aspires to stay at these storied places.

The influence of collaboration culture has even reached the automotive realm, where several collaborations have made headlines and become sought after by high-end car collectors. One of the earliest examples was in 1978, when Lincoln launched a Continental MkV coupe customized by Givenchy. That same year, American manufacturer Cadillac upped the ante with its collaborative Seville with Gucci. Conceived by Gucci family heir Aldo Gucci, the luxury car was

But as the hype cycle shifted in the mid-2000s, consumers who had grown up with streetwear and sneakers as their primary modes of go-to style choices also found their own tastes evolving and buying habits shifting. The timing aligned so that perhaps someone who grew up buying Kith sneakers would probably be interested in a Kith BMW. At the same time, high-end carmakers began working with luxury brands at a faster clip. In 2006, there was a white Lamborghini Murciélago with the Versace Medusa emblazoned on the side, limited to just 20 cars. In 2011, Maserati's GranCabrio Fendi debuted at the Frankfurt Motor Show, with 50 cars produced in a special Grigio Fiamma Fendi shade of gray—featuring a unique iridescent gold effect, developed in partnership with Silvia Venturini Fendi to combine the house's signature yellow and grey colors. Yet it wasn't until 2020 that the convergence of car culture and collaboration culture hit a brand new stride.

Teddy Santis's Aimé Leon Dore label quickly became a favorite of streetwear enthusiasts when it launched in 2014. Known for its visually rich lookbooks and elegant storytelling abilities, it channeled the aspiration of 1990s Ralph Lauren with the everyday wearability and casual coziness that characterized trends at the time. In 2020, Santis began collaborating with Porsche on one-off car restorations tied to purchasable capsule collections. The first was a Porsche 964 Carrera 4, whose brilliant white exterior contrasted with its vibrant interior, which mixed rich sunflower leather from Schott with upscale Loro Piana houndstooth fabrics. Both fabrics, in turn, were incorporated into items for the corresponding capsule collection. It set a precedent for using a covetable vehicle as a means to sell the lifestyle associated with it, and although Aimé Leon Dore's Porsche

THE CONVERGENCE OF STREETWEAR, HIGH FASHION, AND DIGITAL PLATFORMS HAS LED TO INNOVATIVE

an attempt to build awareness with an American audience. Originally priced at $19,900 ($7,000 more than the standard model), the bells and whistles included a five-piece set of monogrammed Gucci luggage, a vinyl roof cover adorned with the house's Double-G monogram, and Gucci nameplates affixed to the stretching wheel rims and glove compartment. The interlocking G's were designed by Aldo Gucci himself, so it was a point of pride that they also became the centerpiece of the vehicle as a 24-karat gold-plated hood ornament.

Outside of the realm of luxury, in 1984 Ford partnered with outdoor purveyor Eddie Bauer to begin a decades-long collaboration that saw the companies come together on a premium customization package for the rugged Ford Explorer SUV. Available in custom colors and upholstery, it became an upper-middle-class status symbol that set the stage for menswear's long-running obsession with outdoor-oriented brands and automotive partnerships. A few years later, in 1999, British designer Paul Smith worked with MINI on a car featuring 84 stripes and 26 colors, shown at the Tokyo Motor Show. Single-colored versions of the car became available for purchase, with coordinating clothing items like a deep-blue shirt made to specifically match the color used on the car. Smith followed up this collaboration with a multicolored Land Rover collab in 2015, and then went in an unexpected direction when he got back together with MINI in 2021. For the MINI STRIP, Smith pared down not just the colors, but also elements of the car itself to reduce the overall carbon footprint of the electric vehicle, creating an irony in having a maximalist known for his embrace of colors take a minimalist approach.

one-off collaborations aren't necessarily available for customers to buy, they can certainly visit the beautiful vehicles in the brand's flagship stores, where they are often proudly on display.

That same year, Santis's close friend Ronnie Fieg debuted Kith's collaboration with BMW. An avid collector and appreciator of the luxury car brand, Fieg's own collection is an impressive fleet. He partnered with the German manufacturer on a restoration of his own E30 M3, but also collaborated with them on a run of 150 BMW M4 x KITH cars, with exclusive branding and colors. Although the cars carried a hefty price tag of $109,250, that didn't stop them from selling out in 11 minutes. Ronnie Fieg's Kith x BMW partnership was rooted in nostalgia, modernizing the classic BMW E30 with elevated details that spoke to both sneakerheads and car aficionados. Fieg's ability to seamlessly bridge generations of BMW fans with Kith's cutting-edge aesthetic showed how collaboration can blend a deep respect for tradition with bold, forward-thinking design.

In the dynamic intersection of fashion, technology, and digital consumer behavior, the future of creative collaborations is being redefined. The convergence of streetwear, high fashion, and digital platforms has led to innovative partnerships that not only captivate audiences but also set new industry standards.

But ironically, this has also inspired a movement towards embracing the physical and classic luxury in new ways. The future of collaboration culture will likely play on this new tension between early adopters of new technologies and an old-school mentality that champions timeless craft and a slower approach to life. After all, hasn't the most-treasured luxury of all always been time?

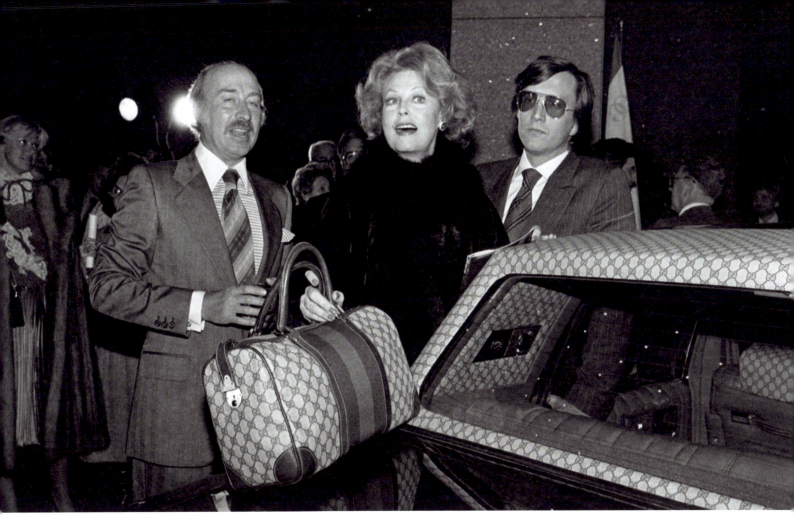

PARTNERSHIPS THAT NOT ONLY CAPTIVATE AUDIENCES BUT ALSO SET NEW INDUSTRY STANDARDS.

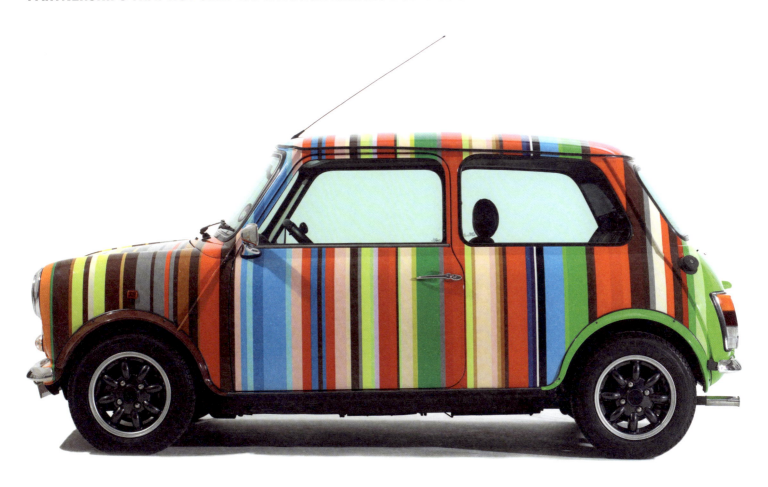

Top: Gucci x Cadillac Seville Luxury Car Debut at the Olympic Towers, 1978
Bottom: Mini x Paul Smith

PHOTO INDEX

ADIDAS ORIGINALS x WALES BONNER
pp. 172–179
Courtesy of adidas Originals, photography by Rennell Medrano/@renellmedrano

AIMÉ LEON DORE x NEW BALANCE
pp. 110–113
Courtesy of New Balance

AIMÉ LEON DORE x PORSCHE
pp. 244–249
Courtesy of Porsche AG

APPLE x BEATS
pp. 98–101
Courtesy of Beats

A$AP ROCKY x PUMA
pp. 6–11, banderole (back middle)
Courtesy of PUMA SE. Photography by Brandon Faith, baggenphotos.com/@baggen.photos

AUDEMARS PIGUET x 1017 ALYX 9SM
pp. 20–23
Courtesy of Audemars Piguet Germany

AUDEMARS PIGUET x KAWS
pp. 12–15
Courtesy of Audemars Piguet Germany

AURALEE x NEW BALANCE
pp. 108–109
Courtesy of New Balance

BALENCIAGA x CROCS
pp. 196–199
Sculpture by Anna Uddenberg, photography by Kristina Nagel. Courtesy of Balenciaga

BEAMS x ARC'TERYX
pp. 114–117, banderole (front middle)
Courtesy of Arc'teryx

BMW x JEFF KOONS
pp. 258–263
BMW THE 8 X JEFF KOONS:
Limited edition of the BMW M850i xDrive Gran Coupé designed by Jeff Koons. © BMW AG (pp. 258–261)
BMW Art Car #17 by Jeff Koons on Pulpit Rock near Stavanger, Norway.
© Dag Myrestrand/www.bitmap.no (p. 262)
BMW Art Car #17 by Jeff Koons.
Photo: Enes Kucevic © BMW AG
(p. 263 top left + bottom)
BMW Art Car #17 by Jeff Koons.
© BMW AG (p. 263 top right)

BMW x JULIE MEHRETU
pp. 252–257
BMW Art Car #20 by Julie Mehretu at Concorso d'Eleganza Villa d'Este 2024.
Photo: Enes Kucevic © BMW AG
(pp. 252–253);
BMW Art Car #20 by artist Julie Mehretu.
Photo: Tereza Mundilová © BMW AG
(pp. 254–256, 257 top);
BMW Art Car #20 by artist Julie Mehretu.
Photo: Andreas Hempel © BMW AG
(p. 257 bottom)

BRAVEST x KID CUDI
pp. 134–135
Courtesy of Bravest Studios

CROCS x KFC
pp. 136–137
Courtesy of Crocs

CROCS x SALEHE BEMBURY
pp. 138–141
Courtesy of Crocs

DENIM TEARS x LEVI'S
pp. 162–167, banderole (front flap, right)
Courtesy of Denim Tears

DIOR x AIR JORDAN
pp. 72–73, banderole (back flap, top left)
Courtesy of Dior, photography by Brett Lloyd (p. 72), Jackie Nickerson (p. 73)

DIOR x KAWS
pp. 142–145
Courtesy of Dior, photography by Brett Lloyd (pp. 143–145)

DIOR x STONE ISLAND
pp. 74–75
Courtesy of Dior, photography by Jackie Nickerson

DUNKIN' x SAUCONY
pp. 130–133
Courtesy of Dunkin'

DUNKIN' x SCRUB DADDY
pp. 128–129
Courtesy of Dunkin'

EVIAN x VIRGIL ABLOH
pp. 30–31
Courtesy of evian and Virgil Abloh Foundation

FENDER x HIROSHI FUJIWARA
pp. 16–19
Courtesy of Fender

GANNI x NEW BALANCE
pp. 102–105
Courtesy of New Balance

HEINZ x ABSOLUT VODKA
pp. 28–29
Courtesy of Kraft Heinz
(H. J. Heinz Foods UK Limited)
VML Spain (VML Young & Rubicam, S.L.),
www.vml.com
Haarala Hamilton, haaralahamilton.com/@haahaphotography
Jennifer Kay, jenniferkay.co.uk/@jenkayprops

HOKA x SATISFY
pp. 188–191, banderole (front left)
Courtesy of HOKA

HUF x KODAK
pp. 168–171
Courtesy of Huf Worldwide

JJJJOUND x BAPE
pp. 78–81
© 2025 NOWHERE Co., Ltd.

LEGO® x NASA
pp. 42–45
Courtesy of LEGO Group

LEGO® x STAR WARS™
pp. 46–51
Courtesy of LEGO Group

LOUIS VUITTON x NIKE
pp. 76–77, banderole (front right)
Courtesy of Louis Vuitton, Runway and Runway details images by Ludwig Bonnet, Backstage images by Matthieu Dortomb (pp. 76–77); Dominique Charriau/Wirelmage/Getty Images (banderole, front right)

LOUIS VUITTON x SUPREME
pp. 84–87
Courtesy of Louis Vuitton

LOUIS VUITTON x TIMBERLAND
pp. 94–97
Courtesy of Louis Vuitton, Runway and Runway details images by Ludwig Bonnet, Backstage images by Matthieu Dortomb, Campaign by Colin Dodgson

MERCEDES-BENZ x MONCLER BY NIGO
pp. 38–41
Courtesy of Mercedes-Benz AG, photography by Lukas Müller (pp. 38, 41 bottom) and Thibaut Grevet (pp. 39, 40, 41 top)

MERCEDES-BENZ x VIRGIL ABLOH
pp. 232–237
Limited Edition MAYBACH by Virgil Abloh, courtesy of Mercedes-Benz AG, images by recom Berlin (pp. 232, 235, 236 top), Lee Wei Swee (pp. 234 top, 236 bottom, 237) and Amos Fricke (p. 234 bottom)

MONCLER GENIUS
pp. 204–221, banderole (back left)
Courtesy of Moncler Genius (pp. 204–205, 208–209); Photography by Julien Tell/Highsnobiety (pp. 206–207, 210–213, banderole back left)

NIKE x OFF-WHITETM
pp. 82–83
Courtesy of Nike

NIKE x SACAI
pp. 36–37
Photography by Julien Tell/Highsnobiety

OMEGA x SWATCH
pp. 266–269, banderole (back right)
Courtesy of Swatch Group Ltd.

OVO x NFL
pp. 158–161
Courtesy of October's Very Own.

PALACE x MERCEDES-BENZ
pp. 238–243
Courtesy of Palace

PAUL SMITH x LAND ROVER
pp. 250–251, banderole (back flap, bottom left)
Courtesy of Paul Smith

PORSCHE x LA MARZOCCO
pp. 264–265
Courtesy of Porsche AG

POKÉMON x VAN GOGH MUSEUM
pp. 24–27
© 2025 Pokémon/Nintendo/Creatures/GAME FREAK. TM, ® Nintendo. Vincent van Gogh, Self-Portrait with Grey Felt Hat, 1887, Van Gogh Museum, Amsterdam (Vincent van Gogh Foundation)

PRADA x ADIDAS
pp. 62–65
Courtesy of Prada SPA

PRADA x HOMER
pp. 66–67
Courtesy of Prada SPA

PUMA x DUNKIN'
pp. 34–35
Courtesy of Dunkin'

RICK OWENS x DR. MARTENS
pp. 68–71
Courtesy of OWENSCORP

RIMOWA x OFF-WHITE™
pp. 106–107
Courtesy of Rimowa

SANDY LIANG x SALOMON
pp. 184–187, banderole (front flap, left)
Courtesy of Sandy Liang and Salomon; Photography by Steven Yatsko (pp. 184–187), Annemarie Kuus (banderole, front flap, left); Talent: Chloe Franzen/APM Models, Sasha Coito/New York Model MGMT

STÜSSY x BIRKENSTOCK
pp. 180–183
Courtesy of Stüssy, Photography by Antosh Cimoszko, Models: Sara, Angel, Gabe, Styling: Landon Ebeling

STÜSSY x DRIES VAN NOTEN
pp. 88–93
Courtesy of Stüssy, Photography by Antosh Cimoszko; Models: Angel, Nas, Jan, Landon & Nati

STÜSSY x MOUNTAIN HARDWEAR
pp. 192–195
Courtesy of Stüssy, Photography by Antosh Cimoszko, Videography by Hayden Rensch, Models: Stafhon, Jed, Jake

THE NORTH FACE x BIALETTI
pp. 32–33
Courtesy of RMP srl.

THE NORTH FACE x MM6 MAISON MARGIELA
pp. 200–203, banderole (back flap, right)
Courtesy of The North Face

UNDERCOVER x EVANGELION
pp. 218–221
© UNDERCOVER, © khara

UNIQLO x JW ANDERSON
pp. 214–217
Courtesy of UNIQLO USA, LLC.

Y/PROJECT x UGG
pp. 146–149
Courtesy of Y/PROJECT; Campaign photography by Arnaud Lajeunie/@arnaudlajeunie and styling by Ursina Gysi/@ursinagysi (pp. 146–148, 149 top left); photography by Matthieu Lemaire-Courrapied/@matthieulemairecourapied (p. 149 top right + bottom)

ADDITIONAL IMAGES

Foreword
p. 4: Alex de Brabant

How Marc Jacobs, Kim Jones, and Virgil Abloh Made Collaborations Luxurious
p. 52: Theo Wargo/Getty Images, Taylor Hill/Getty Images, Mike Marsland/Getty Images; p. 55 top left + right: Courtesy of Farfetch; p. 55 bottom: Gregory Pace/FilmMagic/Getty Images; p. 56 top left: Antonio de Moraes Barros Filho/WireImage/Getty Images; p. 56 top right: Catwalking/Getty Images; p. 57: Peter White/Getty Images; p. 58: Lexie Moreland/WWD/Penske Media/Getty Images; p. 59: Peter White/Getty Images; p. 60: Matthieu Dortomb / Courtesy of Louis Vuitton, p. 61: Courtesy of Louis Vuitton

Novel Ideas: Kitsch, Novelty, and the Power of Surprise
p. 118: John Deeb; p. 121 top left + right: Estrop/Getty Images; p. 121 bottom: @pkyesway; p. 122: Retro AdArchives/Alamy Stock Photo; p. 123 top left: Frank Micelotta/Getty Images; p. 123 top right: Jared Siskin/GC Images/Getty Images; p. 123 bottom left: Arnaldo Magnani/Getty Images; p. 123 bottom right: David M. Benett/Dave Benett/Getty Images for i-D; p. 124: Maison Jules Auction House; p. 125: Courtesy of Kith; p. 127 top: Jerritt Clark/Getty Images for McDonald's; p. 127 bottom: Courtesy of Palace

From Pop to Pop Culture: Art's Crossovers with Streetwear, Fashion, and Consumer Products
p. 150: Floortje/Getty Images/Highsnobiety; p. 153 top: CFOTO/Future Publishing/Getty Images; p. 153 bottom: Salvatore Laporta/Getty images; p. 154: Dominique Maître/WWD/Penske Media/Getty Images; p. 155: Bryan Luna; p. 156: Matteo Canestraro

"X" Marks the Spot: The Recipe for a Perfect Collab
p. 222: Courtesy of Sotheby's; p. 225 top left: Courtesy of Farfetch; p. 225 top right: Doug Pensinger/Getty Images; p. 225 bottom: Gregory Bojorquez/Getty Images; p. 226: Jay L. Clendenin/Los Angeles Times/Getty Images; p. 227: Courtesy of adidas; p. 229 + 230: Julien Tell/Highsnobiety

URL to IRL: The Future of Collaboration
p. 270: Pascal Le Segretain/Getty Images; p. 273 top: Noam Galai/Getty Images; p. 273 bottom: Frazer Harrison/Getty Images; p. 274: Alain Gadoffre/NBAE/Getty Images; p. 275: Alice Gao; p. 277 top: Tony Palmieri/WWD/Penske Media/Getty Images; p. 277 bottom: Courtesy of Paul Smith

The Incomplete

Volume 2

Highsnobiety Guide
to Creative Collaborations

The book was conceived, edited, and designed by gestalten.

Edited by Robert Klanten and François-Luc Giraldeau for gestalten
Co-edited by Highsnobiety

Feature texts by Jian DeLeon
Collaboration texts by Puja Patel

Design and Layout: Hy-Ran Kilian
Project Management: Lars Pietzschmann for gestalten
Managing Editor: Jake Indiana for Highsnobiety
Image Research: Callum Leyden for Highsnobiety
Photo Editing: Madeline Dudley-Yates for gestalten

Highsnobiety Publisher: David Fischer
Highsnobiety Managing Director: Jeff Carvalho
Highsnobiety Brand Manager: Hendrik Jürgens

Typeface: Univers by Adrian Frutiger

Printed by aprinta druck GmbH, Wemding
Made in Germany

Published by gestalten, Berlin 2025
1st printing, 2025

ISBN 978-3-96704-156-9

© Die Gestalten Verlag GmbH & Co. KG, Berlin 2025

All rights reserved. No part of this publication may be reproduced or transmitted in any form or by any means, electronic or mechanical, including photocopy or any storage and retrieval system, without permission in writing from the publisher. Respect copyrights, encourage creativity!

Die Gestalten Verlag GmbH & Co. KG
Mariannenstrasse 9–10
10999 Berlin, Germany
hello@gestalten.com

For more information, please visit www.gestalten.com.

Bibliographic information published by
the Deutsche Nationalbibliothek.

The Deutsche Nationalbibliothek lists this publication in the Deutsche Nationalbibliografie; detailed bibliographic data are available online at www.dnb.de.

None of the content in this book was published in exchange for payment by commercial parties or designers; gestalten selected all included work based solely on its artistic merit.

This book was printed on paper certified according to the standards of the FSC®.

Since its start in 2005, **Highsnobiety** has emerged as a highly influential media company among young, educated, and affluent readers, namely for its ability to detect and induce emerging trends across fashion, music, art, and style. Highsnobiety's print and digital reporting is widely recognized for having spurred the growth of streetwear and later, for helping to close the gap between high fashion and street style. Due to its niche voice and its consistency in providing highly curated and original content, Highsnobiety has grown a fiercely loyal and global readership and social following.

Jian DeLeon is a fashion expert, consultant, and author based in New York. As former Editorial Director of Highsnobiety, he covered the intersection of streetwear, sneakers, and luxury fashion. He is the author of two books published by gestalten: *The Incomplete: Highsnobiety Guide to Street Fashion and Culture* and *The New Luxury*.

Puja Patel is a journalist and curator. She has previously served as the editor of Pitchfork and SPIN. Her writing has appeared in the *New Yorker, Harper's Bazaar, Rolling Stone,* and MTV among others.